NEW ATLAS OF
HUMAN
ANATOMY

S0-ARJ-837

NEW ATLAS OF
HUMAN
ANATOMY

General Editor: **Thomas McCracken**
Contributing Editor: **Richard Walker**

**BARNES
&NOBLE
BOOKS**
NEW YORK

Text and design copyright © 1999 by Anatographica, LLC
All digital anatomy images copyright © 1999 by Visible Productions, LLC

Visible Human Project™ is a trademark of the National Library of Medicine

This edition published by Barnes & Noble, Inc.,
by arrangement with Anatographica, LLC

All rights reserved. No part of this book may be used or reproduced
in any manner whatsoever without the written permission of the Publisher.

1999 Barnes & Noble Books

ISBN 0-7607-1921-7 (HC)
ISBN 0-7607-4607-9 (PB)

03 04 05 06 07 MC 9 8 7 6 5 4 3
03 04 05 06 07 MP 9 8 7 6 5 4 3 2 1 (PB)

General Editor: Thomas O. McCracken, MS
 Vice President for Product and Development,
 Visible Productions, LLC, Fort Collins, Colorado
 Former Associate Professor of Anatomy, College of
 Veterinary Medicine and Biomedical Sciences,
 Colorado State University

Contributing Editor: Richard Walker, BSc, PhD

Editor: Martin Griffiths, BSc, PhD
Designer: Peter Laws
Jacket design by Kevin McGuiness

Designed, edited and typeset by Anatographica, LLC

Printed and bound in China

LFA

•CONTENTS•

CONTENTS

SYSTEMIC ANATOMY

REGIONAL ANATOMY

We are indebted to the National Library of Medicine for having
the foresight to fund and direct "The Visible Human Project™", from
which the models used in this book were derived.

We would also like to thank **Dr David Whitlock** and **Dr Vic Spitzer**
(Center for Human Simulation, University of Colorado Health
Sciences Center) for performing the arduous task of creating
the original data.

Special thanks and credit are due to the members of Visible Productions
that helped make the extraordinary images contained in this book:

Dottye A. Baker: Assistant to the Editor

Phillip Guzy: Director of 3D Model Production,
Senior Animator, Medical Illustrator

Sean McCracken: 3D Model Production Assistant

Gale Mueller: Medical Illustrator

Sherra Cook: Medical Illustrator

Conery Calhoon: Medical Illustrator

In addition to the digital imagery derived from the Visible Human Project™ resource, a small number
of other images have been used to illustrate this book, where they are more appropriate to the subject.

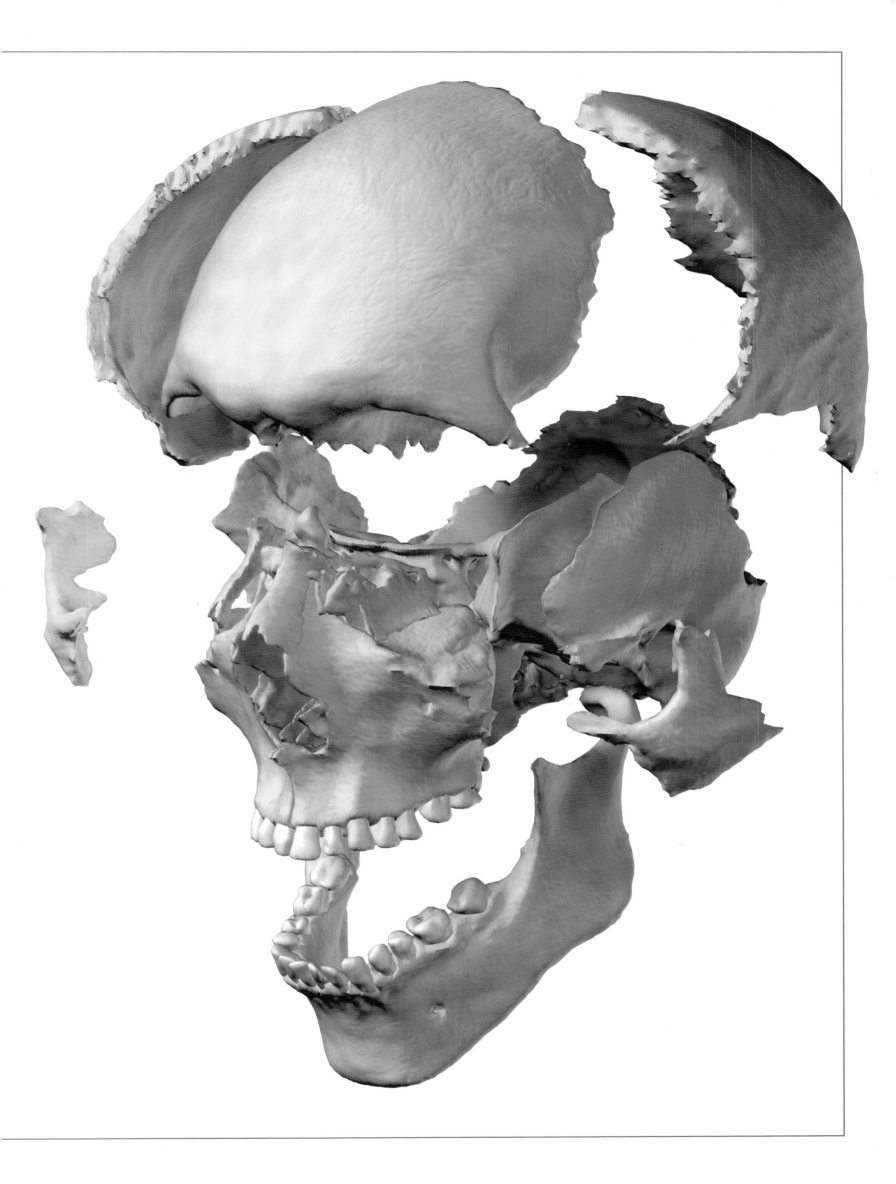

•INTRODUCTION•

AN OVERVIEW

INTRODUCTION BY THOMAS O. MCCRACKEN

"WHAT A PIECE OF WORK IS MAN," PROCLAIMED SHAKESPEARE'S HAMLET. NOT ONLY DURING THE ELIZABETHAN AGE, BUT SINCE LONG BEFORE, THE STUDY OF MAN—AND SPECIFICALLY THE HUMAN BODY—HAS BEEN A PRIMARY FIELD OF SCIENTIFIC INTEREST TO ACADEMICS, HEALTH PROFESSIONALS, AND ORDINARY PEOPLE TOO. THE DEVELOPMENT OF ANATOMICAL ILLUSTRATION HAS ECHOED THIS INTEREST, WITH THE QUANTITY AND QUALITY OF ILLUSTRATIONS PRODUCED REFLECTING THE LEVELS OF POPULAR INTEREST AT DIFFERENT TIMES. AND NEVER BEFORE HAS THERE BEEN AS MUCH INTEREST AS THERE IS TODAY.

The history of anatomical illustration is punctuated by dramatic innovations, followed by periods of refinement and development. One of the greatest innovations occurred in the early 16th century, when Andreas Vesalius published his collection of detailed anatomical drawings, which established the realism that has persisted to this day. Another innovation coincided with the development of printing and graphic reproduction technology, in the late 18th and early 19th centuries, which enabled wonderfully detailed and beautifully colored images to become more widely available. The 20th century has also seen several important landmarks, including the use of photography in anatomical atlases and the introduction of X-ray, computerized axial tomography (CAT), and magnetic resonance imaging (MRI) in medical science itself. The use of endoscopy and video to film internal living tissues is a further ground-breaking step in the development of our visual appreciation of the human body, from the inside rather than from without.

At the turn of the millennium, we are in the midst of yet another extraordinary development, which this book celebrates in print, although the development itself spans various media. This is the first, anatomically exact and complete, three-dimensional, computer-generated reconstruction of a human body.

This technique comes closest to achieving the ideal of anatomical representation—which is to recreate visually the exact forms of the human body and all its parts. And what is even more extraordinary is that because images such as the one on the facing page have been created in digital, computerized form, the way is now open for the next development— the recreation of the same in not just visual, but virtual form as well. The dawn of virtual anatomy is finally here.

The human respiratory system. From the sinuses in the forehead and cheeks, to the trachea and lungs, new developments in digital imaging techniques allow the organs and systems of the human to be visualized as they really are.

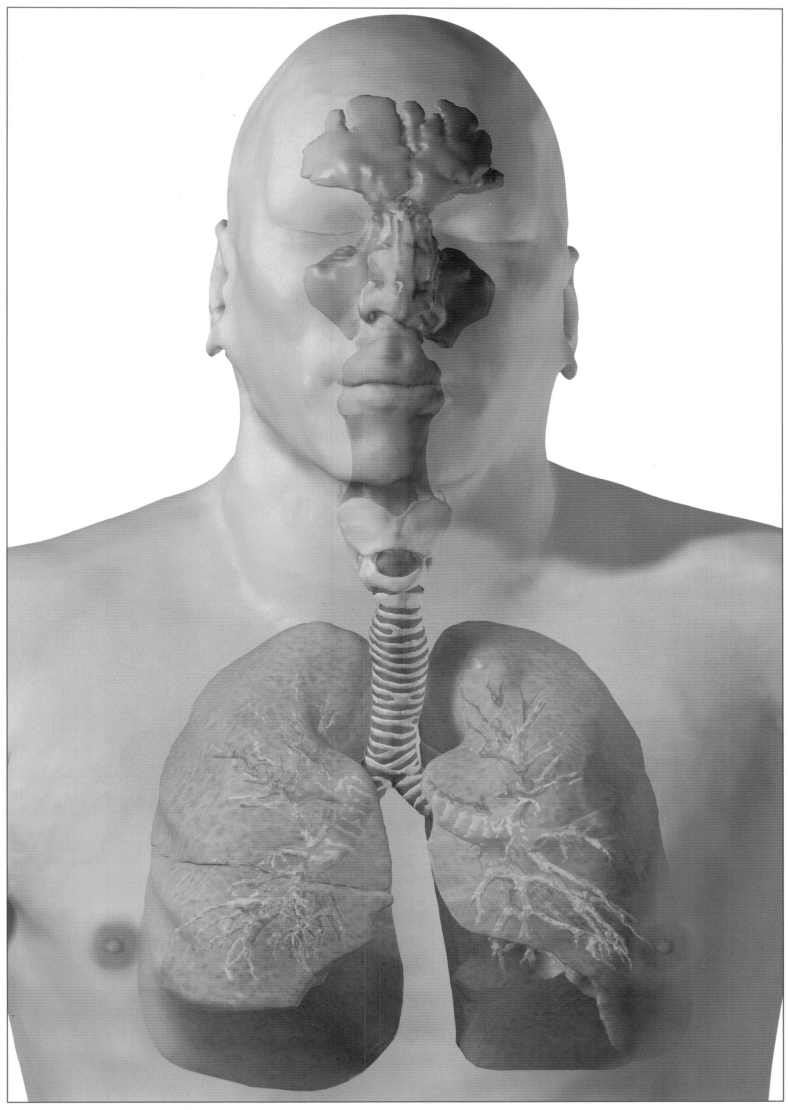

THE HISTORY OF ANATOMICAL ILLUSTRATION

TO APPRECIATE FULLY THE CONTEXT AND SIGNIFICANCE OF THE AMAZING IMAGES THAT CAN BE SEEN IN THIS BOOK, IT IS USEFUL TO GLANCE BACK THROUGH TIME, AND REVIEW HOW THE ART AND SCIENCE OF ANATOMICAL ILLUSTRATION HAS EVOLVED.

The European Tradition

In the west, the tradition of anatomical study, in which illustration plays a crucial part, can be traced to the medical schools of Alexandria, where dissection and the science of anatomy were practised and studied as long ago as 300 BC. A profound knowledge of anatomy had clearly been acquired long before this time, however—not only in this part of the world, where the Egyptians had been preparing their dead for mummification for hundreds of years, but also in distant Asia, where most notably the Chinese medical tradition, which required detailed study of the body and its parts, had long been established.

Ancient teaching traditions tended to rely on transmitting knowledge from person to person, master to student, expert to novice, and such communication leaves little in the way of permanent records. Thus the evidence of anatomical illustration from these times is scant. The codification of medical knowledge in the Roman world was undertaken several hundred years later, by a Greek physician called Galen. He lived from about AD 130 to AD 200, and the titles of his two most famous works on the human body can be translated as *The Usefulness of Parts* and *On Anatomical Procedures*. These studies drew heavily on Alexandrian sources.

When Alexandria was captured by the Arabs, in AD 642, the wealth of scholarship that had amassed in the city passed into their hands. The Arabs' development of it played an important role in ensuring its continuance, until it re-emerged in Medieval Europe in the form of traditions and associated Arabic manuscripts that had persisted and flourished under Moorish rule. Only in the Eastern Mediterranean were original Greek texts preserved, typically in Christian hands.

Anatomy in Medieval Europe

Medical schools in Italy (Bologna and Salerno) and France (Paris and Montpellier) existed in the early 13th century; the most influential anatomical work of this time was an Italian dissection manual, *Anatomia Corporis Humani*, by Mondino de' Luzzi. The earliest-known illustrations to this work date from the 15th century, but these give more information about the process of dissection than of anatomical detail.

One difficulty faced in representing real anatomy was the variance between the generalized descriptions of Galen and others, and what could actually be seen as tissues were lifted or pared away. The humanist views of Renaissance philosophers and scientists presented them with potentially conflicting aims—on the one hand they were eager to re-establish the classical authority of the Greeks; yet on the other hand, they valued the scientific process of empirical observation. The anatomical drawings of Leonardo da

Vinci can be seen to reflect these contradictions, in that some idealize the body and its parts, following traditional views, while others represent meticulously what his eyes observed.

The Birth of Modern Anatomy

The most significant change in the history of anatomical illustration is attributed to a near-contemporary of Leonardo da Vinci, Andreas Vesalius, who was born in Belgium in 1514, four years before Leonardo died. After studying medicine in Paris and other great European centers of learning, Vesalius settled in Padua, in Northern Italy, and established his reputation there as an anatomist. His major work, *De Humani Corporis Fabrica*, translated as *On the Structure of the Human Body*, was published in 1543, and established definitively the science of anatomy based on observation.

De Humani Corporis Fabrica is without doubt one of the single greatest contributions to medical science and marks the beginning of modern medical and biological science. Although its impact was to undermine the precepts of Galenic anatomy, this was not Vesalius's intention. Rather than seeking to oppose completely the teachings of Galen, he was attempting to correct Galen's anatomical descriptions where they disagreed with his own discoveries and observations. Nevertheless, it was from Vesalius's illustrations that the search for realism in anatomical illustration was born.

Succeeding centuries have witnessed increasing refinement in representing human anatomy—both in terms of the techniques used and the details that result. One prominent landmark in this progression was the development of cost-effective printing and coloring techniques, which enabled large color plates of fascinating detail and remarkable beauty to be made widely available, as early as the 1830s. Another landmark was the first edition of Henry

Gray's *Anatomy Descriptive and Surgical*, published in 1858. This was considered unremarkable at the time, as the illustrations were relatively small and not as artistically executed as other works of descriptive anatomy. But Gray was initiating a new tradition, of primarily didactic anatomy for the instruction of medical students and practicing doctors.

Plate 22 from Vesalius's *De Humani Corporis Fabrica*, perhaps the most famous of the Vesalian illustrations. Artworks of this period typically try to present the dissection as if it had been performed without loss of life—hence the Shakespearean pose of the skeletal Hamlet addressing his Yorrick.

TEXTBOOK ILLUSTRATIONS

ILLUSTRATED MEDICAL TEXTBOOKS HAVE DOMINATED THE FIELD OF ANATOMICAL ILLUSTRATION FROM THE MIDDLE OF THE 19TH CENTURY TO THE PRESENT DAY. TWO TRADITIONS PREVAILED. ONE, WHICH IS STILL TO THE FORE IN WORKS ABOUT SYSTEMIC ANATOMY, EMPHASIZES DIAGRAMMATIC REPRESENTATIONS OF LARGER PARTS, ESPECIALLY WHOLE SYSTEMS, AND RESERVES FINE DRAWING FOR SMALL COMPONENTS AND SIGNIFICANT ANATOMICAL DETAILS. THE OTHER, WHICH IS PREVALENT IN STUDIES OF REGIONAL ANATOMY, IN THE FINE TRADITION OF ANATOMICAL ATLASES, SEEKS TO GIVE THE BODY AND ITS PARTS A REALISTIC, EVEN LIFELIKE, APPEARANCE.

While the sequence of editions of *Gray's Anatomy* continues to exemplify the systemic tradition, the more realistic style has its champions in the atlases of anatomy of Johannes Sobotta, of Wurtzburg in Germany, and Eduard Pernkopf, of Vienna in Austria.

However, although the beautiful works of regional anatomy begun by these last two eminent professors, and continued by their successors, offer the appearance of reality—as we might wish to imagine it: bright, clear, and clean—they are, in fact, also idealizations, and in this sense have more in common with the spectacular illustrations of the early 19th century than with the realities of

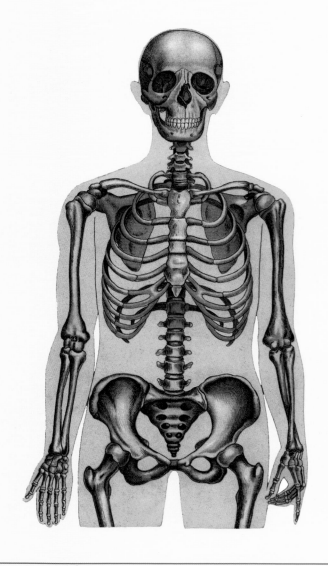

the dissecting table that anatomy students must face today.

In stark contrast, such reality is addressed directly in the innovation, made possible by the camera, of the photographic atlas of dissected anatomy. This is particularly effective when combined with explanatory drawings, as it allows the student to cross the intellectual gap between the generalized diagram and the often confusing tissue beneath the dissecting scalpel blade. Other atlases, most notably those in the tradition initiated by J. C. Boileau Grant—who was born and studied in Scotland, but achieved fame in Toronto, Canada, where he was Professor of Anatomy from 1930 to 1956—concentrate wholly on the task of teaching the relationship of organs to each other, simply and

clearly, as an expert might demonstrate to a student. In color, atlases composed of such photographs represent the dissecting room experience even more realistically, although the colors portrayed are those of the preserved cadaver rather than of the living flesh anyone who graduates as a surgeon can expect.

In terms of pure anatomical illustration, it can be argued that the ideal balance between the realistic and the explanatory is achieved by the American Frank H. Netter. Trained as both a commercial artist and a surgeon, Netter chose to pursue his life's work in the former field, as a medical illustrator. The result can be regarded as the epitome of the scientific illustrator's art, in which the beauty of artistic form is modified to optimize the intended function, which is to reveal and explain.

A sequence of traditional anatomical illustrations revealing different aspects of the anatomy. Note the serene and smiling faces, typical of such works.

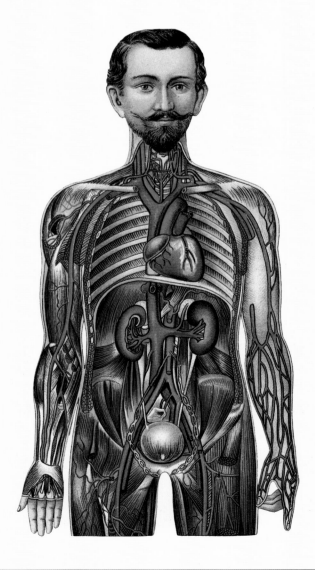

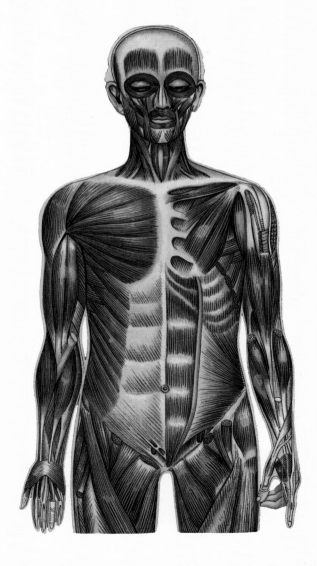

USING ANATOMICAL ILLUSTRATION

Anatomical illustration traditionally adopted two distinct approaches, according to the intended purpose. Regional anatomy is largely descriptive, aiming to illustrate what is visible to the naked eye in a particular part of the body. In contrast, systemic anatomy emphasizes the function of bodily structures—the digestive system or the cardiovascular system, for example. Such systems might extend over the whole body, like the nervous system, or be located in discrete organs, which might be widely separated "anatomically" (on the regional view), for example the endocrine system.

Since an accurate representation of how tissues and structures appear is vital for the performance of medical and surgical procedures, the regional approach—geared to allow recognition and manipulation—is dominant in texts for trainee and practicing surgeons. This approach pays great attention to portraying the actual appearance of, say, the kidney and its surrounding structures with as much accuracy and attention to detail as possible.

The systemic approach is geared towards understanding what is happening in the body, for example when one of the systems is damaged. Accurate details of the appearance of tissues are less important than a pictorial representation that enables understanding the function and interrelations between parts. The systemic approach —typified by *Gray's Anatomy*, and predominant in works aimed at medical students—typically represents a standardized human with "average" features and proportions. Systemic illustrations are more concerned with conveying information about, say, kidney function and less concerned with anatomical accuracy. Simplification aids understanding and diagrammatic approaches

enhance explanations of function. The systemic approach is often restricted to what is necessary to explain function.

Development of Anatomical Realism

Inevitably, the two approaches overlap to an extent and have developed hand in hand. There is a need to know about the structure of body components, say, the alimentary canal in order to understand how various constituent parts work together to achieve function. On the other hand, practical maneuvers require not just detailed knowledge of location and surrounding structures, but also an understanding of their purpose and importance in order to preserve or cut as needed.

Early anatomical drawings based on dissection were concerned not only with revealing structure but also with demonstrating the extent to which contemporary theories of function—for example, of how the circulatory system worked—were supported (or not) by anatomical reality. Moreover, the naked-eye dissection on which early descriptive anatomy was based was gradually expanded by other techniques, such as histology and embryology, which added factual and explanatory detail. Topographical anatomy came to embrace analysis of function; applied anatomy gave these observations practical application, translating them into useful principles for clinical medicine and surgery.

Advances in viewing techniques have enabled the study of progressively finer detail in human structure: the revelations of light microscopy and then electron microscopy enhanced the understandings of macroscopic dissection.

Anatomical studies have been progressively integrated with knowledge from other areas,.

for example the study of growth and development (embryology) or of what can go wrong within tissues (pathology), to yield enhanced understanding of both structure and function. As research progressed, the study of anatomy could be correlated with that of yet more "distant" disciplines, such as biochemistry, which highlight the significance of ultra-structural details, such as the cell membrane. These studies are integral to the modern study of anatomy, yet fundamentally depend upon the basic knowledge of topographical anatomy: function can only be understood in the context of structure.

The development of modern surgical techniques would have been impossible without the detailed knowledge passed on for centuries through traditions of anatomical dissection and illustration. So too, the remarkable progress of recent years has depended upon increasing accuracy and detail in representations of the body. Traditional methods of anatomical study were limited by the materials available: a dissection, however accurately represented, can only give a layer-by-layer view from one direction. The development of imaging techniques in clinical medicine enabled anatomical viewpoints of the body never before envisaged. Scanning technology using computerized tomography (CT) and magnetic resonance imaging (MRI) presented representations based upon cross-sectional "slices" of real people, which added much to anatomical understanding.

The need for accurate and accessible anatomical representation continues to increase along with advances in technology, medical capabilities, and, especially, surgical techniques, including the development of minimally invasive and microsurgery. Such innovations would have been impossible without recent advances in anatomical knowledge, and continue to drive the search for yet greater improvements in depicting the body.

The Virtual Body

By using digital mapping of the cross sections from the Visible Human Project™, anatomical illustration has reached a further stage, enabling a unique representation of the complete human body.

Descriptive anatomy has always paid great attention to position: illustrations based on the flat plane must be able to specify what is anterior or posterior, medial or lateral, superficial or deep. This relies on the standard anatomical position which, of course, is rarely encountered outside the textbook. The computer modeling of the dataset from the Visible Human Project™ releases anatomical illustration from such constraints and allows a

These two digital images of a real human brain show the incredible detail and capabilities of virtual anatomy. In the top picture, the gray matter of the brain has been removed revealing the white matter underneath. The lower brain has had the right cerebrum removed revealing the underlying structures. The ability to produce images with such detail and accuracy is of tremendous importance to medical education.

In regional anatomy, these techniques are unsurpassed in their ability to show neighboring structures clearly and precisely, located as they are in life. This sequence which shows muscles, tendons, and vasculature in the first two images, and bone, nerves and blood vessels in the third, demonstrates how different components can be "stripped away" to reveal the tissues underneath, something conventional dissection and imaging cannot do.

unique blend of both systemic and regional approaches based on an actual body captured in perfect detail.

The potential value of this project to medicine is immense. In addition, these images offer a new outlet for the public fascination with the body and its complexities. Perhaps not since the seventeenth and eighteenth centuries, when dissection was a spectacle performed before an audience in public anatomy theaters, has realistic portrayal of anatomical features been so accessible to those without medical training.

While anatomical illustration for medical purposes has been necessarily less concerned with artistic merit than with the intended application of the information, Visible Productions' 3D images could be seen as contributing to the long tradition of

artistic portrayal, which has produced so many great works of art depicting the human form. The clarity of these images, the quality and versatility of the representations and the authenticity of biological details offer a return to the aesthetic traditions of anatomical illustrations, as well as remarkable new insights into the human body.

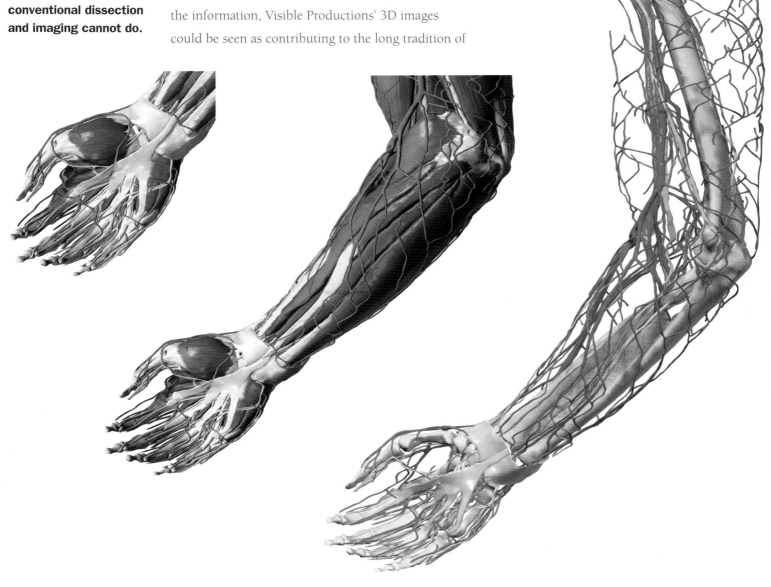

THE STORY OF VISIBLE PRODUCTIONS

The Vesalius Project

The origins of virtual anatomy lie in the Vesalius Project, which was initiated in 1986 by a team of scientists and anatomical illustrators at Colorado State University, consisting of Thomas Spurgeon, Assistant Professor of Anatomy, Stephen Roper, Professor and Chairman of the Department of Anatomy and Neurobiology, and myself, at the time Assistant Professor of Anatomy and Anatomical Illustration.

In particular, it was my dream to be able to turn the 2D artistic illustrations of modern anatomy teaching into 3D graphic computer images that could be rotated and viewed from any angle. So began the study and creation of the process necessary in order to accomplish this.

Our team had funding for three years to develop the skills, techniques, and technology necessary to turn 2D into 3D. Early on, we concentrated on simple anatomy and used the knee (due to its availability) as a prototype. We took cross-sections through the knee and then photographed and digitized the cross-sections by identifying and outlining structures of interest with an electronic digitizer. The digitizer converts the data into a series of 2D coordinates that are then organized and stacked by the computer into a 3D image, giving an accurate representation of the real object.

At the culmination of the project the team modeled and generated a 3D dog's head from CT scans. The resulting 3D image was simple, of low quality and low resolution, but it demonstrated the future potential.

The artwork of the Vesalian plates from the 16th century is all the more astonishing when considered that they were created from woodcuts.

Andreas Vesalius of Brussels

Andreas Vesalius of Brussels (1514–1564) was a 16th-century physician and anatomist who revolutionized the teaching of anatomy. He also illustrated his discussions by producing large charts, on which he drew his findings, much to the pleasure and encouragement of his students and fellow professors. In order to protect his interests, Vesalius decided to publish his drawings, and with the help of his fellow countryman and artist, Jan Stefan van Kalkar, a student of Titian, prepared a series of six woodcuts, which were published in 1538 and became known as the *Tabulae Anatomicae Sex*.

In 1543, Vesalius published what was to be his most important work and pinnacle achievement, *De Humani Corporis Fabrica*.

For every structure, an incredibly detailed "wireframe" image is generated (top left, detail top right) To this a surface is added by contour mapping— wrapping a surface around each structure to produce the final image (bottom).

In 1992, marketing executives from the pharmaceutical company Glaxo Welcome set a challenge—is it possible to put a human body into a computer to generate a 3D computer image? Bob Butler, of Butler Communications, had heard about the Vesalius Project and pooled a team of experts to accomplish the goal. Thus began the Virtual Anatomy Project.

It soon became apparent that the complicated programs for developing this idea weren't available and so it was necessary to bring together experts from many teams, for while we had the vision and knew what we wanted to do, we didn't have all the expertise to do it. Thus, a group of mathematicians, computer engineers, programmers, anatomists, and medical illustrators was formed to accomplish the task.

The anatomists were Tom Spurgeon, one of the best anatomical instructors at Colorado State University and an important resource for anatomical issues, and myself. Biographics, which had the expertise to render realistic images provided the biomedical illustrators, and brought an artistic and anatomical eye to the project. Rick Miranda, who specializes in topographical mathematics, the study of the surface of structures, dealt in the highly complex and detailed mathematical algorithms necessary to make the project work. Dave Alciatore is a professor of engineering who specializes in robotics, artificial intelligence, and computer simulation. The programmers were Dan Steward and Chris Fedde.

One important aspect has been to develop the postmarketing applications of the project. Visible Productions has a genuine interest in medical education and in how virtual anatomy is applicable to this, from the elementary level all the way up to the most scientific level: research that brings the drugs to the medical community. We have taken the different images and put them into different interfaces and scenarios to see how the images could be applied.

The next problem was obtaining a body and having access to the equipment necessary to slice such a body. Fortunately for the team, Victor Spitzer and Dave Whitlock, colleagues at the University of Colorado School of Medicine in Denver, Colorado, stepped in. They had such facilities and had just won the contract for the Visible Human Project™, the idea of which was to develop a visual image database of the human body. As practice for cutting the Visible Human they cut the thorax of a 59-year-old male who had died of a heart attack. Taking 500 µm sections (half the thickness of those taken for the Visible Human Project), the team constructed a 3D model of the thorax. This was the beginning.

The techniques and knowledge that enabled the team to take an actual human thorax, put it into the computer in 3D, and then communicate the very detailed and complex information, now existed. This information could, and can, be sent into any computer system, IBM-compatible or Apple Macintosh, into print, video, CD-rom, CDI, laptop, virtual reality—indeed, any technology platform.

An important aspect of virtual anatomy is its ability to make structures transparent, revealing the intricate detail within. In the image below you can clearly see the ventricles within the brain.

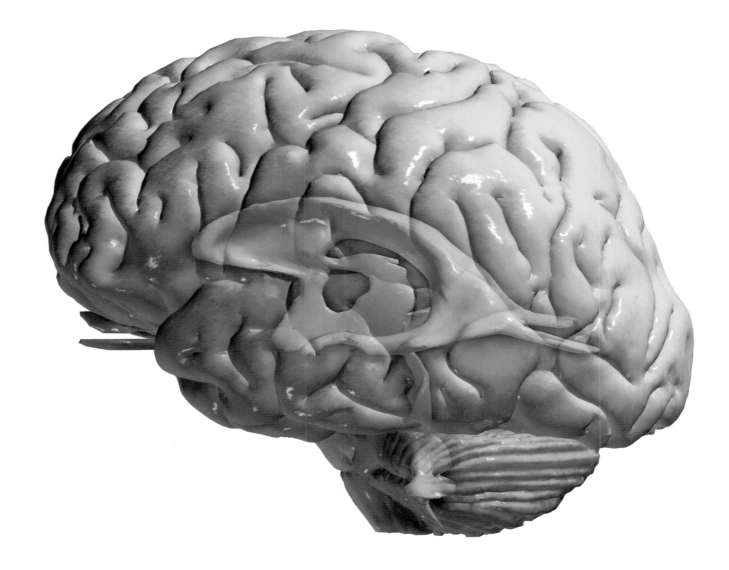

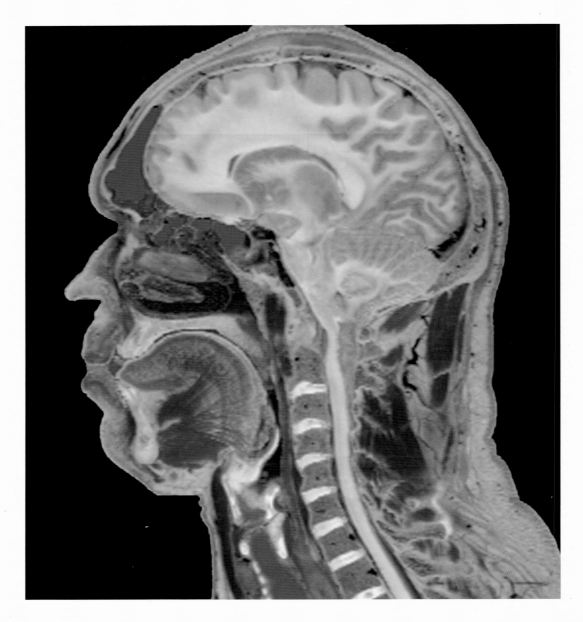

A midsagittal section through the head of the Visible Human. Two-dimensional photographs such as these were scanned and converted into a series of digital images in order to build up the three-dimensional images of which the virtual anatomy is comprised.

THE VISIBLE HUMAN PROJECT

The Visible Human Project™ first came about in 1988 after it was decided at a meeting at the National Library of Medicine (NLM), in Bethesda, Maryland—which houses one of the largest collections of medical knowledge in the world—to further medical information by creating a digital database of volumetric data that would represent a complete adult male and female as computer models. At that meeting were representatives from eight centers of learning who all specialize in the area of 3D anatomical imaging. The contract for the development of the dataset was tendered out and applied for by over one hundred medical schools. The grant was finally awarded to Victor Spitzer and Dave Whitlock of the University of

Colorado School of Medicine, who received US$1.4 million for the contract.

Having won the contract the first problem was to find a body. The idea was to use a representative male—they would image the female form later. However, suitable cadavers are surprisingly difficult to come by. What was needed was the body of a man between 21 and 60 years of age, less than six feet tall, less than 22 inches wide, less than 14 inches from front to back, and with a normal height for his body weight. These criteria were set mostly on the basis of the limitations of the equipment necessary to either image or slice the body.

The opportunity arose in 1993, after the body of convict Joseph Paul Jernigan, who was executed by

lethal injection, was donated to medical science. Jernigan was one of several inmates on death row in Texas who had donated their bodies to science. Because of the nature of their execution—the state of Texas executes by lethal injection—the organs were rendered unsuitable for use in transplant procedures, but otherwise they had the bodies of young, relatively healthy men.

Following his execution, Jernigan's body was shipped to Colorado by airplane, and was then documented and imaged using several different radiological procedures commonly used in the medical profession. Formats such as traditional X-rays, CAT, MRI, ultrasound, and positron emission tomography (PET) were all used. The cadaver was positioned in a wooden box and then encased in a foaming agent that hardened to form a cradle in which the body could be kept in a stable position throughout the imaging procedures. It was then frozen to -94°C, quartered, and embedded in a gelatin-ice mix. The team started with the feet, as it was felt that they should begin with the least complicated part first. Using a cryomacrotome, a highly accurate cutting device, 1-mm coronal (horizontal) sections were planed from each quarter revealing slice-by-slice the intricate detail within.

After taking each slice, the exposed surfaces were sprayed with alcohol and then photographed using a digital camera. The resulting 1878 color photographs could

then be stored as electronic, high-resolution digital images—digital images that would constitute 15 gigabytes of information.

Following the sectioning and imaging of the Visible Man, work started on the Visible Woman, an anonymous 59-year-old woman from Maryland, who died in 1993 following a blockage to the heart—the images that can be seen in this book of the female form came from this dataset. The Visible Human Project™ was an achievement in itself. However, in terms of virtual anatomy it was just the beginning.

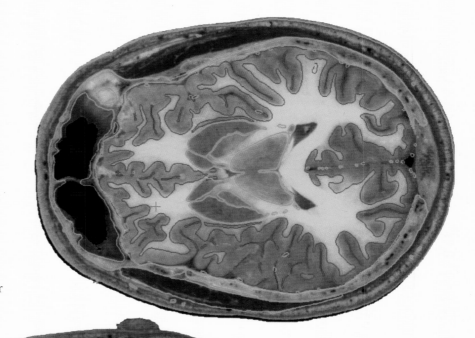

Horizontal (transverse) sections through the head of the Visible Human. In the top photograph the frontal sinuses can be clearly seen as the space in front of the brain. The lower photograph shows the eyes and the optic nerves as well as the nose and part of one ear.

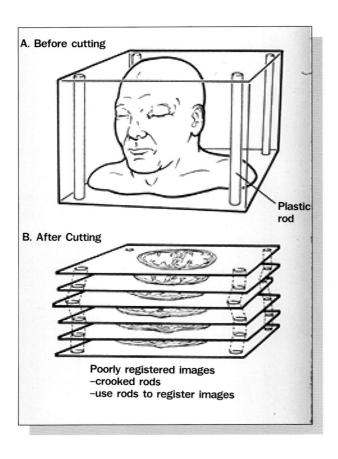

A. Before cutting

Plastic rod

B. After Cutting

Poorly registered images
–crooked rods
–use rods to register images

Part of the explanatory notes of one of the researchers on the Visible Human Project. The human cadaver was cut into a series of 1-mm sections and photographed. The note explains how the cadaver was supported in order to align the subsequent photographs.

From two dimensions to three

Once the slices and photographs from the Visible Human had been obtained, the next stage was to process the information in such a way that 3D structures could be constructed. Between 500–700 photographs were generated for every structure. These digital photographs were then outlined using a contour tracer, translating real human anatomy into points that describe a structure. Once the contours that defined the outside of a structure had been produced, they were stacked together to form a wireframe image. A surface was generated to connect the shapes by linking lines between the contours, forming a lattice-like effect. This is known as triangulation as the lines between the contours create triangles.

Each structure generates thousands of triangles, making the images very complex. To enable the computer to cope with the vast datasets and allow rapid manipulation of the 3D images it was necessary to simplify the images. This was accomplished by generating decimation algorithms that "decimated" unnecessary points or triangles, resulting in fewer, larger triangles, which the computer could rapidly manipulate. However, to the naked eye the images would be identical.

Once decimation was complete, surfaces and shading could be added to make the images more realistic. By photographing identical tissue specimens to the ones of interest and then texture mapping—wrapping the surface around each structure—a real, live image could be generated.

Since individual objects are created from separate files they can therefore be colored and shaded, deleted, or made transparent. This means that the objects can be made as real to life as possible or can be "dissected" out to reveal underlying structures. For example, the skin and muscles can be removed to reveal the underlying organs or the cardiovascular system can be highlighted. Since the images are 3D, anatomically correct, and real-time this means that they are completely accurate and can be manipulated by the viewer. The images can be rotated so that they can be viewed from any angle.

The liver revealed

This fascinating sequence of images through a virtual liver demonstrates the power as well as the beauty of virtual anatomy.

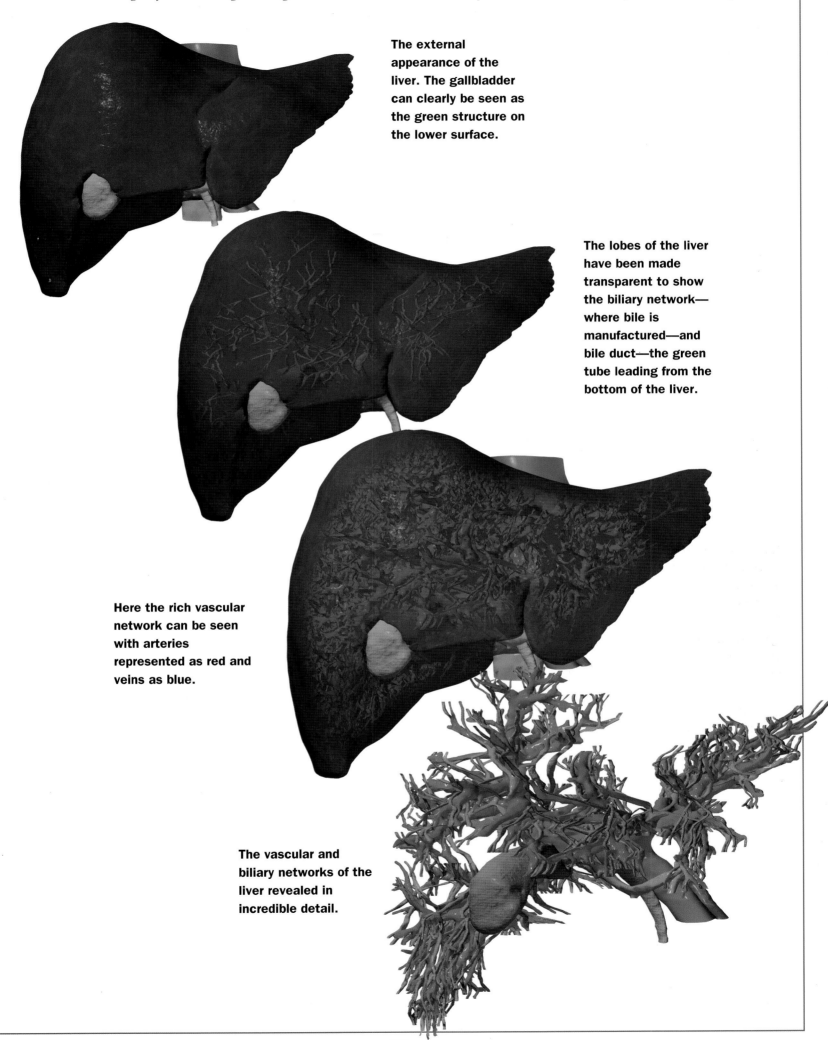

The external appearance of the liver. The gallbladder can clearly be seen as the green structure on the lower surface.

The lobes of the liver have been made transparent to show the biliary network— where bile is manufactured—and bile duct—the green tube leading from the bottom of the liver.

Here the rich vascular network can be seen with arteries represented as red and veins as blue.

The vascular and biliary networks of the liver revealed in incredible detail.

JUST THE BEGINNING

The Visible Human Project™ is unique in the sense that the images were sliced from an actual human body: anyone using it knows that the images are accurate, precise, and realistic. However, in terms of virtual anatomy, the VHP™ was just the beginning. Using Visible Productions' virtual anatomy, different aspects can be selected and the anatomy of that part visualized as it really is, not in a cartoon version. It is possible to make the images look like they came from a cadaver (conversely, the usual goal of anatomical depiction in anatomy textbooks is to make the image look like it was drawn from a living individual).

Because the images came from an actual human body they are accurate in terms of the spatial relationships of organs and parts: they are correct in terms of where things are. However, they are also accurate in terms of what the organs look like in an actual living individual. This is not so in cadaver dissection. The images will therefore be an important adjunct to cadaver use in anatomy teaching.

Anatomy and Medical Education

Another important aspect of the use of virtual anatomy in education is that the anatomy can be re-used, re-dissected. Once a cadaver has been dissected it is, in effect, not useful any more. A cadaver cannot be dissected twice. The virtual cadaver can be used over and over by many people, as many times as they want. Users of the virtual anatomy are not restricted to what is depicted on a page or on a screen.

What the user has available on the screen is just the starting point for further investigation with a virtual anatomy product. The user can probe at a deeper level at the touch of a button. This is of tremendous importance within the education system. Current teaching is almost entirely reliant upon 2D drawings of human anatomy. The availability of 3D computer material will dramatically advance understanding and learning.

Unlike conventional teaching, where each turn of the page of a book moves you on and allows you to see what is next, virtual anatomy is not linear. It is possible to look at a section of a program that deals with, say, the skeleton and then jump forward to see how the muscles and joints work within that particular region; or to see how two organs are connected so that a greater understanding of their function can be ascertained before returning to the original point in order to better understand their role. Whole systems or the individual components comprising them can be studied. The use of such a learning tool will help make clear the connections that are so difficult and yet so important to the process of learning. It will enable the student to put together the facts in order to develop the concept.

A particularly advantageous aspect of 3D computer generated anatomy to users of the data is that they are able to interact and immerse themselves into the data. This interactivity aspect of virtual anatomy cannot be overstated and is a very powerful teaching tool. For it is one thing to be able to look at a flat picture of a lung in a book, but an altogether different one to be able to see a virtual live breathing lung on the computer.

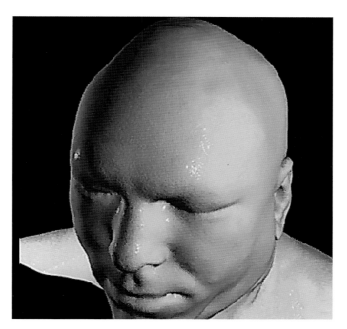

Sequences such as this one through the head are incredibly powerful training tools. As each layer is stripped away the interrelationships between the different aspects of anatomy are revealed.

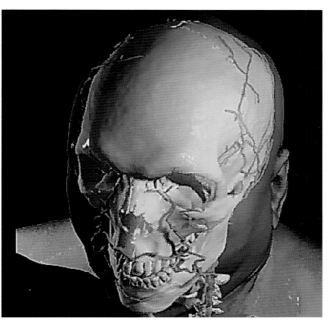

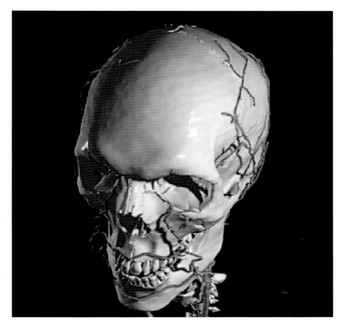

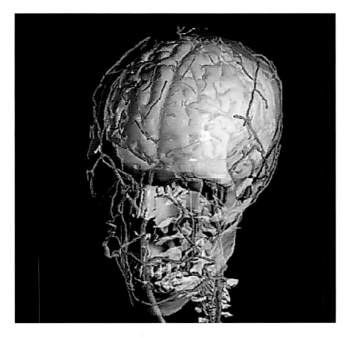

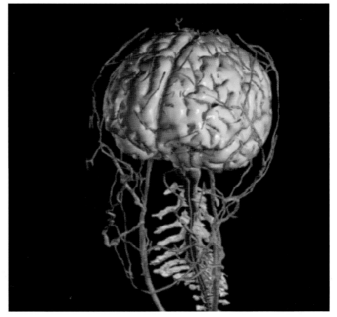

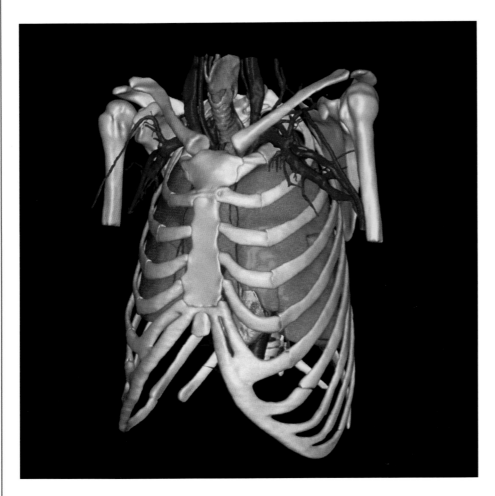

The amazing detail in these images allows them to be used as teaching materials, but also means that they stand on their own as works of art.

accurate and realistic models it is possible to idealize the action of a drug within a particular tissue. This is an aspect that could be of particular significance and importance to drug companies as well as to students studying drug action.

It is possible to "fly through" tissues and observe their normal state. The next stage would be to look at a diseased tissue and observe the differences between that and the healthy version. Finally, the observer could be taken through the diseased tissue while the medication is being applied in order to observe the effect that a particular drug has. This particular aspect could prove immensely useful to drug companies who are marketing their products. All of this is done on models based on real human beings.

The dataset from which the models were derived—the Visible Human Project™—is a potential resource from which other products for the delivery of information can be obtained. The data is freely available over the internet and, indeed, anyone with the patience and determination can download it—a download time of some two weeks!

The response to this 3D anatomy from the medical community has been overwhelming and demonstrates the crystal-clear differences between currently available anatomical materials and virtual anatomy. Physicians are amazed when they see the images, and many have commented that the Visible Productions' models go far beyond traditionally available materials and provide them with the opportunity to further their own learning as well as helping them in the instruction of others. It also gives them the opportunity to demonstrate and teach patients about potential surgical procedures that they may be undergoing, in order to allow them a greater understanding of their condition as well as to allay their fears of an upcoming procedure.

The possibilities for virtual anatomy are limitless. The models are just the beginning. Once they exist, each can be manipulated in any way, its shape changed, it can even be animated. Using very

Biomechanics

One other area where Visible Productions are working is biomechanical movement. Now that the models of organs and tissues exist, the principles of biomechanics can be applied to them. This means that the computer can now show a lung breathing or a heart beating. It is possible to show the cadaver moving. Visible Productions are reaching the point where they can apply physical attributes to models, to be able to give physical properties to tissues that medical professionals or students can, in a virtual world, use a virtual scalpel to slice through, enabling them to simulate surgery on the computer.

To have a virtual patient that can be operated on, can have anatomy/dissection performed on it, can walk around, can be pulled apart, can be looked at

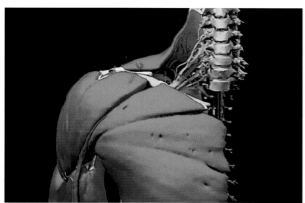

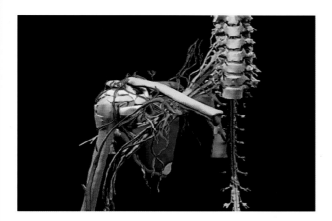

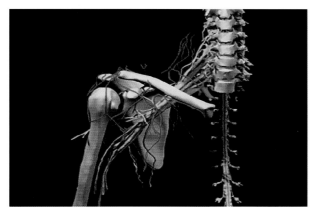

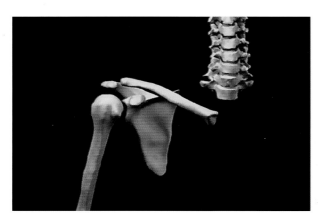

in any way, aspect, or form—this is the ideal. For surgeons, such techniques could prove invaluable, enabling them to practise difficult operations prior to surgery, making them aware of potential difficulties before they arise, allowing them to anticipate them in advance. It also allows for medical planning and training in the preparation and readiness for possible disasters or in the case of mass casualties.

One other area where such available virtual patients would be invaluable is in research and development. They would allow for the rapid development and testing of surgical procedures, new medical equipment and instruments, and even the design and development of emergency treatment rooms or operating theaters.

The images themselves are extraordinary. Indeed, the whole project is extraordinary. For although it could be said that just developing the images themselves is accomplishment enough—and indeed it is—the Visible Productions team is not satisfied with merely that. We believe that this is just the beginning, and that this technology can revolutionize anatomical and medical training. Anyone with any interest in anatomy, medicine, or health will be fascinated by these images. Not only are they fantastic to look at but, they are, at the same time, real—they have come from a real body. One has only to look at them closely to see that there are minor discrepancies between these images and the textbook example—the missing tooth, the removed appendix—but this goes to show that we are all individuals.

Thomas O. McCracken
Fort Collins, Colorado

The upper chest and shoulder is stripped away. The beauty of these images on screen is that they can be rotated and viewed from any angle—this helps the interactive viewer to understand how the structures work and how they relate to each other.

HOW TO USE THIS BOOK

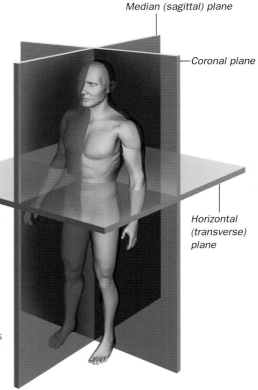

Median (sagittal) plane

Coronal plane

Horizontal (transverse) plane

The planes of section.

The New Atlas of Human Anatomy is divided into two main sections: the first on systemic anatomy and the second on regional anatomy.

Systemic anatomy looks at the body in terms of its systems (for example, the endocrine system, which encompasses organs all over the body). In contrast, regional anatomy focuses on individual regions or "parts" of the body (for example, the head and neck).

Terminology

It is necessary to have universally acceptable names for the different structures of the body, and for their different spatial relationships. Partly for the standardization, although partly because of historical precedent, anatomical names are expressed in Latin or are derived from the Greek.

Some anatomical names are explained in the text, but for more comprehensive reference a glossary of terms is included at the end of the book.

Planes of section

In order to standardize the way anatomists view the human body, it is assumed that the standard anatomical body is in an upright position, with the arms down by the side, and the eyes and palms of the hands facing forward. In this position, the body can be imagined in three dimensions. There are specific terms for the way these three dimensions can be divided; the lines of division are called planes of "section".

- the median (or sagittal) plane divides the body vertically into right and left halves;
- vertical planes at right angles to the median plane are known as coronal planes;
- horizontal planes cut the body at right angles to both coronal and median planes.

Once the planes of section have been established, different terms are used to describe the ways different parts are arranged spatially in relation to others.

- The terms anterior (ventral) and posterior (dorsal) are used to refer to the front and back surfaces, respectively, of the head, trunk and limbs. Therefore, the spinal cord is dorsal to the wall of the abdomen and ventral to the skin of the back.
- The terms superior (cranial) and inferior (caudal) refer to the relative positions in the vertical plane, where a superior (upper) surface is above (or dorsal to) an inferior (lower) one.

Main text
Explains what this part of the
body is and what it does.

Locator image
Shows which part
of the body is
being discussed.

Main illustration
Showing the
subject of the
two-page article.

**Secondary
illustration**
Different view of
the subject, with
annotation.

Caption
Caption to the
main illustration.

Caption
Caption to the
secondary
illustration.

**Annotated
illustration**
A smaller
version of the
main
illustration.

Feature box
Additional or special
aspects of the subject.

Key
Key to annotation lists the
different parts identified by
numbers.

These terms are often used to refer to the position of one organ or structure relative to another one. For instance, the kidneys are inferior to (i.e. below) the liver but superior to (i.e. above) the bladder, and lateral (toward the side) to the spinal column, which is medial to (between) the kidneys. The relative positioning of structures can be further defined by using combinations of terms; hence, posterolateral (or dorsolateral) and anterosuperior (or ventrocranial).

- In the limbs, proximal is used to refer to something that is nearer the root of the limb (i.e. nearer the shoulder or hip), whereas something farther away (towards the hand or foot) is referred to as distal.
- Palmar and plantar refer to the bending (flexor) or front (anterior) surface of the hand and foot—i.e., to the hand's palm and the foot's sole.
- In the forearm, radial and ulnar, following the

bones, may be used instead of lateral and medial, and in the lower limb fibular and tibial are often used, for the same reason.

- Finally, superficial and deep refer to the relative distance of organs between the surface and the center of the body.

The book also describes structures in terms of their function. Systemic anatomy, in particular, lends itself well to descriptions of function and is, in fact, based on recognition of function (for example, the digestive system, whose function is the intake, breakdown and absorption of nutrients (fuel) from food, and the subsequent elimination of waste matter). It is difficult to look at the anatomical relationships between different, but connected, structures without studying their functional relationships. For if one organ is attached or connected to another, why is this so, for what purpose?

**An annotated,
representative spread
from within the book
explaining the page
layout.**

•SECTION ONE•

SYSTEMIC ANATOMY

THE SKIN COVERS AND PROTECTS THE BODY AND, WITH ITS DERIVATIVES, HAIR AND NAILS, FORMS THE INTEGUMENTARY SYSTEM. AS A PHYSICAL BARRIER, SKIN PREVENTS WATER LEAKING OUT OF, OR INTO, THE BODY'S TISSUES, THEREBY HELPING TO MAINTAIN HOMEOSTASIS. IT ALSO PREVENTS THE ENTRY OF HARMFUL, DISEASE-CAUSING MICROORGANISMS; REPAIRS ITSELF IF CUT OR OTHERWISE DAMAGED; FILTERS OUT HARMFUL ULTRAVIOLET (UV) RAYS IN SUNLIGHT; ACTS AS AN IMPORTANT SENSORY STRUCTURE FOR DETECTING TOUCH, PRESSURE, PAIN, HEAT AND COLD; AND PLAYS AN IMPORTANT PART IN MAINTAINING THE BODY'S TEMPERATURE AT AROUND 37°C (98.6°F) REGARDLESS OF THE AMBIENT TEMPERATURE.

THE INTEGUMENTARY SYSTEM

All parts of the body are covered and protected by a living "overcoat" in the form of the skin. The skin also provides a sensory interface between the body and its surroundings that enables humans to experience a wide range of sensations.

Skin structure

Skin is made up of two layers, the epidermis and dermis. The superficial epidermis is primarily protective and consists of a number of layers, or **strata**. The outermost layer, the stratum corneum, consists of dead, flattened cells packed with **keratin**, a tough, waterproof protein also found in hairs and nails. As this protective "overcoat" is constantly worn away and lost as skin flakes, living cells in the deepest epidermal layer—the stratum basale— divide to provide replacement cells. As these are pushed upward through the other strata they flatten, fill with keratin and die.

Other cells in the deeper epidermis produce granules of the brown pigment melanin that protects against the harmful effects of UV light.

The thicker dermis is a flexible, strong layer embedded with collagen and **elastin** fibers that give it resilience and elasticity. It also contains sensory nerve endings and receptors; blood vessels; sweat glands that produce cooling sweat and release it through ducts onto the skin's surface; hair follicles, deep pits from which hairs grow; and sebaceous glands that release an oily liquid called **sebum** that helps keep the skin and hairs soft, flexible and waterproof.

Two types of skin are found on the human body. Thick skin, up to 4 mm (¼ in) thick is hairless and has a thicker, protective epidermis. It is found in those areas, such as the palms, soles, and fingertips, that are involved in movement and manipulation and have a greater need to resist abrasion. Thin, hairy skin, which covers the rest of the body, has a much thinner epidermis and lacks one of the five layers—the stratum lucidum—found in thick skin.

Hair and nails

Apart from the lips, parts of the genitals, and the undersides of the hands and feet, the body is covered by millions of hairs. Cells in the bulb, or base, of hair follicles divide to produce cells that move up the follicle to form the shaft of the hair. The coarse terminal hairs of the head are protective, while the finer vellus hairs on the rest of the body aid sensation. Nails are scaly outgrowths of the epidermis that serve to protect the ends of fingers and toes, and to help the fingers to grip objects.

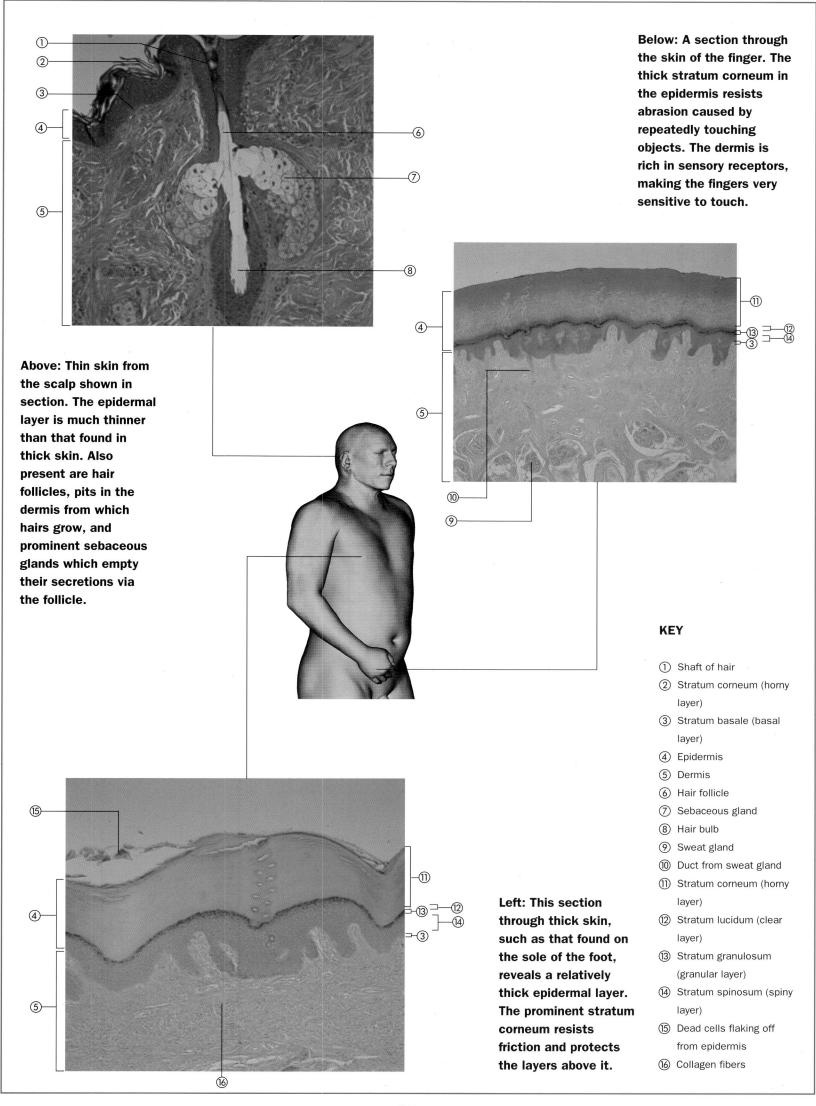

Below: A section through the skin of the finger. The thick stratum corneum in the epidermis resists abrasion caused by repeatedly touching objects. The dermis is rich in sensory receptors, making the fingers very sensitive to touch.

Above: Thin skin from the scalp shown in section. The epidermal layer is much thinner than that found in thick skin. Also present are hair follicles, pits in the dermis from which hairs grow, and prominent sebaceous glands which empty their secretions via the follicle.

Left: This section through thick skin, such as that found on the sole of the foot, reveals a relatively thick epidermal layer. The prominent stratum corneum resists friction and protects the layers above it.

KEY

① Shaft of hair
② Stratum corneum (horny layer)
③ Stratum basale (basal layer)
④ Epidermis
⑤ Dermis
⑥ Hair follicle
⑦ Sebaceous gland
⑧ Hair bulb
⑨ Sweat gland
⑩ Duct from sweat gland
⑪ Stratum corneum (horny layer)
⑫ Stratum lucidum (clear layer)
⑬ Stratum granulosum (granular layer)
⑭ Stratum spinosum (spiny layer)
⑮ Dead cells flaking off from epidermis
⑯ Collagen fibers

U NLIKE THE DRY AND DUSTY SKELETAL REMAINS FOUND IN ARCHEOLOGICAL

MUSEUMS, THE LIVING SKELETON IS A STRONG, LIGHTWEIGHT FRAMEWORK

THAT IS BOTH DYNAMIC AND FLEXIBLE. AS WELL AS SUPPORTING AND SHAPING THE

BODY, THE SKELETON ALSO PROVIDES AN ANCHORAGE FOR SKELETAL MUSCLES, WHICH

CONTRACT TO PRODUCE MOVEMENT, AND SURROUNDS AND PROTECTS INTERNAL ORGANS

THAT WOULD OTHERWISE BE DAMAGED IN THE COURSE OF EVERYDAY LIFE.

THE FULL SKELETON

Strong yet lightweight and flexible, the skeleton provides the ideal framework for support, movement, and protection.

The human skeletal system is made up of on average 206 bones, many of which can be seen opposite; flexible cartilage (gristle), which plays a structural role in the ear flaps, nose, and part of the ribs, as well as covering the ends of bones in joints; and tough ligaments that stabilize the skeleton by holding bones together at joints, where two or more bones meet. Altogether, the skeletal system makes up about 20 percent of our body mass.

Types of bones

Bones can be divided into four main types—long, short, flat, and irregular—according to their shape. Shape also provides an indication of mechanical function.

- Long bones, which include all the limb bones, with the exception of the wrist and ankle bones and the patella (kneecap), are longer than they are wide. Each consists of a diaphysis (shaft) and, at each end, an epiphysis (extremity or bone end), which is usually more expanded than the shaft. They act as levers that make the body move when pulled by contracting muscles, and some, notably the bones of the legs, have an important weight-bearing role.
- Short bones—the carpals (wrist bones) and tarsals (ankle bones) are roughly cube-like in

shape. They form a connective "bridge" in the wrist and ankle where only limited movement is needed but stability is essential.

- Flat bones, which include the sternum (breastbone), ribs, scapulae (shoulder blades), and the cranial bones of the skull, are thin, flattened and slightly curved. Some, such as the ribs and cranial bones, form protective cages, while each scapula provides a large surface for muscle attachment.
- Irregular bones, which include the facial bones of the skull, the vertebrae (the bones that make up the vertebral column), and the pelvic or hip bones, are those that do not fit into the other three categories.

Cartilage

Cartilage is a specialized **connective tissue** that covers the ends of joints and plays a small structural role in the ear, nose, and ribs, as well as forming the spongy cushion between vertebrae. This resilient and elastic jelly-like substance is rigid, has a high tensile strength, and is resistant to both compressive and shearing forces. At joints, cartilage is highly wear-resistant, smooth, and has a polished surface that is bathed with a lubricating **synovial fluid** that has an extremely low coefficient of friction.

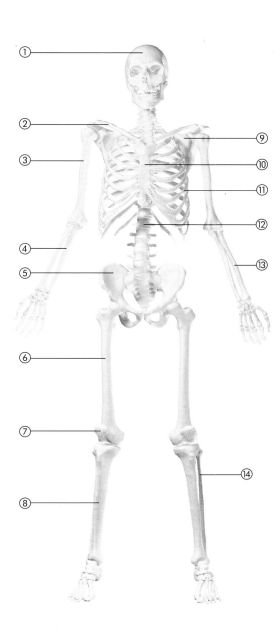

Anterior view of the full skeleton with the arms in the correct anatomical position.

KEY

1. Skull
2. Clavicle
3. Humerus
4. Ulna
5. Pelvic (hip) girdle
6. Femur
7. Patella
8. Tibia
9. Scapula
10. Sternum
11. Rib
12. Vertebral column
13. Radius
14. Fibula

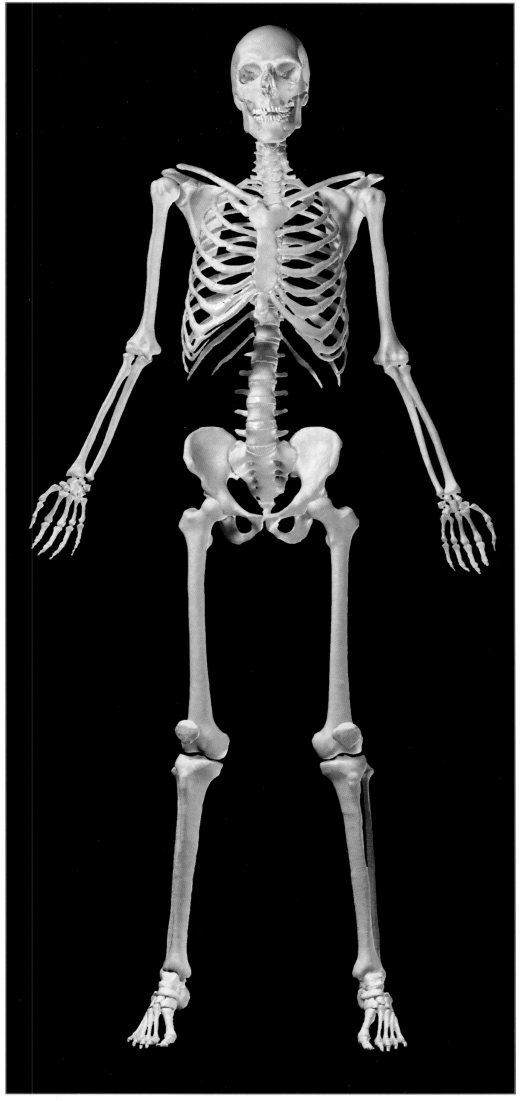

THE SKELETON EVOLVED INTO ITS PRESENT FORM SOME FIVE MILLION YEARS AGO WHEN HUMAN ANCESTORS FIRST WALKED ON TWO LEGS. THE S-SHAPED BACKBONE KEEPS THE BODY UPRIGHT AND SUPPORTS THE HEAD, WHILE STILL PERMITTING BENDING. THE NEAR VERTICAL PELVIS BALANCES THE UPPER BODY DIRECTLY OVER THE FEET, WHILE STRONG LEG BONES SUPPORT ITS WEIGHT.

Bone contains two types of **osseous** (bony) tissue that together give it its strength and lightness. Compact bone, found on the outside of bones where stresses are greatest, consists of parallel cylinders called **osteons** made up of concentric tubes of matrix. A central canal in each osteon carries blood vessels. Tiny spaces within osteons contain isolated osteocytes. Lighter spongy, or cancellous, bone has a honeycomb structure of spaces and bony struts called **trabeculae**. The spaces

THE FULL SKELETON

The curvature to the body conveys mechanical support and strength, from the S-shaped, spring-like vertebral column to the slight curvature of the long limb bones.

KEY

① Scapula
② Vertebra
③ Radius
④ Ulna
⑤ Fibula
⑥ Cranium
⑦ Humerus
⑧ Ilium
⑨ Sacrum
⑩ Ischium
⑪ Pubis
⑫ Tibia
⑬ Calcaneous

For descriptive purposes the skeleton can be divided into two broad categories. The axial skeleton—the backbone, skull, ribs and sternum—forms the main axis of the body. The appendicular skeleton consists of the limb bones and those of the pectoral (shoulder) and pelvic (hip) girdles, which connect the limbs to the axial skeleton.

Bone structure

Bones are made of living tissues that, in addition to their mechanical functions, store calcium and other minerals and make blood cells. Bone consists of cells surrounded by a matrix. This matrix consists of about 35 percent protein, particularly collagen, which provides hardness and flexibility; and about 65 percent mineral salts, particularly calcium and phosphate, which confer hardness. Weight for weight, this combination makes bone five times stronger than steel. Bone cells include **osteocytes**, the cells that maintain the matrix; **osteoblasts**, cells that manufacture bone; and **osteoclasts**, cells that erode bone matrix. Between them, osteoblasts and osteoclasts constantly remodel bones according to the forces exerted on them by muscles and either release or store calcium according to the body's requirements.

contain jelly-like marrow: yellow marrow forms a fat store, while red marrow, found mainly in flat bones in adults, manufactures blood cells. Covering and encasing most of the bone is a thin membrane called the **periosteum**.

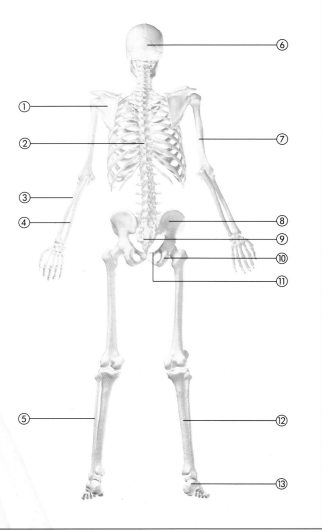

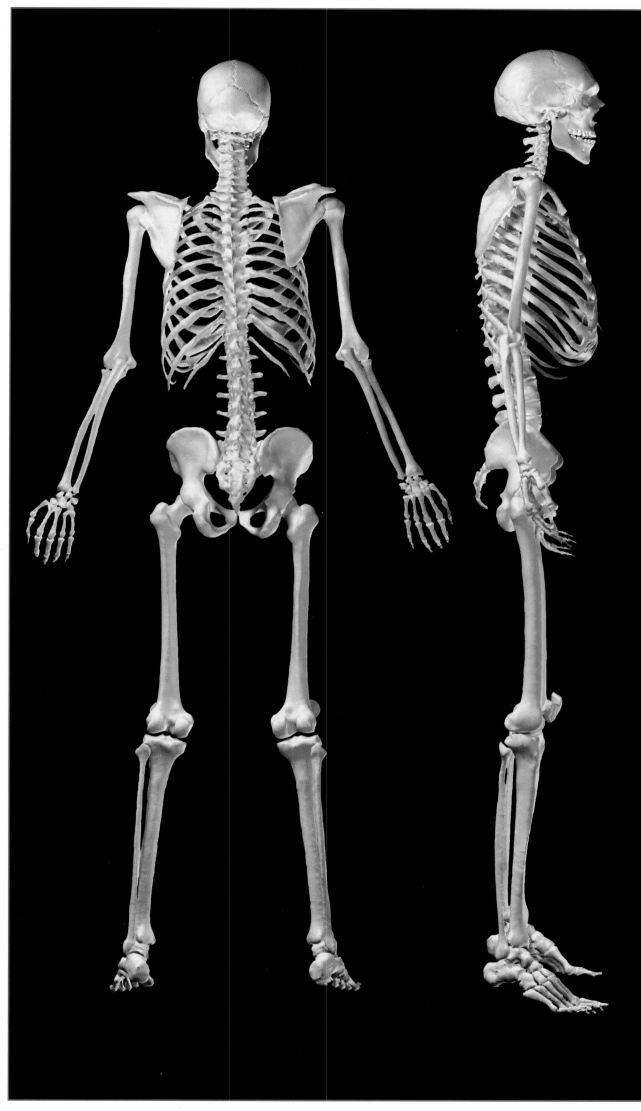

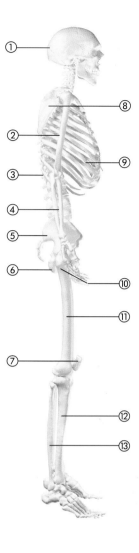

Posterior (left) and lateral (right) views of the full skeleton. In the lateral view the S-shaped curvature of the spine, which places the trunk over the feet to facilitate balance, can be appreciated.

KEY

① Cranium
② Humerus
③ Vertebra
④ Radius
⑤ Ilium
⑥ Ischium
⑦ Patella
⑧ Scapula
⑨ Rib
⑩ Greater trochanter
⑪ Femur
⑫ Tibia
⑬ Fibula

Housing the body's control center—the brain— and most of its sense organs—eyes, ears, tongue, and nose—the skull is the most complicated part of the skeleton. It consists of a collection of 22 bones that are divided into two groups: eight cranial bones form the cranium, which surrounds the brain, while 14 facial bones form the framework of the face.

THE SKULL

The skull houses and protects not only the brain but also the sense organs that enable a person to hear, see, taste, and smell.

In addition to the large cavity formed by the cranial bones, there are other smaller cavities in the skull including the nasal cavity, the orbits (eye sockets) that hold the eyes, and the ear cavities within the temporal bones. Each ear cavity houses three additional tiny bones, called ossicles, which transmit sounds into the sensory part of the ear.

Small holes in skull bones called foramina (sing. foramen) and canals enable blood vessels, such as the carotid arteries, and nerves, to enter and leave the skull. The spinal cord passes through the largest hole, the foramen magnum in the base of the cranium, to join the brain. The occipital condyles on either side of this foramen articulate with the first vertebra of the backbone to permit nodding "Yes" movements of the head.

How skull bones are made

Early in its development the skeleton of a human fetus consists of either fibrous connective tissue membranes or cartilage. Gradually, these structures are replaced by bone tissue, a process called ossification. The replacement of fibrous tissue is known as **intramembranous** ("inside membrane") ossification, while cartilage

replacement is termed **endochondral** ("within cartilage") ossification.

Skull bones are formed by intramembranous ossification. Osteoblasts (*see page 40*) secrete bone matrix directly within the fibrous membrane at a "center of ossification" to form first spongy bone, and later an outer layer of compact bone. In the skull of the newborn, this process is still incomplete: skull bones are linked by areas of as yet unossified fibrous membrane called fontanels. These flexible patches allow the skull to be slightly compressed during birth, and accommodate the growth of the brain during early infancy. By the age of one and a half intramembranous ossification is complete and the fontanels have disappeared.

View from below

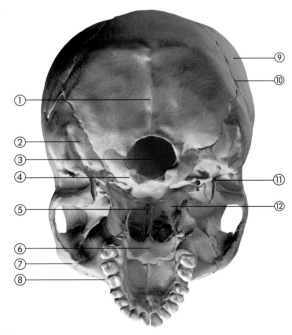

KEY

① Occipital bone
② Temporal bone
③ Foramen magnum
④ Occipital condyle
⑤ Vomer
⑥ Palatine bone
⑦ Zygomatic bone
⑧ Maxilla
⑨ Parietal bone
⑩ Lambdoidal suture
⑪ External auditory meatus
⑫ Sphenoid bone

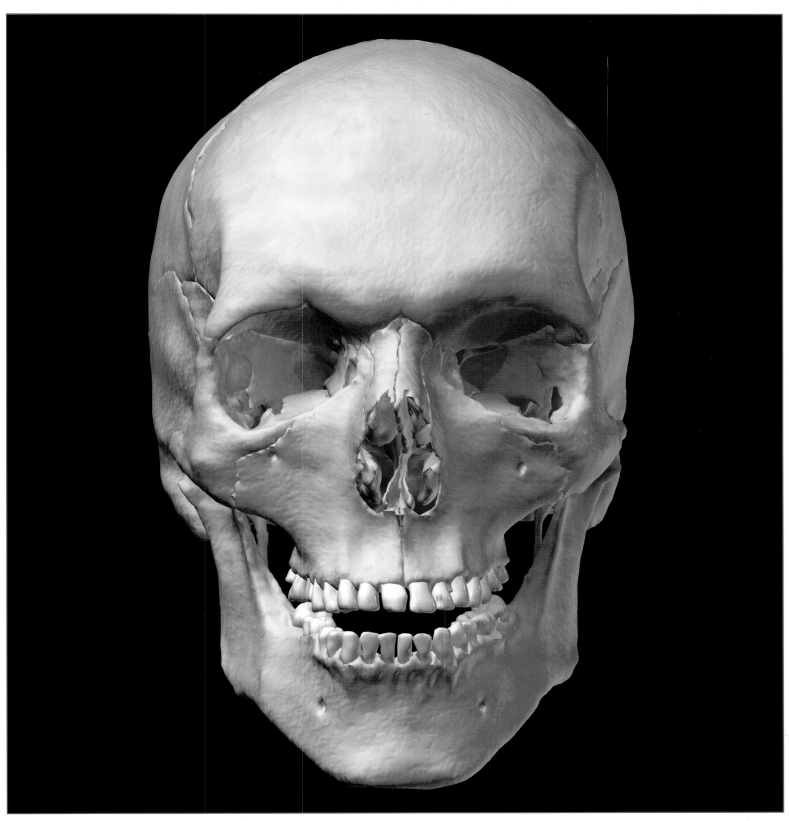

Small holes (foramina) within the surface of the skull enable blood vessels, arteries and nerves to enter the skull.

KEY

① Frontal bone

② Parietal bone

③ Temporal bone

④ Orbit

⑤ Lacrimal bone

⑥ Zygomatic bone

⑦ Maxilla

⑧ Mandible

⑨ Nasal bone

⑩ Sphenoid bone

⑪ Infraorbital foramen

⑫ Mental foramen

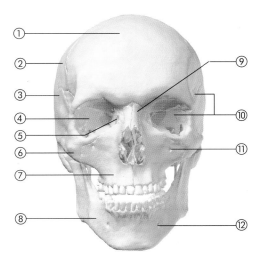

IN ADULTS, ALL BUT ONE OF THE 22 SKULL BONES—THE EXCEPTION IS THE MANDIBLE, OR LOWER JAW—ARE HELD TOGETHER BY IMMOVABLE JOINTS CALLED SUTURES. WITHIN A SUTURE, THE EDGES OF BONES LOCK TOGETHER LIKE PIECES IN A JIGSAW TO FORM A STRUCTURE THAT IS BOTH RIGID AND STRONG. THE THINNESS OF THE CRANIAL BONES COMBINED WITH THE PRESENCE OF HOLLOW, AIR-FILLED SPACES CALLED SINUSES IN CERTAIN CRANIAL AND FACIAL BONES SERVE TO REDUCE THE SKULL'S WEIGHT.

THE SKULL

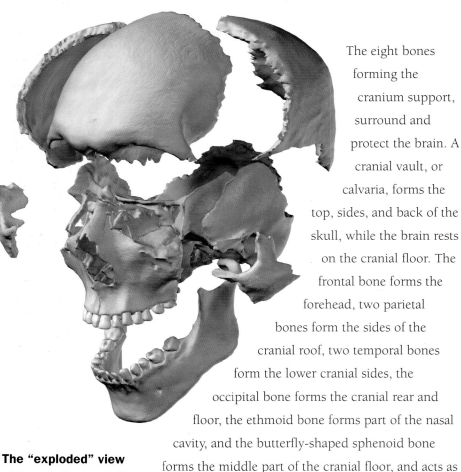

The "exploded" view of the skull reveals its component bones and the jagged edges that fit together in sutures.

The eight bones forming the cranium support, surround and protect the brain. A cranial vault, or calvaria, forms the top, sides, and back of the skull, while the brain rests on the cranial floor. The frontal bone forms the forehead, two parietal bones form the sides of the cranial roof, two temporal bones form the lower cranial sides, the occipital bone forms the cranial rear and floor, the ethmoid bone forms part of the nasal cavity, and the butterfly-shaped sphenoid bone forms the middle part of the cranial floor, and acts as a keystone that holds the other cranial bones together.

As well as forming the framework of the face, the 14 facial bones also provide the openings through which food, water, and air enter the body. Muscles attached to the facial bones pull on the skin to produce the wide range of facial expressions.

The paired facial bones are the maxillae, which form the upper jaw and front of the hard palate, acting as a keystone with which all other facial bones, apart from the mandible, articulate; the zygomatic bones or cheek bones; the nasal bones, which form the bridge of the nose; the lacrimal bones, which form part of the orbit; the palatine bones, which form the rear of the hard palate; and the inferior nasal conchae, which form part of the nasal cavity. Occurring singly, the vomer makes up part of the nasal septum, which divides the nasal cavity, while the mandible forms the lower jaw. Teeth are secured in sockets in the maxillae and mandible.

Bones as chemical factories

In addition to their mechanical roles—support, protection, and movement—bones perform the vital physiological roles of storing calcium and making blood cells.

Calcium is one of about 20 minerals—others include iron and zinc—obtained from food and essential for the normal functioning of the body. Ninety-nine percent of the body's calcium is stored in bones. Calcium confers hardness on bones and teeth, and is needed for muscle contraction, the transmission of nerve impulses, and blood clotting. To maintain constant levels of calcium in the blood, two hormones (*see page 110*) with opposing effects either cause the release of calcium from bones into the bloodstream, or stimulate the sequestration of calcium from blood and its storage in bones.

Blood cells—red blood cells, white blood cells, and platelets (*see page 124*)—are manufactured by red bone marrow found, in adults, inside the cranial bones, vertebrae, clavicles, sternum, ribs, scapulae, pelvis, and the upper ends of the femur and humerus. In healthy adults about 2 million red blood cells are produced per second.

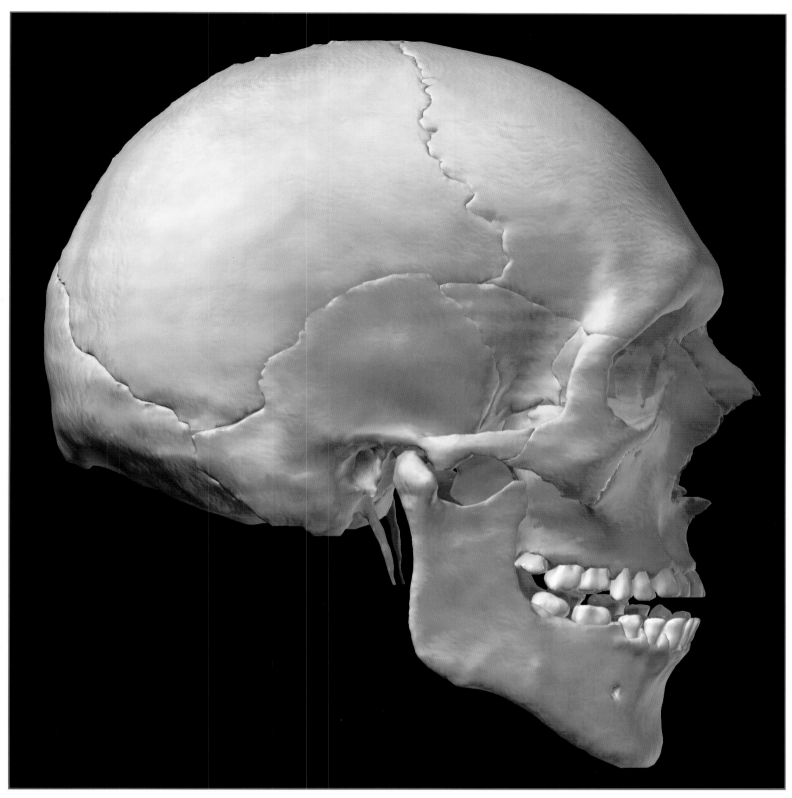

Lateral view of the skull. In this position the sutures connecting the different skull bones can be clearly seen.

KEY

① Parietal bone
② Squamous suture
③ Temporal bone
④ Lambdoidal suture
⑤ Occipital bone
⑥ External auditory meatus
⑦ Styloid process
⑧ Mandible
⑨ Coronal suture
⑩ Frontal bone
⑪ Sphenoid bone
⑫ Ethmoid bone
⑬ Nasal bone
⑭ Lacrimal bone
⑮ Zygomatic bone
⑯ Maxilla

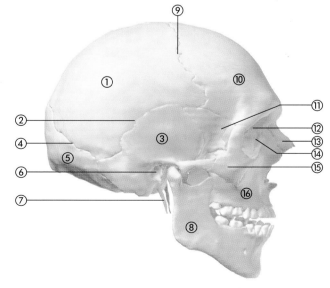

Providing support for the body's head and trunk is the vertebral column—also known as the spinal column, spine, or backbone—a strong but flexible chain of bones known as vertebrae. The joints between neighboring vertebrae (sing. vertebra) permit only limited movement, but collectively they give the vertebral column considerable flexibility.

or body, is attached posteriorly to a ring-shaped neural arch. Together, the centrum and arch surround an opening called the vertebral foramen through which the spinal cord passes. Bony projections on the neural arch—two transverse processes and a single spinous process—form attachment points for the ligaments and back muscles that stabilize the vertebral column by preventing excessive bending, and hold it upright. Lying between the centra of adjacent vertebrae are

THE VERTEBRAL COLUMN

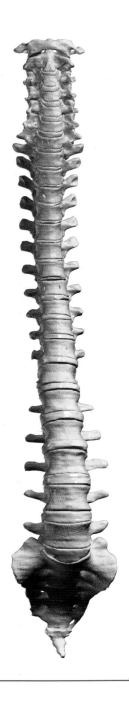

The vertebral column extends from the skull to its anchoring point in the pelvis (*see page 54*), through which it transmits the weight of the head and trunk to the legs. It surrounds and protects the delicate spinal cord (*see page 96*), which runs downward from the base of the brain. The springlike, S-shape of the vertebral column, visible in side view, enhances its strength and flexibility, facilitates balance by positioning the trunk directly over the feet, and absorbs shocks during movement.

Adults have 26 vertebrae, although two of these—the sacrum and coccyx— are composites composed of fused vertebrae. All vertebrae have the same basic structure. A short, pillarlike, weightbearing bone, called the centrum

An anterior view shows some of the processes to which the muscles and ligaments that support the vertebral column are attached.

intervertebral discs, cartilage pads with a jellylike filling, which allow limited movement and cushion vertebrae against sudden jolts that occur during walking, running, or jumping.

Vertebrae are divided into five types according to their position, size, shape, and role. Seven small, light cervical vertebrae form the flexible neck. The uppermost, the atlas, articulates with the skull to produce nodding, "Yes", movements, and forms a pivot joint (*see page 50*) with its neighbor, the axis, that allows the head to shake in a "No" movement. Twelve thoracic vertebrae form the central part of the backbone, each one articulating with a rib. Five large lumbar vertebrae, which form the small of the back, bear most of the weight of the trunk and head. The triangular sacrum, formed from five fused bones, forms strong joints with the bones of the pelvis. The coccyx, or tailbone, consists of four fused vertebrae.

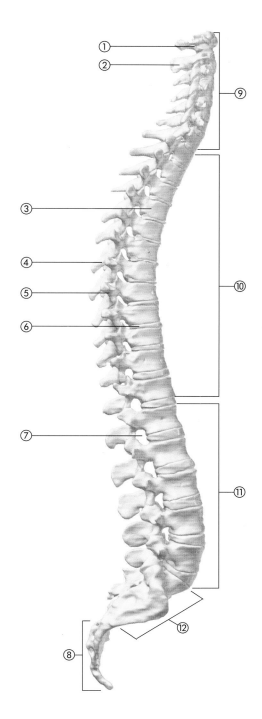

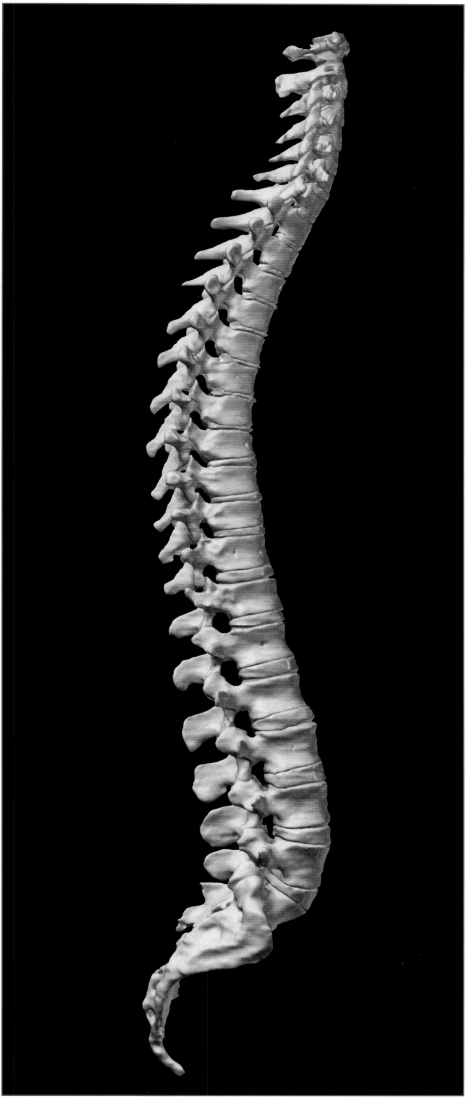

KEY

1. Atlas
2. Axis
3. Centrum of thoracic vertebra
4. Spinous process
5. Transverse process
6. Intervertebral disc
7. Intervertebral foramen
8. Coccyx
9. Cervical vertebrae (7)
10. Thoracic vertebrae (12)
11. Lumbar vertebrae (5)
12. Sacrum

This lateral view (right) of the vertebral column reveals the four curvatures that give it an S-shape.

WHY THE SKELETON OF THE THORAX (CHEST) IS CALLED THE
RIBCAGE IS PLAIN TO SEE. WITH RIBS FORMING ITS "BARS",
THIS BONY CAGE ENCIRCLES AND PROTECTS THE HEART
AND LUNGS, AS WELL AS MOST OF THE STOMACH AND LIVER IN THE UPPER
ABDOMEN. THE RIBCAGE IS ALSO SUFFICIENTLY FLEXIBLE TO PERMIT THE UP
AND DOWN MOVEMENTS THAT MOVE AIR INTO AND OUT OF THE LUNGS DURING
BREATHING (*see page* 132).

THE RIBCAGE

Below, posterior (left) and lateral (right) views of the ribcage; opposite, an anterior view showing the sternum.

The ribcage consists of 12 pairs of curved ribs, that section of the vertebral column containing the 12 thoracic vertebrae (*see page 46*), and, anteriorly, the sternum or breastbone. The ribs are flat bones, each with a bowed, slightly-twisted, shaft, that curve forward and downward to the anterior body surface. At its posterior end, each rib articulates with its corresponding vertebra through plane joints (*see page 50*), called vertebrocostal joints, that allow limited gliding movements. At their anterior ends, the upper ten pairs of ribs are connected directly or indirectly to the sternum by flexible costal ("rib") cartilages. Together, vertebrocostal joints and costal cartilages give the ribcage its flexibility.

The ribs gradually increase in size up to the seventh pair, after which they progressively decrease in size. Rib pairs 1 through 7—called true or vertebrosternal ribs—are attached to the sternum through their own costal cartilage. The remaining rib pairs are called false ribs: the costal cartilages of rib pairs 8 through 10, the vertebrochondral ribs, attach to each other and to the costal cartilages of rib pair 7; rib pairs 11 and 12, the floating or vertebral ribs, are attached solely to the vertebral column, terminating in the abdominal muscles at their anterior end.

The dagger-shaped sternum has three parts. The upper manubrium articulates with the clavicle, which is part of the shoulder girdle (*see page 50*), at the clavicular notch, and with the first rib. The central sternal body is notched where it articulates with the costal cartilages of ribs 3 through 7. Where manubrium and sternal body meet, at the sternal angle, a hinge-like cartilaginous joint allows the sternal body to swing forward whilst breathing in. At the sternum's lower end, and not attached to any ribs, is the xiphoid process.

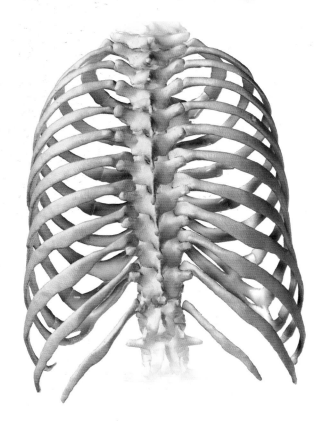
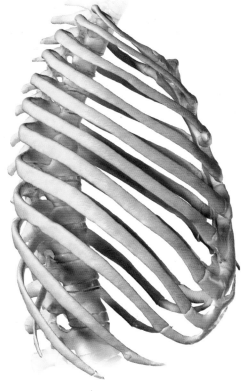

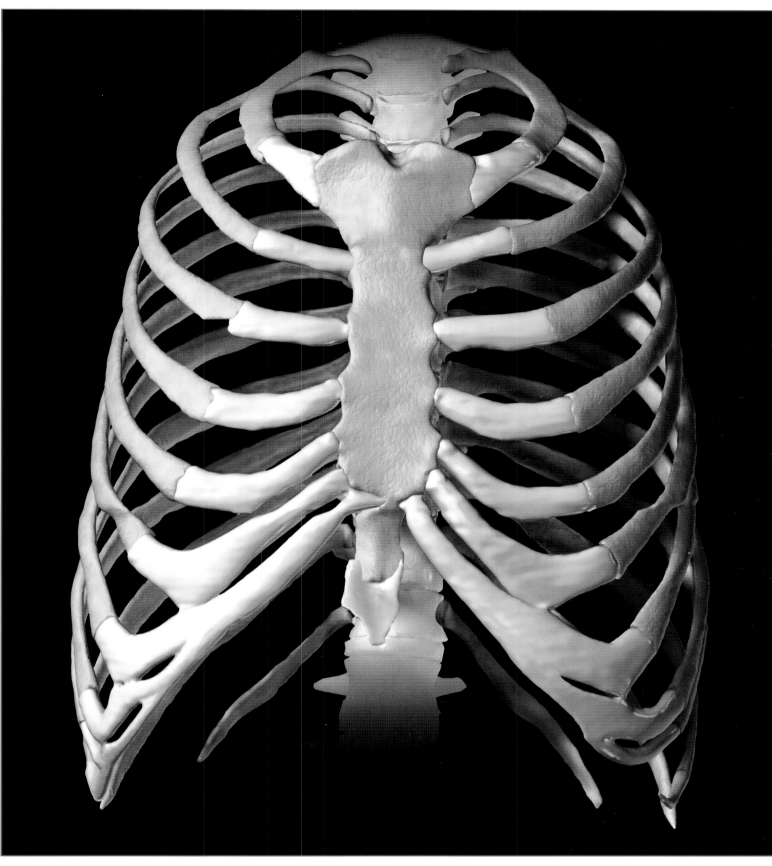

Anterior view of the ribcage. The flexible bony cage consists of a combination of bone and cartilage that houses and protects the delicate thoracic organs while still allowing sufficient movement for breathing.

KEY

① Clavicular notch

② Sternal angle

③ Body of sternum

④ Xiphoid process of sternum

⑤ Articulation of rib with vertebra

⑥ Vertebrochondral ribs

⑦ 1st thoracic vertebra

⑧ Manubrium of sternum

⑨ Vertebrosternal (true) ribs

⑩ Costal cartilage

⑪ 12th thoracic vertebra

⑫ Vertebral (floating) rib

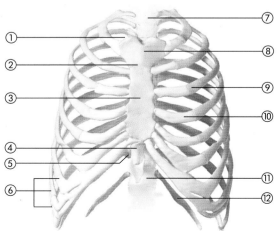

U NLIKE THEIR CLOSE MAMMALIAN RELATIVES, HUMANS WALK ON THEIR

HINDLEGS, LEAVING THEIR FORELIMBS FREE FOR THE MANIPULATION OF

OBJECTS. HUMAN FORELIMBS, AND THEIR ASSOCIATED SHOULDER

GIRDLE, ARE ACCORDINGLY ADAPTED FOR MANIPULATION RATHER THAN LOCOMOTION.

THE SHOULDER & ARM

Each shoulder is formed by two bones, the clavicle or collarbone, and the scapula or shoulder blade. Together they comprise half of the pectoral, or shoulder, girdle, which attaches the arms to the axial skeleton. The pectoral girdle is lightweight and flexible compared to the pelvic girdle (*see page 54*), and is not attached to the vertebral column. This arrangement reflects its lack of weightbearing role, but gives it a flexibility and mobility not found anywhere else in the body. The long, narrow clavicle articulates at one end with the sternum (*see page 48*), and at the other with the scapula, and serves to support the shoulder and arm. The triangular scapula provides a large surface for muscle attachment, and has a hollow, called the glenoid fossa. The head of the humerus, the upper arm bone, fits into the glenoid fossa to form the highly mobile shoulder joint, a ball and socket joint.

Three bones make up the skeleton of the arm—the humerus in the upper arm, and the ulna (inner) and radius (outer) in the lower arm. They are not as heavily-built as the femur or tibia in the leg. At their proximal ends, the ulna and, to a lesser extent, the radius form a hinge joint with the humerus at the elbow. Here the radius also forms a pivot joint with the ulna; this allows the radius to cross over the ulna enabling the palm of the hand to move through 180°. At their distal ends, the radius and, to a lesser extent, the ulna articulate with the carpal bones in the hand to form the wrist joint.

The single upper arm bone and the two forearm bones form a hinge joint at the elbow.

Joints

Wherever two or more bones meet in the skeleton, a joint is formed. Joints allow bones to move. They also maintain stability because the bones in a joint are held together and stabilized by strong strips of tough fibrous connective tissue called ligaments that while unyielding are, at the same time, pliant and flexible.

There are three types of joints. Fixed joints, such as the sutures between skull bones, do not permit movement. Partially movable cartilaginous joints, such as the discs between vertebrae, allow limited movements. Synovial joints are freely movable.

Most joints are synovial. Inside a synovial joint, oily synovial fluid lubricates the glassy cartilage that cover the ends of the bones so that they slide over each other easily. Different types of synovial joints each have their own range of movement.

- Ball and socket joints, such as the shoulder and hip joints, permit movement in many directions.
- Hinge joints, such as the elbow, knee, and ankle, work like a door hinge to allow movement in just one plane.
- Pivot joints, such as the joint between the atlas and axis in the neck, allow one bone to swivel around another.
- Plane, or gliding joints, between carpals (wrist bones) and tarsals (ankle bones), allow short, sliding movements between the flat surfaces of bones.
- Ellipsoidal, or condyloid, joints, such as those found between the radius and carpals in the wrist, allow movement from side to side and backward and forward.
- Saddle joints, found at the base of the thumb, allow movement in two planes.

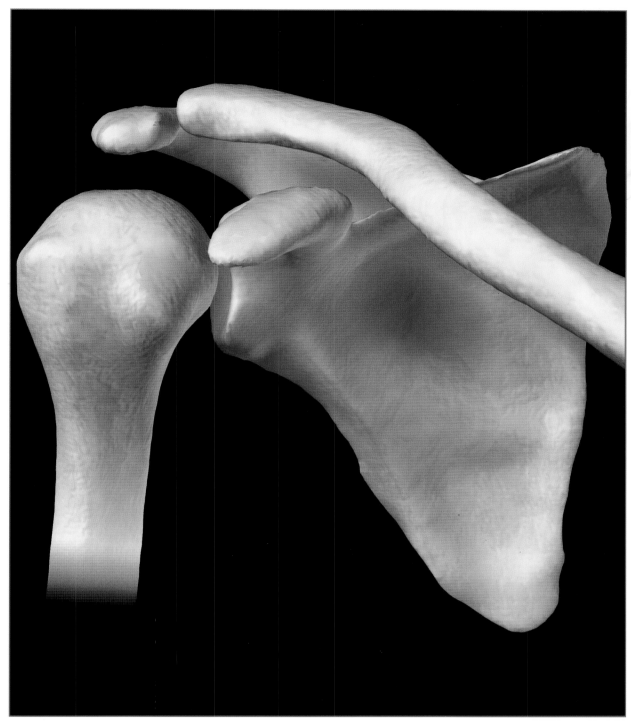

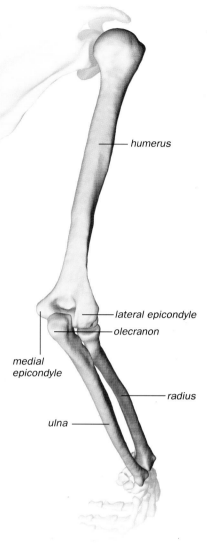

Above: posterior view of the right arm. The hinge joint of the elbow allows a variety of movements of the forearm.

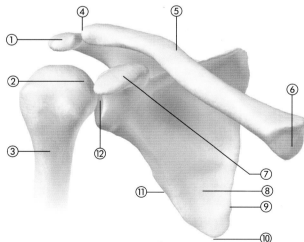

Above is an anterior view of the bones of the shoulder, while to the right is a posterior view.

KEY

1. Acromion
2. Head of humerus
3. Shaft of humerus
4. Acromial end of clavicle
5. Clavicle
6. Sternal end of clavicle
7. Coracoid process
8. Scapula
9. Medial border of scapula
10. Inferior angle
11. Lateral border of scapula
12. Glenoid fossa
13. Superior angle
14. Spine of scapula

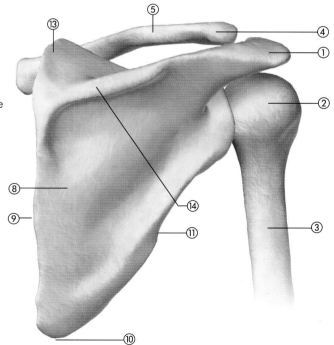

THE HANDS ARE THE MOST FLEXIBLE AND VERSATILE PARTS OF THE HUMAN BODY: STRONG ENOUGH TO HOLD AND GRIP HEAVY WEIGHTS, PRECISE ENOUGH TO CHOP VEGETABLES WITH A KNIFE, YET SUFFICIENTLY DELICATE TO PAINT A WATERCOLOR. SUCH VERSATILITY RESULTS FROM THE NUMBERS, SHAPES AND ARRANGEMENT OF THE 27 BONES THAT FORM THE FRAMEWORK OF THE HAND. THESE BONES FALL INTO THREE GROUPS.

THE HAND & WRIST

The large number of small component bones found in the hand give it great flexibility and versatility.

Eight short carpal bones, arranged in two rows, make up the carpus or wrist. The bones are named for their shapes. In the proximal row are the pisiform (pea-shaped), triquetrum (three-edged), lunate (crescent-shaped), and scaphoid (boat-shaped); while in the distal row are the hamate (hookshaped), capitate (roundheaded), and two four-sided bones, the trapezium and trapezoid. The pisiform can be felt and seen easily as the "bump" on the lower wrist. The carpals form a "bridge" between the forearm bones and the palm and fingers. They articulate through plane joints, but their gliding movements are restricted by stabilizing ligaments.

Five long bones called metacarpals make up the metacarpus or palm. The metacarpal of the thumb forms a saddle joint with the trapezium that gives it extra mobility, enabling it to swing across the palm and oppose, or touch, the fingers. This opposability allows the hand to perform its precise movements and power grips. The distal ends of the metacarpals can be seen as "knuckles" in a clenched fist.

The digits, or fingers, and the pollex, or thumb, are formed from 14 long bones called phalanges (sing. phalanx). Each finger has three phalanges—proximal, middle, and distal—while the thumb has two—proximal and distal. The large number of joints—condyloid joints between metacarpals and phalanges, and hinge joints between phalanges—in the fingers gives them great flexibility.

Endochondral ossification

Ossification is the process by which bones are made both before birth, and during infancy, childhood and adolescence. Most bones—apart from those in the skull and clavicles (*see pages 42–45 and 50*)—are made by a process called endochondral ("inside cartilage") ossification. Initially, the skeleton is made up of flexible cartilage "templates". Gradually these cartilage models break down to be replaced by bony tissue—both compact and spongy bone—produced by osteoblasts. During childhood, bones also lengthen and broaden allowing the body to grow in size. By late adolescence, when growth ceases, the process of ossification is largely complete.

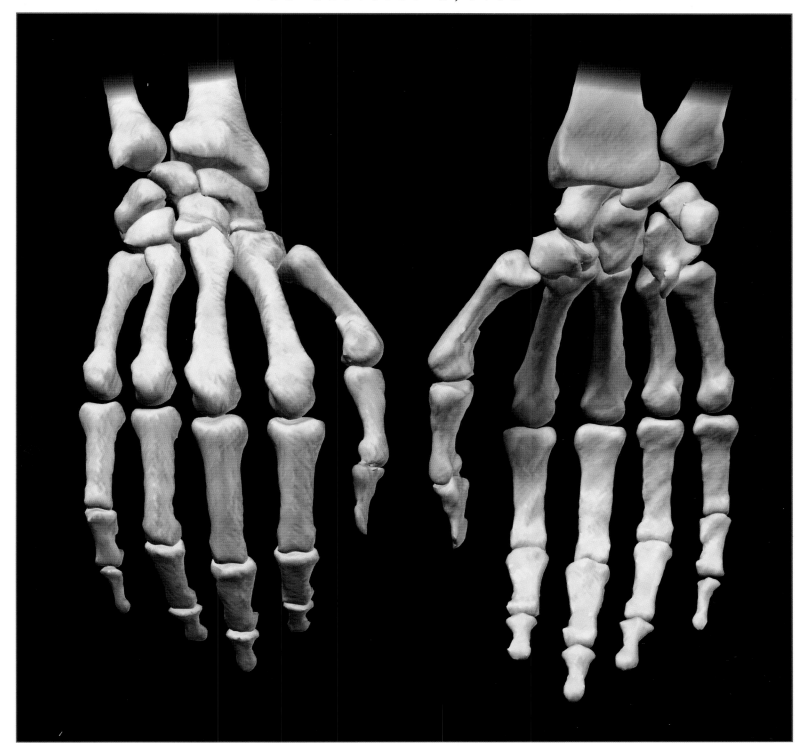

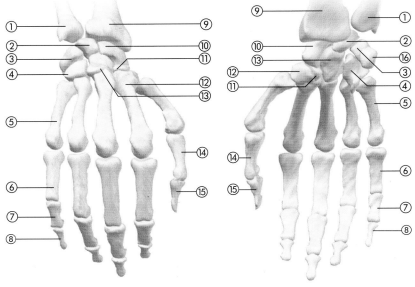

KEY

1. Ulna
2. Lunate
3. Triquetral
4. Hamate
5. Metacarpal
6. Proximal phalanx
7. Middle phalanx
8. Distal phalanx
9. Radius
10. Scaphoid
11. Trapezoid
12. Trapezium
13. Capitate
14. Proximal phalanx of pollex
15. Distal phalanx of pollex
16. Pisiform

Palm downwards

Palm upwards

Two views of the bones of the right hand and wrist: on the left a dorsal (palm downward) view; on the right a palmar (palm upward) view.

53

THE PELVIS FORMS THE KEY LINK BETWEEN THE LIMBS AND THE TRUNK. ITS BASINLIKE STRUCTURE CONSISTS OF TWO **COXAL**, OR HIP, BONES—THESE FORM THE PELVIC GIRDLE—AND THE SACRUM AND COCCYX, THE LOWEST REGIONS OF THE VERTEBRAL COLUMN. AS WELL AS KEEPING THE BODY UPRIGHT, THE PELVIS TRANSMITS WEIGHT FROM THE TRUNK TO THE LEGS AND, IN RETURN, TRANSMITS THE FORCES GENERATED BY MOVEMENT IN THE OPPOSITE DIRECTION. IT SUPPORTS AND PROTECTS THE REPRODUCTIVE ORGANS AND THE URINARY BLADDER IN THE LOWER ABDOMEN. ITS LARGE SURFACE ALSO PROVIDES AN ANCHORAGE FOR POWERFUL MUSCLES, SUCH AS THE GLUTEUS MAXIMUS (BUTTOCK MUSCLE), WHICH EXTEND INTO THE LEGS AND TRUNK.

THE PELVIS

The female (left) and male (right) pelves, viewed from above. The female pelvis is wider and rounder compared to the male, which is heart-shaped. These differences reflect the female's role in childbearing.

Each coxal bone is formed from three bones—the ilium, ischium, and pubis—that fuse during adolescence. The ilium, which forms a major part of the coxal bone, articulates with the sacrum at a sacroiliac joint at the rear of the pelvis. The ischium, which is inferior and posterior, bears a person's weight when they sit. At the front of the pelvis the pubis, or pubic bone, is linked to its opposite number by a cartilaginous disc called the pubic symphysis. Strong ligaments reinforce both the sacroiliac joint and the pubic symphysis to maintain the structural stability of the pelvis. On the lateral surface of each coxal bone, where the ilium, ischium and pubis meet, is a deep socket, called the acetabulum, which articulates with the head of the femur. This ball and socket joint allows less freedom of movement than the one formed between the upper arm and shoulder bones (*see page 50*) because it is constrained by strong stabilizing ligaments.

Male and female pelves differ. The female pelvis is shallower than the male, and its central opening—the pelvic inlet—is rounder and wider compared to the narrow, heartshaped opening found in males. The female sacrum is also wider and shorter, making the pubic arch correspondingly broader. These differences reflect the female's role in childbearing. The pelvic inlet must be—and is just—big enough to accommodate the head of a full term fetus as it passes through the uterine cervix and the vagina during birth.

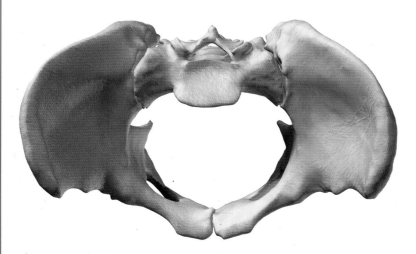

Female pelvis

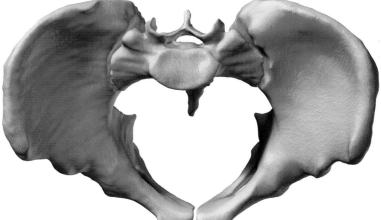

Male pelvis

The female (top) and
male (bottom) pelves,
viewed from the front.
The pelvis forms an
important central
point in the body. It
is not only a link
between the trunk and
the lower limbs, but
provides a large
surface area for
muscle attachment
and also houses and
protects the bladder
and reproductive
organs.

Female pelvis

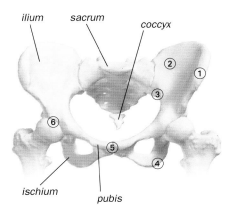

ilium *sacrum* *coccyx*

ischium *pubis*

Male pelvis

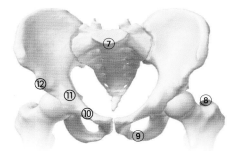

KEY

1. Iliac crest
2. Iliac tuberosity
3. Greater sciatic notch
4. Ischial tuberosity
5. Pubic symphysis
6. Acetabulum
7. Sacral promontory
8. Greater trochanter of femur
9. Inferior pubic ramus
10. Superior pubic ramus
11. Iliopubic eminence
12. Anterior inferior iliac spine

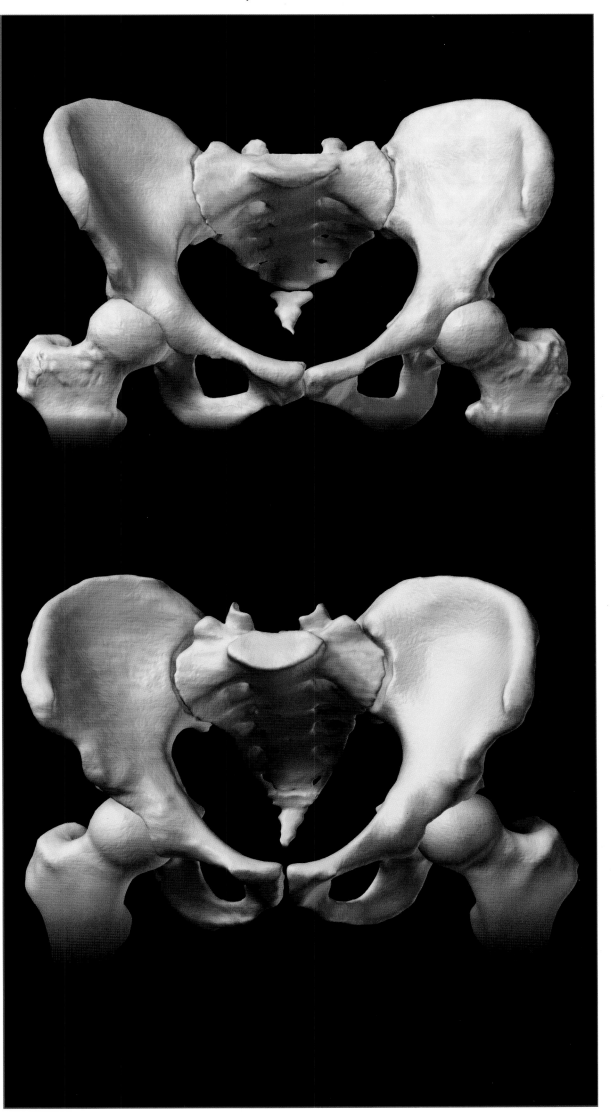

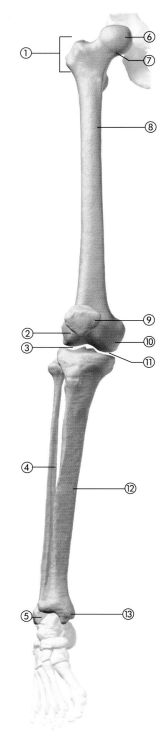

WHILE THE LOWER AND UPPER LIMBS SHARE THE SAME

NUMBER OF BONES (30) AND OVERALL STRUCTURE,

THEIR FUNCTIONS DIFFER. THE LONGER, STRONGER

BONES AND BROAD FEET OF THE LOWER LIMB PROVIDE STABILITY, BEAR

THE BODY'S WEIGHT, AND ABSORB THE FORCES GENERATED BY RUNNING,

AND JUMPING. THE THREE PARTS OF THE LOWER LIMB ARE THE UPPER

LEG, LOWER LEG, AND FOOT (*see pages* 216–221).

THE LEG & ANKLE

The femur, or thighbone, is the largest of the body's bones and bears its weight. At its proximal end, a rounded head fits into the acetabulum (*see page 55*), the socket in the side of the pelvis, to form a ball and socket joint that is reinforced by strong ligaments. An angled neck leads to a long shaft, which is curved like that of other long bones to provide more resistance to stresses. Where neck meets shaft can be found the greater and lesser trochanters, which are sites of attachment for thigh and buttock muscles. At its distal end the femur broadens into medial and lateral condyles that form a hinge joint—the knee—with the lower leg bones. The patella, or kneecap, is a triangular bone that is enclosed in the tendon of the thigh muscle, the quadriceps femoris (*see page 84*), and protects the knee joint anteriorly.

The larger of the lower leg bones is the tibia, or shinbone, which transmits the weight of the body to the feet. The lateral and medial condyles of its proximal end articulate with the femur at the knee, while at its distal end the tibia forms the ankle joint—a hinge joint—with the talus, one of the ankle bones of the foot. The slender fibula, the other lower leg bone, articulates at both ends with the tibia. Unlike the forearm bones, these joints do not permit movement, but provide stability. The medial malleolus of the tibia and the lateral malleolus of the fibula form the characteristic bony bulges on each side of the ankle.

Bone remodeling and repair

Bone shape and size do not remain unchanged throughout life. Bones are made of dynamic and active tissues that constantly renew themselves by a process called remodeling. This is the result of two complementary processes: bone deposition by osteoblasts and bone resorption by osteoclasts (*see page 40*). Bone shape is altered in response to mechanical stress caused by the pull of muscles and by gravity. Bone deposit is also responsible for the process of self-repair that occurs when bones fracture or break.

The three major bones of the leg—one in the thigh and two in the lower leg—articulate at a hinge joint in the knee.

KEY

① Greater trochanter
② Lateral epicondyle
③ Lateral condyle
④ Fibula
⑤ Lateral malleolus
⑥ Head of femur
⑦ Neck of femur
⑧ Femur
⑨ Patella
⑩ Medial epicondyle
⑪ Medial condyle
⑫ Tibia
⑬ Medial malleolus

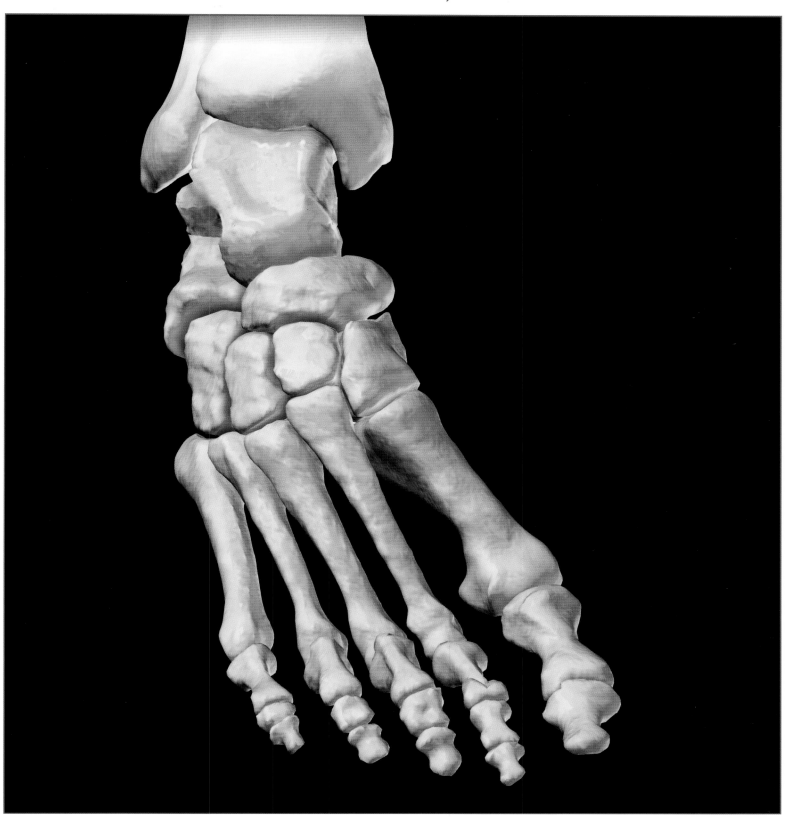

KEY

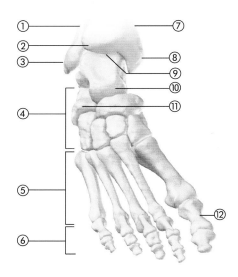

① Fibula

② Distal tibiofibular joint

③ Lateral malleolus of
 fibula

④ Tarsals

⑤ Metatarsals

⑥ Phalanges

⑦ Tibia

⑧ Medial malleolus of tibia

⑨ Articular surface of
 medial malleolus

⑩ Talus

⑪ Calcaneus (heel bone)

⑫ Hallux (great toe)

The ankle joint of this right leg and foot is a hinge joint formed by the tibia—the shinbone—and the talus, one of the tarsal bones in the foot.

THE FEET BEAR THE BODY'S WEIGHT, KEEP IT BALANCED AND STOP IT FALLING OVER WHETHER STATIONARY OR MOVING. THE FEET ALSO ACT AS LEVERS THAT PUSH THE BODY FORWARD DURING MOVEMENT. WHILE EACH FOOT HAS 26 BONES, JUST ONE LESS THAN EACH HAND, IT IS FAR LESS FLEXIBLE AND MOBILE THAN A HAND. THE BONES OF THE FOOT ARE BROADER AND FLATTER THAN THOSE IN THE HAND; THEIR ARRANGEMENT COUPLED WITH THE PRESENCE OF STRONG LIGAMENTS ALLOWS LITTLE FREE MOVEMENT OF BONES, BUT FACILITATES THE FOOT'S FUNCTION AS A WEIGHTBEARER AND MOVER. DESPITE THE LACK OF MOBILITY, BEING MADE OF MANY BONES MAKES FEET PLIABLE, SO THAT THEY CAN MOVE COMFORTABLY OVER BOTH SMOOTH AND UNEVEN SURFACES.

THE FOOT

KEY

1. Calcaneus
2. Cuboid
3. Metatarsal
4. Proximal phalanx
5. Middle phalanx
6. Distal phalanx
7. Talus
8. Navicular
9. 3rd cuneiform
10. 2nd cuneiform
11. 1st cuneiform
12. Distal phalanx of hallux

Like the hands, the feet contain three sets of bones. Seven tarsal bones form the tarsus or ankle. The talus articulates with the tibia and fibula to form the ankle joint. The calcaneus, the largest ankle bone, forms the heel, and is the attachment point of the large calcaneal (Achilles tendon) from the muscles of the calf (*see page* 219). On standing, both calcaneus and talus bear the body's weight initially before transferring it forward. The other tarsals are the navicular (boatshaped), cuboid, and first, second, and third cuneiform (wedgeshaped).

Five metatarsals form the tarsus, or sole, of the foot. At their distal ends, where they articulate with the toe bones, they form the "ball" of the foot. The first (medial) metatarsal is the strongest and bears more body weight. Together, the bones of the tarsus and metatarsus, by virtue of their arrangement and the reinforcement of ligaments and tendons, form an arch shape that keeps the sole off the ground. These springlike arches absorb impact experienced during walking and running—by first flattening and then springing back into shape—and spread the weight of the body. The tarsal and metatarsal bones also act as levers, raising the body and pushing it forward during walking and running.

The fourteen phalanges in the toes are much shorter and less mobile than those in the fingers. Each toe has three phalanges except for the hallux, or great toe, which has two. Functionally, the toes play a subordinate role to the tarsus and metatarsus, but they do contribute to stability.

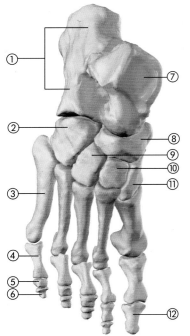

View from above

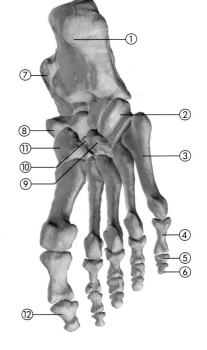

View from below

Two views of the bones of the right foot: on the left, a dorsal view from above; on the right, a plantar view from below.

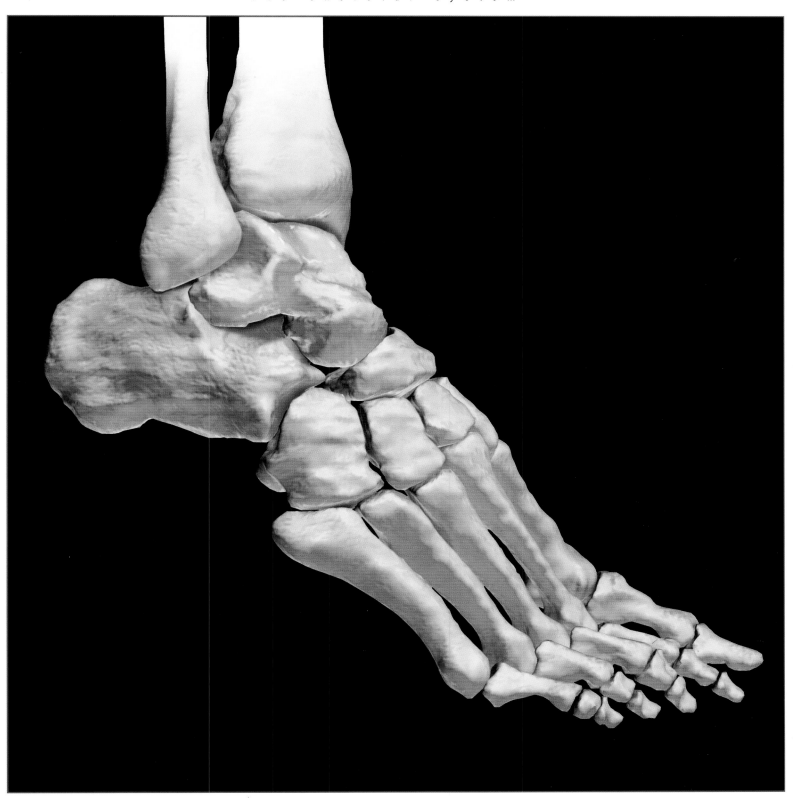

This lateral view of the bones of the right foot shows the springlike arches that flatten to absorb shocks and then recoil back to their arched shape.

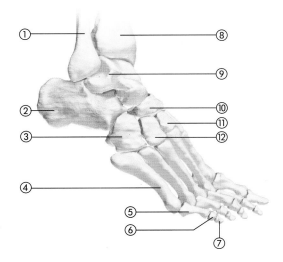

KEY

① Fibula
② Calcaneus
③ Cuboid
④ Metatarsal of little toe
⑤ Proximal phalanx
⑥ Middle phalanx
⑦ Distal phalanx
⑧ Tibia
⑨ Talus
⑩ Navicular
⑪ 2nd cuneiform
⑫ 3rd cuneiform

THE MUSCULAR SYSTEM MOVES THE BODY. IT CONSISTS OF OVER 640 SKELETAL MUSCLES THAT ARE ATTACHED TO THE BONES OF THE SKELETON ACROSS THEIR JOINTS. SKELETAL MUSCLES MAKE UP ABOUT 40 PERCENT OF THE BODY'S WEIGHT AND, WITH THE BONES AND SKIN, GIVE THE BODY ITS SHAPE.

THE FULL BODY

Anterior view of the whole body with skin and subcutaneous fat removed to reveal the major superficial skeletal muscles including those that produce facial expression, and those that flex the arm at the elbow and straighten the leg at the knee.

KEY

① Frontalis
② Orbicularis oculi
③ Deltoid
④ Biceps brachii
⑤ Brachialis
⑥ Brachioradialis
⑦ Flexor carpi radialis
⑧ Quadriceps femoris
⑨ Tibialis anterior
⑩ Zygomaticus
⑪ Orbicularis oris
⑫ Sternocleidomastoid
⑬ Pectoralis major
⑭ Rectus abdominis
⑮ External oblique
⑯ Palmaris longus
⑰ Tensor fasciae latae
⑱ Sartorius
⑲ Peroneus longus
⑳ Extensor digitorum longus

Muscle tissue uses energy to contract, or get shorter. This shortening movement provides the power to pull bones and produce a wide range of body movements from running to smiling. Muscles also maintain the body's posture, and stabilize joints. Heat released as a by-product of muscle contraction helps to keep the body warm.

Origins and insertions

Typically, each skeletal muscle is attached to bones at two or more points by cords of connective tissue called tendons. When a muscle contracts, one bone remains stationary and forms a fixed point, while the other bone moves. The end of the muscle attached to the immovable bone is called its **origin**; the other end, attached to the moving bone, is called its **insertion**. The body moves when muscles contract across joints and insertions move towards origins.

Range of movements

The movement, or movements, produced by a muscle depend on its position, the other muscles it may work with, and the type of synovial joint (*see page 50*) it crosses. The main movements produced by muscles are listed below. The principal action of a particular muscle—such as flexor or extensor—may be included in its name (*see below*).

• **Flexion**—a decrease in the angle of a joint bringing bones together, such as flexing (bending) the arm.

• **Extension**—the opposite of flexion; an increase in the angle of a joint, such as straightening the arm.

• **Abduction**—moving a bone away from the midline of the body, such as moving the arm laterally and upward (sideways).

• **Adduction**—the opposite of abduction, moving a bone towards the midline, such as moving the arm medially and downward (inwards).

• **Elevation**—lifting upward, such as the jaw, or the shoulder blades when shrugging the shoulders.

• **Depression**—the opposite of elevation, a downward movement.

• **Supination**—movement of the radius around the ulna in the forearm to turn the palm upward.

• **Pronation**—the opposite of supination, turning the palm downward.

• **Rotation**—moving a bone around its long axis.

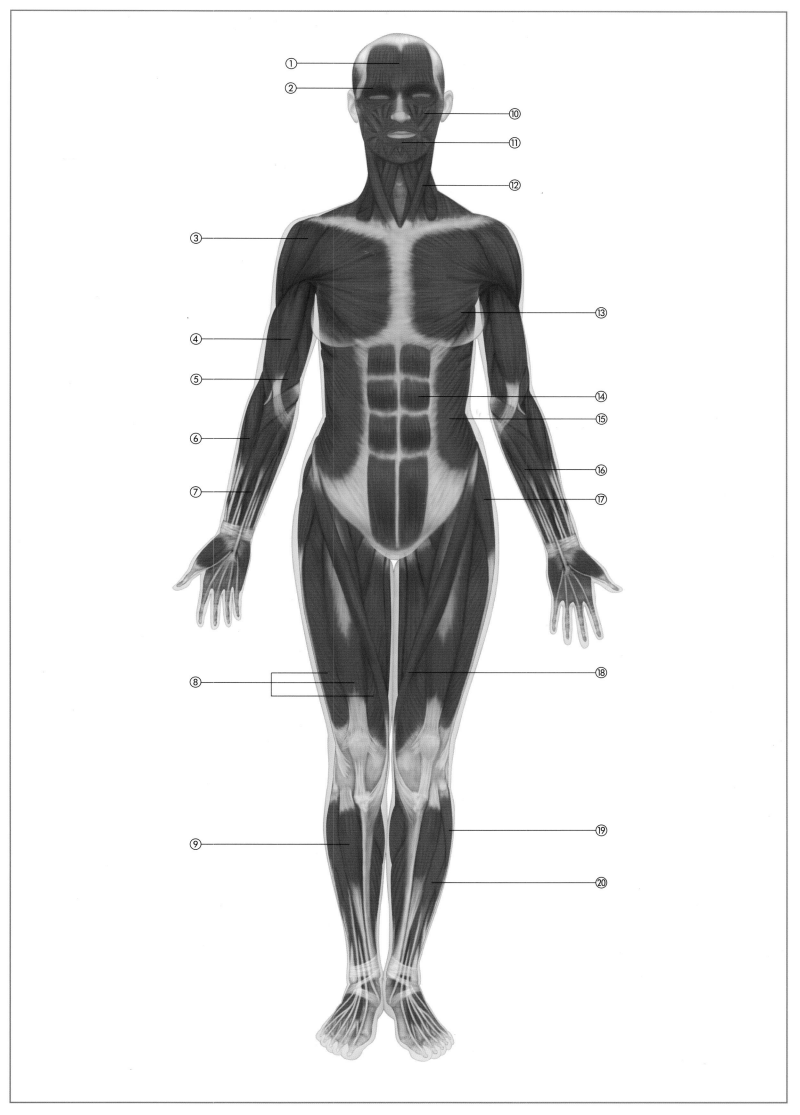

At first sight, the names of skeletal muscles may appear incomprehensible. The majority are in Latin or derived from Latin or Greek roots. However, most muscle names are based on one or more of the structural or functional characteristics listed below.

THE FULL BODY

- Shape—the relative shape of a muscle such as the deltoid (triangular), the trapezius (trapezoid), or rhomboideus (rhomboid).

- Location—the body region or bone with which the muscle is associated. For example, the intercostal muscles (costal means "ribs") run between the ribs; the frontalis muscle overlies the frontal bone of the skull.

- Number of origins—some muscles have more than one origin or head ("-ceps" indicates "head"). The biceps brachii and triceps brachii in the arm have, respectively, two and three origins; the quadriceps femoris in the thigh has four origins.

- Direction of muscle fibers in relation to the midline of the body—rectus (straight) fibers run parallel to the midline, as in the rectus femoris (the straight muscle of the thigh); transversus fibers run at right angles to the midline, as in the transversus abdominis (the transverse muscle of the abdomen); and oblique fibers run diagonally to the midline, as in the external oblique (the diagonal muscle of the abdomen).

- Relative size—"maximus" means largest and "minimus" smallest, as in the large and small buttock muscles (gluteus maximus and gluteus minimus); "longus" means long and "brevis" means short, as in the lower leg muscles—the peroneus longus and peroneus brevis—that move the foot.

- The origin and insertion of a muscle—the sternocleidomastoid in the neck, for example, has two origins on the sternum ("sterno-") and the clavicle ("-cleido-"), and inserts on the mastoid process of the temporal bone of the skull.

- Muscle action (*see page 60*)—for example, "flexor" means the muscle bends a joint. Other terms that relate to muscle action include extensor, abductor, adductor, levator, depressor, supinator, pronator.

- Combination names—for example, the extensor carpi radialis longus is an extensor muscle that straightens the wrist ("carpi"), lies along the radius bone of the forearm ("radialis"), and is longer than other wrist extensors.

Posterior view of the superficial muscles including those that support the head and neck, and those that straighten the arm at the elbow, and flex the leg at the knee. The tendons that link the muscles to bones are clearly visible, including the calcaneal (Achilles) tendon, the largest tendon in the body.

KEY

1. Occipitalis
2. Trapezius
3. Deltoid
4. Triceps brachii
5. Extensor digitorum
6. Adductor magnus
7. Gastrocnemius
8. Soleus
9. Sternocleidomastoid
10. Infraspinatus
11. Teres major
12. Latissimus dorsi
13. External oblique
14. Gluteus medius
15. Gluteus maximus
16. Biceps femoris
17. Semitendinosus
18. Semimembranosus
19. Hamstrings
20. Calcaneal (Achilles) tendon

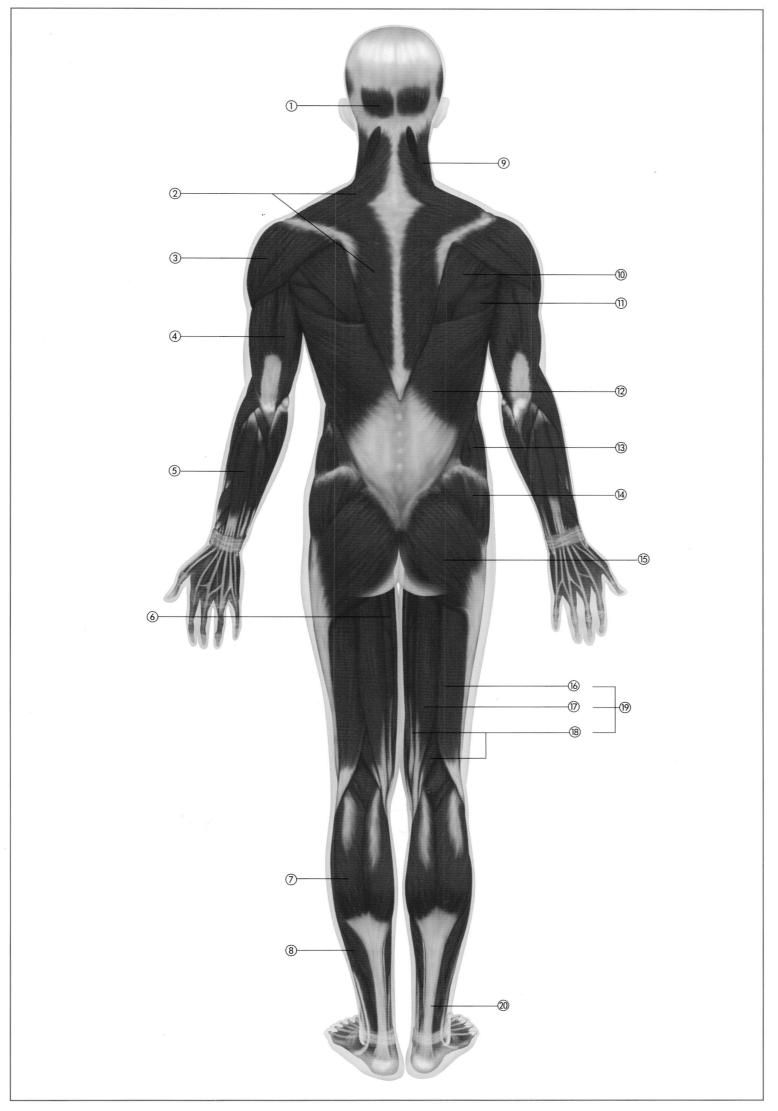

S O FAR, ONLY SKELETAL MUSCLE HAS BEEN DESCRIBED, HOWEVER, THERE ARE TWO OTHER TYPES OF MUSCLE IN THE BODY: SMOOTH MUSCLE AND CARDIAC MUSCLE. DESPITE DIFFERENCES IN LOCATION AND FUNCTION, ALL THREE TYPES SHARE COMMON CHARACTERISTICS. ALL ARE MADE OF LONG CELLS, CALLED FIBERS, THAT ARE EXCITABLE—ABLE TO RESPOND WHEN STIMULATED BY A NERVE IMPULSE (*see page* 90) OR A HORMONE (*see page* 106)—AND CONTRACTILE—ABLE TO SHORTEN WHEN STIMULATED. MUSCLE FIBERS CONTAIN TWO TYPES OF PROTEIN FILAMENTS, CALLED **ACTIN** AND **MYOSIN**, THAT INTERACT WHEN THE FIBER IS STIMULATED TO MAKE IT SHORTEN. MUSCLE FIBERS ARE ALSO EXTENSIBLE—CAPABLE OF STRETCHING—AND ELASTIC—ABLE TO RECOIL.

MUSCLE HISTOLOGY

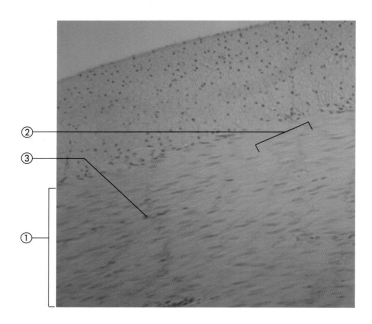

Smooth muscle fibers taken from the wall of a hollow organ. The short, spindle-shaped fibers typically interlock to form muscle sheets. They lack the striations seen in the other two fibers.

KEY

① Smooth muscle sheet
② Smooth muscle fiber
③ Nucleus of smooth
 muscle fiber

Skeletal muscle

Longest of the muscle fibers, skeletal muscle fibers have a striate (striped) appearance because of the arrangement of filaments inside them, and are also under conscious, voluntary control, hence their alternative names striate or voluntary muscle. Skeletal muscle fibers contract rapidly and powerfully, but tire easily. They are bound into bundles called **fascicles** by connective tissue called **perimysium**; fascicles are bound together by a protective connective tissue sheath, called the **epimysium**, to form a complete muscle.

Smooth muscle

Smooth muscle is found in the walls of hollow organs such as the small intestine, bladder, or blood vessels. Its fibers are short with tapering ends, do not have a striped appearance and are typically arranged in sheets. Smooth muscle contraction is involuntary—hence its alternative name, involuntary muscle—and is controlled automatically by the autonomic nervous system (*see page 98*). Without a person being consciously aware of it, slow, sustained contractions of their smooth muscle, for example, move food along the intestines or squeeze urine out of the bladder.

Cardiac muscle

Cardiac muscle is found only in the heart. Its fibers are striated and branched. Cardiac muscle contracts and relaxes automatically without external stimulation, and never tires as it provides a lifelong service squeezing the heart wall to pump blood around the body. Its own inbuilt rhythm is speeded up or slowed by the autonomic nervous system, according to the body's needs; its rate cannot be consciously controlled by most people.

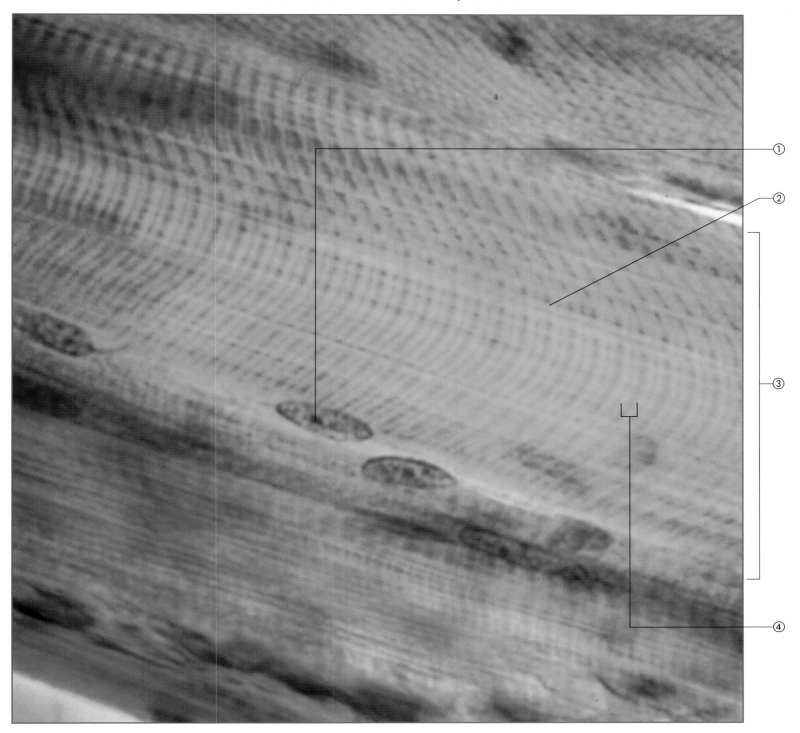

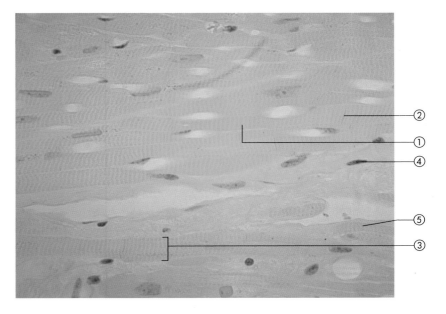

Above: microscopic view of part of three skeletal muscle fibers running in parallel. The central fiber shows the striped pattern, produced by the internal arrangement of contractile filaments.

KEY

① Nucleus

② Striation (stripe)

③ Skeletal muscle fiber

④ Sarcomere

Right: a network of branching cardiac fibers taken from the wall of the heart. The fibers interconnect at junctions called intercalated discs, which allow transmission of electrical signals that cause cardiac muscle to contract.

KEY

① Striation (stripe)

② Intercalated disc

③ Cardiac muscle fiber

④ Nucleus

⑤ Branch of cardiac muscle fiber

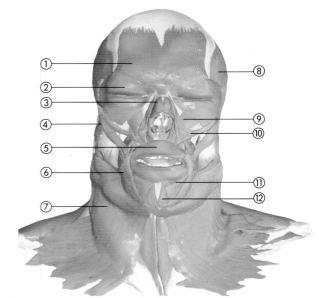

THE HEAD AND NECK CONTAIN MORE THAN 30 SMALL FACIAL MUSCLES. THESE MUSCLES PULL ON THE SKIN OF THE FACE, ENABLING A PERSON TO NONVERBALLY COMMUNICATE A WIDE RANGE OF EMOTIONS FROM PLEASURE TO ANGER. IN ADDITION, LARGER MUSCLES MOVE THE HEAD AND KEEP IT UPRIGHT, AND CLOSE THE LOWER JAW DURING SPEAKING AND EATING.

THE HEAD & NECK

Muscles visible in front view are the frontalis, which pulls the scalp forward to wrinkle the forehead and raise the eyebrows; orbicularis oculi, which surrounds the eye socket and closes the eye; levator labii superioris, which raises the upper lip and flares the nostril to indicate disgust; orbicularis oris, which surrounds the mouth and closes the lips; depressor anguli oris, which draws the corners of the mouth downward in a grimace; depressor labii inferioris, which draws the lower lip downward in a pout; and platysma, in the side of the chin and neck, which stretches the sides of the mouth downward.

Muscle shape and position

All skeletal muscles typically have the same basic features: the center of the muscle, called the belly, is attached by two ends to bones or other structures. However, the shape, power, and mobility of individual muscles depends on how their fascicles (bundles of fibers) are arranged.

- Parallel muscles—fascicles are arranged parallel to the long axis of the muscle. They can be fusiform, with a fleshy belly (e.g., biceps brachii in the upper arm), or straplike (e.g., sartorius in thigh).

- **Pennate** muscles—fascicles are arranged obliquely to a tendon running along the center of the muscle. These muscles can be **unipennate**, with fascicles attached to one side of the tendon (e.g., extensor digitorum longus in the lower leg), **bipennate**, with fascicles attached to both sides of the central tendon like a feather (e.g., rectus femoris in the thigh), or **multipennate**, with many bipennate units (e.g., deltoid muscle in the shoulder).

- Circular—with concentric rows of fascicles, which form a **sphincter** controlling the closing of external body openings (e.g., orbicularis oculi around the eyes).

These muscles tug at the skin to alter the face's topography, thereby producing a wide range of facial expressions.

KEY

① Frontalis
② Orbicularis oculi
③ Nasalis
④ Zygomaticus major
⑤ Orbicularis oris
⑥ Depressor anguli oris
⑦ Platysma
⑧ Temporalis
⑨ Levator labii superioris
⑩ Zygomaticus minor
⑪ Depressor labii inferioris
⑫ Mentalis

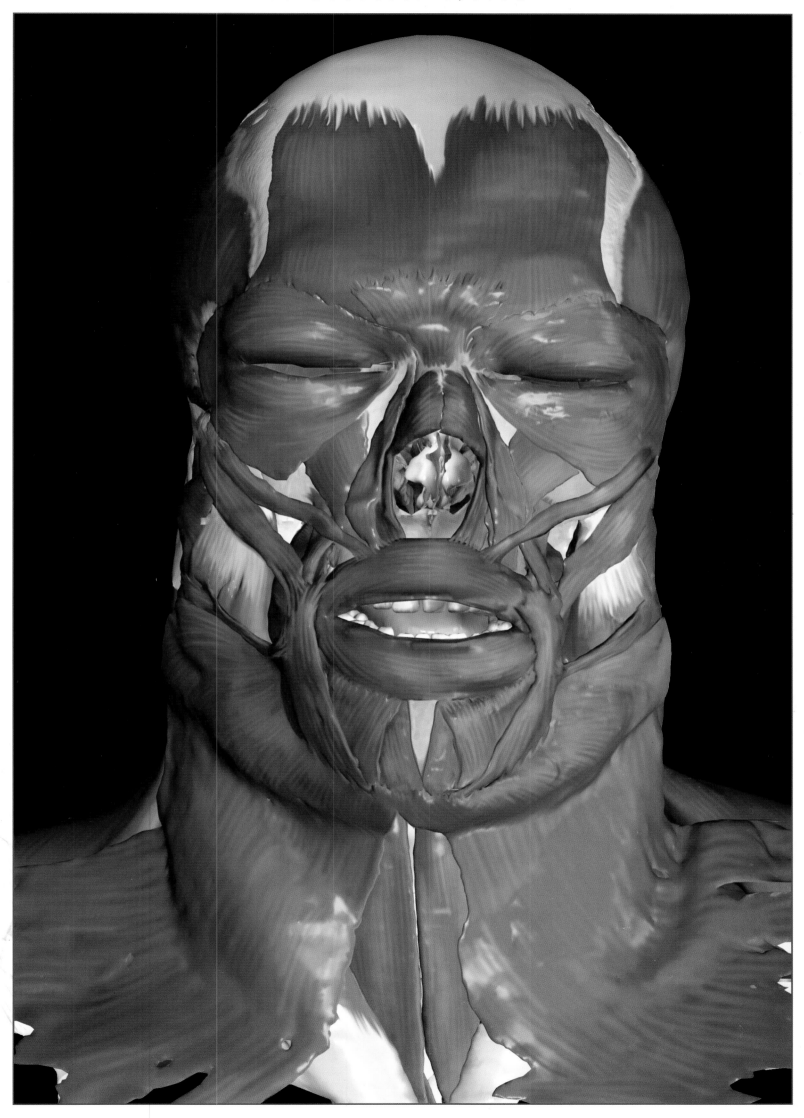

THE HEAD & NECK

Large, powerful muscles in the head move the jaws during eating, while those in the neck support and move the head.

KEY

1. Occipitalis
2. Temporalis
3. Masseter
4. Sternocleidomastoid
5. Trapezius
6. Galea aponeurotica
7. Frontalis
8. Cartilage plates of external nose
9. Zygomaticus major
10. Buccinator
11. Depressor anguli oris

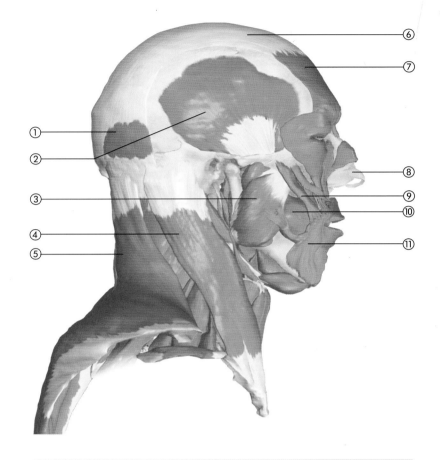

A side view of the head and neck reveals more of the muscles involved in facial expression, and in supporting and moving the head and neck. The risorius pulls the corners of the lips laterally in smiling, while the zygomaticus raises the corners of the mouth in smiling and laughing. The buccinator, or cheek muscle, pushes the cheeks inward during sucking, and forces food inward between the teeth during chewing. The temporalis and masseter are two powerful muscles that elevate the lower jaw to close the mouth, during chewing, for example. The occipitalis, at the back of the skull, is linked to the frontalis by a flat tendon, the galea aponeurotica. Together, these two muscles move the scalp forward (frontalis) and backward (occipitalis). The sternocleidomastoids flex the head, pulling it toward the chest; acting individually, a sternocleidomastoid rotates the head to one side. The trapezius has an opposing action, and pulls the head and shoulders backward.

How muscle fibers contract

A single skeletal muscle fiber—which can range in length from 1 mm to 30 cm (1/16 in to 12 in)—is packed with thousands of parallel, rod-like **myofibrils** that extend for the entire length of the fiber. Each myofibril consists of a chain of linked units called **sarcomeres**. Inside each sarcomere are parallel arrays of contractile protein filaments: thin, actin filaments, attached to each end of the sarcomere, but not meeting in its center; and thick, myosin filaments, located in the center of the sarcomere. When the muscle is at rest, actin and myosin filaments partially overlap.

When stimulated by a nerve to contract, electrical signals pass to the muscle's constituent fibers, causing the actin filaments to slide towards the center of the sarcomere. This happens because actin and myosin filaments repeatedly make and break cross bridges between them; this energy-requiring action produces a ratchetlike effect, pulling the actin filaments towards the center of the sarcomere. As actin filaments slide, myofibrils and their fibers shorten, contracting the muscle. When nervous stimulation ceases, the actin filaments slide back, and the muscle relaxes.

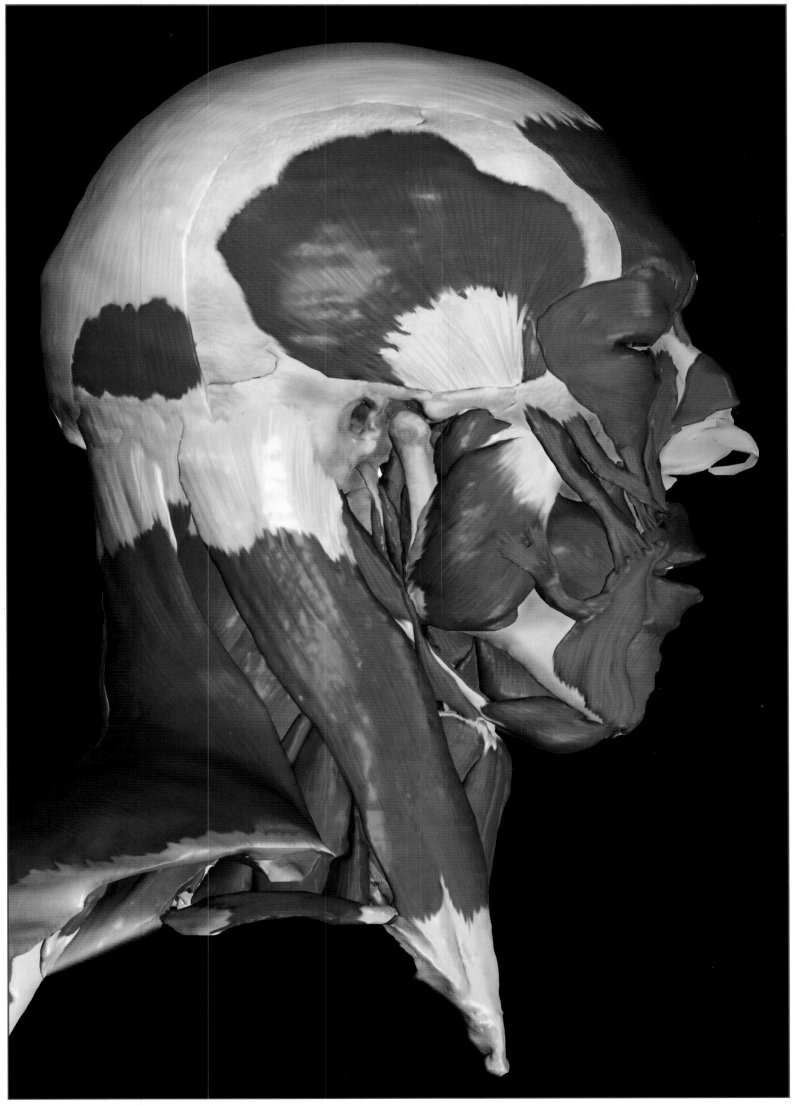

Dominating the superficial muscles at the front of the thorax is the pectoralis major, a large, fan-shaped muscle with its origins in the clavicle, sternum, and the costal cartilages of ribs 1 through 6. Its insertion is in the great tubercle at the top of the humerus. The pectoralis major flexes the arm at the shoulder so that it is lifted anteriorly (forward). It also adducts the arm, pulling it inward towards the body, and rotates the arm medially (toward the body). The pectoralis major is used in activities such as climbing, throwing, and pushing.

THE THORAX

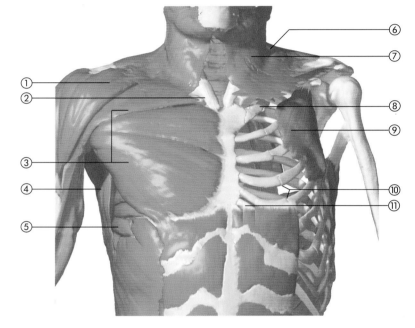

The pectoralis minor muscle, which lies deep to (underneath) the pectoralis major, has its origin in the ribs and insertion in the scapula. With the ribs held stationary, it pulls the scapula forward and downward; with the scapula fixed, it helps elevate the ribs during forced breathing. The serratus anterior muscle, with its sawtooth appearance, plays an important part in raising the arm and in horizontal arm movements. Running obliquely between the ribs are the intercostal muscles that help to move the chest during breathing.

Muscle actions

Most skeletal muscles function as part of a lever system. A lever is a rigid rod that moves on a fixed point, called a **fulcrum**, when a force, the effort, is applied to overcome another force, called the load. Levers allow a heavier load to be moved with less of an effort than would normally be possible.

In the body, bones act as levers, a joint is the fulcrum, effort is provided by muscle contraction, and the load is that part of the body to be moved.

There are three classes of levers, according to the relative positions of effort (E), load (L), and fulcrum (F).

- First class: F is between E and L, as in a seesaw or scissors. In the body, the trapezius (E) lifts the head (L), with F being the joint between atlas and skull.
- Second class: L is between F and E, as in a wheelbarrow. To put the body on tiptoe, calf muscles (E) pull the body upwards (L) with the ball of the foot acting as F.
- Third class: E is between L and F, as in forceps (tweezers). Most skeletal muscles work in third class systems. In the elbow joint (F) the biceps brachii muscle (E) pulls the radius bone to lift the forearm and hand (L).

KEY

1. Deltoid
2. Sternocleidomastoid
3. Pectoralis major
4. Latissimus dorsi
5. Serratus anterior
6. Trapezius
7. Platysma
8. Costal cartilage of rib no. 1
9. Pectoralis minor
10. Position of intercostal muscles
11. Costal cartilage of rib no. 6

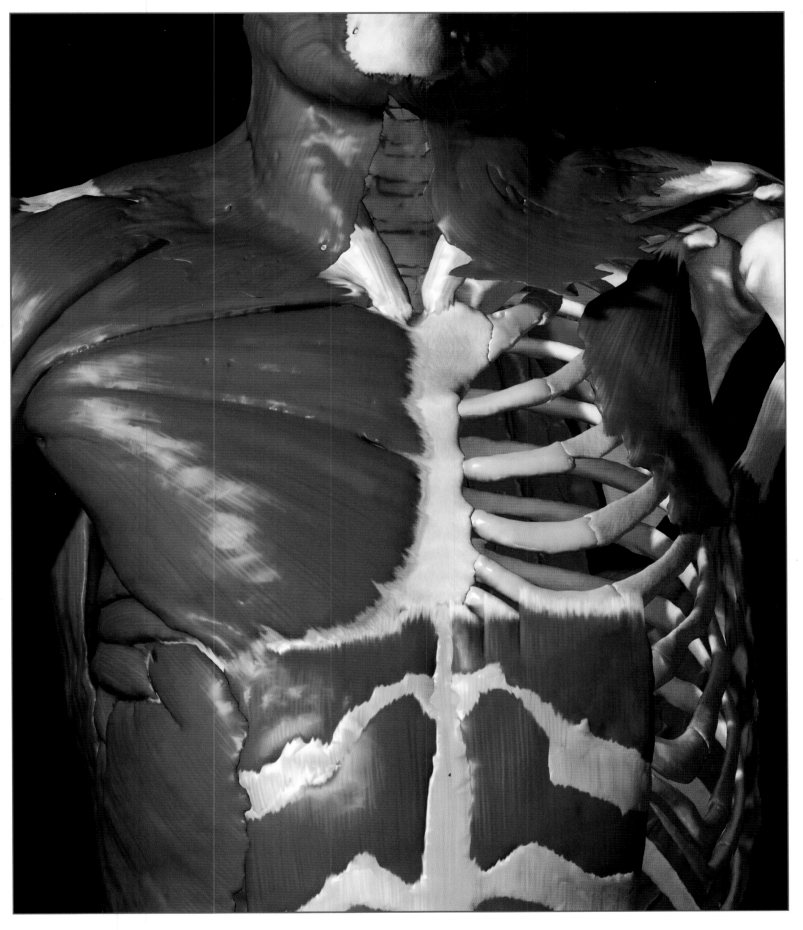

The muscles of the anterior thorax control movements of the shoulder and arm, and provide stability for both shoulder blade and shoulder joint.

T HE SUPERFICIAL MUSCLES OF THE POSTERIOR THORAX MOVE THE ARMS AND STABILIZE THE SHOULDER. THE TRAPEZIUS HAS ITS ORIGIN IN THE SKULL AND VERTEBRAL COLUMN AND ITS INSERTION IN THE SCAPULA AND CLAVICLE. IT STABILIZES THE SCAPULA WHILE OTHER MUSCLES ARE ACTING, PULLS THE SHOULDERS UPWARD, AND HELPS TO SUPPORT THE HEAD. BOTH TERES MAJOR AND INFRASPINATUS HAVE THEIR ORIGIN IN THE SCAPULA AND INSERTION IN THE HUMERUS. THE TERES MAJOR EXTENDS, ADDUCTS, AND MEDIALLY ROTATES THE ARMS; THE INFRASPINATUS STABILIZES THE SHOULDER JOINT BY HOLDING THE HEAD OF THE HUMERUS IN PLACE, AND LATERALLY ROTATES THE ARM. THE LATISSIMUS DORSI ("WIDEST OF THE BACK") HAS A BROAD ORIGIN IN THE VERTEBRAL COLUMN AND PELVIS, AND ITS INSERTION IN THE HUMERUS. IT IS THE PRIME MOVER OF ARM EXTENSION (MOVEMENT OF THE ARM POSTERIORLY), AS WELL AS ADDUCTING AND MEDIALLY ROTATING THE ARM. THE LATISSIMUS DORSI SUPPORTS THE ARM WHEN IT IS HELD ABOVE THE HEAD, AND PULLS THE ARM DOWN IN A POWER STROKE DURING, FOR EXAMPLE, SWIMMING OR HAMMERING.

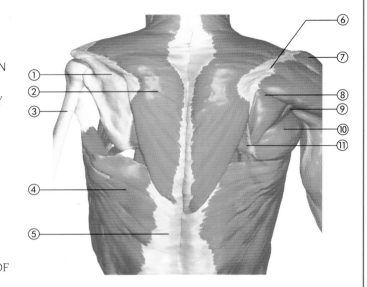

The powerful muscles of the posterior thorax, like those of the anterior thorax, move and stabilize the scapula, and move the arm.

THE THORAX

Muscle interactions

Most movements require several muscles working together in a group. Since muscles can only pull, and not push, some of these muscles pull a body part in one direction while others pull in the opposite direction. According to their role (or roles) muscles are divided into four groups.

- Prime mover or **agonist**—the muscle that provides the main force to achieve a specific movement. For example, the pectoralis major in the thorax is the prime mover of arm flexion.
- **Antagonist**—a muscle that opposes the action of a prime mover. For example, the antagonist of the biceps brachii, the prime mover of forearm flexion, is the triceps brachii, the prime mover of forearm extension.

- **Synergist**—a muscle that works with a prime mover to produce the same movement or to reduce any unnecessary movements that may occur when the prime mover contracts. For example, synergists stabilize the wrist joint while forearm flexor muscles—whose tendons pass over the wrist joint—bend the fingers.
- **Fixator**—this is a synergist that fixes a bone to stabilize the origin of the prime mover. For example, the scapula (which is only attached to the skeleton by muscles) is fixed by muscles such as the pectoralis minor and trapezius, while the prime mover, the deltoid, abducts the arm.

KEY

1. Scapula
2. Trapezius
3. Humerus
4. Latissimus dorsi
5. Lumbodorsal fascia
6. Spine of scapula
7. Deltoid
8. Infraspinatus
9. Teres minor
10. Teres major
11. Rhomboid major

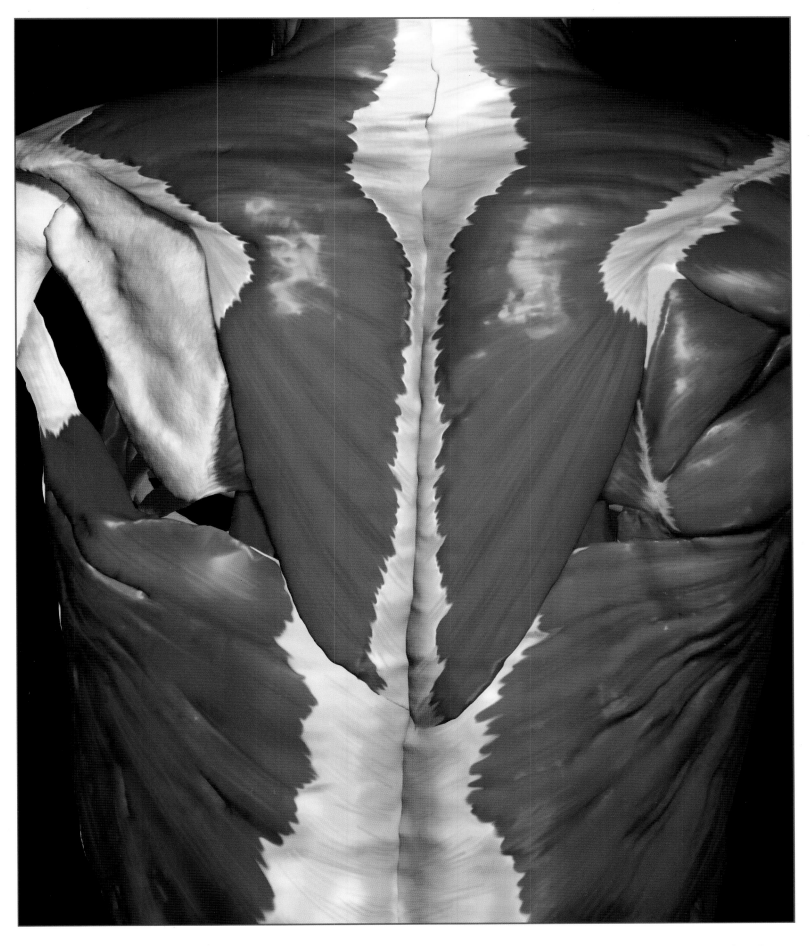

On the left side the deltoid, infraspinatus, and the teres major have been removed to expose the scapula and the shoulder joint.

THE MUSCLES OF THE SHOULDER AND UPPER ARM ARE RESPONSIBLE FOR ARM

MOVEMENT. MUSCLES THAT CROSS THE SHOULDER JOINT AND INSERT INTO THE

HUMERUS (*see page* 50), EITHER MOVE THE ARM OR STABILIZE THE SHOULDER JOINT,

THE MOST FLEXIBLE BUT ALSO THE MOST UNSTABLE JOINT IN THE BODY. THE MUSCLES THAT

FLESH OUT THE UPPER ARM AND CROSS THE ELBOW JOINT—A HINGE JOINT—TO INSERT

ON THE BONES OF THE FOREARM, EITHER FLEX OR EXTEND THE FOREARM.

Shoulder muscles provide stability to the shoulder joint, a ball and socket joint that is highly mobile but also quite unstable.

THE SHOULDER & UPPER ARM

Bending and straightening of the elbow joint is achieved by the muscles of the upper arm.

KEY

① Vertebral column (3rd cervical vertebra)
② Trapezius
③ Clavicle
④ Deltoid
⑤ Pectoralis major
⑥ Triceps brachii
⑦ Latissimus dorsi
⑧ Biceps brachii
⑨ Serratus anterior
⑩ Brachialis
⑪ Brachioradialis
⑫ Rib

Of the nine muscles that cross the shoulder joint, seven have their origins on the scapula, while two—the pectoralis major and latissimus dorsi (*see page 72*) arise from the axial skeleton. One of these seven "scapular" muscles is the deltoid, which, like the pectoralis major and latissimus dorsi, is a prime mover of arm motility. The deltoid wraps around the shoulder, provides its round contours, and is involved in all arm movements. It is the prime mover of arm abduction (acting as an antagonist to the pectoralis major and latissimus dorsi, which both adduct the arm) and, depending on which part of the deltoid is contracting, it either flexes (pulls anteriorly) and medially rotates the humerus, or extends (pulls posteriorly) the humerus and laterally rotates it. The other scapular muscles, apart from the coracobrachialis, are found posteriorly to the shoulder joint. The coracobrachialis is a small muscle that flexes and adducts the humerus.

The muscles of the anterior (front) part of the forearm cause the arm to bend at the elbow. The strong brachialis has its origin in the humerus and inserts on the ulna, pulling on the ulna to lift the forearm. It contracts at the same time as the biceps brachii (*see page 78*), which both lifts and supinates the forearm. The less powerful brachioradialis, which has its origin in the distal humerus and insertion on the distal radius, acts as a synergist to the brachialis and the biceps brachii when they have already partially flexed the elbow joint.

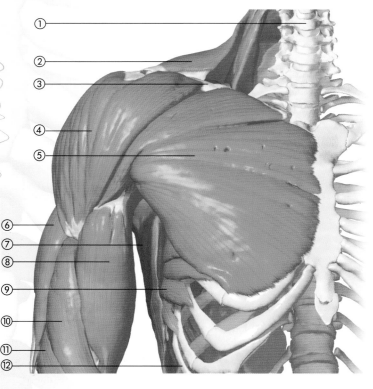

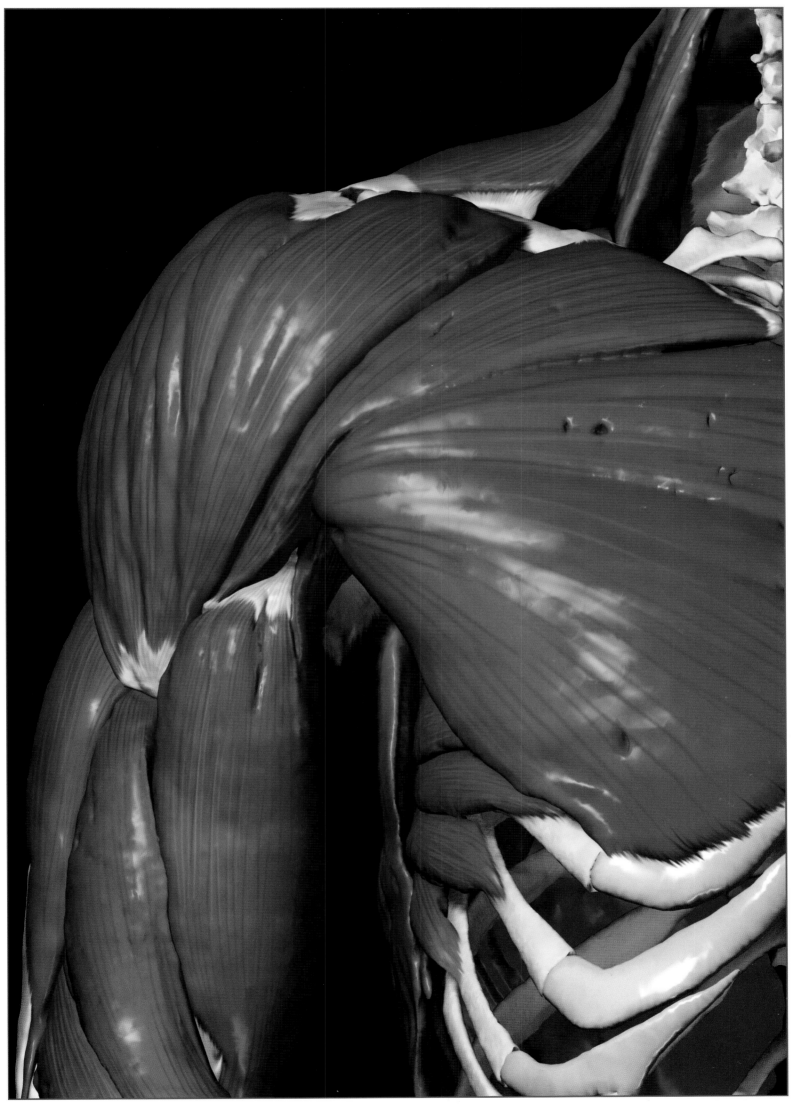

A T THE REAR OF THE SHOULDER, FOUR OF THE SCAPULAR MUSCLES —

THE SUPRASPINATUS, INFRASPINATUS, TERES MINOR, AND

SUBSCAPULARIS—HAVE THEIR ORIGINS ON THE SCAPULA AND

INSERTION ON THE HUMERUS (*see page* 50). THEIR ASSOCIATED TENDONS

AMALGAMATE EN ROUTE WITH THE FIBROUS CAPSULE SURROUNDING THE SHOULDER

JOINT. KNOWN AS THE **ROTATOR CUFF MUSCLES**, THEY STABILIZE THE SHOULDER

JOINT BY HOLDING THE HEAD OF THE HUMERUS IN ITS BALL AND SOCKET JOINT. THE

TERES MAJOR EXTENDS, MEDIALLY ROTATES, AND ADDUCTS THE HUMERUS.

THE SHOULDER & UPPER ARM

The bulk of the posterior (rear) part of the upper arm is formed by the triceps brachii muscle, the prime mover of elbow extension. The triceps brachii has three heads: the long head has its origin on the scapula, and the lateral and medial heads on the humerus; the insertion is through a common tendon on the olecranon process of the ulna (the projection that can be felt at the posterior of the elbow).

Fast and slow twitch

How rapidly a muscle contracts, and how long it can stay contracted before it experiences fatigue (through a lack of energy necessary for contraction), varies from one muscle to the next. These variations are caused primarily by differences in muscle fibers. There are three basic types of fiber. These vary in the amount of the red pigment **myoglobin** they contain— myoglobin, like hemoglobin in the blood, stores oxygen needed to release energy—and in their speed of contraction.

- Red slow twitch (a twitch is a single muscle contraction) fibers are red in color, have plenty of myoglobin and contract slowly, have high endurance, and are fatigue-resistant, allowing them to contract for prolonged periods.
- White fast twitch fibers have little myoglobin and fatigue easily, contracting rapidly for short periods, and usually producing powerful contractions.
- Intermediate fast twitch fibers are red because of a high myoglobin content, but also contract rapidly and do not fatigue easily.

Most skeletal muscles contain a mixture of fibers, although relative proportions depend on the function of the muscle. Muscles in the neck, back and legs that maintain posture, for example, contain more red slow twitch fibers; muscles, such as those in the arms, used from time to time to produce sudden strong actions such as throwing or lifting, contain more white fast twitch fibers; leg muscles, for example, involved in running contain more intermediate fast twitch fibers.

The "three headed" triceps brachii at the back of the arm acts as an antagonist to the biceps brachii by straightening the elbow.

KEY

① Trapezius
② Deltoid
③ Infraspinatus
④ Teres minor
⑤ Teres major
⑥ Rhomboid
⑦ Triceps brachii (long head)
⑧ Triceps brachii (medial head)
⑨ Biceps brachii
⑩ Brachialis
⑪ Latissimus dorsi
⑫ Tendon of triceps brachii
⑬ Medial epicondyle of humerus

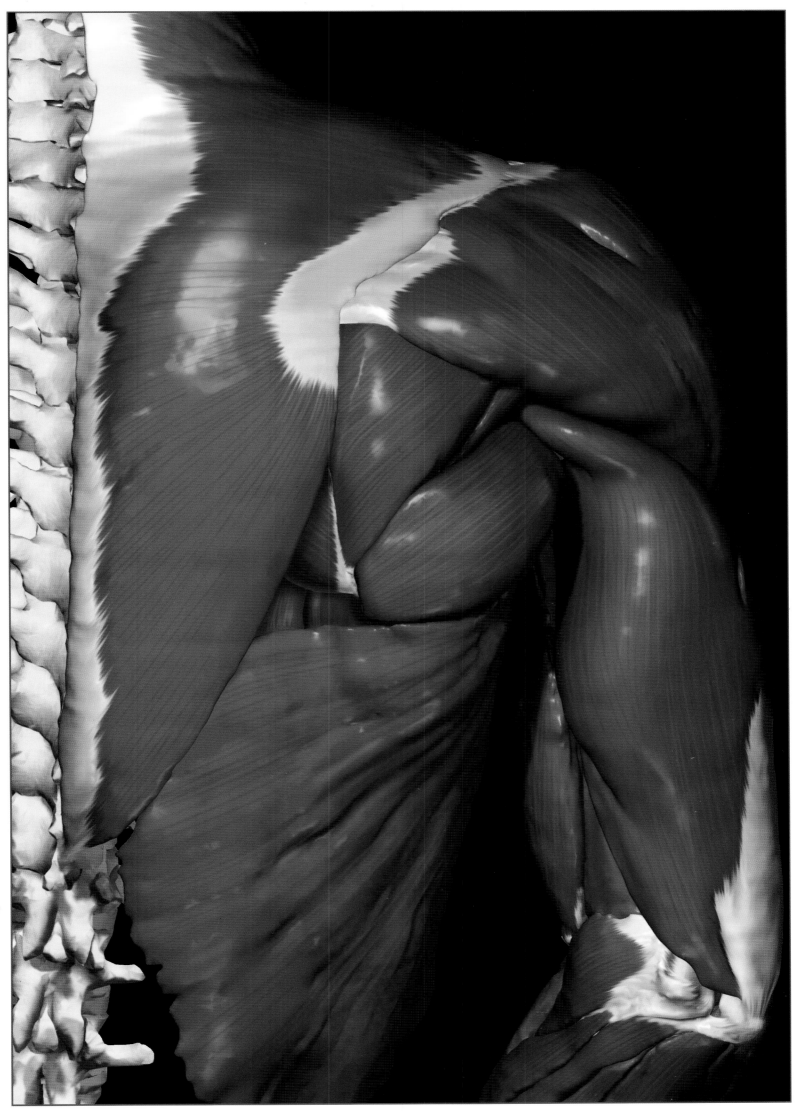

THE BICEPS BRACHII—THE NAME MEANS "TWO HEADS IN THE ARM"—IN THE UPPER ARM IS THE

MUSCLE COMMONLY FLEXED BY THOSE WISHING TO SHOW OFF THEIR MUSCULAR PROWESS BECAUSE

IT BULGES VISIBLY DURING CONTRACTION. IT IS A FUSIFORM MUSCLE, SPINDLE-SHAPED WITH A

FLESHY BODY TAPERING AT BOTH ENDS INTO TENDONS. THE TWO HEADS OF ITS NAME ARE AT ITS

ORIGIN, WHERE TWO TENDONS ATTACH IT TO THE SCAPULA. ITS INSERTION IS IN THE RADIUS OF THE FOREARM.

THE BICEPS BRACHII FLEXES THE ARM AT THE ELBOW AND ALSO HELPS TO SUPINATE THE FOREARM, TURNING

THE FOREARM SO THE PALM OF THE HAND FACES UPWARD.

THE BICEPS BRACHII

Posterior view of the right shoulder, upper arm, and shoulder shows clearly the triceps brachii and its synergist, the anconeus, which assists in arm extension.

KEY

① Deltoid
② Scapula
③ Teres minor
④ Teres major
⑤ Triceps brachii
⑥ Brachialis
⑦ Brachioradialis
⑧ Lateral epicondyle of humerus
⑨ Extensor carpi radialis longus
⑩ Extensor carpi radialis brevis
⑪ Extensor digitorum
⑫ Medial epicondyle of humerus
⑬ Olecranon of ulna
⑭ Anconeus

The structure and function of tendons

Skeletal muscles are attached to bones by tendons. When the muscle contracts, the tendon pulls the bone to which it is attached, to make the bone move at its joint with another bone. Some tendons link muscles to other muscles, while others, such as those in the face, link the muscles that produce

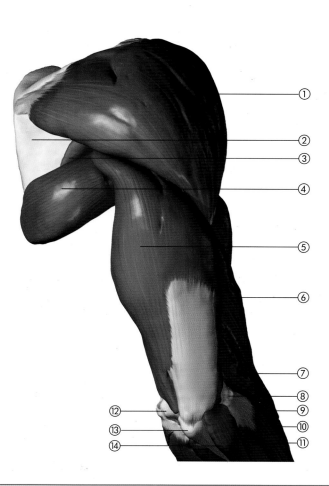

facial expression to the skin. Tendons also help to stabilize joints.

Tendons are an extension of the connective tissue sheaths that bind and surround muscle fibers. They are made of dense connective tissue that contains regularly arranged bundles of collagen (a type of protein) fibers running in parallel. This produces a white flexible tissue, which has considerable resistance to pulling forces.

The majority of tendons extend from the tapering ends of muscles like white cables. Extensions of the tendon's collagen fibers, called **Sharpey's fibers**, firmly anchor the tendon to its bone. These fibers penetrate the periosteum, the membrane covering the bone, and embed themselves in the layer of compact bone (*see page 40*).

Long tendons, such as those in the hands and feet, are surrounded by tendon sheaths. These contain oily synovial fluid (*see page 38*) that lubricate the sliding tendons as the forearm muscles they are attached to pull on the fingers or toes. Some tendons, called **aponeuroses**, are flat rather than cablelike. Aponeuroses not only link muscles to bone but also muscles to muscles.

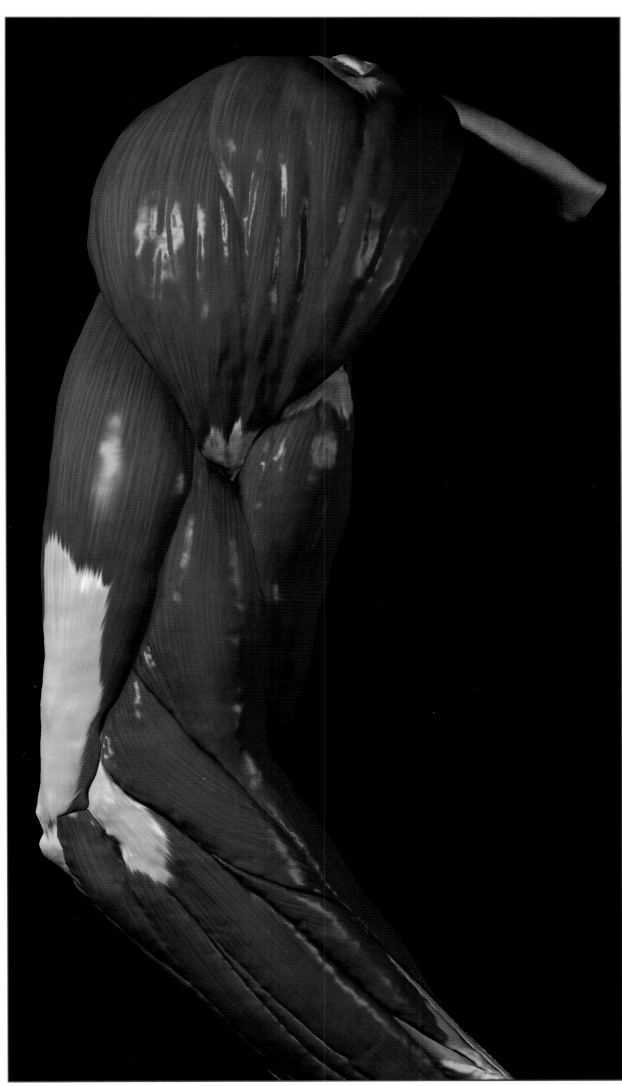

The right shoulder and upper arm seen from the right side showing the biceps brachii and the other arm flexors in the anterior upper arm, and the triceps brachii, the prime mover of arm extension, in the posterior upper arm.

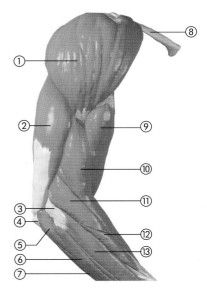

KEY

1. Deltoid
2. Triceps brachii
3. Lateral epicondyle of humerus
4. Olecranon process of ulna
5. Anconeus
6. Extensor carpi ulnaris
7. Flexor carpi ulnaris
8. Clavicle
9. Biceps brachii
10. Brachialis
11. Extensor carpi radialis longus
12. Extensor carpi radialis brevis
13. Extensor digitorum

THE HAND OWES ITS VERSATILITY AND FLEXIBILITY TO ITS FRAMEWORK OF SMALL BONES, AND TO THE MANY MUSCLES IN THE FOREARM AND HAND THAT MOVE THEM. MOST MOVEMENTS OF THE WRIST AND FINGERS ARE PRODUCED BY FOREARM MUSCLES. THESE HAVE THEIR ORIGIN AT THE ELBOW, THEN TAPER INTO LONG TENDONS THAT EXTEND INTO THE HAND, AND HAVE THEIR INSERTIONS IN THE WRIST OR FINGER BONES. THE TENDONS PASS UNDER FIBROUS STRAPS CALLED **RETINACULA** ("RETAINERS"), WHICH HOLD THEM IN PLACE, AND ARE SURROUNDED BY SLIPPERY SYNOVIAL SHEATHS THAT LUBRICATE THEM.

THE FOREARM & HAND

KEY

① Brachioradialis
② Flexor carpi radialis
③ Flexor digitorum superficialis
④ Flexor retinaculum
⑤ Abductor pollicis brevis
⑥ Palmaris longus
⑦ Flexor carpi ulnaris
⑧ Extensor carpi ulnaris
⑨ Extensor digiti minimi
⑩ Extensor carpi radialis brevis
⑪ Extensor digitorum
⑫ Abductor pollicis longus
⑬ Extensor retinaculum
⑭ Interosseous

Most muscles in the anterior (inner or underside) forearm are flexors. Their tendons are held in place by the flexor retinaculum. Among the superficial muscles the flexor digitorum superficialis flexes the fingers; the flexor carpi ulnaris flexes and adducts the wrist; the flexor carpi radialis flexes and abducts the wrist; and the palmaris longus flexes the wrist and tenses the palm. A deep muscle, the flexor pollicis longus, flexes the thumb. The pronator teres performs the important action of pronating the forearm, so that the palm turns downward. The brachioradialis is a synergist of the biceps brachii of the upper arm in forearm flexion.

Most muscles in the posterior (outer or upper side) forearm are extensors that act as antagonists to the flexors of the anterior forearm. Their tendons are held in place by the extensor retinaculum. Among the superficial muscles, the extensors carpi radialis longus and brevis extend and abduct the wrist; the extensor carpi ulnaris extends and adducts the wrist; and the extensor digitorum is the prime mover of finger extension. Other muscles include the extensors pollicis brevis and longus,

which extend the thumb; and the extensor digiti minimi, that extends the little finger.

Movements produced by the forearm muscles are assisted and made more precise by smaller muscles in the hand. These intrinsic muscles include the lumbrical and interosseus muscles between the metacarpals, which flex the metacarpophalangeal (knuckle) joints, but extend the fingers, thenar muscles, including the flexor pollicis brevis, which bends the thumb, and the abductor pollicis brevis, which abducts the thumb.

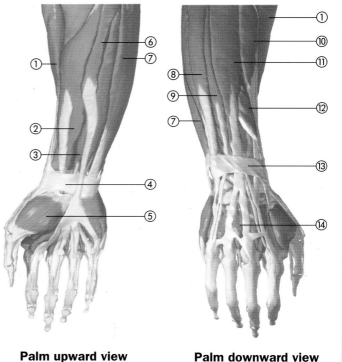

Palm upward view

Palm downward view

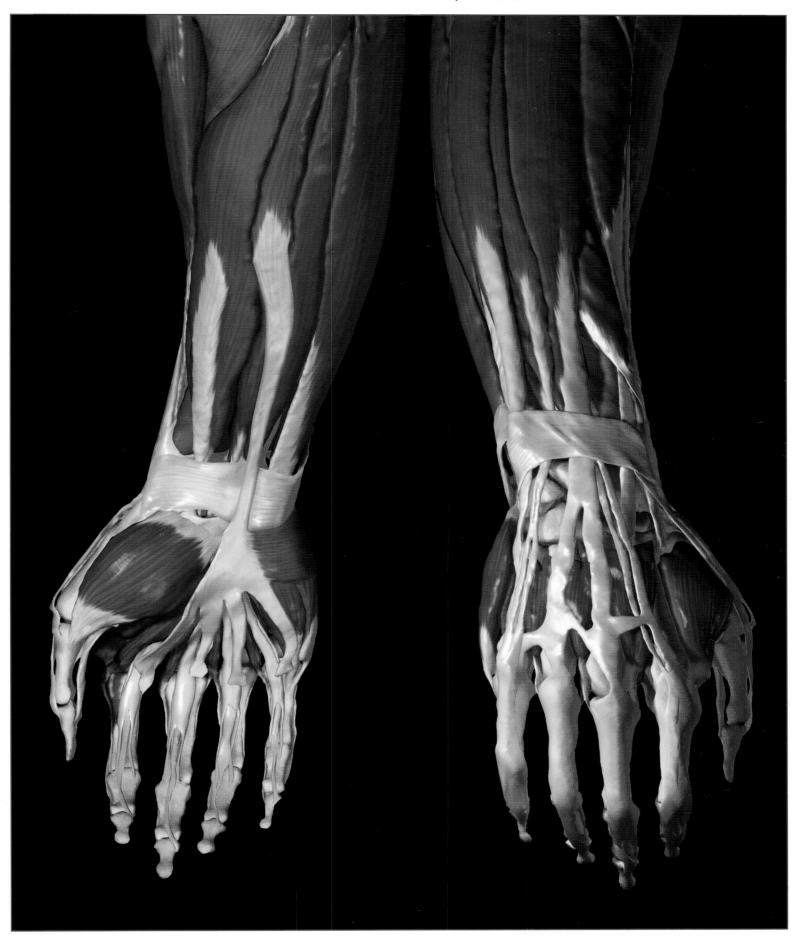

The superficial
muscles of the right
forearm and hand
seen in anterior, palm
upward view (left)
and posterior, palm
downward view
(right).

Unlike the thorax, the walls of the abdomen do not have the support of a framework of bones. Instead, the organs of the lower trunk are held in place and protected by anterior (front) and lateral (side) walls made up of four paired, flat muscles and their aponeuroses (flattened tendons). These muscles also promote movement of the vertebral column to flex the trunk forward and to the sides, and to rotate it; and to prevent hyperextension of the backbone (bending back too far).

THE ABDOMEN

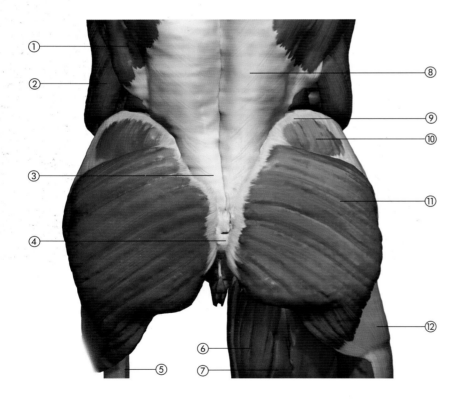

Posterior view of the muscles of the pelvis and thigh. The massive gluteal muscles act during forceful thigh extension; the thigh muscles extend the hip and flex the knee.

KEY

① Latissimus dorsi
② External oblique
③ Sacrum
④ Coccyx
⑤ Femur
⑥ Adductor magnus
⑦ Semimembranosus
⑧ Lumbodorsal fascia
⑨ Iliac crest
⑩ Gluteus medius
⑪ Gluteus maximus
⑫ Iliotibial tract

In the anterior section, the straplike rectus abdominis has its origin in the pubic bone of the pelvis and insertion in the sternum and ribs. It flexes and rotates the trunk, promotes anterior flexion of the trunk against resistance (as when a person does sit-ups), and pushes the abdominal organs inwards. It is assisted in these roles by the lateral muscles that are layered on top of each other. On top, on each side, is the external oblique, whose fibers run downward and inward and which has its origin in the ribs and insertion via a broad aponeurosis and into the pelvic girdle. Below this lies the internal oblique, whose fibers run at 90° to the external oblique, and which has its origin in the posterior pelvis and insertion in the ribs, anterior pelvis, and linea alba, the tendinous seam that runs from sternum to pubic bone. Deep to the internal oblique is the transversus abdominis, whose fibers run horizontally, and which compresses the abdominal contents.

Isotonic and isometric contraction

Muscles do not always get shorter when they contract. Muscle contraction is an active process in which a force—called muscle tension—is generated. This muscle tension is exerted on part of the body. That body part, called the load, exerts an opposing force that resists the pull of the muscle.

During **isotonic contraction**, the familiar form of contraction already described, a muscle gets shorter and causes movement; the muscle tension generated is greater than the load. In **isometric contraction**, tension develops and the muscle exerts a pulling force, but it does not shorten because opposing forces are equal.

Most movements involve both isotonic and isometric contractions. However, contractions that cause clear movements, such as kicking or waving, are primarily isotonic, while those that maintain upright posture are primarily isometric.

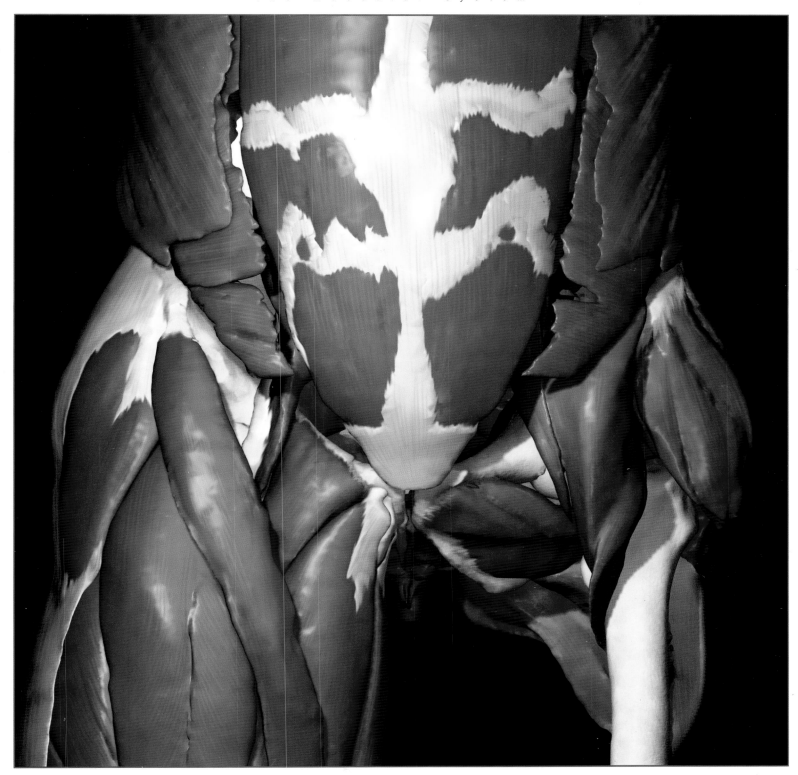

Anterior view of the muscles of the pelvis and thigh. The size and strength of these muscles reflects the role of the lower limbs in movement and support.

KEY

1. External oblique
2. Iliopsoas
3. Pectineus
4. Tensor fasciae latae
5. Rectus femoris
6. Rectus abdominis
7. Anterior superior iliac crest (point of the hip)
8. Pubis of left coxal (hip) bone
9. Femur
10. Ischium of left coxal (hip) bone
11. Adductor longus
12. Sartorius
13. Gracilis

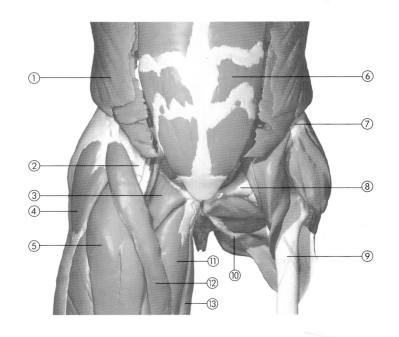

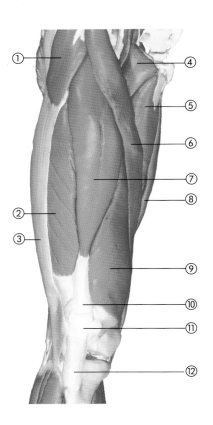

① ④
⑤
⑥
⑦
② ⑧
③
⑨
⑩
⑪
⑫

THE MOST MUSCULAR PARTS OF THE BODY, WITH THE MOST POWERFUL

MUSCLES, THE LEGS ARE STRONG ENOUGH TO SUPPORT THE BODY AND TO

MOVE IT DURING WALKING, RUNNING, OR JUMPING. MOST THIGH (UPPER

LEG) MUSCLES HAVE THEIR ORIGIN IN THE PELVIC GIRDLE AND THEIR INSERTION IN THE

TIBIA. SOME ACT ONLY AT THE HIP JOINT, OTHERS ACT ONLY AT THE KNEE JOINT, AND A

FEW ACT AT BOTH JOINTS. MUSCLES IN THE ANTERIOR (FRONT) PART OF THE PELVIS

AND THIGH FLEX THE HIP TO LIFT THE THIGH, ADDUCT AND ROTATE THE THIGH, AND

EXTEND (STRAIGHTEN) THE LEG AT THE KNEE. BY SO DOING, THESE MUSCLES

PRODUCE THE FORWARD SWINGING PHASE OF WALKING.

THE PELVIS, THIGH & KNEE

The size and power of the thigh muscles reflects their function of moving the weight of the upper body during walking or running.

The powerful, fleshy quadriceps femoris is a composite of four muscles (quadriceps means "four heads"): the rectus femoris has its origin in the pelvic girdle; the other three muscles, the vastus lateralis, vastus medialis, and vastus intermedius, have their origins on the femur. All four have a common insertion via the patella (kneecap) to the tibia. The quadriceps femoris extends the knee during standing up, climbing, jumping, and running; the rectus femoris also flexes the hip.

The pectineus, which has its origin in the pelvic girdle and insertion in the femur, flexes and adducts the thigh. The strap-like sartorius, with its origin in the pelvic girdle and insertion in the medial tibia, both flexes the thigh and laterally rotates it.

The adductor muscles of the thigh—adductor magnus, adductor longus, adductor brevis, pectineus, and gracilis—pull the thigh inwards towards the body. Adduction (and abduction) of the thigh is important during walking to keep the weight of the upper body balanced over the legs. The adductors

magnus, longus, and brevis have their origins in the inferior part of the pelvic girdle and insertions in various parts of the femur. These muscles flex and laterally rotate the thigh. The gracilis, which also has its origin in the inferior pelvic girdle, inserts in the tibia. The gracilis also flexes the thigh and medially rotates the leg.

The tensor fasciae latae has its origin in the pelvic girdle and inserts via a long tendon, the iliotibial tract, into the tibia. This muscle flexes and abducts the thigh, and rotates it medially.

KEY

1. Tensor fasciae latae
2. Vastus lateralis
3. Iliotibial tract
4. Pectineus
5. Adductor longus
6. Sartorius
7. Rectus femoris (overlies vastus intermedius)
8. Gracilis
9. Vastus medialis
10. Tendon of quadriceps femoris
11. Patella
12. Patellar ligament

This anterior view of the right leg reveals the powerful muscles that lift the thigh upward and straighten the leg at the knee.

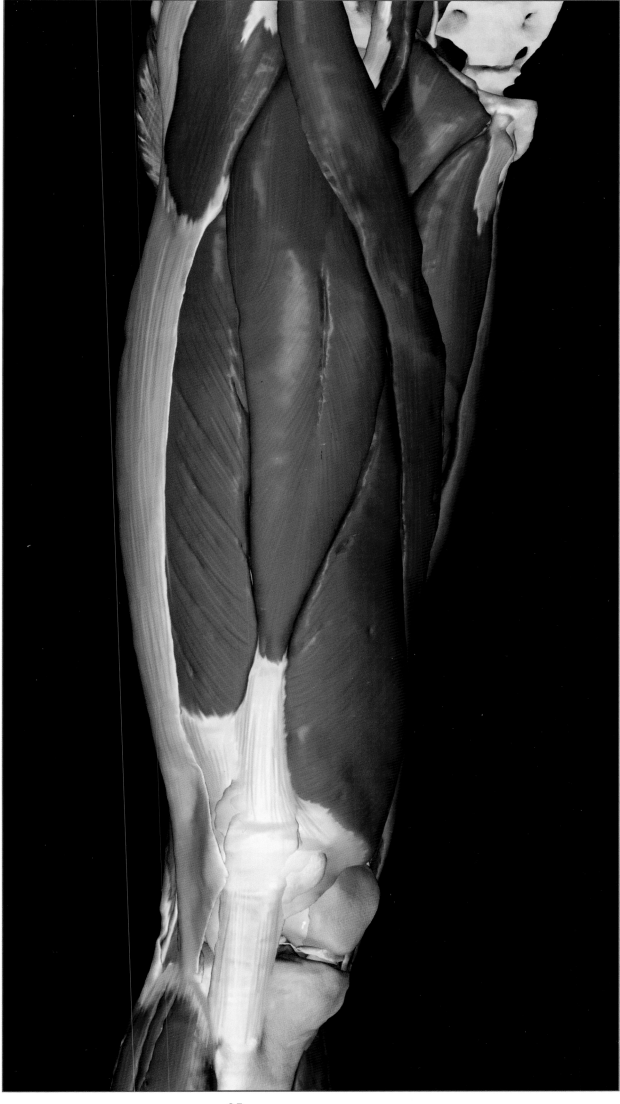

THE POSTERIOR (REAR) MUSCLES OF THE HIP AND THIGH EXTEND (STRAIGHTEN) THE HIP BY PULLING THE THIGH POSTERIORLY, ABDUCT THE LEG AND ROTATE IT, AND FLEX (BEND) THE LEG AT THE KNEE. THESE ACTIONS MAKE UP THE BACKWARD SWINGING PART OF WALKING.

THE PELVIS, THIGH & KNEE

The large, fleshy muscles of the posterior part of the thigh—the biceps femoris, semitendinosus, and semimembranosus—are collectively called the hamstrings. Their name derives from the habit, in times past, of butchers hanging pork legs by the tendons of this muscle group when making ham. The hamstring tendons can be felt behind the knee by sitting and tensing the leg. Antagonists of the quadriceps femoris, the hamstrings cross both hip and knee joints, and are the prime movers of hip extension and knee flexion. How the hamstrings act depends on which of two joints—hip or knee—is fixed. If the hip is fixed and extended, the hamstrings cause knee flexion; if the knee is fixed and extended, the hamstrings cause hip extension. All three hamstring muscles have their origin in the pelvic girdle, and all insert into the tibia, although the biceps femoris also inserts into the fibula. As well as extending the thigh and flexing the knee, the hamstrings also laterally rotate the thigh, especially when the knee is flexed.

The gluteus maximus, the largest muscle in the body, has its origins in the pelvic girdle and insertion in the femur and the iliotibial tract (*see page 217*). It extends the thigh at the hip and rotates it laterally, especially when the knee is flexed. The gluteus maximus comes into its own when forceful thigh extension is needed in order to move it from the flexed position such as during running or climbing stairs. The smaller gluteus medius and gluteus minimus, which with the gluteus maximus make up the bulk of the buttock, also run between pelvic girdle and femur. They abduct and medially rotate the thigh, an action that is important during walking in order to ensure that the foot of the leg that is swinging does not touch the ground.

The posterior hip and thigh muscles, shown here in the right leg, move the body and help to maintain its posture.

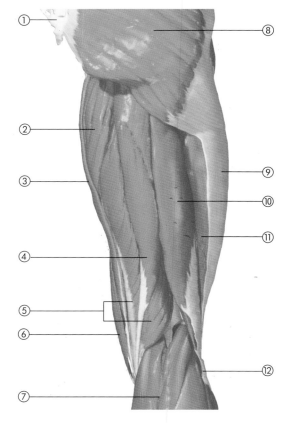

KEY

1. Sacrum
2. Adductor magnus
3. Gracilis
4. Semitendinosus
5. Semimembranosus
6. Sartorius
7. Gastrocnemius
8. Gluteus maximus
9. Iliotibial tract
10. Biceps femoris
11. Vastus lateralis
12. Tendon of biceps femoris

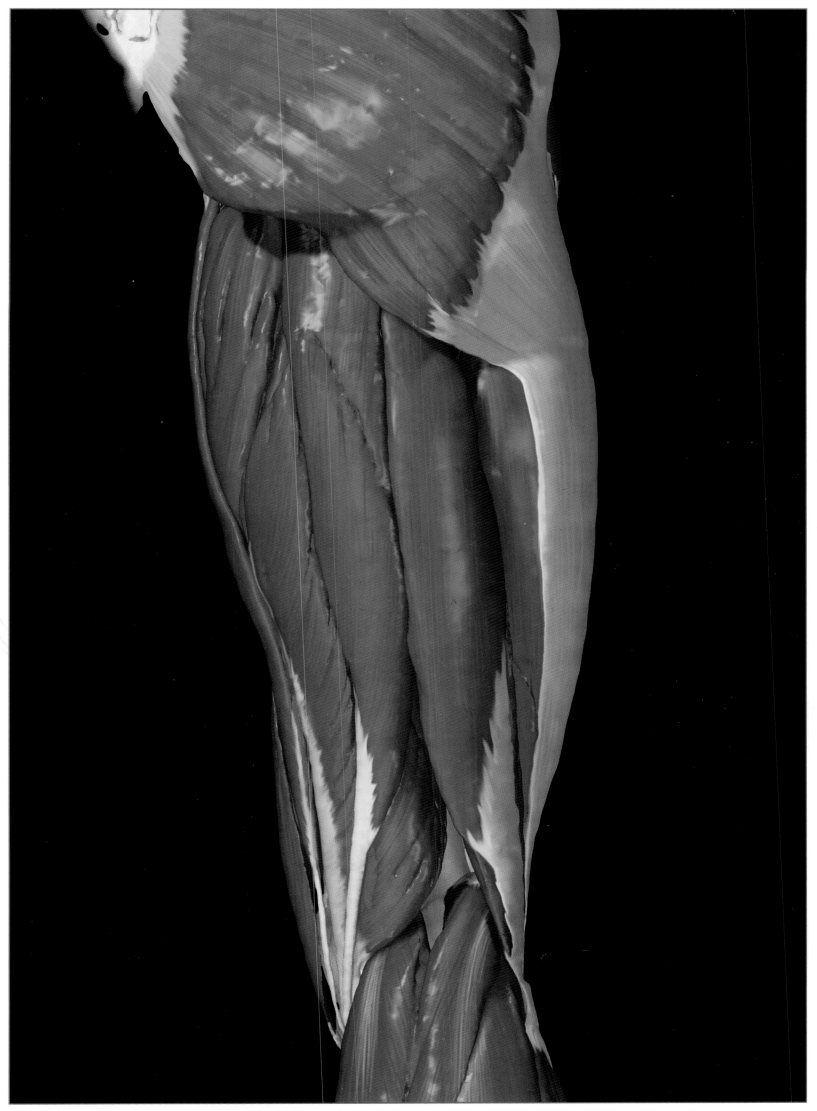

THE MUSCLES OF THE LOWER LEG AND FOOT MOVE THE FOOT AND TOES TO PROVIDE THE THRUST NEEDED TO PUSH THE BODY OFF THE GROUND DURING WALKING AND RUNNING, AND ALSO STABILIZE THE FOOT DURING STANDING. WHILE THE ARRANGEMENT OF LOWER LEG MUSCLES—TAPERING WITH LONG TENDONS—AND FOOT MUSCLES IS SIMILAR TO THAT OF THE HANDS, THE FEET ARE STRONGER AND LESS FLEXIBLE THAN THE HANDS. THIS REFLECTS THEIR ROLE IN SUPPORT AND MOVEMENT. AT THE ANKLE, A HINGE JOINT, MUSCLES PROMOTE **DORSIFLEXION** (BENDING OF THE FOOT UPWARD) AND **PLANTAR FLEXION** (EXTENSION OR STRAIGHTENING OF THE FOOT TO POINT THE TOES). OTHER MUSCLES FLEX AND EXTEND THE TOES, AND **INVERT** (TURNING THE SOLE OF THE FOOT INWARD) OR **EVERT** (TURNING THE SOLE OF THE FOOT OUTWARD) THE FOOT. WITHIN THE FOOT, INTRINSIC MUSCLES HELP TO MOVE THE TOES BUT, MORE IMPORTANTLY, ACT WITH THE LOWER LEG MUSCLES TO SUPPORT THE ARCHES OF THE FOOT.

THE LEG & FOOT

The right ankle and foot seen from the underside right; opposite, the right lower leg and foot in lateral (left) and anterior (right) views.

KEY

1. Flexor digitorum longus
2. Plantar aponeurosis
3. Flexor digitorum brevis
4. Abductor hallucis
5. Flexor hallucis longus
6. Flexor hallucis brevis
7. Hallux (great toe)
8. Calcaneal (Achilles) tendon
9. Calcaneus (heel bone)
10. Abductor digiti minimi
11. Flexor digiti minimi brevis
12. Lumbrical

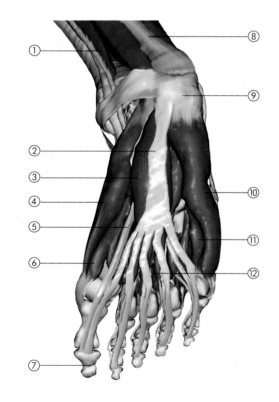

In the anterior (front) part of the lower leg, extensor muscles dorsiflex the ankle and pull the foot upward. Dorsiflexion is not a powerful movement but it prevents the toes dragging along the ground when the foot is lifted. Prime mover of dorsiflexion is the tibialis anterior, which also inverts the foot and supports the arch of the foot. Other anterior muscles that dorsiflex the foot are the extensor digitorum longus, which also extends the toes; the peroneus tertius, which also everts the foot; and the extensor hallucis longus, which also extends the hallux or great toe.

The muscles of the posterior (rear) of the lower leg plantar flex the foot. Plantar flexion is the most powerful movement of the ankle, necessary to provide thrust during the take-off phase of walking and running. The prime movers of plantar flexion are the gastrocnemius and soleus. Both insert via the large calcaneal (Achilles) tendon into the calcaneus or heel bone. The flexor digitorum longus and flexor hallucis longus plantar flex the foot and invert it; the former also flexes the toes, while the latter flexes the great toe. Toe flexion helps the foot "grip" the ground. On the lateral (outer) side of the lower leg, the peroneus longus and peroneus brevis also plantar flex the foot, and evert it to help keep the foot flat on the ground.

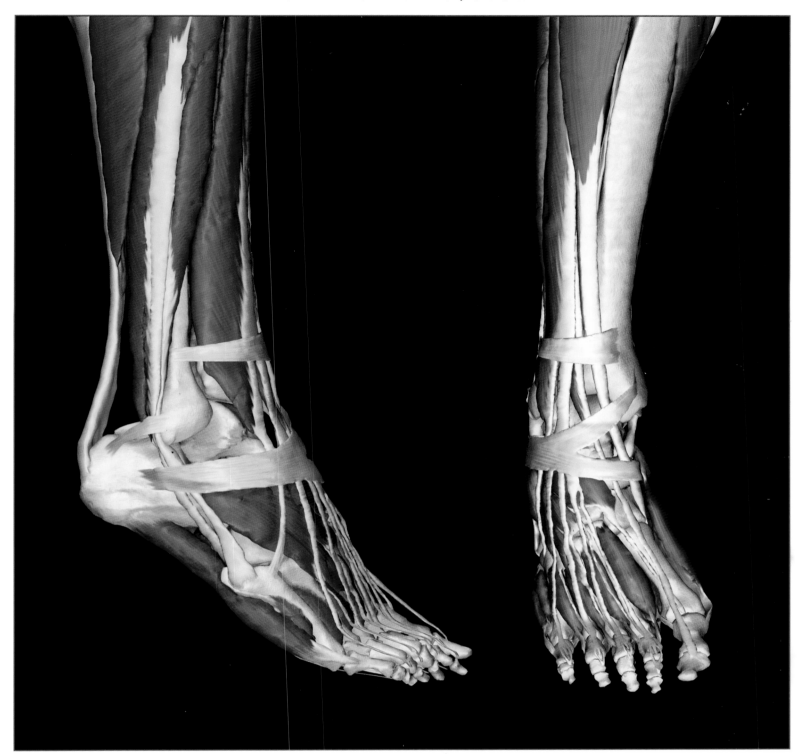

KEY

Plantaris.

1. Gastrocnemius
2. Soleus
3. Peroneus longus
4. Peroneus brevis
5. Calcaneal (Achilles) tendon
6. Peroneus tertius
7. Fibula
8. Calcaneus (heel bone)
9. Extensor digitorum brevis
10. Tibialis anterior
11. Extensor digitorum longus
12. Extensor hallucis longus
13. Extensor hallucis brevis
14. Tendon of extensor
 digitorum longus
15. Tibia
16. Extensor retinacula

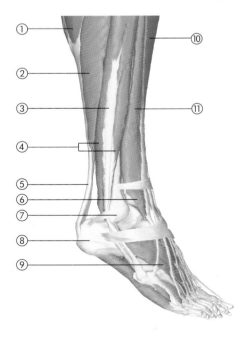

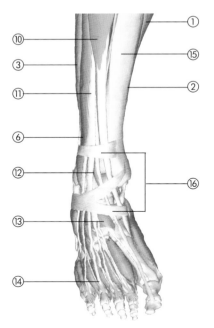

THE NERVOUS SYSTEM IS A COMMUNICATION NETWORK THAT CONTROLS AND COORDINATES MOST BODY ACTIVITIES. EVERY THOUGHT, MEMORY, EMOTION, OR SENSATION A PERSON HAS, AND EVERY ACTION SHE OR HE CARRIES OUT, IS A REFLECTION OF THE ACTIVITY OF THIS SYSTEM. IN ADDITION, THE NERVOUS SYSTEM WORKS UNNOTICED TO REGULATE A MULTITUDE OF INTERNAL EVENTS, SUCH AS MODULATING BODY TEMPERATURE OR ALTERING HEART RATE, IN ORDER TO MAINTAIN **HOMEOSTASIS**—THE STATE OF BALANCE AND STABILITY THAT EXISTS INSIDE A HEALTHY BODY REGARDLESS OF CHANGES IN THE EXTERNAL AND INTERNAL ENVIRONMENTS.

THE NERVOUS SYSTEM

The nervous system extends throughout the body to provide a high speed co-ordination and control network. At its core are the brain and spinal cord which receive and send out messages along the nerves.

KEY

① Brain
② Spinal cord
③ Brachial plexus
④ Median nerve
⑤ Radial nerve
⑥ Lumbar plexus
⑦ Ulnar nerve
⑧ Sacral plexus
⑨ Femoral nerve
⑩ Sciatic nerve
⑪ Cerebrum
⑫ Brain stem
⑬ Cerebellum
⑭ Cervical spinal nerves
⑮ Thoracic spinal nerves
⑯ Lumbar spinal nerves
⑰ Sacral spinal nerves

Making up this communication network are trillions of interconnected **neurons**, or nerve cells, that extend throughout the body. These cells are unique in their ability to transmit electrical signals, called **nerve impulses**, at high speed, so that all the information needed to run the body can be collected, processed, and distributed in a split-second, and is constantly updated as the body's internal and external environments change.

Three linked functions drive the nervous system. Firstly, sensory input is provided by millions of sensory receptors that monitor changes—called stimuli—taking place inside and outside the body. Secondly, a processing and integration center analyzes, stores and collates sensory input and makes decisions about what actions should be taken. Thirdly, a motor output activates effectors—either muscles or glands—resulting in a response. So, for example, seeing a charging elephant (sensory input) means danger (processing and integration) so the leg muscles are activated (motor output) to effect an escape.

Parts of the nervous system

The nervous system has two main parts. The central nervous system (CNS) consists of the brain and spinal cord, and it fulfills the function of processing and integration described above. The peripheral nervous system consists of cablelike nerves that are made up of bundles of two types of neurons. **Sensory neurons** carry sensory input from receptors to the CNS, while **motor neurons** transmit motor output from the CNS to muscles and glands. Motor neurons fall into two groups. Those of the somatic nervous system carry signals to skeletal muscles in order to make them move. The motor neurons that make up the autonomic nervous system (ANS - *see page 98*) control involuntary activities, such as breathing rate and digestion, by activating glands and other organs.

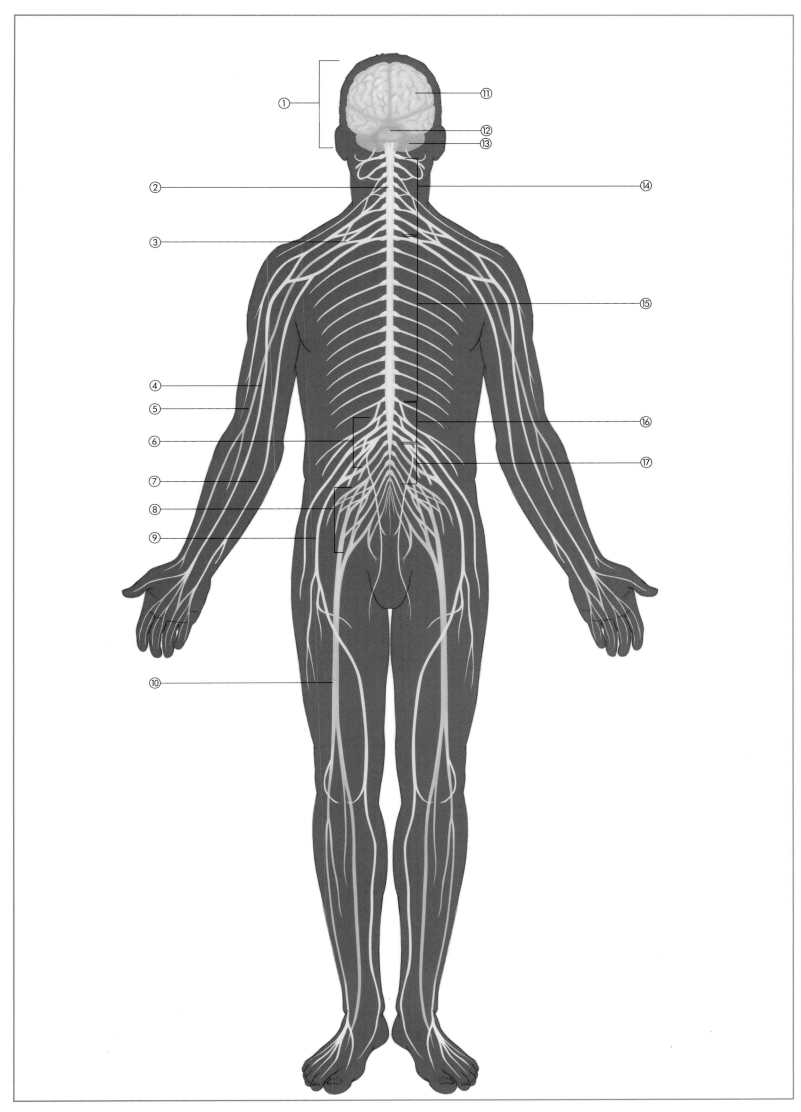

THE BRAIN

THE BRAIN IS THE CONTROL CENTER OF THE NERVOUS SYSTEM. THESE SUPERIOR AND LATERAL VIEWS REVEAL ITS MAIN PARTS. THE LEFT AND RIGHT CEREBRAL HEMISPHERES MAKE UP THE CEREBRUM, THE LARGEST PART OF THE BRAIN AND THE SITE OF THOUGHT, MEMORY, SENSATION, MOVEMENT, AND OTHER ASPECTS OF CONSCIOUS BEHAVIOR. THE CEREBELLUM MAKES UP ABOUT 10 PERCENT OF THE BRAIN AND ENSURES THAT THE BODY IS BALANCED AND THAT MUSCLE CONTRACTIONS PRODUCE SMOOTH, COORDINATED MOVEMENTS; WHILE THE BRAIN STEM, WHICH LINKS THE BRAIN TO THE SPINAL CORD, CONTROLS MANY VITAL FUNCTIONS INCLUDING HEART RATE, BREATHING RATE, AND BLOOD PRESSURE. THE **VENTRICLES** WITHIN THE BRAIN ARE FILLED WITH CLEAR, **CEREBROSPINAL FLUID** THAT HELPS TO NOURISH AND PROTECT THE BRAIN (AND THE SPINAL CORD).

Neurons and nervous transmission

The billions of neurons in the nervous system are long thin cells adapted for carrying electrical signals called nerve impulses, which form a communication system capable of transmitting information at high speed and permitting humans to think, feel, and act. Each neuron has a cell body, containing the **nucleus**; several branched processes, called **dendrites**, which carry impulses toward the cell body; and a long **axon**, or nerve fiber, which carries impulses away from the cell body toward another neuron or an effector, such as a muscle. There are three types of neurons. Sensory neurons carry sensory information from sense organs and other structures toward the CNS. Motor neurons carry nerve impulses away from the CNS to effectors, such as muscles and glands. Association neurons—which make up 90 percent of all neurons and are only found in the brain and spinal cord—relay nerve impulses between other neurons as well as sorting and analyzing them.

Where two or more neurons come into close contact they do not touch but are separated at junctions called **synapses**. When a neuron is stimulated, a wave of electrical disturbance—the nerve impulse—sweeps along it at speeds of up to 100 meters (300 ft) per second. At the end of the axon of that neuron is a swelling, called the presynaptic terminal or synaptic knob. When the impulse arrives at the synaptic knob it causes the release of a chemical, called a **neurotransmitter**, which crosses the gap between the two neurons and causes the generation of a nerve impulse in the recipient neuron. This one-way process is how nerve impulses are transmitted through the nervous system.

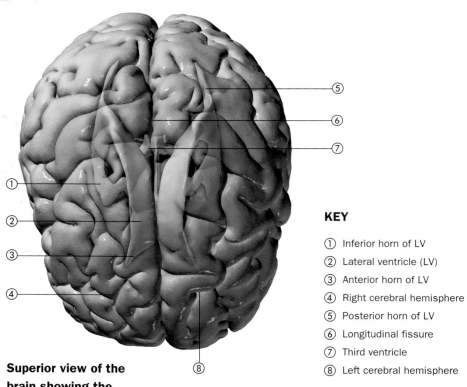

Superior view of the brain showing the longitudinal fissure that divides the cerebrum into two hemispheres and, internally, the ventricles.

KEY

1. Inferior horn of LV
2. Lateral ventricle (LV)
3. Anterior horn of LV
4. Right cerebral hemisphere
5. Posterior horn of LV
6. Longitudinal fissure
7. Third ventricle
8. Left cerebral hemisphere

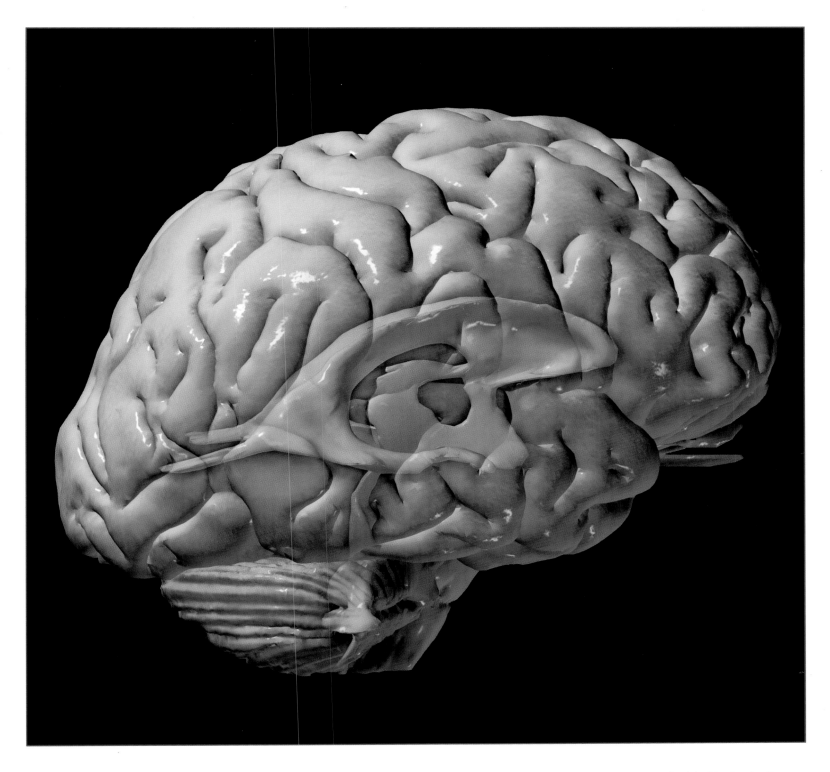

KEY

1. Right cerebral hemisphere
2. Posterior horn of LV
3. Third ventricle
4. Cerebellum
5. Lateral ventricle (LV)
6. Anterior horn of LV
7. Interventricular foramen
8. Cerebral aqueduct
9. Fourth ventricle
10. Pons
11. Medulla oblongata

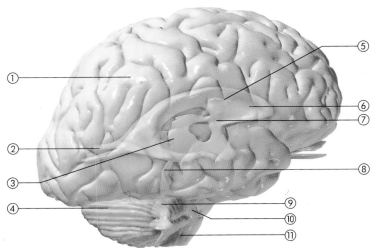

Inside the brain there are four cavities called ventricles filled with cerebrospinal fluid: two lateral ventricles and the third and fourth ventricles.

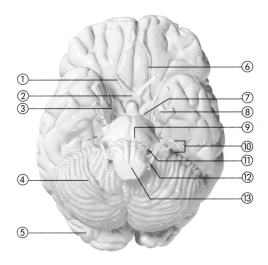

THE TWELVE PAIRS OF CRANIAL NERVES ARISING FROM THE UNDERSIDE OF THE BRAIN ARE CONCERNED MOSTLY WITH CARRYING SENSORY INPUT FROM THE SKIN AND SENSE ORGANS OF THE HEAD AND NECK, AND TRANSMITTING MOTOR OUTPUT TO THE MUSCLES OF THESE REGIONS. SOME CRANIAL NERVES ARE PURELY SENSORY, OTHERS ARE MIXED, CONTAINING BOTH SENSORY AND MOTOR NEURONS.

THE BRAIN

Cranial nerves are numbered (using Roman numerals) and typically named according to their primary functions.

- Olfactory nerve (I)—carries information about smells from the nasal cavity.
- Optic nerve (II)—carries visual signals from the retina of the eye.
- Oculomotor nerve (III) and trochlear nerve (IV)—control extrinsic muscles that move the eyeballs.
- Trigeminal nerve (V)—carries sensory input from eye, face, and teeth; controls chewing muscles.
- Abducens nerve (VI)—controls the muscle that turns the eyeballs laterally.
- Facial nerve (VII)—controls muscles of facial expression.
- Vestibulocochlear nerve (VIII)—carries sensory input from the ears about hearing and balance.
- Glossopharyngeal nerve (IX)—carries information about taste from tongue; controls swallowing.
- Vagus nerve (X)—extends into the thorax and abdomen to control many vital functions such as heart rate.
- Accessory nerve (XI)—controls movement of the head and shoulders, and is involved in voice production.
- Hypoglossal nerve (XII)—controls movements of the tongue.

The blood-brain barrier

The brain requires a constant, plentiful blood supply in order to deliver sufficient glucose and oxygen to meet its high energy demands. In fact, although making up just 2 percent of the body's mass, it receives 20 percent of the body's blood flow per unit time. Starved of oxygen, the brain rapidly becomes comatose and dies. Despite this absolute requirement, the brain, more than any other tissue, must also be protected from fluctuating levels of blood and tissue fluid chemicals that occur, for example, after eating or exercise. Such fluctuations could cause the random firing of neurons and the breakdown of the control center. This protection is provided by the blood-brain barrier. Capillaries supplying brain tissues have walls that form a barrier to impede the flow of most substances, including many drugs. Generally, only small molecules such as glucose, oxygen, and carbon dioxide can pass through. However, some fat-soluble substances such as ethanol (alcohol), and nicotine can also pass through—hence their effects on the CNS—as well as anesthetics.

KEY

1. Optic nerve (II)
2. Optic chiasma
3. Trochlear nerve (IV)
4. Cerebellum
5. Right cerebral hemisphere
6. Olfactory nerve (I)
7. Oculomotor nerve (III)
8. Trigeminal nerve (V)
9. Abducens nerve (VI)
10. Facial (VII), Vestibulocochlear (VIII), Glossopharyngeal (IX), and Vagus (X) nerves
11. Hypoglossal nerve (XII)
12. Accessory nerve (XI)
13. Medulla oblongata

A ventral view of the brain, with the anterior end pointing to the top of the page, showing the cranial nerves.

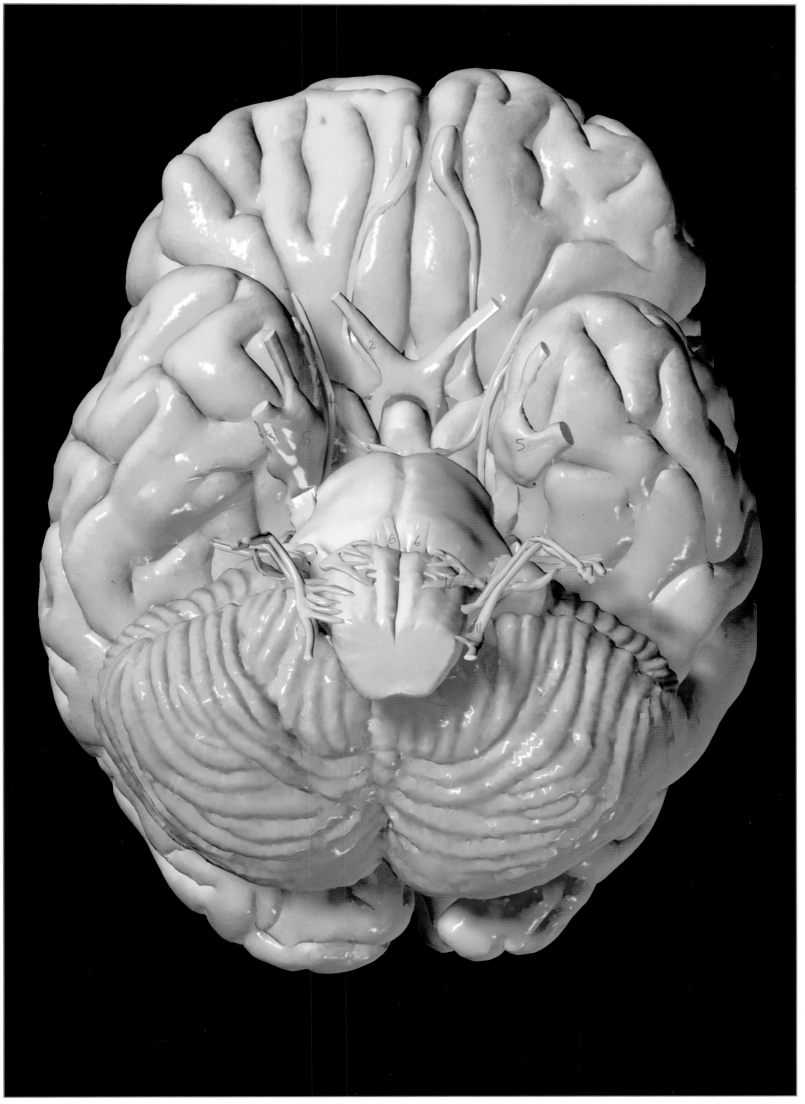

L INKED TO THE BRAIN BY THE BRAIN STEM, THE SPINAL CORD EXTENDS ABOUT 45 CM

(18 IN) DOWN THE BACK FROM THE FORAMEN MAGNUM (*see page* 42), THE LARGE

OPENING IN THE BASE OF THE SKULL, TO THE LEVEL OF THE FIRST LUMBAR VERTEBRA.

AT ITS MIDPOINT, THE SPINAL CORD IS ABOUT 1.8 CM (¾ IN) WIDE, NO MORE THAN THE WIDTH OF A

FINGER. THE SPINAL CORD IS PROTECTED BY A BONY TUNNEL FORMED BY ADJACENT VERTEBRAE OF

THE BACKBONE. ARISING FROM THE SPINAL CORD ARE 31 PAIRS OF SPINAL NERVES THAT PROTRUDE

THROUGH GAPS BETWEEN THESE VERTEBRAE.

THE SPINAL CORD

Role of the spinal cord

The spinal cord relays information between the brain and the rest of the body by way of the spinal nerves. As well as forming a vital communication link, the spinal cord is also involved in many reflex actions. These are automatic split-second responses, many of which protect the body from hazards, such as automatically withdrawing the hand from a hot object.

Internal structure of the spinal cord

Internally, the spinal cord is composed of a central, H-shaped core of gray matter, that consists of association neurons, the endings of sensory neurons, and the cell bodies of motor neurons. Surrounding the gray matter is white matter, which is made up of nerve fibers, and arranged in bundles called tracts that pass up and down the spinal cord. Ascending tracts carry information about sensory input, arriving through the sensory neurons of spinal nerves, to the brain, and descending tracts carry instructions from the brain that will travel along the motor neurons of spinal nerves to muscles and glands.

Nerve structure

Nerves are creamy-colored, glistening cords that form the body's "wiring" or peripheral nervous system. Both cranial nerves, which arise from the brain, and spinal nerves, which arise from the spinal cord, share the same structure. A nerve contains bundles of neurons—or, more specifically, the long nerve fibers (axons) of neurons—called **fascicles**. Each fascicle is surrounded by a sheath of connective tissue, called **perineurium**, while several fascicles, and the nerve's blood vessels, are bound together by **epineurium**, the outer connective tissue coating of the nerve. Most nerves are mixed, carrying both sensory and motor neurons.

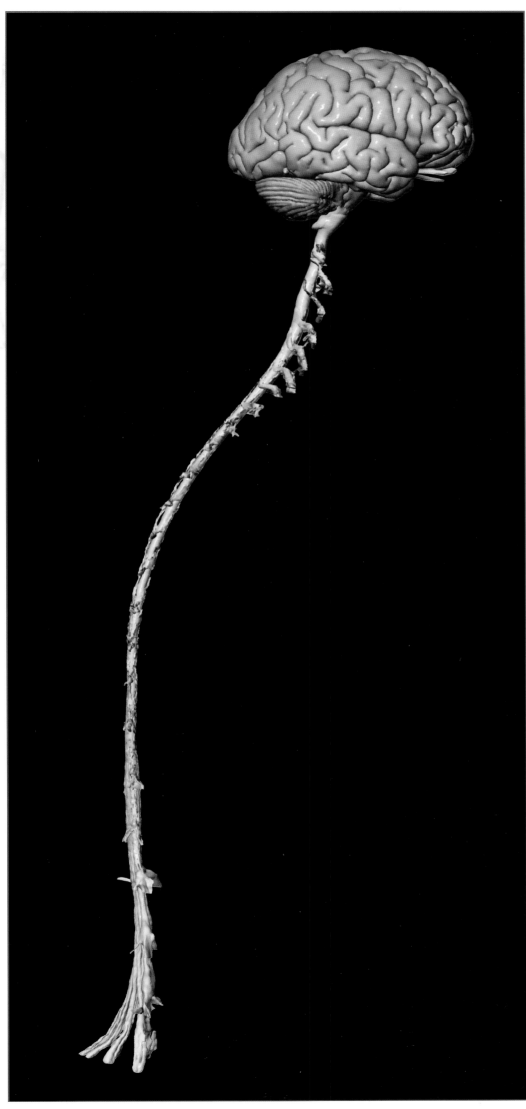

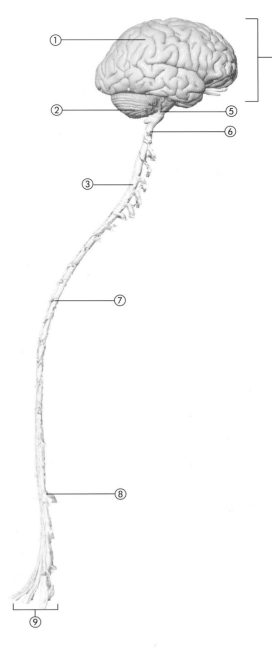

The brain and spinal cord from the right side. The curvature of the spinal cord follows that of the vertebral column, which normally surrounds and protects it.

KEY

① Right cerebral hemisphere
② Cerebellum
③ Spinal cord
④ Brain
⑤ Brain stem
⑥ Cervical spinal nerve
⑦ Thoracic spinal nerve
⑧ Lumbar spinal nerve
⑨ Cauda equina

THE AUTONOMIC NERVOUS SYSTEM (ANS) IS A DIVISION OF THE PERIPHERAL NERVOUS SYSTEM THAT, SECOND BY SECOND, AUTOMATICALLY CONTROLS INVOLUNTARY FUNCTIONS IN ORDER TO MAINTAIN HOMEOSTASIS—A STABLE, INTERNAL ENVIRONMENT—REGARDLESS OF VARIATIONS IN INTERNAL OR EXTERNAL CONDITIONS. IF, FOR EXAMPLE, WASTE CARBON DIOXIDE LEVELS IN THE BLOOD INCREASE, THE ANS TRIGGERS DEEPER AND FASTER BREATHING IN

THE AUTONOMIC NERVOUS SYSTEM

ORDER TO REDUCE CARBON DIOXIDE LEVELS, AND TO INCREASE OXYGEN LEVELS. IT CONSISTS OF MOTOR NEURONS, ARISING FROM THE BRAIN STEM AND SPINAL CORD, WHICH CARRY NERVE IMPULSES TO SMOOTH MUSCLE IN GLANDS, BLOOD VESSELS, AND OTHER ORGANS, AND TO THE CARDIAC MUSCLE OF THE HEART.

The ANS works by receiving, indirectly, information from sensors around the body that detect internal and external changes and send information along sensory neurons to the brain, primarily to the hypothalamus and brain stem. Instructions are sent from the brain or spinal cord along the motor neurons of the ANS in order to fine tune the activities of **effectors** as conditions change. For example, the smell of delicious food would cause the release of extra saliva from the salivary glands.

The ANS has two divisions that maintain an internal balance by having opposing effects. The sympathetic nervous system is typically excitatory and prepares the body for stress by, for example, increasing heart rate or slowing the movement of the intestines. The parasympathetic nervous system restores or maintains energy by, for example, slowing heart rate or by speeding up the movement of the intestines. The two divisions of the ANS can innervate the same organ but exert different effects because their motor neurons release different neurotransmitters.

Differences between the somatic and autonomic nervous systems

The motor neurons of the somatic nervous system extend from the CNS and terminate in the skeletal muscles whose movement they control and that move the body. In the ANS, a two-neuron chain forms the link between the CNS and the effector organs, in this case smooth muscle, cardiac muscle, or glands. The **preganglionic** (first) neuron synapses with the **postganglionic** (second) neuron at a **ganglion** (swelling). In the case of the sympathetic nervous system, preganglionic neurons arise from the thoracic and lumbar parts of the spinal cord and synapse in a chain of ganglia that runs adjacent to the spinal cord. As for the parasympathetic nervous system, preganglionic neurons arise in the brain stem and sacral part of the spinal cord, and synapse in ganglia within or near their effector organ.

KEY

① Brain
② Spinal cord
③ Paravertebral (chain) ganglion
④ Sympathetic trunk or chain
⑤ Oculomotor nerves (III)
⑥ Facial nerves (VII)
⑦ Glossopharyngeal nerves (IX)
⑧ Vagus nerves
⑨ Cranial parasympathetic outflow
⑩ Pelvic splanchnic nerves (sacral parasympathetic outflow)

A diagrammatic view of the autonomic nervous system. Messages carried by the sympathetic division pass from the thoracic and lumbar parts of the spinal cord via the chain of paravertebral ganglia to their destination; messages carried by the parasympathetic division arise from either the brain stem (cranial outflow) or the sacral spinal cord (sacral outflow). For the sake of clarity, only one division is shown on each side of the spinal cord.

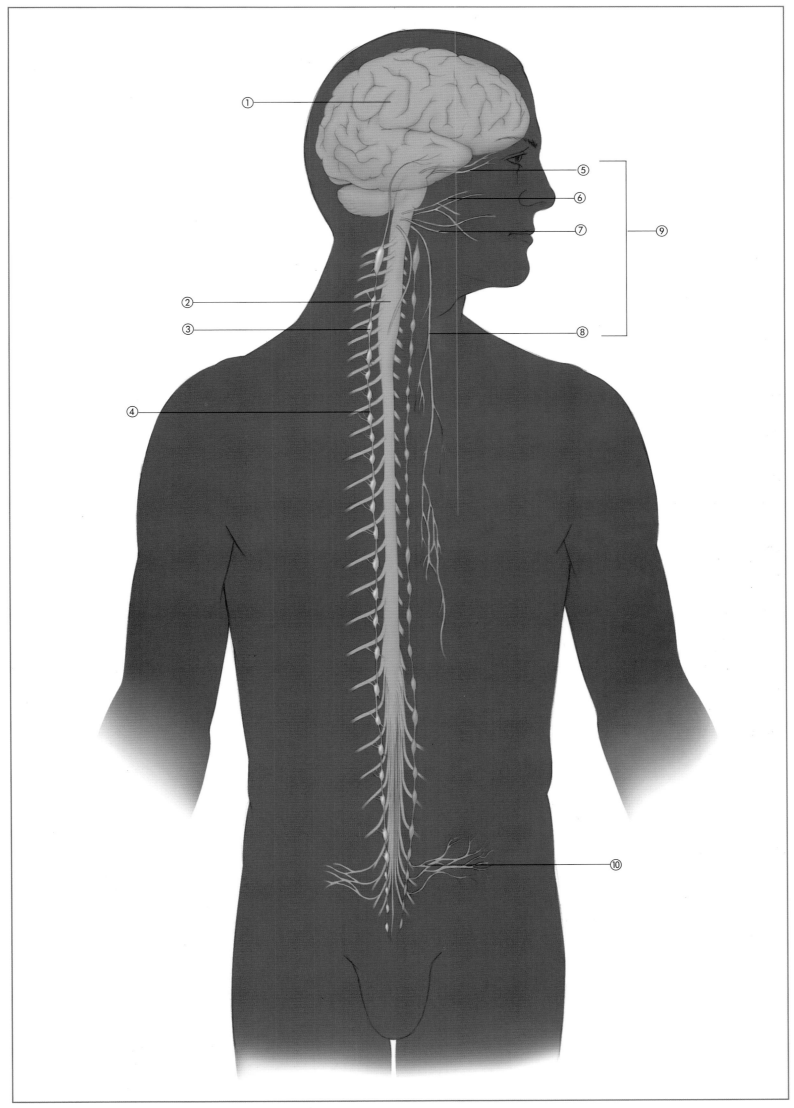

Vision is the most important of the body's five senses. It provides a means of understanding the world around, as well as facilitating communication. The visual sense organs are the eyes: they detect light, and send nerve impulses to the brain that are interpreted as "seen" images.

THE EYE

Only a small portion of each eye, or eyeball, is visible; the rest of the hollow, spherical organ lies enclosed and protected by a cushion of fat within the bony orbit formed by certain skull bones (*see page 98*). The eyeball has three layers. The outer fibrous layer consists mostly of the tough, white, protective sclera; at the front of the eye it forms a clear window—the cornea—through which light is admitted. Extrinsic muscles attached to the sclera and orbit move the eyeball. The middle vascular layer forms the iris, the colored part of the eye that surrounds the pupil, as well as the suspensory ligaments that hold the focusing lens in place. The inner layer, the retina, contains over 70 percent of the body's sensory receptors. These **photoreceptors** detect the patterns produced by light reflected from objects outside the body and send messages to the brain.

Vision and the visual cortex

The conscious perception of visual images—seeing—happens in the **primary visual cortex** located in the occipital lobe of left and right cerebral hemispheres. Nerve fibers from the retina, the light-detecting layer inside the eye, travel along the optic nerves to the primary visual areas. En route, certain fibers cross over so that the left primary visual area receives visual images from the right side of the object in view, and the right primary visual area receives visual images from the left side.

Different centers within each primary visual cortex process information about the shape, color, movement, and location of the object being looked at. Because each primary visual area receives a slightly different view of the object, information from both areas is "pooled" to produce **binocular** or three-dimensional vision that enables a person to perceive depth. Surrounding the primary visual areas are the **visual association areas**. Here, incoming visual information is compared to previous visual experiences so that, for example, a person can recognize a familiar face or object.

Most of the eyeball lies protected within a bony socket, the orbit, formed by the skull; just one-sixth is visible to the outside.

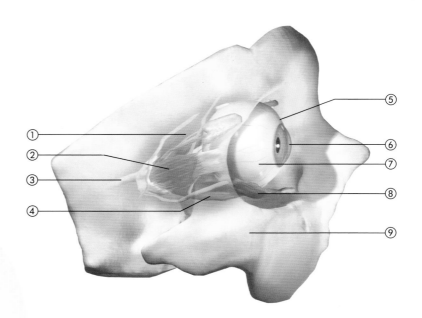

KEY

① Superior rectus muscle
② Lateral rectus muscle
③ Optic nerve
④ Inferior rectus muscle
⑤ Eyeball
⑥ Cornea
⑦ Sclera
⑧ Inferior oblique muscle
⑨ Skull

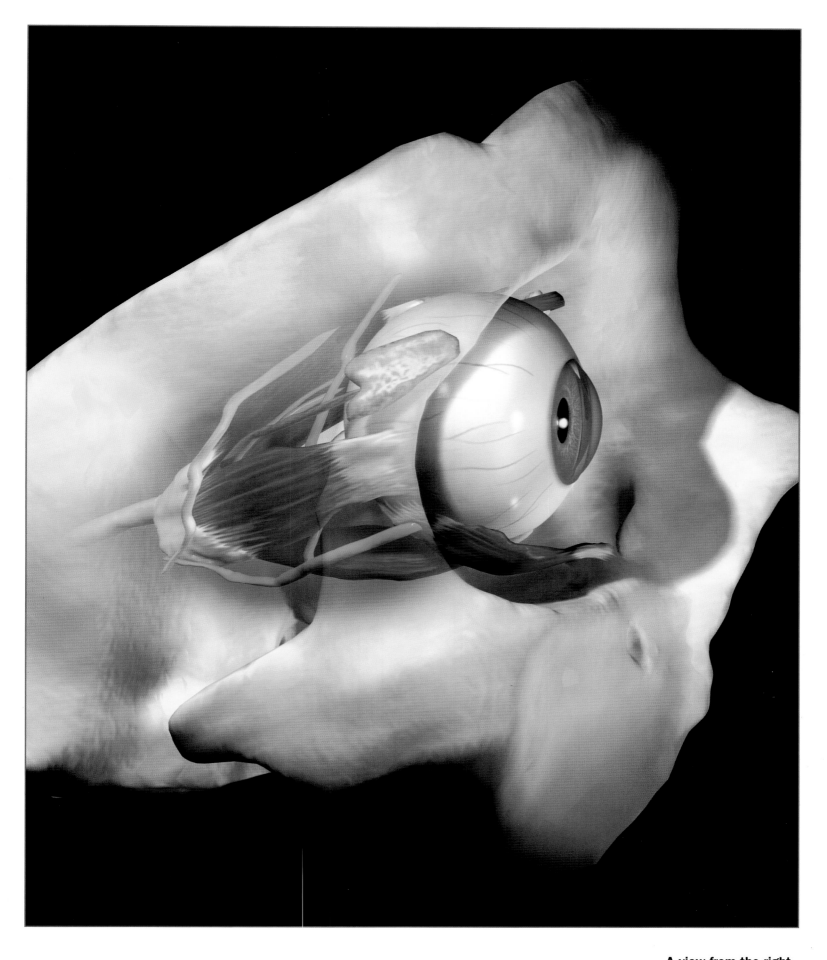

A view from the right side of the eyeball within the socket, showing the extrinsic muscles that move it.

THEIR SENSE OF HEARING ENABLES HUMANS TO HEAR OVER 400,000 DIFFERENT SOUNDS PRODUCED BY THEIR SURROUNDINGS. SOUNDS ARE DETECTED BY THE EARS, WHICH ALSO PLAY AN IMPORTANT ROLE IN BALANCE, OR EQUILIBRIUM. THE STRUCTURES OF THE EAR FUNCTION AS A CONDUCTION SYSTEM THAT CONVEYS SOUND WAVES—PRESSURE WAVES IN THE EAR—TO THE FLUID-FILLED INNER PART OF THE EAR WHERE THEY ARE DETECTED BY VIBRATION-SENSITIVE RECEPTORS THAT SEND NERVE IMPULSES TO THE BRAIN WHERE THEY ARE INTERPRETED AS SOUNDS.

Most of the ear lies concealed and protected within the temporal bone of the skull; only the external ear flap is visible.

THE EAR

The ear has three sections and is mostly embedded in, and protected by, the temporal bone of the skull. The outer ear includes the pinna, or ear flap, the only visible part of the ear, and the ear canal, 2.5 cm (1 in) long. Covering the inner end of the ear canal is a taut membrane, the tympanum or eardrum. The air-filled middle ear is traversed by three tiny bones, the ossicles, which link the tympanum to a membrane covering the oval window, the entrance to the inner ear. Sound waves pass along the ear canal, through the eardrum, across the ossicles, and through the oval window into the inner ear.

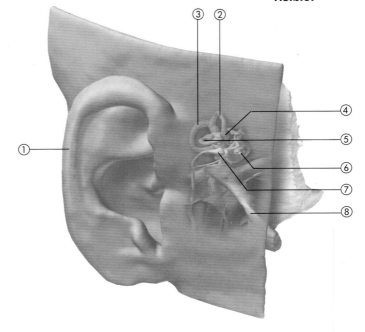

The auditory cortex

The arrival of sound waves in the ear causes the production of vibrations in the fluid filling the snail shell-shaped cochlea of the inner ear. Within the cochlea, **mechanoreceptors** sense the vibrations and send nerve impulses along the cochlear division of the vestibulocochlear nerve to the brain by way of the thalamus, an area of the brain that processes most sensory input and relays it to the cerebral cortex.

Nerve impulses carried by the vestibulocochlear nerve arrive in the **primary auditory area** of the brain located in the superior margin of the temporal lobe. Some nerve fibers "cross over" on their journey from the ears, so that each primary auditory area receives impulses from both ears. The primary auditory area distinguishes sounds in terms of their basic characteristics: pitch, rhythm, and loudness. The **auditory association area**, posterior to the primary auditory area, determines whether these sounds are speech, music, or noise so that they are perceived, or heard.

KEY

1. Pinna (ear flap)
2. Anterior semicircular canal
3. Posterior semicircular canal
4. Ampulla of semicircular canal
5. Lateral semicircular canal
6. Cochlea
7. Ossicles
8. Zygomatic process of temporal bone

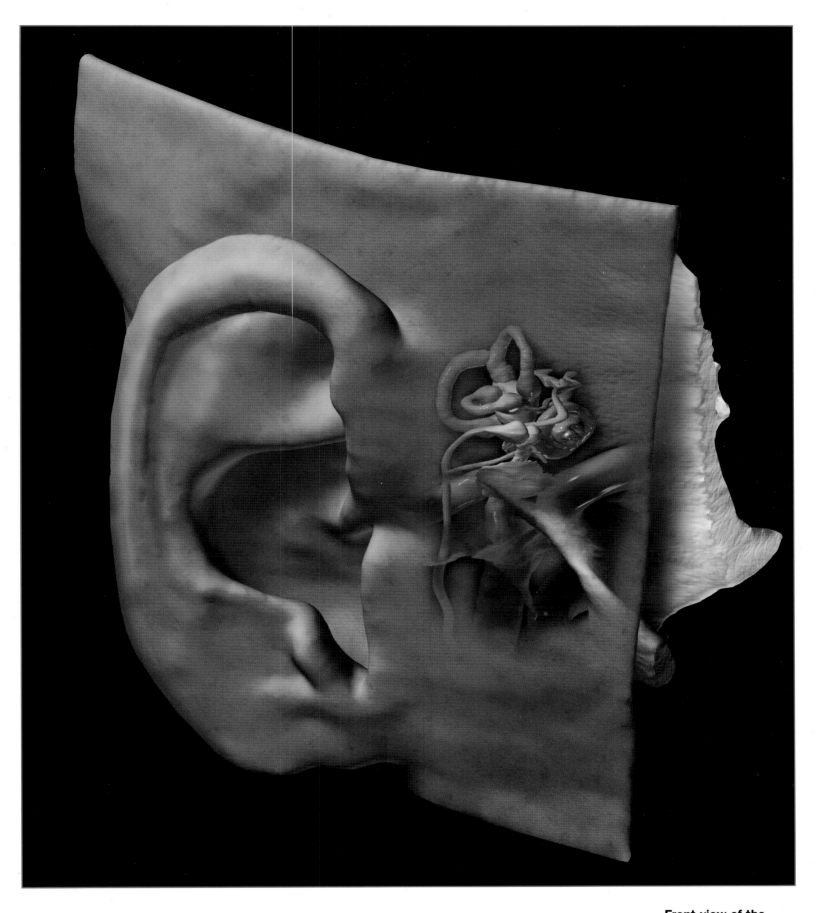

Front view of the head with part of the temporal bone removed to reveal the component parts of the right ear.

THE NOSE PROVIDES A PASSAGEWAY FOR AIR DURING

BREATHING; WARMING, MOISTENING AND FILTERING AIR AS IT

IS BEING INHALED. IT ALSO HOUSES SMELL DETECTORS.

THERE ARE TWO PARTS TO THE NOSE. THE EXTERNAL NOSE IS

SUPPORTED BY A FRAMEWORK PROVIDED BY THREE OF THE SKULL

BONES—THE NASAL AND FRONTAL BONES, AND THE MAXILLA (*see*

page 43)—AND BY FLEXIBLE PLATES OF CARTILAGE.

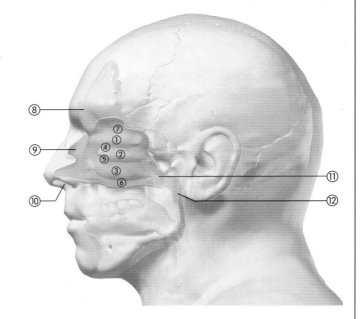

THE NOSE

Behind the external nose is the nasal cavity. Its roof is formed by the ethmoid and sphenoid bones (*see page 45*), and its floor by the palate, which separates it from the mouth. Vertically, the nasal cavity is divided into left and right halves by the nasal septum. The external opening of the nasal cavity is through the nostrils, or external nares. Posteriorly, the nasal cavity opens into the upper pharynx (throat) through the internal nares. The nasal cavity is lined with a mucous membrane that secretes watery mucus, which moistens incoming air, dissolves chemicals so that they can be detected by smell receptors, and traps dirt and bacteria.

Smelling, the olfactory cortex, and the limbic system

In the upper part of each side of the nasal cavity is a postage-stamp sized area of mucous membrane, called the **olfactory epithelium**, that contains more than 10 million olfactory (smell) receptors. Specifically, these are **chemoreceptors** that can detect airborne chemicals that dissolve in the watery mucus. The olfactory chemoreceptors can detect

more than 10,000 different smells. When stimulated, the receptors send nerve impulses along fibers of the olfactory nerve, which pass through holes in the ethmoid bone, and into the olfactory bulbs that project anteriorly on the underside of the brain.

Olfactory tracts within the bulbs lead to the olfactory cortex on the lateral and medial surfaces of the temporal lobe of the brain. This primitive region of the cortex, which forms part of the limbic system—the part of the brain responsible for emotions and memory (*see page 168*)—is the primary olfactory area, where the conscious awareness of smells occurs. Some smell information from the nose travels to other parts of the limbic system and also to the hypothalamus, provoking subconscious emotional and memory-linked responses to smells, for example, the odor of a particular food evoking memories of childhood.

The sensory part of the nose lies in the upper part of the nasal cavity, the space behind each of the nostrils. In this view of the left side of the head, the left medial wall of the nasal cavity and the left frontal sinus can be seen.

KEY

1. Superior concha
2. Middle concha
3. Inferior concha
4. Superior meatus
5. Middle meatus
6. Inferior meatus
7. Olfactory epithelium
8. Frontal paranasal sinus
9. Nasal cavity
10. Left external nares
11. Opening of auditory (eustachian tube)
12. Nasopharynx

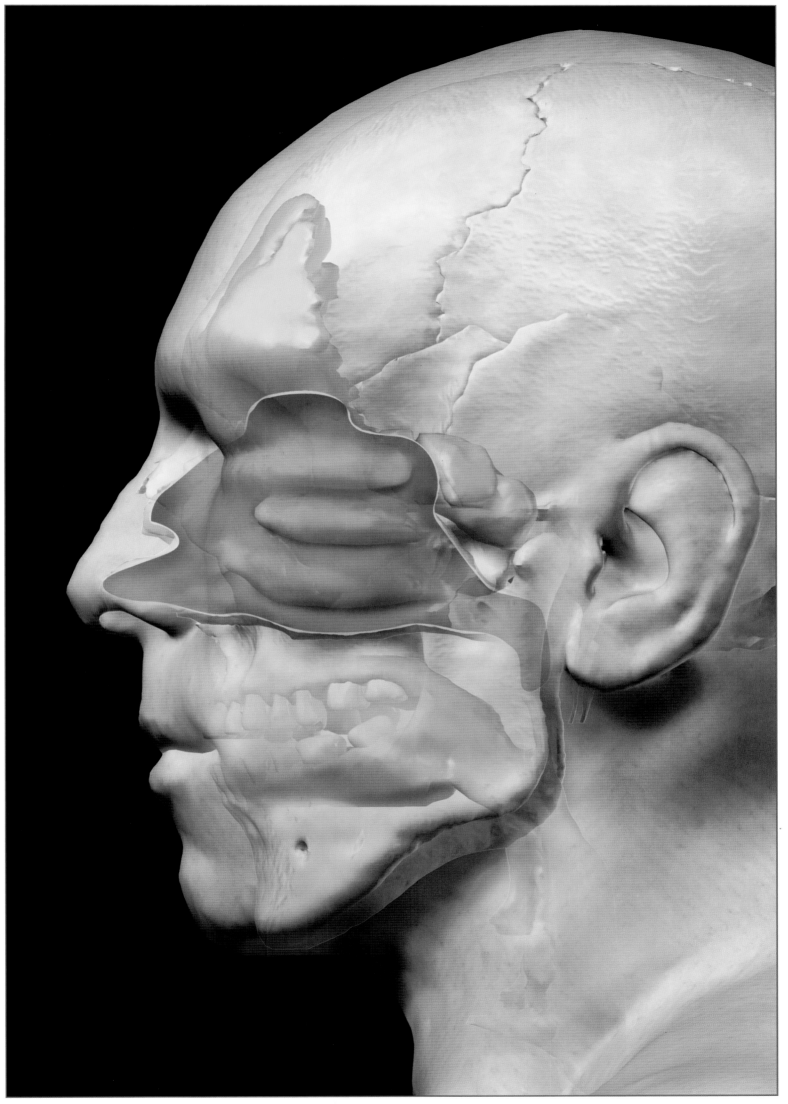

TWO SYSTEMS ENSURE THAT THE BODY WORKS IN A CONTROLLED AND COORDINATED MANNER. ONE IS THE NERVOUS SYSTEM (*see page* 90); THE SECOND IS THE ENDOCRINE, OR HORMONAL, SYSTEM, WHICH CONSISTS OF ENDOCRINE GLANDS LOCATED IN THE HEAD AND TRUNK. AMONG THE MANY BODY ACTIVITIES IT COORDINATES ARE THE PRODUCTION OF SECONDARY SEXUAL CHARACTERISTICS (SUCH AS BREASTS AND PUBIC HAIR), REPRODUCTION, AND GROWTH.

THE ENDOCRINE SYSTEM

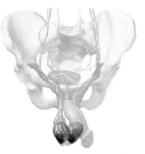

This comparison of the male and female pelves reveals the difference between the male and female endocrine systems. The female pelvis (above top) contains the ovaries, while below the male pelvis (above bottom) are the testes.

Endocrine glands

Glands are organs, or groups of cells, that release substances called secretions into or onto the body. There are two types of glands. Exocrine glands release their secretions along ducts into spaces within the body—such as the salivary glands releasing saliva into the mouth—or onto the skin— or sweat glands releasing sweat.

Endocrine glands lack ducts and release their secretions, called **hormones**, directly into the bloodstream. The main endocrine glands are the pituitary, pineal, thyroid, parathyroids, and adrenal glands. The pancreas, ovaries, and testes (*see pages 114, 116, and 118 respectively*) also contain endocrine sections.

How hormones work

Each hormone travels in the bloodstream to deliver a chemical message to a specific target area on which it has an effect. Some hormones may target all or most body cells while others affect only one particular tissue. When a hormone reaches a target cell it locks onto a specific receptor site. This action either increases or decreases the rates of certain chemical reactions going on inside the cell, altering the cell's activity.

The endocrine and nervous systems—a comparison

The endocrine and nervous systems work together to coordinate body activities, but each works in a very different way. The endocrine system releases chemicals into the blood in order to alter the metabolic activities of cells. It works relatively slowly, and typically has long-lasting effects. The nervous system, on the other hand, uses electrical impulses that travel at high speed along neurons in order to alter the activities of muscles and glands, and has immediate, short-term effects.

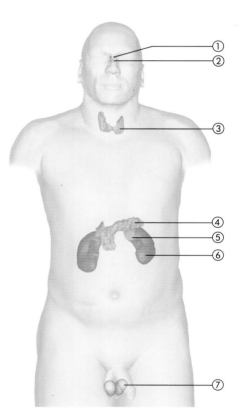

The major endocrine organs found in the male body. The hypothalamus is a part of the brain that controls the activity of the pituitary gland. The kidneys are included here because the adrenal glands "sit" on top of them.

KEY

① Hypothalamus
② Pituitary gland
③ Thyroid gland (parathyroid gland on posterior surface)
④ Pancreas
⑤ Adrenal gland
⑥ Kidneys
⑦ Testes

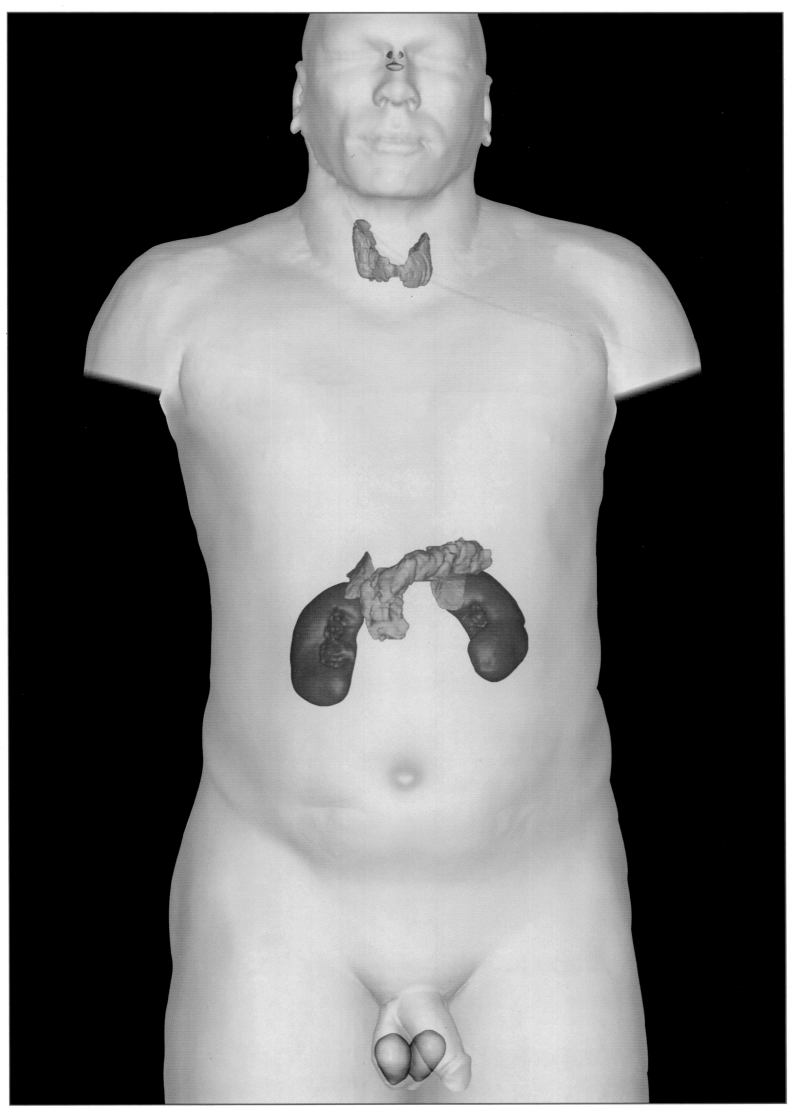

RESEMBLING A PEA, THE PITUITARY GLAND LIES JUST BELOW THE BRAIN. IT IS CONNECTED BY A STALK TO THE HYPOTHALAMUS, A SMALL AREA OF THE BRAIN THAT MONITORS AND REGULATES MANY OF THE BODY'S ACTIVITIES. THE PITUITARY GLAND RELEASES MORE THAN EIGHT HORMONES, MANY OF WHICH CONTROL OTHER ENDOCRINE ORGANS. FOR THAT REASON, IT IS REGARDED AS THE MOST IMPORTANT ENDOCRINE GLAND. HOWEVER, THE DRIVING FORCE BEHIND THE PITUITARY GLAND IS THE HYPOTHALAMUS.

THE HYPOTHALAMUS & PITUITARY

The pituitary gland has two parts. The larger anterior lobe produces most pituitary hormones. It is controlled by the hypothalamus which secretes its own hormones, called **releasing factors**, in order to stimulate the release of pituitary hormones. The smaller posterior lobe releases two hormones, **oxytocin** and **antidiuretic hormones** (ADH), which are made by the hypothalamus and carried by special nerve fibers to the posterior lobe.

Pituitary gland hormones

The anterior lobe hormones are:

- **Growth hormone**, which stimulates growth during childhood and adolescence.
- **Thyroid-stimulating hormone** (TSH), which stimulates the release of **thyroid hormone** by the thyroid gland.
- **Adrenocorticotropic hormone** (ACTH), which stimulates release of glucocorticoid hormones by the adrenal glands.
- **Follicle-stimulating hormone** (FSH), which stimulates egg maturation in, and release of **estrogen** by, the ovary; and stimulates sperm production in the testes.

- **Luteinizing hormone** (LH), which stimulates **ovulation** and **progesterone** production in the ovary; and **testosterone** production in the testes.
- **Prolactin**, which stimulates milk production by the mammary glands.

The posterior lobe hormones are:

- **Oxytocin**, which stimulates the uterus to contract during childbirth, and the mammary glands to release milk.
- **ADH**, which acts on the kidneys to reduce the volume of urine released.

The control of hormone levels

Hormone levels must be carefully controlled so that they do not have too great, or too little, effect. In most cases control is achieved by a **negative feedback** system that automatically reverses an unwanted change. For example, low levels of thyroid hormone are detected by the hypothalamus, which secretes releasing factor that stimulates the pituitary gland to secrete thyroid stimulating hormone (TSH). In turn, this causes the thyroid gland to secrete more thyroid hormone. High levels of thyroid hormone, on the other hand, stop secretion of the releasing factor and slow the production of TSH, thereby reducing levels of thyroid hormone.

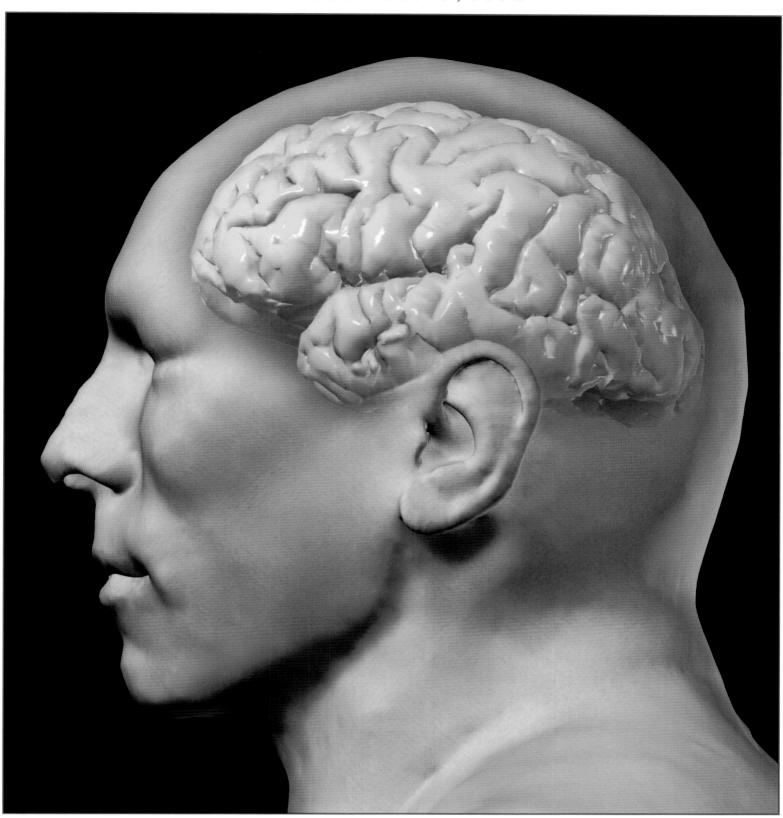

A view of the head from the left side to show the position of the pituitary gland. It lies just below the brain, between the temporal lobes of the two cerebral hemispheres. Most of the hormones released by the anterior pituitary gland control the secretions of other endocrine glands.

KEY

1 Position of the hypothalamus

2 Position of the pituitary gland

3 Left cerebral hemisphere of brain

4 Left temporal lobe

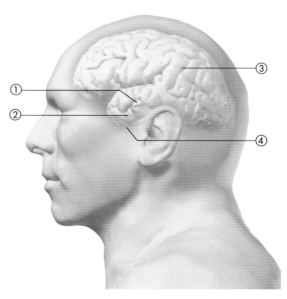

THE BUTTERFLY-SHAPED THYROID GLAND IS FOUND IN THE FRONT OF THE NECK, OVERLYING THE TRACHEA AND JUST BELOW THE LARYNX. HOLLOW FOLLICLES INSIDE THE THYROID RELEASE THREE HORMONES: **TRIIODOTHYRONINE** AND **THYROXINE**, BOTH OF WHICH CONTAIN IODINE AND ARE KNOWN COLLECTIVELY AS THYROID HORMONE; AND CALCITONIN.

The largest pure endocrine gland in the body, the thyroid gland consists of two lateral lobes linked by a narrow isthmus. On the posterior surface of each lobe are embedded two yellow-brown parathyroid glands.

THE THYROID & PARATHYROIDS

KEY

① Neck
② Thyroid cartilage
③ Larynx
④ Cricoid cartilage
⑤ Right lateral lobe
⑥ Thyroid gland
⑦ Isthmus
⑧ Head
⑨ Left lateral lobe
⑩ Trachea

Thyroid hormone acts as the body's "accelerator pedal". It speeds up **metabolic rate**, the rate of chemical reactions inside cells. Among its other roles, thyroid hormone also promotes growth during childhood and adolescence, and ensures the normal functioning of both heart and nervous system. The release of thyroid hormone is controlled by thyroid stimulating hormone (TSH), which is produced by the pituitary gland.

The third thyroid hormone, calcitonin, helps to control levels of calcium in the blood. The most abundant mineral in the body, calcium is essential for building bones and teeth, the transmission of nerve impulses, muscle contraction, and blood clotting. It is vitally important, therefore, to maintain stable levels of calcium in the blood. Calcitonin decreases calcium levels in the blood by slowing down the rate at which bone—the body's major storehouse of calcium—is resorbed or broken down, and speeding up the uptake of calcium to make more bone matrix. If calcium levels in the blood increase, so does calcitonin secretion by the thyroid gland. Precise control of blood calcium levels depends on calcitonin working with a hormone that has opposing effects. This hormone is released by the parathyroid glands.

Parathyroid glands

Four tiny parathyroid glands are embedded in the posterior part of the thyroid gland. They release **parathyroid hormone** (PTH), which raises calcium levels in the blood by increasing the rate at which bone is broken down, by stimulating the uptake of calcium from digested food in the small intestine, and by increasing the resorption of calcium into the bloodstream via the kidneys. Release of PTH is triggered by low levels of calcium, and inhibited by high levels of calcium in the blood.

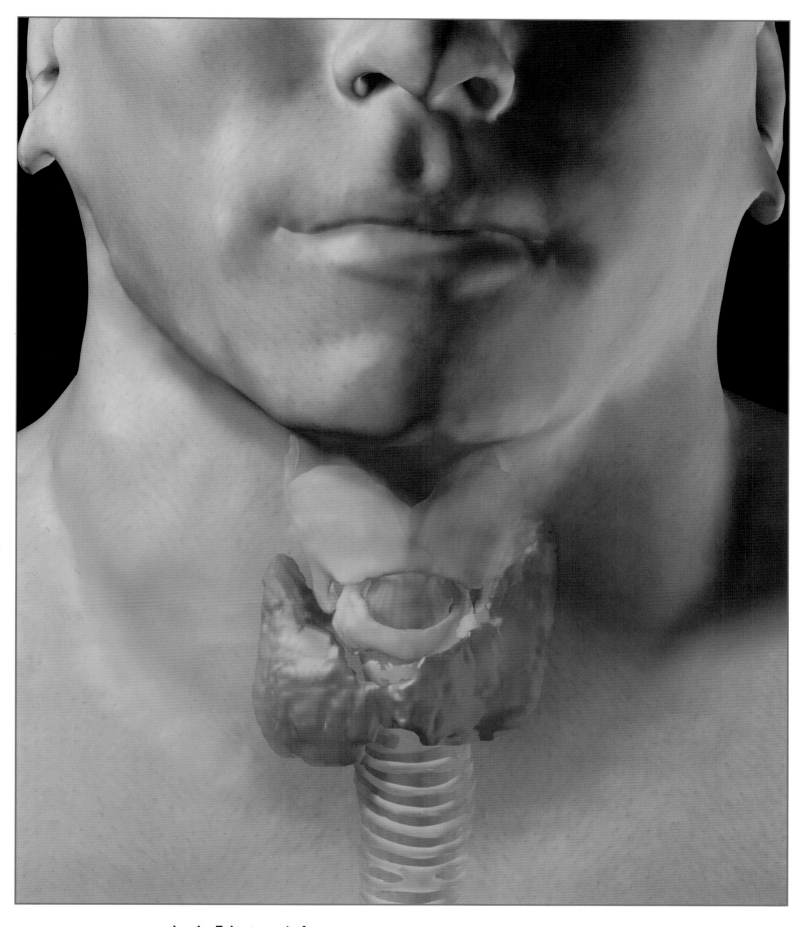

Iodine is the principal chemical element of the thyroid hormones. It is vitally important that sufficient iodine is obtained from the diet otherwise the thyroid gland will enlarge in an attempt to increase and maintain normal levels. Enlargement of the thyroid gland causes a characteristic swelling of the neck known as a goiter.

THE TWO, PYRAMID-SHAPED ADRENAL GLANDS RESEMBLE "HATS" THAT ARE PERCHED ON TOP OF THE KIDNEYS. EACH GLAND HAS TWO DISTINCT SECTIONS. THE OUTER ZONE, OR CORTEX, PRODUCES STEROID HORMONES CALLED **CORTICOSTEROIDS**. THE INNER ZONE, OR MEDULLA, PRODUCES TWO HORMONES—**EPINEPHRINE (ADRENALINE)** AND **NOREPINEPHRINE (NORADRENALINE)**—THAT TRIGGER THE "FIGHT-OR-FLIGHT" RESPONSE (SEE BELOW) WHEN THE BODY IS EXPOSED TO DANGER OR STRESS.

THE ADRENAL GLANDS

The two adrenal glands are located in the posterior part of the upper abdomen, perched on top of the kidneys. Each adrenal gland is surrounded and protected by a fibrous capsule and a cushioning layer of fat.

KEY

① Right adrenal gland
② Right kidney
③ Left adrenal gland
④ Left kidney

Three groups of corticosteroid hormones are made by the adrenal cortex. **Mineralocorticoids**, such as **aldosterone**, control the levels of sodium and potassium in blood and other body fluids. Maintaining balanced and stable levels of sodium and potassium is essential for regulating blood pressure and blood volume; both minerals are also vital for the conduction of nerve impulses and for muscle contraction. Aldosterone acts on the kidneys by preventing the loss of sodium in the urine.

Glucocorticoids, notably **cortisol**, help the body adapt to changing conditions by stabilizing blood glucose levels and influencing cell metabolism. Cortisol release is stimulated and regulated by the pituitary hormone, **adrenocorticotropic hormone** (ACTH). During times of stress resulting from, for example, surgery, bleeding, trauma, or infection, cortisol sets various processes in motion that help the body overcome its crisis.

Gonadocorticoids are principally male sex hormones or **androgens**. In men, the amount of androgen produced by the adrenals is minute compared to that released by the testes. In women, however, adrenal androgens stimulate the growth of pubic and axial (armpit) hair, as well as promoting sex drive and other sexual behaviors.

The "fight-or-flight" reaction and stress

Faced with the threat of short-term stress or danger, the body prepares itself to stay and fight, or to run away. This fight-or-flight reaction is mediated by epinephrine and norepinephrine, whose release is stimulated by the autonomic nervous system (*see page 98*). Unlike other hormones, epinephrine and norepinephrine are fast acting and short-lived in their effects. They act rapidly to increase heart and breathing rates (extra oxygen), increase levels of glucose in the blood (extra fuel), and to direct more blood to skeletal muscles (extra energy for muscle contraction) so that the body is geared up to either fight or run.

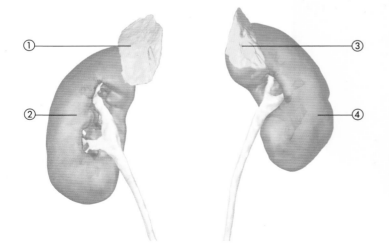

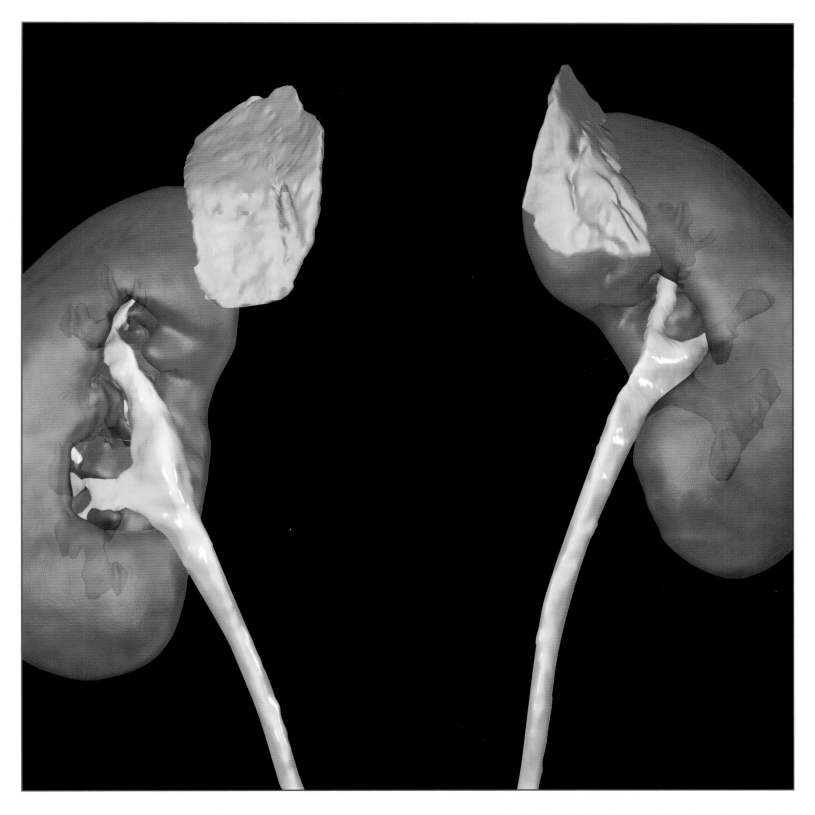

Each adrenal gland has two main parts, an outer cortex and an inner medulla. The outer cortex produces the glucocorticoids, the gonadocorticoids, and the mineralocorticoids, while the inner medulla produces epinephrine (adrenaline) and norepinephrine (noradrenaline).

LYING HORIZONTALLY BELOW AND BEHIND THE STOMACH, THE PANCREAS CONSISTS OF A HEAD, NECK, AND TAIL, THE HEAD BEING TUCKED INTO THE CURVE FORMED BY THE DUODENUM, THE FIRST PART OF THE SMALL INTESTINE. THE PANCREAS IS ACTUALLY TWO GLANDS IN ONE: PART EXOCRINE AND PART ENDOCRINE. NINETY-NINE PERCENT OF ITS MASS CONSISTS OF TINY EXOCRINE GLANDS CALLED ACINI THAT RELEASE A DIGESTIVE JUICE INTO THE DUODENUM (*see page* 142). SCATTERED AMONG THE ACINI ARE BETWEEN 1 AND 2 MILLION TINY CLUSTERS OF ENDOCRINE CELLS CALLED PANCREATIC ISLETS, OR ISLETS OF LANGERHANS.

THE PANCREAS

The pancreas is a mixed gland: most of its tissues are involved in producing and secreting enzymes that are released into the duodenum to digest food; but part of it secretes two hormones that between them control the level of glucose in the blood.

KEY

1. Liver
2. Gallbladder
3. Head of pancreas
4. Duodenum
5. Pancreas
6. Spleen
7. Tail of pancreas
8. Body of pancreas

Pancreatic islets produce two hormones—glucagon and insulin—that ensure the body has sufficient fuel, in the form of the sugar glucose, to supply its cells with the energy they need to function normally. Glucose levels in the bloodstream must be kept relatively stable regardless of whether a person has not eaten for several hours, or whether glucose from a recently eaten meal is flooding into the bloodstream. Too little or too much glucose in the blood inhibits glucose uptake by cells. In the case of the brain, fluctuating glucose levels can result in confusion, convulsions and, possibly, coma.

Glucagon and insulin have opposing effects and balance each other to maintain stable blood glucose levels. If blood glucose levels are low, more glucagon is released by **alpha cells** in the pancreatic islets. This hormone stimulates the liver to turn the **glycogen**—a complex carbohydrate reserve made up of glucose molecules— stored inside its cells into glucose, which passes into the bloodstream to restore normal glucose levels.

The level of blood glucose rises after a meal, which stimulates the beta cells of the pancreatic islets to release insulin. Insulin reduces blood glucose levels by storing the excess to meet future demands. It has three major targets. It encourages skeletal muscles to take up glucose from the bloodstream and either store it as glycogen, or use it to release the energy needed for movement. It stimulates **adipose** (fat) cells to use glucose as an immediate energy source or to store it as fat. Finally, it encourages liver cells to remove glucose from the blood and convert it into glycogen.

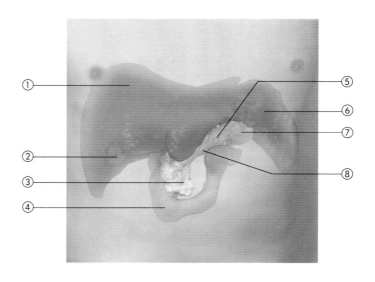

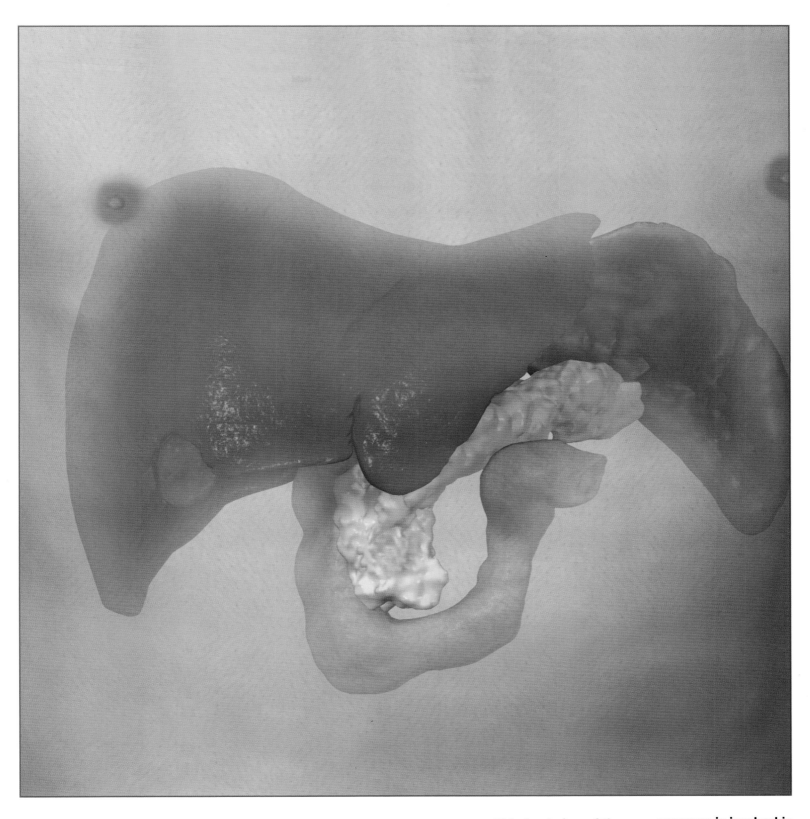

This front view of the abdomen shows the pancreas extending from the liver to the lateral surface of the stomach, the organ that also partially covers and conceals it. The larger head end of the pancreas tapers into its body and terminates in its tail. While much of the pancreas is involved in the production of digestive enzymes, dotted within the pancreas are thousands of cell groups called the islets of Langerhans. These are responsible for the production of insulin.

THE TWO ALMOND-SHAPED OVARIES LIE ONE ON EITHER SIDE OF THE UTERUS. AS THE PRIMARY FEMALE SEX ORGANS, OVARIES SERVE A DUAL PURPOSE. AS STOREHOUSES OF EGGS OR **OOCYTES**, THE OVARIES RELEASE ONE MATURE OOCYTE, OR **OVUM**, EACH MONTH BETWEEN **PUBERTY** AND THE **MENOPAUSE**. IF FERTILIZED BY A SPERM, THE OVUM WILL DEVELOP INTO A BABY. AS ENDOCRINE ORGANS, THE OVARIES RELEASE TWO SEX HORMONES— ESTROGEN AND PROGESTERONE—THAT MAINTAIN THE REPRODUCTIVE SYSTEM, AND PREPARE THE BODY FOR PREGNANCY.

KEY

① Pelvic girdle
② Right coxa (hip bone)
③ Right ovary
④ Uterus
⑤ Left coxa (hip bone)
⑥ Left ovary
⑦ Vagina

THE OVARIES

The ovaries, the primary female sex organs, lie within the pelvic cavity, one on each side of the uterus. As endocrine glands, the ovaries release the hormones that control the ovarian and menstrual cycles and maintain female secondary sexual characteristics.

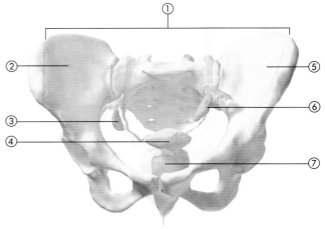

Estrogen first exerts its effects at puberty. It causes the reproductive system to mature and start working, and stimulates the production and maintenance of secondary female sexual characteristics, which include the growth of breasts; the development of a female body through characteristic fat deposition; the broadening of the pelvis; and the pattern of hair growth on the face and body. Estrogen also works with growth hormone (*see page 108*) to promote rapid growth during puberty. Each month between puberty and the menopause, estrogen stimulates the thickening of the **endometrium**, the lining of the uterus, so that it can receive an ovum if it is fertilized. Progesterone acts with estrogen to thicken the endometrium.

The release of both estrogen and progesterone is controlled by two other hormones—the **gonadotropins** FSH and LH—released by the pituitary gland. The gonadotropins also control the maturation and release of an ovum from an ovary each month. As levels of estrogen and progesterone increase they inhibit the release of gonadotropins. However, if fertilization does not occur, the secretion

of estrogen and progesterone by the ovaries decreases and levels of gonadotropins increase. As sex hormones and gonadotropins interact with each other, and their levels fluctuate, they synchronize two events or cycles that follow the same sequence on a monthly basis: the **ovarian cycle** (*see page 156*), which releases an ovum from the ovary; and the **menstrual cycle** (*see page 156*), which thickens the endometrium and prepares the uterus to receive the fertilized egg and then, if fertilization does not occur, causes the endometrium to break down. If fertilization does occur, high levels of estrogen and progesterone are maintained in order to inhibit the release of gonadotropins and prevent either ovarian or menstrual cycles occurring during the pregnancy.

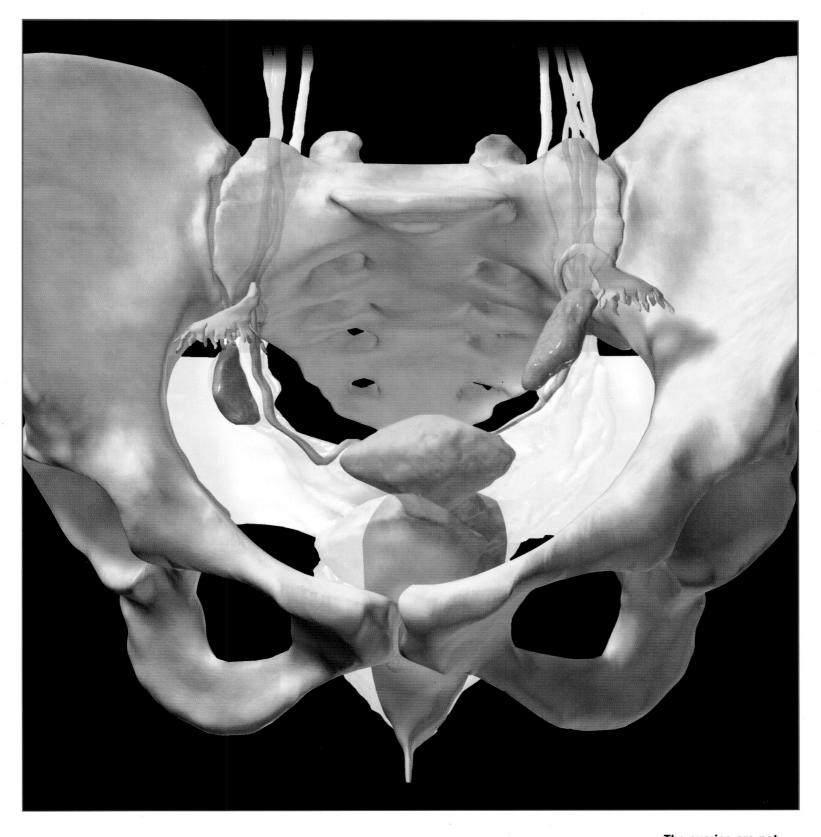

The ovaries are not fully functional at birth, only producing a few hormones. At the onset of puberty, a sudden increase in the levels of sex hormones occurs, causing the initiation of the reproductive cycle and the development of secondary sexual characteristics.

THE PAIRED, OVAL TESTES LIE IN A SKIN POUCH, CALLED THE SCROTUM, THAT HANGS

BETWEEN THE LEGS. THE TESTES ARE A MAN'S PRIMARY SEX ORGANS, AND LIKE THE

OVARIES—THE FEMALE PRIMARY SEX ORGANS—THEY HAVE TWO ROLES. FIRSTLY, COILED

TUBULES, CALLED SEMINIFEROUS TUBULES, INSIDE THE TESTES ARE RESPONSIBLE FOR THE

MANUFACTURE OF HUNDREDS OF MILLIONS OF SEX CELLS, CALLED SPERM, THROUGHOUT LIFE FROM

ABOUT THE AGE OF FOURTEEN. SECONDLY, THE TESTES ARE ENDOCRINE ORGANS THAT RELEASE

MALE SEX HORMONES CALLED ANDROGENS INTO THE BLOODSTREAM.

THE TESTES

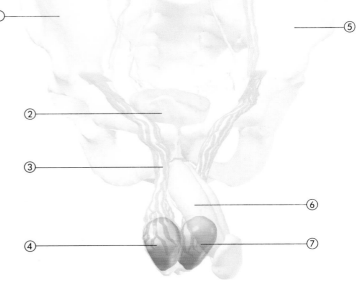

The testes, the primary male sex organs, lie outside and below the pelvic cavity, and produce hormones that stimulate sperm production and maintain male secondary sexual characteristics. The spermatic cord contains the blood vessels that convey hormones away from the testes.

KEY

1. Right coxa (hip bone)
2. Urinary bladder
3. Spermatic cord
4. Right testis
5. Left coxa (hip bone)
6. Penis
7. Left testis

Androgens, most notably the hormone testosterone, are secreted by endocrine cells called **interstitial**, or **Leydig**, cells that surround the seminiferous tubules. When a boy reaches puberty, testosterone secretion increases and stimulates the growth and maturation of the reproductive system, works with growth hormone to cause rapid growth, and causes the appearance of secondary sexual characteristics. In males, these characteristics include the growth of skeletal muscles and bones to produce a typical male body shape with wide shoulders and narrow hips; the appearance of facial, pubic, axial (armpit), and chest hair; and the growth of the larynx, which results in the voice "breaking" and deepening. In adults, testosterone maintains the secondary sexual characteristics, promotes sperm production, and powers the sex drive or **libido**. (Sex drive and the appearance of pubic hair in women are also controlled by testosterone, but the hormone is released by the adrenal glands—*see page 112*).

Testosterone release is controlled by another hormone, a gonadotropin called LH, released by the pituitary gland. LH stimulates interstitial cells to release testosterone. The whole system is overseen by a feedback mechanism that controls testosterone release: if there is too much testosterone in the bloodstream it inhibits the release of LH by the pituitary gland; too little testosterone has the opposite effect. In this way, testosterone levels in the blood remain relatively stable, unlike the cyclical fluctuations of female sex hormones (*see page 156*). Another gonadotropin, FSH, released by the pituitary gland, works with testosterone to stimulate the seminiferous tubules to manufacture sperm.

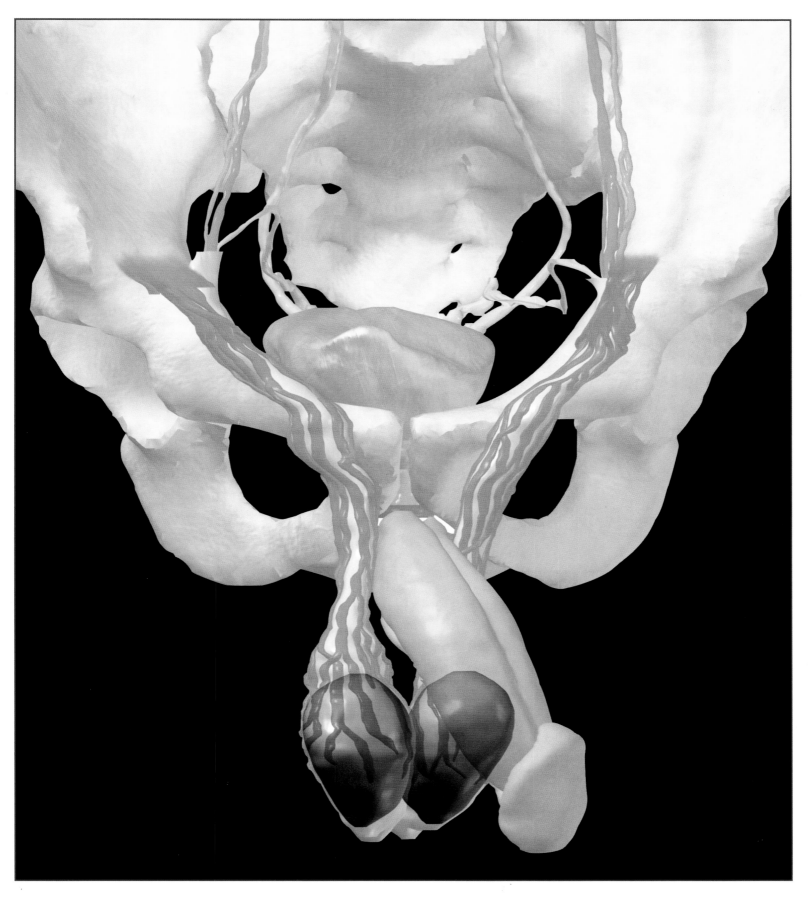

The production of androgens by the testes stimulates the maturation of the male reproductive system and the development of secondary sexual characteristics, such as the development of a typical body shape, the growth of facial, armpit, and chest hair, and the "breaking" of the voice, caused by the growth of the larynx.

119

THE HUMAN BODY IS MADE UP OF TRILLIONS OF CELLS. THESE CELLS ARE SURROUNDED BY TISSUE FLUID, OR **INTERSTITIAL FLUID**, FROM WHICH THEY CONSTANTLY EXTRACT THE OXYGEN, NUTRIENTS, AND OTHER SUBSTANCES THEY NEED IN ORDER TO STAY ALIVE, AND INTO WHICH THEY DEPOSIT WASTE MATERIAL PRODUCED BY THE CHEMICAL REACTIONS OF METABOLISM. FOR CELLS TO STAY ALIVE, TISSUE FLUID STOCKS OF NUTRIENTS AND OXYGEN MUST BE CONSTANTLY REPLENISHED, AND WASTE MUST BE REMOVED BEFORE CELLS ARE POISONED BY THEIR OWN POLLUTION. THESE DELIVERY AND REMOVAL FUNCTIONS ARE PERFORMED BY THE CARDIOVASCULAR, OR CIRCULATORY, SYSTEM. IT HAS THREE MAIN ELEMENTS: BLOOD, BLOOD VESSELS, AND THE HEART.

THE CARDIOVASCULAR SYSTEM

Blood is the liquid transport medium that carries oxygen, nutrients, waste matter and many other substances. It also contains cells, called white blood cells, which are involved in tracking down and destroying microorganisms, such as bacteria and viruses, before they can infect the body and cause disease.

Blood vessels are living, flexible tubes that form a network that channels blood to and from every part of the body apart from the hair, nails, the outer layer of skin, the corneas of the eyes, and tooth enamel.

There are three main types of blood vessels: **arteries** carry blood away from the heart; **veins** carry blood to the heart; **capillaries** link arteries and veins, and carry blood through the tissues where nutrients and oxygen pass into cells via tissue fluid, and wastes pass in the opposite direction into the blood.

At the core of the system is the heart. This muscular pump has two sides—left and right—that simultaneously pump blood in a figure-of-eight path through two circuits of blood vessels. In the

pulmonary circuit, the right side of the heart pumps oxygen-poor blood to the lungs along the pulmonary artery, and oxygen-rich blood returns to the left side of the heart along the pulmonary vein. In the systemic circuit, the left side of the heart pumps oxygen-rich blood along the aorta, which divides into smaller arteries that supply the body's organs where oxygen is consumed. Veins from these organs merge to form the superior vena cava and inferior vena cava, which empty oxygen-poor blood into the right side of the heart, thereby completing the circuit.

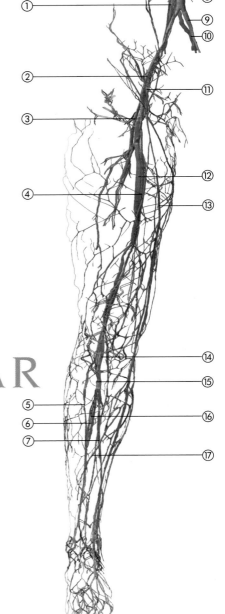

Anterior view of the lower pelvis and right leg showing the main arteries and veins. These blood vessels serve the muscles, bones, and skin of the thigh, leg and foot.

KEY

1. Inferior vena cava
2. External iliac artery
3. Deep femoral artery
4. Femoral artery
5. Anterior tibial artery
6. Peroneal vein
7. Posterior tibial artery
8. Descending aorta
9. Common iliac artery
10. Common iliac vein
11. External iliac vein
12. Femoral vein
13. Great saphenous vein
14. Popliteal vein
15. Popliteal artery
16. Peroneal artery
17. Anterior tibial vein

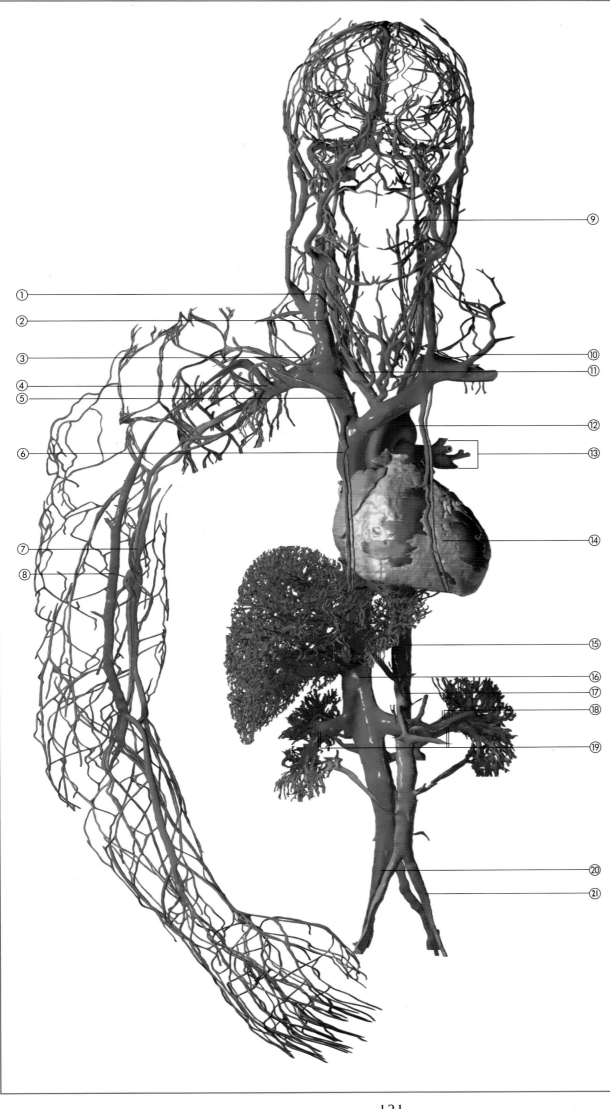

KEY

1. Common carotid artery
2. Internal jugular vein
3. Right subclavian artery
4. Right subclavian vein
5. Brachiocephalic vein
6. Superior vena cava
7. Brachial artery
8. Cephalic vein
9. External carotid artery
10. Left subclavian artery
11. Brachiocephalic artery
12. Aortic arch
13. Pulmonary arteries
14. Heart
15. Abdominal aorta
16. Inferior vena cava
17. Celiac trunk
18. Renal artery
19. Renal veins
20. Common iliac vein
21. Common iliac artery

Anterior view of the heart and the main arteries and veins of the head, right upper limb, and the trunk.

ARTERIES, VEINS AND CAPILLARIES FORM A TUBULAR DISTRIBUTION SYSTEM THAT

TOTALS SOME 150,000 KM (93,000 MILES) IN LENGTH. SHARING THE SAME BASIC

STRUCTURE, ARTERIES AND VEINS DIFFER IN THE RELATIVE THICKNESS OF THEIR WALLS.

THE WALLS OF ARTERIES AND VEINS HAVE THREE LAYERS OR COATS THAT ENCLOSE THE **LUMEN**,

THE INNER CHANNEL THAT CARRIES BLOOD. THE INNERMOST LAYER, THE **TUNICA INTIMA**,

CONSISTS OF A LINING OF **ENDOTHELIUM**—A SINGLE LAYER OF SMOOTH, FLATTENED CELLS IN

CONTACT WITH BLOOD—UNDERPINNED BY SUPPORTING TISSUE. THE **TUNICA MEDIA** CONSISTS OF

SMOOTH MUSCLE AND ELASTIC FIBERS. THE OUTERMOST **TUNICA ADVENTITIA** CONTAINS TOUGH

COLLAGEN FIBERS AND PROTECTS THE BLOOD VESSEL.

THE CARDIOVASCULAR SYSTEM

Arteries carry oxygen-rich blood (the pulmonary artery carries oxygen-poor blood) away from the heart. Typically, they have thick walls (especially the tunica media) enabling them to withstand the high pressure created when the heart pumps blood along them. As blood is forced into an artery, it expands and then recoils in order to push blood onwards. This means that blood flows in a continuous stream even when the heart relaxes between contractions. This expansion and recoil can be felt as a pulse where arteries pass near the surface of the skin, such as in the wrist. The smaller artery branches that supply organs and tissues divide to form thin-walled arterioles, that are less than 0.3 mm (⅟₁₀₀ in) in diameter, which divide to form capillaries.

Veins carry oxygen-poor blood (the pulmonary veins carry oxygen-rich blood) towards the heart. They have thinner walls than arteries—with the tunica media being significantly narrower—because the blood flowing along them is at a much lower pressure. Because blood pressure is low, veins contain valves that prevent the backflow of blood away from the heart. Veins are formed from smaller venules that, in turn, are formed in the tissue from the merging of capillaries.

Capillaries, the smallest blood vessels, form extensive networks, called capillary beds, in tissues and organs. Each capillary is about 0.008 mm (⅟₁₀₀₀₀ in) in diameter, just wide enough for red blood cells to squeeze through. The wall consists of a layer of endothelium one cell thick. Food and oxygen pass across the capillary wall into tissue fluid and, in return, waste is carried in the reverse direction. Where tissues are infected or inflamed, white blood cells squeeze between endothelial cells and pass into the infected tissues in order to destroy pathogens.

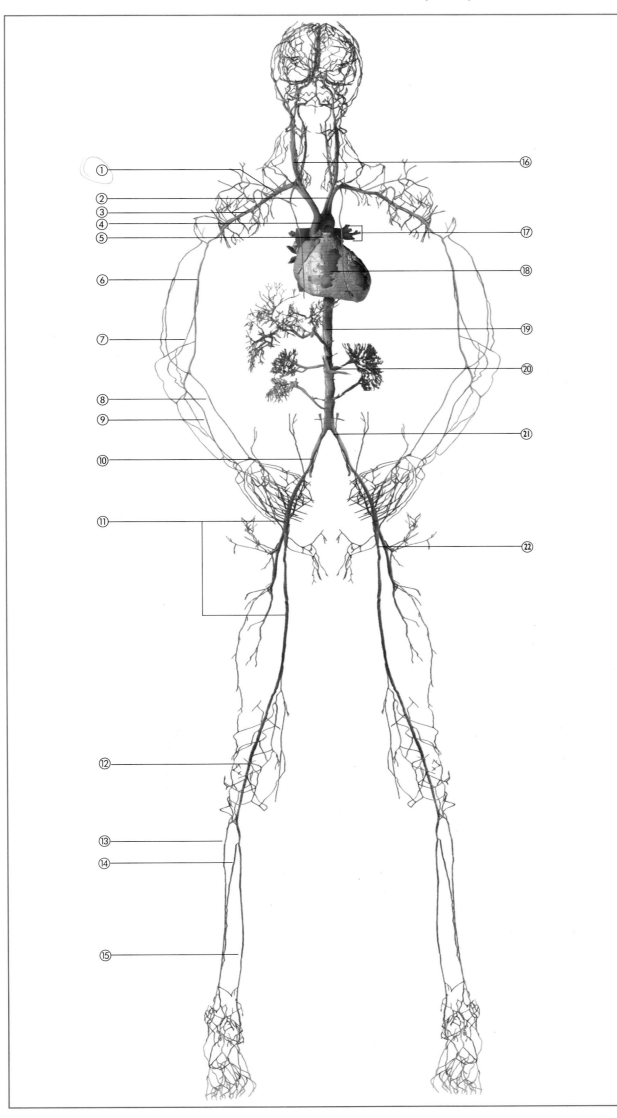

KEY

1. Subclavian artery
2. Brachiocephalic artery
3. Axillary artery
4. Aortic arch
5. Pulmonary trunk
6. Brachial artery
7. Deep brachial artery
8. Radial artery
9. Ulnar artery
10. External iliac artery
11. Femoral artery
12. Popliteal artery
13. Anterior tibial artery
14. Peroneal artery
15. Posterior tibial artery
16. Common carotid artery
17. Pulmonary arteries
18. Heart
19. Abdominal aorta
20. Left renal artery
21. Common iliac artery
22. Deep femoral artery

Anterior view of the body showing the main arteries. Arteries are blood vessels that carry oxygen-rich blood from the heart to the tissues; the pulmonary arteries carry oxygen-poor blood from the heart to the lungs.

BLOOD IS A LIVING, LIQUID TISSUE THAT FLOWS CONSTANTLY THROUGH THE BODY AND

PERFORMS THREE BASIC ROLES. AS A TRANSPORT MEDIUM, BLOOD DELIVERS

ESSENTIAL MATERIALS TO CELLS AND, IN RETURN, REMOVES THEIR WASTES; AS A

REGULATOR, BLOOD DISTRIBUTES HEAT TO HELP KEEP THE BODY WARM; AND AS A PROTECTOR,

BLOOD CELLS DETECT AND DESTROY PATHOGENS.

THE CARDIOVASCULAR SYSTEM

The composition of blood

Adult females have between 4 and 5 liters (8 and 10 pints) of blood, while adult males have between 5 and 6 liters (10 and 12 pints). Blood has two main components. Liquid plasma makes up about 55 percent of blood, while the other 45 percent consists of blood cells. Straw-colored plasma consists mostly of water in which are dissolved over 100 substances such as nutrients, hormones, antibodies, and waste substances that are transported by blood. Other substances, such as sodium and potassium ions and plasma proteins help to regulate the normal composition of blood. The second-by-second changes in plasma composition that occur as cells absorb and release materials are monitored by homeostatic mechanisms that keep plasma composition fairly stable.

There are three main types of blood cells: red blood cells, white blood cells, and platelets. Red blood cells, which make up 99 percent of blood cells, are doughnut-shaped, lack a nucleus and are packed with an orange-red protein called **hemoglobin**. During their 120-day lifespan, red blood cells pick up oxygen in the lungs and carry it to the tissues. Hemoglobin has the ability to

bind oxygen where concentrations are high, and unload it where, as in the tissues, oxygen concentrations are low.

White blood cells, of which there are three types, play a defensive role. **Granulocytes** detect pathogens, surrounding and engulfing them, and then digesting them. **Monocytes** pass into tissues where they become voracious pathogen hunters called **macrophages**. **Lymphocytes** release killer chemicals called **antibodies** that disable pathogens so that they can be destroyed. Macrophages and lymphocytes are also found in lymph nodes (*see page 126*). Together, the population of macrophages and lymphocytes in the blood and lymphatic systems form the immune system.

Platelets are smaller cell fragments that stick together to form a plug if a blood vessel is damaged. They also initiate the conversion of a blood protein, called **fibrinogen** into strands of **fibrin** that, like a fishing net, trap red blood cells in order to clot the blood and seal a wound.

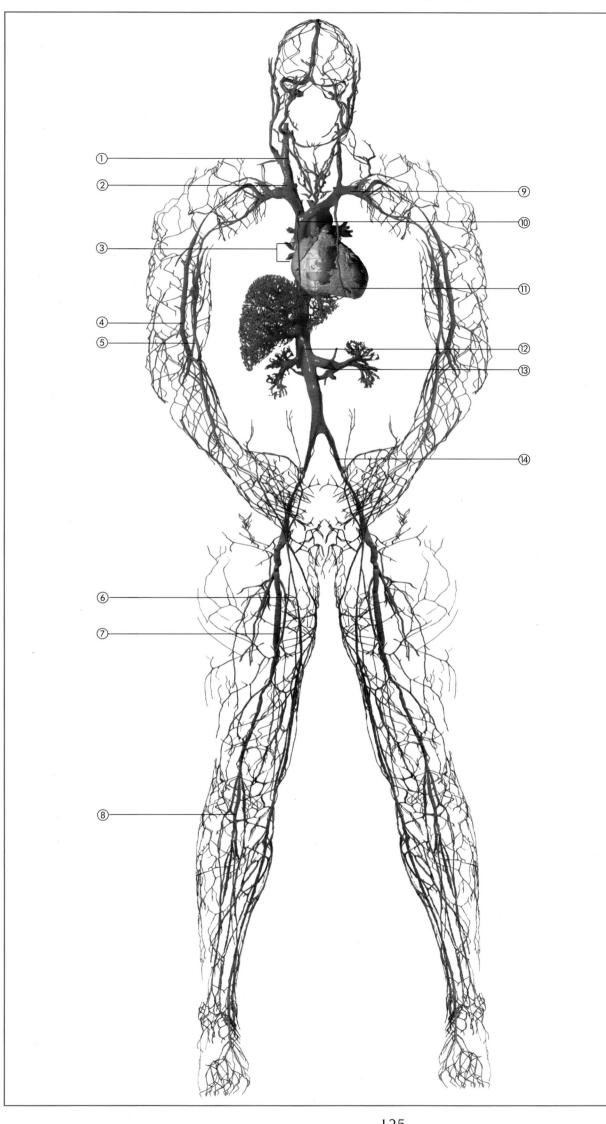

KEY

1. Common trunk for facial, retromandibular and lingual veins
2. Internal jugular vein
3. Pulmonary vein
4. Cephalic vein
5. Basilic vein
6. Great saphenous vein
7. Femoral vein
8. Anterior tibial
9. Left subclavian vein
10. Superior vena cava
11. Heart
12. Inferior vena cava
13. Left renal vein
14. Left common iliac vein

Anterior view of the body showing the main veins. Veins are blood vessels that carry oxygen-poor blood from tissues to the heart; the pulmonary veins carry oxygen-rich blood from the lungs to the heart.

LIKE THE CARDIOVASCULAR SYSTEM (*see page* 120), THE LYMPHATIC SYSTEM CONSISTS OF A NETWORK OF TUBES, OR VESSELS, THAT REACH ALL PARTS OF THE BODY. UNLIKE BLOOD VESSELS, THESE LYMPHATIC VESSELS ARE BLIND-ENDING, AND THERE IS NO HEART TO PUMP FLUID THROUGH THEM. THE LYMPHATIC SYSTEM ALSO INCLUDES ASSOCIATED LYMPHATIC ORGANS, SUCH AS LYMPH NODES AND THE SPLEEN (*see page* 194). THE LYMPHATIC SYSTEM HAS TWO DISTINCT YET OVERLAPPING ROLES: TO DRAIN FLUID THAT HAS ACCUMULATED IN THE TISSUES AND RETURN IT TO THE BLOODSTREAM SO THAT ITS VOLUME AND CONCENTRATION REMAIN CONSTANT; AND TO DEFEND THE BODY BY DESTROYING PATHOGENS (DISEASE-CAUSING MICROORGANISMS).

THE LYMPHATIC SYSTEM

Consider the drainage function first. As blood flows along blood capillaries, fluid oozes out through the capillary walls to bathe the cells of the surrounding tissue. This fluid delivers essentials such as food and oxygen to cells, and removes waste before returning to the bloodstream. However, about one-sixth of the fluid does not return through the capillary wall, remaining instead in the tissues as tissue fluid. Permeating the tissues are tiny, blind-ending lymph capillaries. Excess tissue fluid—now called lymph— passes through tiny valves in these capillaries, which then remove it. Lymph capillaries merge to form larger and larger lymph vessels which eventually form lymphatic trunks that empty via two lymphatic ducts into the left and right subclavian veins. Lymph is pushed along by the contraction of skeletal muscles that surround lymph vessels; as with veins, valves help prevent backflow.

Lymph is a clear fluid that also contains debris and pathogens, such as bacteria and viruses. Lying along the lymphatic vessels are swellings called lymph nodes. As lymph passes through them, large numbers of lymphocytes and macrophages (*see page 124*) detect and destroy pathogens, kill cancer cells, and remove debris, and by doing so filter the lymph before it returns to the bloodstream. The defensive white blood cells—lymphocytes, which release killer chemicals called antibodies and macrophages that engulf and destroy pathogens—found in the circulatory and lymphatic systems together comprise the immune system. Other lymphatic organs such as the spleen and tonsils also play a part in the body's immune response.

The lymph system consists of vessels and associated nodes that reach most parts of the body, returning excess fluid to the bloodstream, and playing an important part in the defense against pathogens.

KEY

① Cervical nodes
② Right lymphatic duct
③ Right subclavian vein
④ Axillary nodes
⑤ Inguinal nodes
⑥ Lymph capillary
⑦ Entrance of thoracic duct into left subclavian vein
⑧ Heart
⑨ Thoracic (left lymphatic) duct
⑩ Cisterna chyli (confluence of lymph vessels from lower body)
⑪ Lymph node
⑫ Lymph vessel

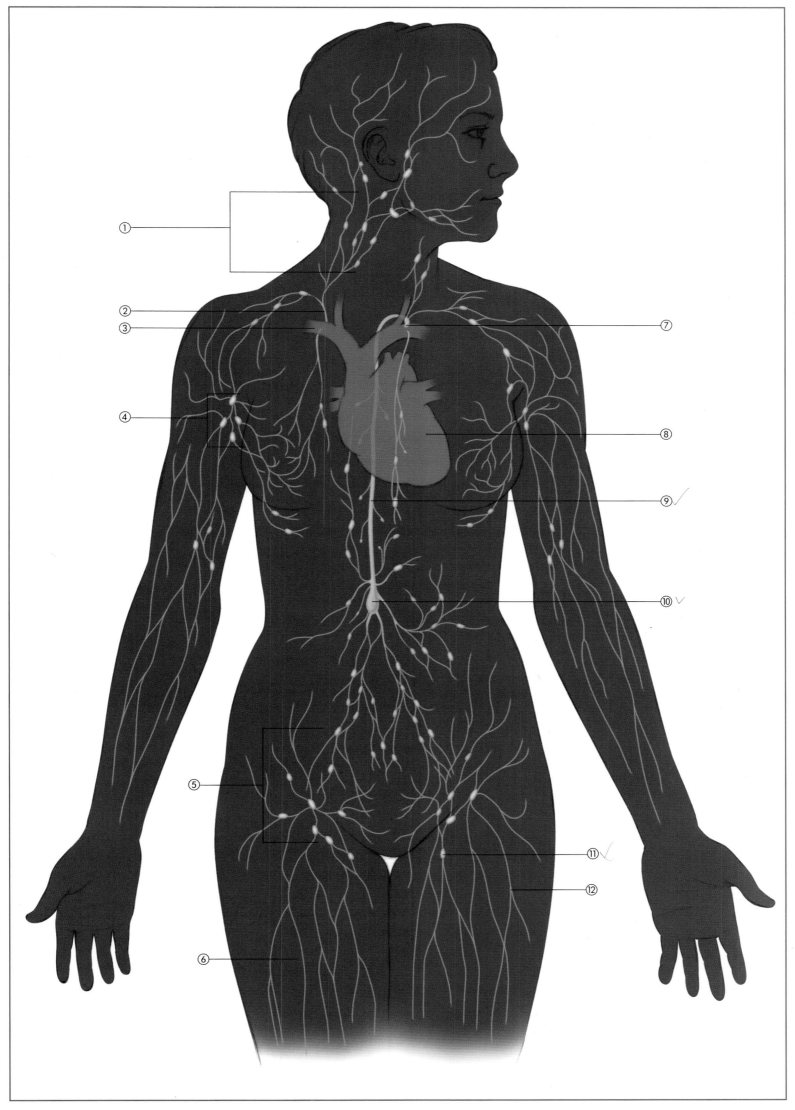

①

②

③

④

⑤

⑥

⑦

⑧

⑨

⑩

⑪

⑫

THE RESPIRATORY SYSTEM FULFILLS AN ESSENTIAL SERVICE BY PROVIDING THE BODY WITH A CONSTANT SUPPLY OF OXYGEN FROM THE AIR. OXYGEN IS USED BY ALL BODY CELLS TO RELEASE ENERGY FROM "FUELS", SUCH AS GLUCOSE, IN A PROCESS CALLED AEROBIC RESPIRATION. RESPIRATION ALSO RELEASES A WASTE PRODUCT, CARBON DIOXIDE, WHICH MUST BE REMOVED FROM THE BODY BY THE RESPIRATORY SYSTEM BEFORE IT CAUSES ANY HARMFUL EFFECTS.

THE RESPIRATORY SYSTEM

Energy released by respiration is used inside cells to power the many chemical reactions—known collectively as metabolism—that keep them functioning as living units. An absolute requirement for oxygen is something that humans share with most other living organisms. The smallest of these—flatworms, for example—take in oxygen directly across their body surface by **diffusion**, and lose carbon dioxide as it passes in the opposite direction. Larger animals, including humans, lack sufficient surface area to take in enough oxygen through their skin to supply the large internal volume made up of trillions of cells. Instead, humans have a respiratory system that consists of two parts: a respiratory tract, or airway, which carries air in and out of the body; and a pair of lungs in the thorax (chest), where oxygen diffuses into, and carbon dioxide diffuses out of, the bloodstream. The respiratory tract consists of the nose, mouth, throat, and trachea (windpipe). The trachea divides at its lower end to form two bronchi (sing. bronchus), one for each lung.

Development of the respiratory system

During normal fetal life, the lungs are filled with fluid and do not take part in gas exchange. That role is performed by the **placenta**, the organ attached to the wall of the **uterus** (*see page 158*) across which

oxygen passes from the maternal blood supply to the fetal blood supply. By the time the baby is ready to be born, the airways in the respiratory tract and lungs have been drained of fluid. At birth, as the oxygen supply from the placenta ceases, rising carbon dioxide levels in the baby's blood are detected by the part of the brain that controls breathing (*see page 92*), and this stimulates the baby to take its first breath, so that gaseous exchange takes place in the lungs.

KEY

1. Cartilage plates of external nose
2. External nares (nostrils)
3. Mouth
4. Pharynx (throat)
5. Larynx (voicebox)
6. Trachea (windpipe)
7. Right lung
8. Fissure
9. Frontal sinus
10. Maxillary sinus
11. Cartilage ring of trachea
12. Left lung

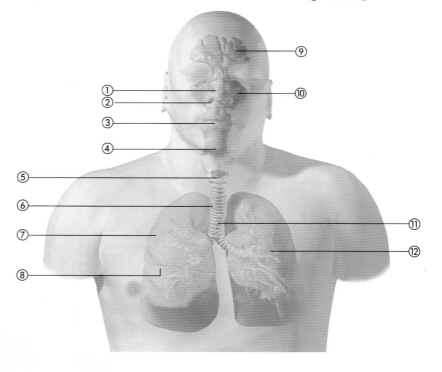

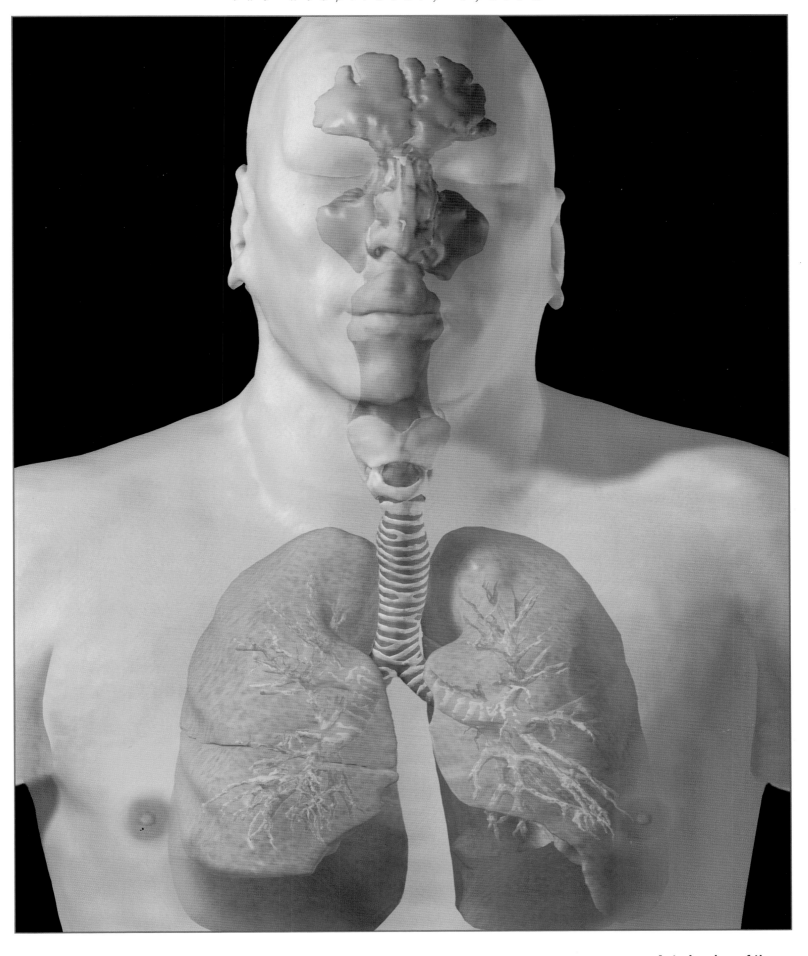

Anterior view of the head and thorax showing the respiratory system and the paranasal sinuses, hollows in skull bones that help to warm and moisten inhaled air.

THE RESPIRATORY TRACT—THE MOUTH, NOSE, PHARYNX (THROAT), LARYNX, AND TRACHEA—PROVIDES AN AIRWAY ALONG WHICH AIR IS CONDUCTED INTO AND OUT OF THE LUNGS. IT ALSO "PROCESSES" AIR AS IT IS BREATHED IN BY WARMING, MOISTENING, AND FILTERING IT: AIR THAT IS COLD, DRY, AND LADEN WITH DIRT AND GERMS DAMAGES DELICATE LUNG TISSUES.

THE MOUTH, NOSE, & THROAT

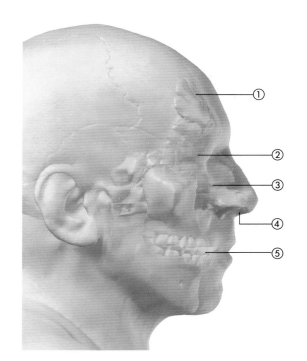

In the nose, hairs lining the nostrils trap larger particles in the air; the mucous membrane that lines the nasal cavity (and much of the respiratory system) moistens and warms the air; while sticky mucus traps dust, dirt, and bacteria. Tiny hair-like **cilia** covering the mucous membrane sway rhythmically, like a field of wheat, pushing dirt-laden mucus to the throat where it can be swallowed and digested by stomach acids (*see page 140*). Paranasal sinuses—membrane-lined cavities in the bones surrounding the nasal passage—also warm and moisten the air. Warming and moistening continues in the pharynx and trachea. The trachea also has cilia that push dirty mucus upward toward the throat where it can be swallowed.

Speech and the larynx

Speech plays a vital role in communication that is unique to humans. Sounds are produced by the larynx, or voice box, a funnel-shaped arrangement of cartilages that links the pharynx to the trachea.

Stretched across the larynx, from front to back, is a pair of membranes called vocal cords. During normal breathing the vocal cords are wide open so that air flow is not impeded. During speech, muscles in the larynx pull the vocal cords together—rather like pulling drapes across a window—

making them more taut. When exhaled air passes in controlled bursts through the closed vocal cords they vibrate and produce sounds. These sounds are amplified by the throat, mouth, nasal cavity, and paranasal sinuses, and are turned into recognizable speech by the tongue and lips. The tighter the vocal cords are pulled, the higher the pitch of the sounds; the greater the force of the exhaled air, the louder the sound. Men have longer, thicker vocal cords that vibrate more slowly and produce lower pitched sounds.

Sinuses—cavities within the skull bones surrounding the nasal passage—warm and moisten the air prior to it entering the delicate lung tissue.

KEY

① Frontal sinus
② Sphenoid sinus
③ Maxillary sinus
④ Nasal vestibule
⑤ Oral cavity

FILLING UP MOST OF THE SPACE INSIDE THE THORAX ARE TWO CONE-SHAPED LUNGS. THE LUNGS REST ON THE DIAPHRAGM, A DOME-SHAPED SHEET OF MUSCLE THAT SEPARATES THORAX FROM ABDOMEN, AND ARE SURROUNDED BY A "CAGE" FORMED BY THE RIBS, STERNUM, AND BACKBONE. MOVEMENT OF THE RIBS AND DIAPHRAGM—KNOWN AS BREATHING OR VENTILATION—FORCES AIR IN AND OUT OF THE LUNGS ABOUT 20,000 TIMES EACH DAY IN ORDER TO PROVIDE A CONTINUOUS SUPPLY OF FRESH AIR (*see page* 180).

THE LUNGS

The trachea and its branches are referred to as the "bronchial tree" because they resemble an upside-down tree.

KEY

① Thyroid cartilage
② Cricoid cartilage
③ Trachea
④ Superior lobe of left lung
⑤ Left primary bronchus
⑥ Oblique fissure
⑦ Inferior lobe of left lung
⑧ Arytenoid cartilage
⑨ Superior lobe of right lung
⑩ Right primary bronchus
⑪ Inferior lobe of right lung

Internally, the lungs consist of a network of tubes and sacs, sometimes called the "bronchial tree" because of its resemblance to an upside down tree with the trachea as the trunk. Inside the lungs, the two bronchi arising from the trachea divide repeatedly to form smaller and smaller bronchi, which in turn divide to form terminal bronchioles that branch further to form microscopic respiratory bronchioles at the end of which are the alveoli, the site of gaseous exchange.

Gaseous exchange

The interchange of life-giving oxygen for waste carbon dioxide takes place through the alveoli. Air breathed into the lungs contains about 21 percent oxygen, while air breathed out contains about 16 percent; the remaining 5 percent passes through the alveoli into the bloodstream. Exhaled air contains over 100 times more waste carbon dioxide than inhaled air.

The lungs contain around 300 million microscopic alveoli, grouped in clusters like bunches of grapes. These alveoli have an internal surface area of about 70 square meters (750 square feet), equivalent to 35 times the surface area of skin covering the body squeezed into the thorax. This large surface area is essential to ensure that enough oxygen is taken in to the body in the fastest possible time to meet the body's demands.

Alveoli are surrounded by a network of blood capillaries that deliver oxygen-poor blood to the alveoli and remove blood enriched with oxygen. Together, alveolar and capillary walls form a thin respiratory membrane, the interface between air and blood—just 0.001 mm (0.00004 in) thick—across which gaseous exchange takes place. Oxygen diffuses across the respiratory membrane from the alveoli, where there is a high concentration of oxygen, to a low concentration in the bloodstream. Carbon dioxide diffuses in the opposite direction. The inner surface of the alveoli is covered by a fluid film in which oxygen dissolves before it diffuses across the respiratory membrane, thereby speeding up the process.

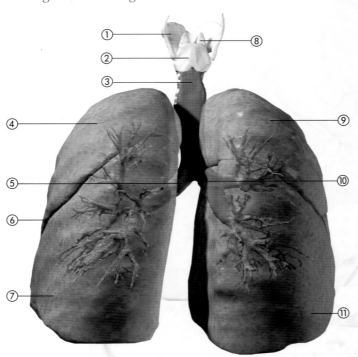

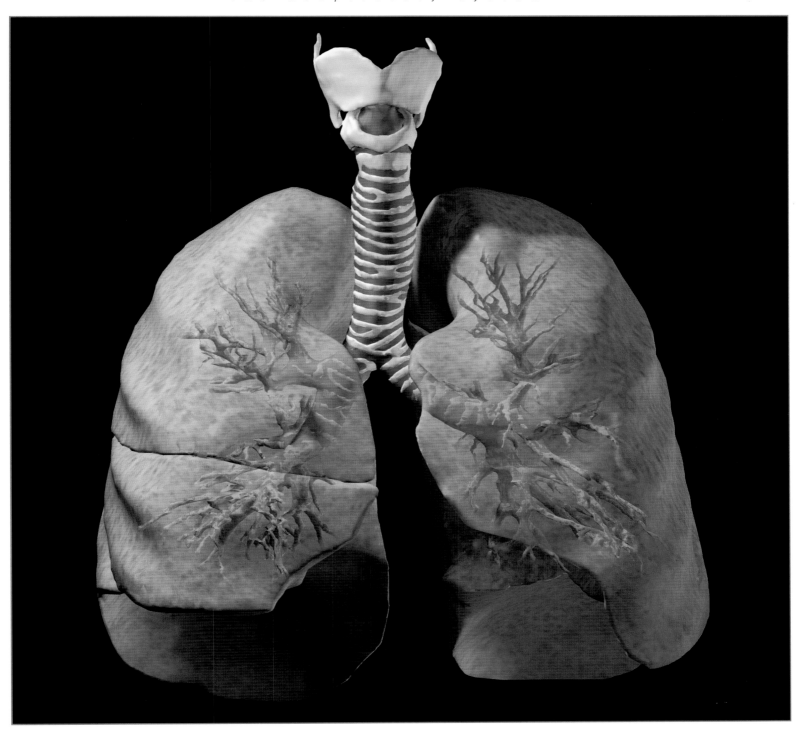

Highly branched airways inside the lungs terminate in microscopic sacs in which oxygen is exchanged for carbon dioxide.

KEY

1. Larynx
2. Trachea
3. Superior lobe of right lung
4. Right primary bronchus
5. Fissure
6. Middle lobe of right lung
7. Inferior lobe of right lung
8. Superior lobe of left lung
9. Left primary bronchus
10. Secondary (lobar) bronchus
11. Tertiary (segmental) bronchus
12. Inferior lobe of left lung

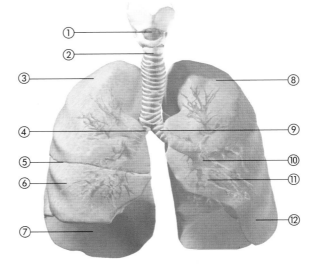

This anterior view of the lungs shows the right lung is divided into three lobes by two fissures, while the left lung has just two lobes.

FOOD IS ESSENTIAL FOR LIFE. THE NUTRIENTS CONTAINED IN FOOD KEEP THE BODY'S CELLS FUNCTIONING BY PROVIDING THEM WITH ENERGY AND THE RAW MATERIALS FOR GROWTH AND REPAIR. THE ONLY PROBLEM IS THAT MOST OF THESE ESSENTIAL NUTRIENTS ARE "LOCKED" INSIDE THE FOOD WE EAT. COMPLEX FOOD MOLECULES MUST BE BROKEN DOWN, OR DIGESTED, IN ORDER TO LIBERATE THE SIMPLE NUTRIENTS SUCH AS GLUCOSE AND AMINO ACIDS THAT CAN BE USED BY THE BODY. THIS PROCESS IS THE FUNCTION OF THE DIGESTIVE SYSTEM.

THE DIGESTIVE SYSTEM

Most foods, such as a slice of bread or a piece of chicken, consist of a mixture of different nutrients, particularly carbohydrates, proteins, fats, vitamins, minerals, and fiber. Carbohydrates include simple sugars, such as glucose, and complex carbohydrates, such as starch, which consist of chains of sugar molecules. During digestion, complex carbohydrates are broken down to release simple sugars that provide energy. Proteins are broken down into their constituent molecules, amino acids, which are used by cells to make new proteins. These are used for the growth and repair of cells, and to make **enzymes** (*see box on page 136*). Fats are broken down during digestion into fatty acids and glycerol, which can be used as a fuel, or reassembled to form fats that are used to insulate the body. Vitamins, such as vitamin C, and minerals, such as calcium and iron, are essential for the normal functioning of the chemical reactions of metabolism. Finally, indigestible strands of vegetable tissue, called fiber, ensure that the intestines work efficiently.

The digestive process

Processing of food by the digestive system takes between 24 and 48 hours and consists of four basic stages.

- **Ingestion** is the taking in of food and drink through the mouth.
- **Digestion** is the breaking down of a wide range of foods into a few simple nutrient molecules. Digestion can be mechanical, such as the chewing action of teeth or the crushing action of the stomach walls; or chemical, by the action of enzymes.
- **Absorption** is the movement of simple nutrient molecules into the bloodstream, which carries them to where they are needed.
- **Egestion** is the elimination of undigested food in the form of **feces** through the anus.

KEY

1. Liver
2. Gallbladder
3. Large intestine
4. Pelvis
5. Esophagus
6. Spleen
7. Stomach
8. Pancreas
9. Small intestine
10. Rectum

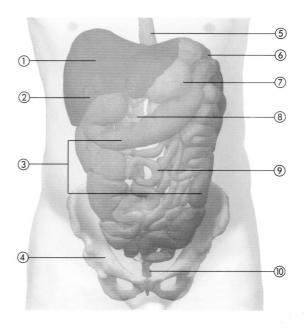

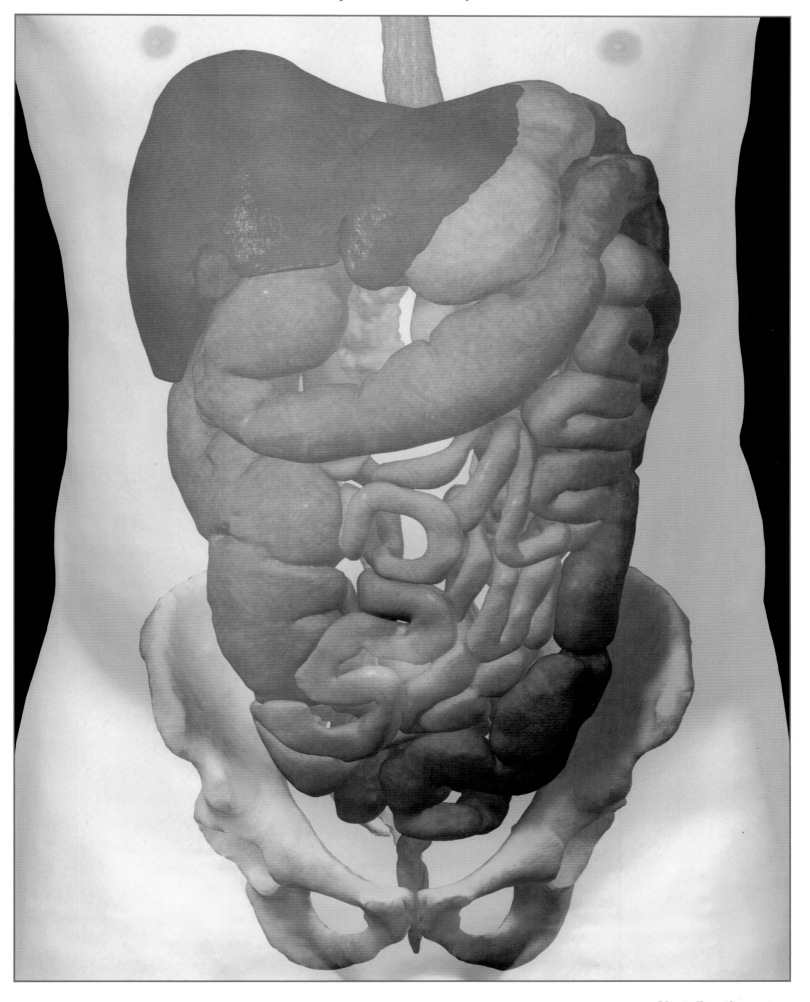

Most digestive organs are located in the abdomen, as revealed by this anterior abdominal view with the organs *in situ*.

THE ALIMENTARY CANAL & ACCESSORY ORGANS

THE ALIMENTARY CANAL IS A LONG TUBE CONSISTING OF LINKED ORGANS—THE MOUTH, PHARYNX (THROAT), ESOPHAGUS, STOMACH, SMALL INTESTINE, AND LARGE INTESTINE—THAT RUNS FROM MOUTH TO ANUS. THE ACCESSORY DIGESTIVE ORGANS ARE THE TONGUE AND TEETH, WHICH MOVE AND CRUSH FOOD; THE SALIVARY GLANDS, LIVER, AND PANCREAS, WHICH RELEASE DIGESTIVE SECRETIONS ALONG DUCTS INTO THE ALIMENTARY CANAL; AND THE GALLBLADDER, WHICH STORES SECRETIONS RELEASED BY THE LIVER. THE LIVER ALSO PROCESSES NUTRIENTS ONCE THEY HAVE BEEN ABSORBED.

What are enzymes?

Enzymes are proteins that act as biological **catalysts**: they speed up chemical reactions inside the body by thousands or millions of times while remaining unchanged. **Intracellular** ("inside cells") enzymes work inside cells, where they accelerate the metabolic reactions. Digestive enzymes are **extracellular** ("outside cells"), released by cells in the salivary glands, stomach, pancreas, and small intestine into the alimentary canal. Without enzymes, digestion would occur too slowly for the body to obtain any nutrients.

Enzymes are specific for certain substrate molecules. The substrate fits precisely into a special area of the enzyme, known as the active site, in the same way that a key fits a lock. The products of the resulting reaction are released from the active site and the enzyme, remaining unchanged, locks onto more **substrate** molecules. Digestive enzymes catalyze reactions involving **hydrolysis** ("water splitting"). The enzyme catalyzes the decomposition of organic compounds (food) by the interaction of water. For example, the enzyme **amylase** (in saliva) breaks down starch into maltose, and the enzyme **maltase** (in pancreatic juice) splits maltose into glucose.

The digestive organs of the abdomen seen in right, lateral view with the front of the body to the right of the picture.

KEY

① Esophagus
② Liver
③ Gallbladder
④ Large intestine
⑤ Ascending colon
⑥ Right kidney
⑦ Pelvis
⑧ Small intestine
⑨ Rectum

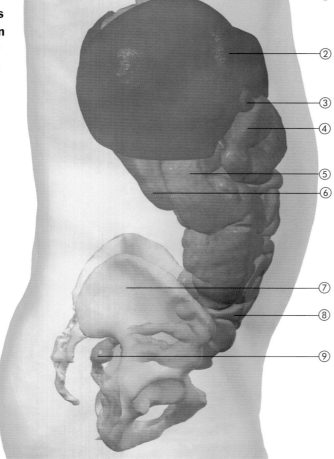

The wall of the alimentary canal typically contains two layers of smooth muscle: an inner circular layer, and an outer longitudinal layer. Waves of muscle contraction called **peristalsis** push food along the canal towards the anus. Movement of the alimentary canal and secretion of digestive juices is controlled automatically by the autonomic nervous system (*see page 98*), and by hormones (*see page 106*). Ingestion is the only part of the digestive process that is under conscious control.

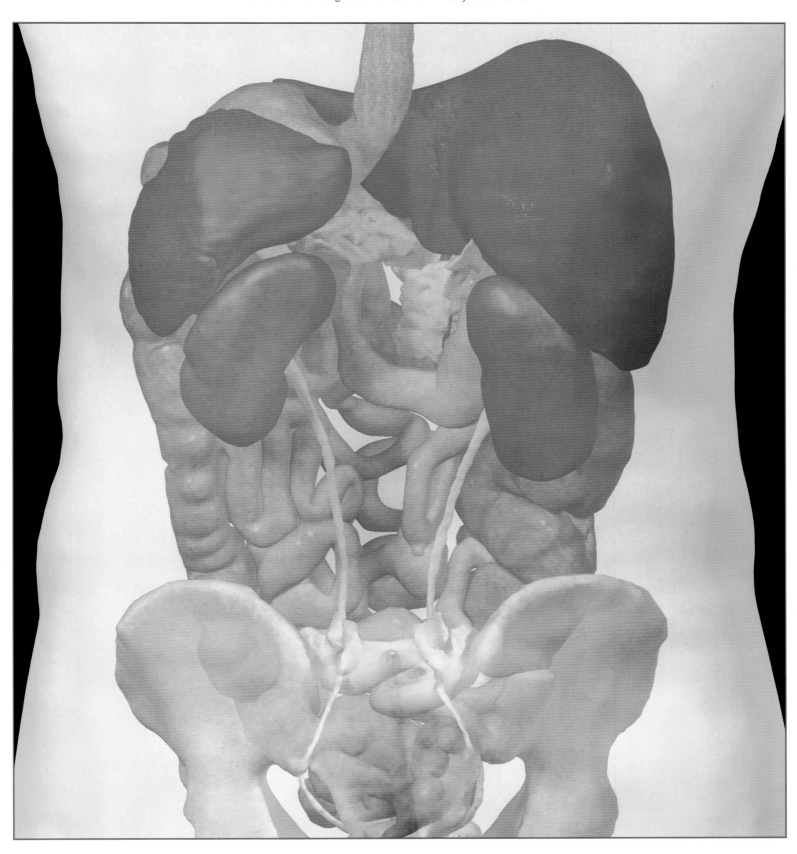

This posterior view of the abdomen shows the digestive system and its relationship to the kidneys.

KEY

① Esophagus

② Spleen

③ Left kidney*

④ Large intestine

⑤ Small intestine

⑥ Left ureter*

⑦ Pelvis

⑧ Liver

⑨ Pancreas

⑩ Right kidney*

⑪ Right ureter*

⑫ Duodenum

* = part of the urinary system

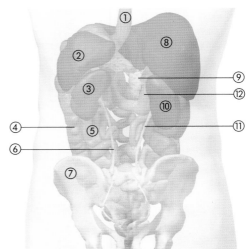

THE FIRST PHASE OF DIGESTION TAKES PLACE IN THE MOUTH, OR BUCCAL CAVITY. HERE, FOOD IS INGESTED AND PARTLY DIGESTED BEFORE BEING SWALLOWED. THE MOUTH IS BOUND BY THE LIPS AT THE FRONT, THE HARD AND SOFT PALATE AT THE TOP, THE TONGUE AT THE BASE, AND BY THE ENTRANCE INTO THE PHARYNX, OR THROAT, AT THE REAR. EMBEDDED IN SOCKETS IN THE UPPER AND LOWER JAW ARE THE TEETH. IN EACH JAW THERE ARE 16 TEETH: 4 CHISEL-LIKE INCISORS CUT FOOD, 2 CANINES GRIP AND TEAR FOOD, AND 4 PREMOLARS AND 6 MOLARS GRIND AND CRUSH FOOD.

THE MOUTH & THROAT

KEY

① Nasal septum
② External naris (nostril)
③ Nasal cavity
④ Hard palate
⑤ Lower lip
⑥ Tongue
⑦ Epiglottis
⑧ Larynx
⑨ Esophagus
⑩ Trachea
⑪ Right cerebral hemisphere
⑫ Brainstem
⑬ Cerebellum
⑭ Nasopharynx
⑮ Soft palate
⑯ Oropharynx
⑰ Laryngopharynx
⑱ Cervical vertebra
⑲ Intervertebral disc
⑳ Spinal cord

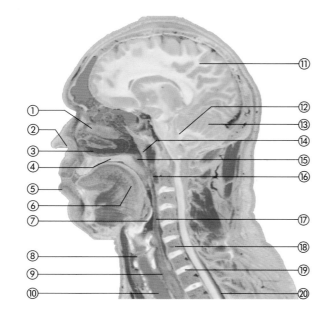

Following its ingestion, food is chewed. The lips are closed, and the cheek muscles push inwards, pulling the lower jaw upwards. As the jaw moves, the teeth cut and crush the food so that it can be swallowed, and to increase the surface area available for enzyme action. At the same time, the three pairs of salivary glands vastly increase saliva production—saliva is released all the time to cleanse the mouth. Saliva release is a reflex action stimulated by the thought, sight, or smell of food. Saliva is a watery liquid that contains slimy mucus and amylase (an enzyme that partly digests starch). During chewing, the tongue, a flap of skeletal muscle, mixes crushed food with saliva. When food molecules dissolve in saliva, taste buds on the tongue's upper surface detect four basic tastes— sweet, sour, salt, and bitter (*see page 164*). After about 60 seconds of chewing, the tongue pushes the slippery ball of crushed food—called a bolus—into the throat for swallowing.

The throat, which extends from the rear of the nasal cavity to about halfway down the neck, acts as a passageway for food, but does not have a digestive role. When chewed food touches the back and sides of the throat, it triggers a reflex action. Muscles in the wall of the throat contract to push the bolus of food downward toward the esophagus. At the same time the larynx (voice box, *see page 130*) rises and a cartilage flap, the epiglottis, folds over its entrance to stop food going the "wrong way" into the trachea.

Sagittal section of the head and neck, the right half seen from the left side.

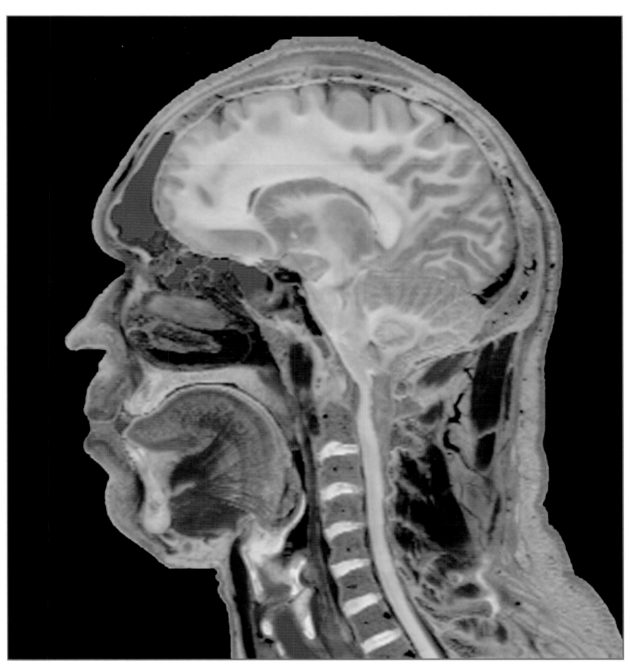

Teeth

Forming the outer surface of each tooth is enamel, the hardest substance in the world. The two incisors are designed for cutting and slicing; the canines for seizing and stabbing; and the molars and premolars for crushing, grinding, and chewing food.

KEY

① Central incisor
② Lateral incisor
③ Canine
④ 1st premolar
⑤ 2nd premolar
⑥ 1st molar
⑦ 2nd molar
⑧ 3rd molar

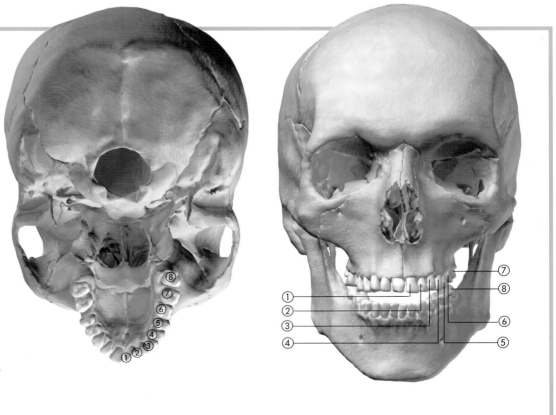

THE ESOPHAGUS IS A MUCUS-LINED MUSCULAR TUBE ABOUT 25 CM (10 IN) LONG THAT CARRIES FOOD FROM THROAT TO STOMACH. THE MOVEMENT OF THE FOOD BOLUS DOWN THE ESOPHAGUS IS THE FINAL PHASE OF SWALLOWING. THE INNER LAYER OF CIRCULAR MUSCLE IN THE ESOPHAGUS WALL CONTRACTS JUST BEHIND THE BOLUS, SQUEEZING THE ESOPHAGEAL WALLS INWARD AND PUSHING THE BOLUS DOWNWARD; AT THE SAME TIME, IN FRONT OF THE BOLUS, THE OUTER LAYER OF LONGITUDINAL MUSCLE CONTRACTS TO MAKE THAT PART OF THE ESOPHAGUS WIDER.

The esophagus provides the link between the mouth, where food is ingested, and the stomach.

THE ESOPHAGUS & STOMACH

A WAVE OF SUCCESSIVE CONTRACTIONS AND RELAXATIONS, CALLED **PERISTALSIS**, PASSES DOWN THE ESOPHAGUS TO PUSH THE BOLUS INTO THE STOMACH. FROM THROAT TO STOMACH TAKES BETWEEN 4 AND 8 SECONDS, OR JUST 1 SECOND FOR LIQUIDS AND VERY SOFT FOODS.

Stomach acid

Stomach, or gastric, acid is secreted by parietal cells within the gastric mucosa lining of the stomach. Stomach acid consists primarily of concentrated hydrochloric acid, which helps kill germs and bacteria, and sterilizes food. Gastric acid also contains water and the enzyme pepsin—a protein splitting enzyme—which combined with the hydrochloric acid helps to breakdown the chemicals that make up food and activates some gastric enzymes. The average adult stomach holds between 1 and 1.5 liters (2 and 3 pints) of gastric

acid and manufactures the same amount every 24 hours.

Gastric acid secretion is controlled by the vagus nerve, which runs from the medulla oblongata in the brain stem; the hormone gastrin, which is secreted into the blood supply by cells in the upper part of the stomach wall in response to nervous stimulation; and by histamine, a local hormone synthesized in the gastric mucosa. The vagus nerve sends impulses to the cells in the stomach lining to secrete gastric acid in response to the smell and taste of food.

The stomach is a J-shaped expandable portion of the alimentary canal that partly digests food and temporarily stores it for between 2 and 4 hours. The stomach wall has three layers of smooth muscle—outer longitudinal, middle circular, and inner oblique—that contract to crush and grind food. The lining of the stomach is dotted with millions of tiny depressions called **gastric pits**. Glands in the bottom of these pits produce about 2 liters (4 pints) of acidic gastric juice daily. Its release is stimulated by the sight, smell, or thought of food, and by the arrival of food in the stomach. Gastric juice contains the enzyme pepsin, which breaks down proteins into smaller molecules called peptides. Hydrochloric acid secreted in gastric juice activates pepsin and provides the right **pH** environment for it to work in; it also plays a defensive role by killing harmful bacteria in food. Coating the stomach lining is mucus, which prevents it being digested by its own secretions.

The crushing action of the stomach wall muscles, and the action of gastric juice, converts the food bolus into a semi-liquid paste called **chyme**. Contraction of the stomach muscles pushes food from the cardiac region of the stomach through its **fundus** (upper region) and body (middle region) to the **pylorus**, the funnel-shaped region linked to the duodenum, the first part of the small intestine. The exit from the pylorus is closed by the pyloric **sphincter**, a ring-shaped muscle in the stomach wall. Pressure of chyme against the sphincter causes the sphincter to open slightly, allowing small amounts of liquid chyme to enter the duodenum.

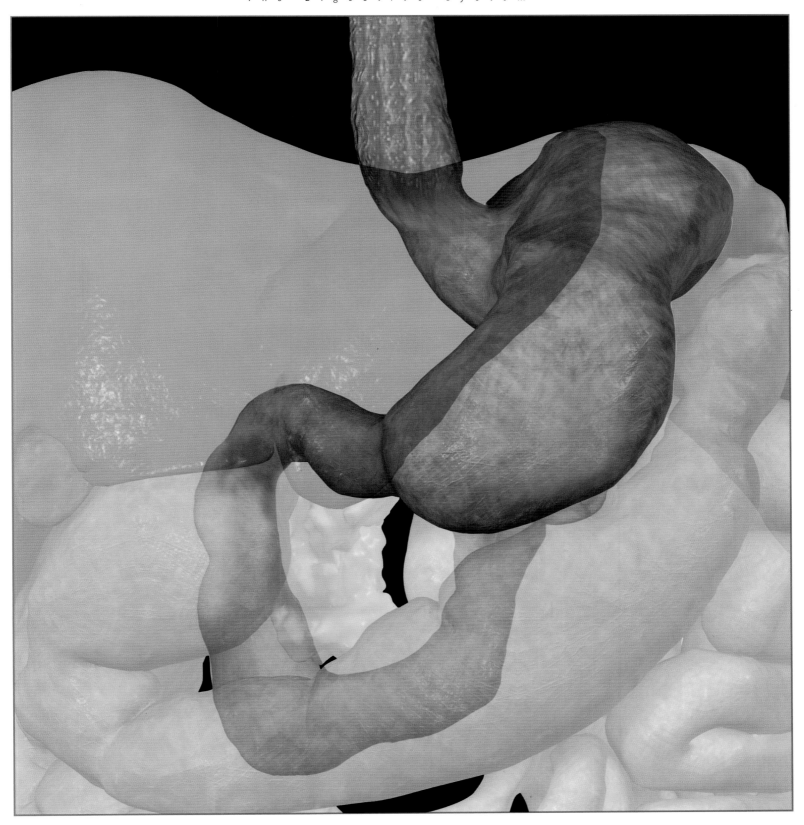

The muscular walls of the stomach contract powerfully to crush swallowed food so that it can be digested by enzymes more efficiently.

KEY

① Cardia (cardiac region)
② Lesser curvature
③ Pylorus
④ Pyloric sphincter
⑤ Duodenum
⑥ Esophagus
⑦ Cardiac sphincter
⑧ Fundus
⑨ Body
⑩ Greater curvature

THE DUODENUM FORMS THE FIRST PART OF THE SMALL INTESTINE, THE LONGEST PART OF THE ALIMENTARY CANAL AND ITS MOST IMPORTANT DIGESTIVE ORGAN. IT IS ALSO THE ENTRY POINT FOR **ALKALINE** SECRETIONS FROM TWO ACCESSORY GLANDS, THE PANCREAS AND LIVER WHICH, WITH INTESTINAL JUICES, SERVE TO NEUTRALIZE ACIDIC CHYME AS IT ENTERS THE DUODENUM THROUGH THE PYLORIC SPHINCTER.

THE LIVER, GALLBLADDER, PANCREAS, & DUODENUM

The pancreas is packed with cell clusters, called **acini**, that secrete digestive juices into the pancreatic duct, from where they empty into the duodenum. About 1.5 liters (3 pints) of alkaline pancreatic juice is secreted daily, its release stimulated by the arrival of chyme in the duodenum. Pancreatic juice contains the enzymes **amylase**, which breaks down starch; **trypsin**, **chymotrypsin**, and **carboxypeptidase**, which break down proteins; **lipase**, which breaks down fats; and **nucleases**, which break down nucleic acids such as DNA. The pancreas also has endocrine cells (*see page 114*) that secrete hormones, which control blood glucose levels.

The liver secretes **bile**, a greenish liquid that is part digestive and part excretory. Bile is stored and concentrated in the gallbladder, a small muscular sac located on the rear, lower surface of the liver. The arrival of chyme triggers the release of bile along the bile duct, which merges with the pancreatic duct before emptying into the duodenum. Bile salts in bile emulsify fats—turn them into small droplets—making their digestion by lipase enzymes more efficient.

The roles of the liver

Billions of liver cells, or **hepatocytes**, carry out hundreds of functions related to the regulation of blood composition. The sole digestive function of the liver is the production of bile, a mixture of water, bile salts, and bile pigments (a waste product from worn out red blood cells). Digestion-related functions include:

• Controlling glucose levels in the blood.
• Metabolizing amino acids and fats.
• Storing vitamins and minerals.

These food processing functions prevent blood from becoming "swamped" with nutrients after a meal. Other functions include:

• Removing poisons, such as drugs, and toxins from the blood.
• Making plasma proteins.
• Generating heat, thereby helping to keep the body warm.

Unusually, this large and important organ receives two blood inputs: the hepatic artery supplies oxygen-rich blood; the hepatic portal vein supplies blood rich in recently-absorbed nutrients direct from the small intestine. This link underpins the many digestion-related functions carried out by the liver.

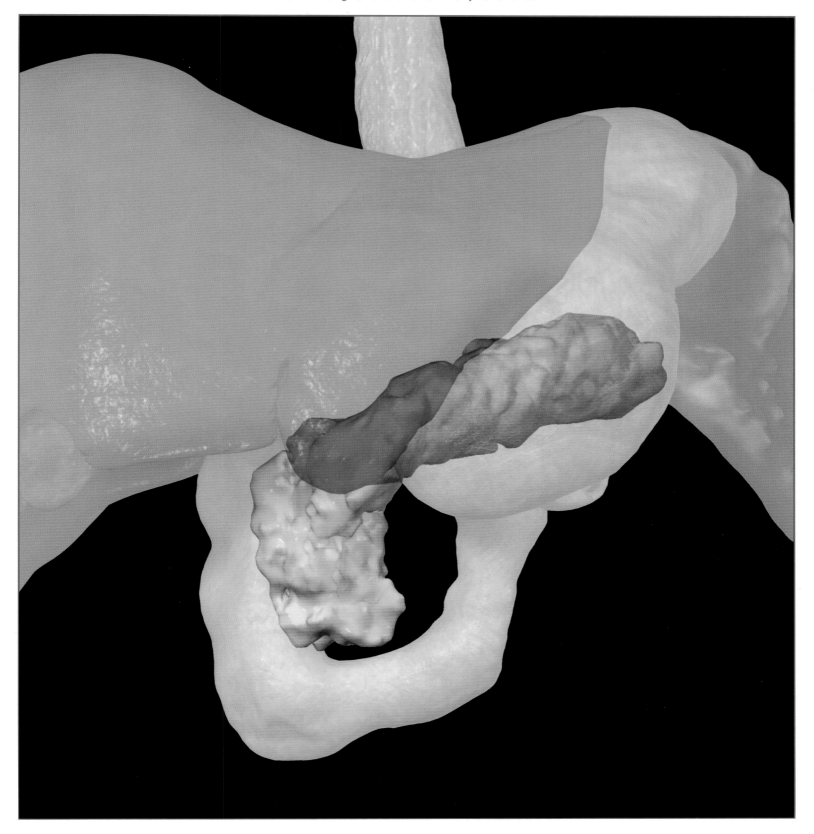

KEY

① Right lobe of liver

② Gallbladder

③ Duodenum

④ Head of pancreas

⑤ Left lobe of liver

⑥ Tail of pancreas

⑦ Body of pancreas

⑧ Jejunum

⑨ Region of the duodenum
where ducts from
accessory organs open

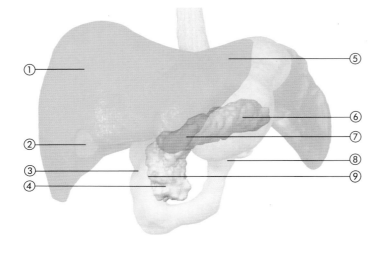

The three accessory organs—the liver, gallbladder, and pancreas—empty secretions into the duodenum to aid digestion there.

THE SMALL INTESTINE LIES COILED UP WITHIN THE CENTRAL ABDOMEN AND EXTENDS FROM THE STOMACH TO THE LARGE INTESTINE. THE TERM "SMALL" RELATES TO ITS DIAMETER, WHICH IS ONLY ABOUT 2.5 CM (1 IN). IT IS, HOWEVER, THE LONGEST PART OF THE ALIMENTARY CANAL AND THIS REFLECTS ITS IMPORTANCE AS THE SITE OF ALMOST ALL DIGESTION AND ABSORPTION OF NUTRIENTS.

THE SMALL INTESTINE

The small intestine has three parts: the 25 cm (10 in) long curved duodenum (*see page 142*) receives chyme from the stomach; the middle jejunum is about 1 meter (3 feet) long; while the final section, the ileum, is about 2 meters (6 feet) long and joins the large intestine at the **ileocecal valve**. These dimensions increase after death when muscle tone is lost and the entire length of the small intestine totals between 6 and 7 meters (20 and 22 feet).

Internally, the lining of the small intestine provides a large surface area with which to maximize the efficiency of both digestion and absorption. This is achieved through three levels of adaptation. Firstly, circular folds called **plicae circulares** form ridges some 10 mm (½ in) high around the inside of the small intestine. Secondly, tiny 1 mm (1/16 in) long, fingerlike processes called **villi** project from the plicae circulares and from the troughs in between them. Each villus contains a capillary network, and a branch of the lymphatic system called a **lacteal**. Thirdly, the outer surface of cells lining the small intestine—including the villi—is covered by microscopic hairlike projections called **microvilli**, of which there are over 200 million per square millimeter of intestinal surface. Microvilli not only further increase the surface area available for absorption; attached to them are digestive enzymes that

complete the last stages of digestion right next to the absorptive surface.

Chyme from the stomach is neutralized by pancreatic and intestinal juices, and bile, and is partly digested by pancreatic enzymes (*see page 142*). Enzymes attached to microvilli—also called **brush border enzymes**—include **maltase**, **sucrase**, and **lactase**, which break down complex sugars into glucose and other simple sugars; and **peptidases**, which break down peptides into amino acids. Simple sugars and amino acids pass through villi cells into blood capillaries. These absorbed nutrients are then carried to the liver via the hepatic portal vein. Fatty acids and glycerol are turned back into fats inside villi cells and then pass into the lymphatic system, by way of the lacteals, which deposit them into the bloodstream.

Resembling a coil of sausages, the small intestine, the longest part of the alimentary canal, provides the most important site for digestion and absorption.

KEY

① Duodenum
② Jejunum
③ Junction with the large intestine
④ Ileum
⑤ Small intestine

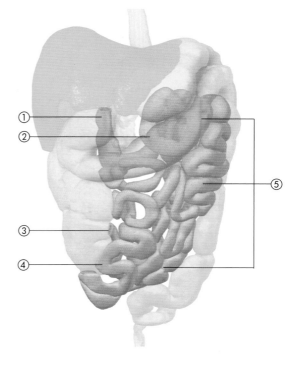

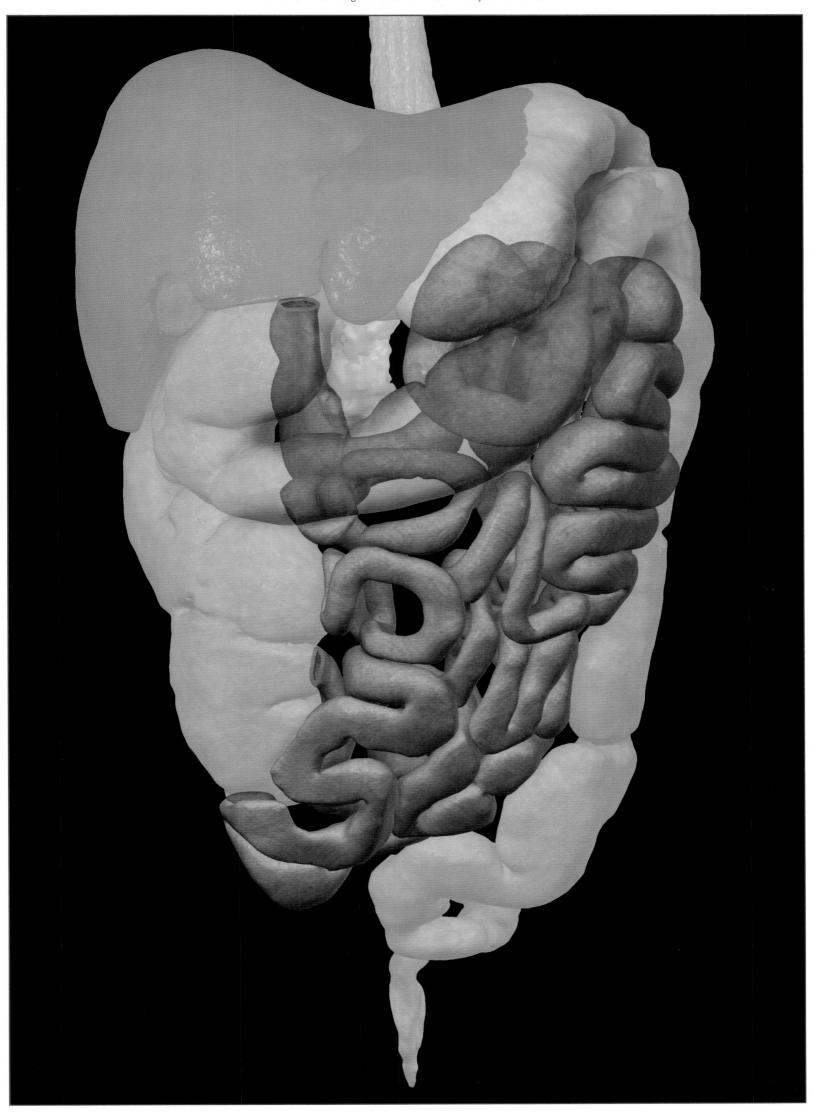

THE LARGE INTESTINE REMOVES UNDIGESTED FOOD AND OTHER WASTE FROM THE BODY. IT HAS FOUR SECTIONS: THE CECUM, COLON, RECTUM, AND ANAL CANAL. THE SHORT CECUM LIES INFERIOR TO THE ILEOCECAL VALVE, THE ONE-WAY ENTRANCE INTO THE LARGE INTESTINE FROM THE ILEUM. THE COLON CONSISTS OF ASCENDING, TRANSVERSE, AND DESCENDING SECTIONS THAT, RESPECTIVELY, PASS UP THE RIGHT HAND SIDE OF, ACROSS, AND DOWN THE LEFT HAND SIDE OF THE ABDOMINAL CAVITY; AND THE S-SHAPED SIGMOID COLON THAT PASSES INTO THE PELVIS. THE RECTUM LEADS TO THE ANAL CANAL, WHICH OPENS THROUGH THE ANUS. IN ALL, THE LARGE INTESTINE IS ABOUT 1.5 METERS (5 FT) LONG. THE NAME "LARGE" REFERS TO ITS DIAMETER, WHICH AT 6.5 CM (3 IN) IS TWICE THE WIDTH OF THE SMALL INTESTINE. THE LARGE INTESTINE CONTAINS BILLIONS OF BACTERIA, WHICH ARE HARMLESS INSIDE THE BODY BUT CAN BE HARMFUL IF THEY ARE TRANSFERRED TO FOOD—HENCE THE IMPORTANCE OF WASHING HANDS AFTER DEFECATION—OR IF FECES POLLUTE WATER SUPPLIES.

THE LARGE INTESTINE

Each day, about 1500 ml (4 pints) of semi-liquid waste enters and is pushed along the large intestine. As this happens, water is absorbed into the bloodstream, thereby helping to maintain the body's fluid balance. Within 10 to 12 hours the liquid waste has been turned into semi-solid material called feces. Apart from fiber and undigested food, feces also contain dead intestinal cells and bacteria. Although movement of the large intestine is usually sluggish, the arrival of food in the stomach triggers a more powerful wave of peristalsis, which pushes feces into the sigmoid colon for temporary storage.

Egestion of feces

The egestion of feces, or defecation, is triggered by a movement of more feces into an already full sigmoid colon, which then contracts to push feces into the normally empty rectum. As the rectal walls stretch, the person feels a conscious desire to defecate. If defecation is desired, the muscles of the rectal wall contract to push the feces into the anal canal. The two sphincters—internal and external—guarding the anus relax and the feces are pushed out.

The large intestine travels up, across, and down the abdomen before opening to the outside through the anus.

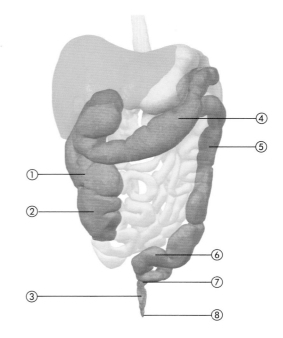

The appendix

The appendix is a blind-ending tube about 9 cm (4 in) long and attached to the cecum. Rabbits and other herbivores have a large appendix containing many bacteria that break down **cellulose**, a key constituent in grasses and other vegetation, in order to release essential glucose. In humans, the appendix is comparatively much smaller and, until recently, was thought to be vestigial. However, recent research has indicated that it may play a part in the immune system (*see page 126*).

KEY

1. Ascending colon
2. Cecum
3. Anal canal
4. Transverse colon
5. Descending colon
6. Sigmoid colon
7. Rectum
8. Anus

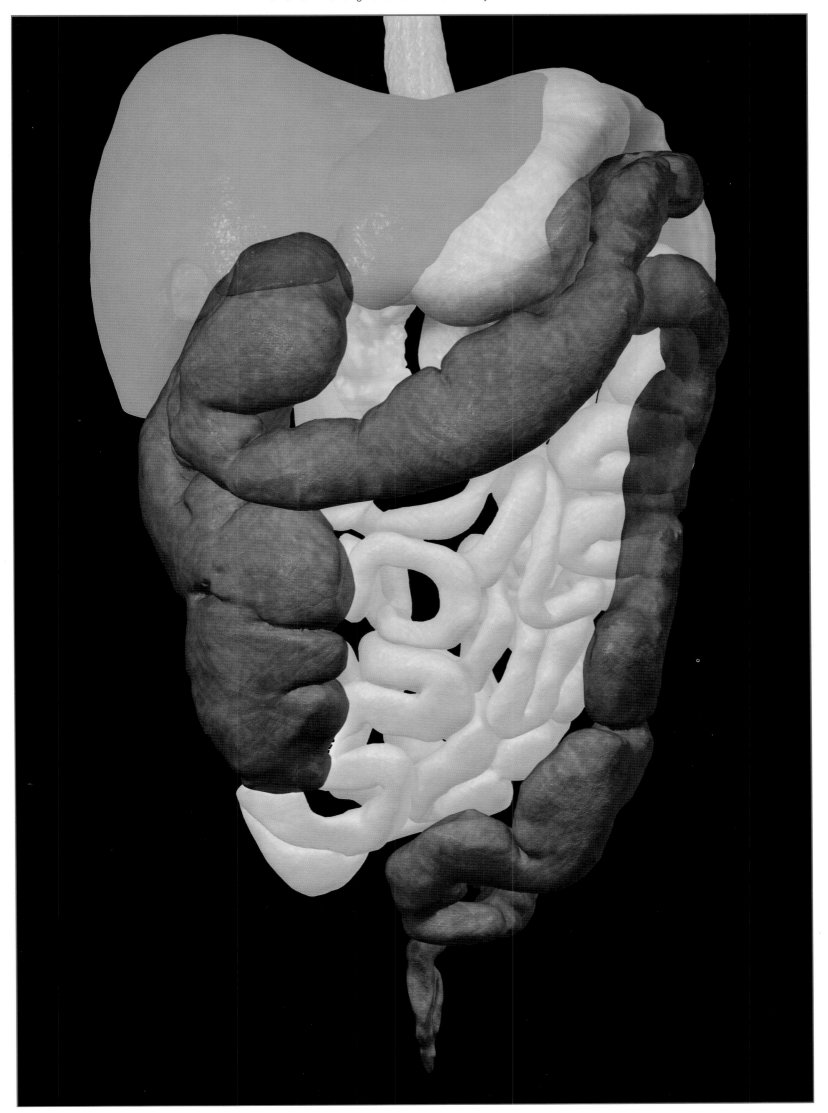

THE URINARY SYSTEM IS THE BODY'S SANITATION DEPARTMENT. IT REMOVES UNWANTED MATERIALS FROM THE BLOOD AND BY DOING SO MAINTAINS THE CONCENTRATION OF BLOOD AND TISSUE FLUID WITHIN NARROW LIMITS. THIS IMPORTANT HOMEOSTATIC ROLE IS ESSENTIAL TO ENSURE THAT THE ACTIVITIES OF THE BODY'S TRILLIONS OF CELLS ARE NOT DISRUPTED BY LIFE-THREATENING FLUCTUATIONS IN THE FLUIDS THAT SURROUND THEM.

THE URINARY SYSTEM

The key organs in the urinary system are the two kidneys. These brown, beanshaped organs—each about 12 cm (5 in) long and 6 cm (3 in) wide—are located in the upper abdomen, one on either side of the backbone. The kidneys receive some 25 percent of the heart's output through the renal arteries—about 1800 liters (475 gallons) of blood per day—and return processed blood to the circulation through the renal veins.

The result of the kidney's processing activities is a waste liquid called **urine**. Urine contains dissolved wastes that must be promptly excreted (eliminated) from the body before they can cause harm. Most wastes are produced as a result of metabolic activities inside cells. The major waste substance is a **nitrogenous** (nitrogen-containing) compound called **urea**. This is formed in the liver from excess amino acids (the building blocks of protein) in food. The nitrogenous component of excess amino acids— ammonia—is highly poisonous and cannot be stored. Instead it is combined with carbon dioxide to make less poisonous urea, which can then be excreted. Other excretory substances include drugs and toxins that have been processed by the liver.

The kidney also removes excess water and salts, such as sodium and potassium, from the blood, thereby regulating the volume and salt concentration of blood, and of tissue fluid, regardless of how much water is consumed in food and drink. In addition, the kidney also helps to regulate blood pressure, releases the hormone **erythropoietin**, which stimulates red blood cell production, and activates vitamin D made by the skin when it is exposed to sunlight.

Urine is carried from the kidneys by long tubes called ureters, which pass into the pelvis and open into the posterior surface of the bladder, a hollow storage organ that has walls which are both elastic and muscular. The bladder opens to the outside through the urethra. In females, the urethra is short and opens between the legs in the vulva (*see page 208*); in males the urethra is longer, and passes through the penis and opens at its tip.

KEY

1. Right kidney
2. Calyx
3. Right ureter
4. Bladder (empty)
5. Urethra
6. Urethral opening
7. Left kidney
8. Hilus
9. Renal pelvis
10. Left ureter
11. Position of external sphincter
12. Penis

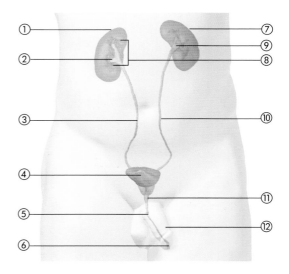

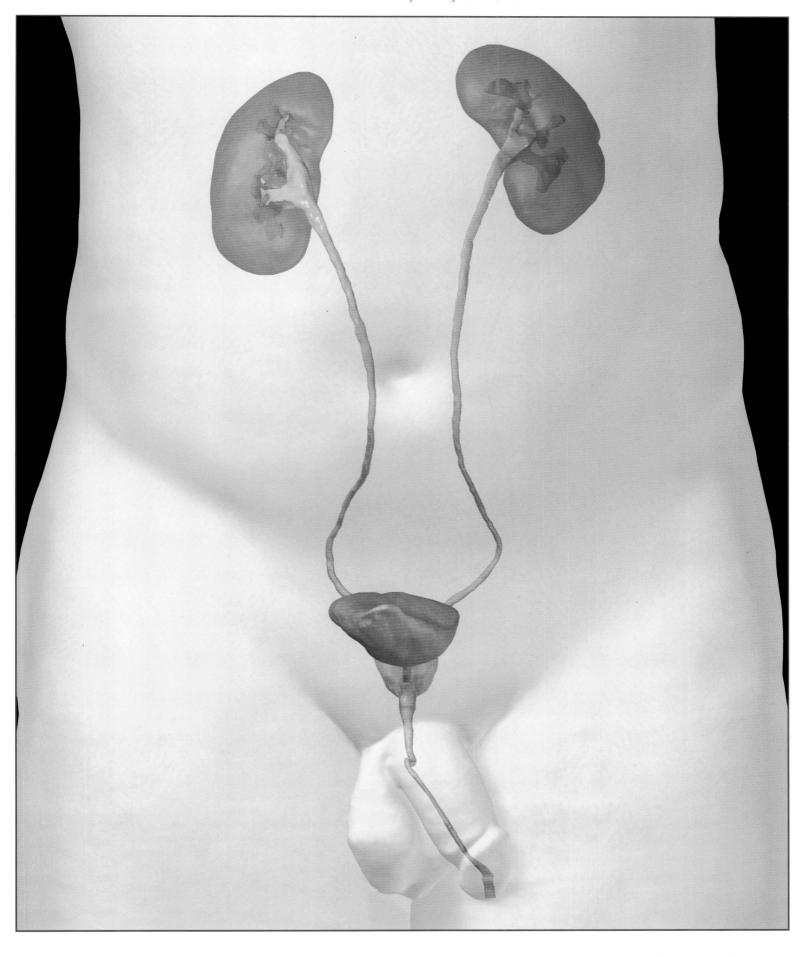

The urinary bladder, which stores waste urine produced by the two kidneys, lies protected within the bony pelvis.

INTERNALLY, THE KIDNEYS ARE DIVIDED INTO THREE ZONES: THE OUTER CORTEX; THE DARKER MEDULLA; AND THE RENAL PELVIS, A FLATTENED, HOLLOW FUNNEL THAT LEADS TO THE URETER.

THE KIDNEYS

KEY

1. Inferior vena cava
2. Common hepatic artery
3. Splenic artery
4. Celiac trunk
5. Superior mesenteric artery
6. Thoracic vertebra
7. Intervertebral disc
8. Abdominal aorta
9. Branches of renal artery and vein inside kidney
10. Left renal artery
11. Left kidney
12. Left renal vein
13. Left ureter

Within the cortex and medulla of each kidney are about a million microscopic units called **nephrons** that filter blood to produce urine. Each nephron has two parts: a **renal tubule** and a **glomerulus**, a mass of blood capillaries. The renal tubule loops between cortex and medulla before joining a common collecting duct that empties into the renal pelvis. High pressure inside the glomerulus forces liquid—the filtrate—out of the blood and into the **glomerular capsule**, the cup-shaped end of the renal tubule. As crude filtrate passes along the tubule, water and salts, and other valuable substances, such as glucose and amino acids, are reabsorbed through the wall of the tubule back

into the bloodstream. Left behind are the unwanted waste products and excess water and salts that form urine, which now flows into the renal pelvis. Each day about 180 liters (50 gallons) of filtrate is produced by the nephrons; most is reabsorbed through the renal tubules. Only about 1.5 liters (3 pints) of fluid leaves the body as urine.

Emptying of the bladder

At the base of the bladder, the muscular bag that stores urine, where it joins the urethra, is the internal urethral sphincter, a ring of muscle that is under involuntary control and which stops urine leaking out. Below this, the pelvic floor muscles form another sphincter muscle—the external urethral sphincter—around the urethra that is under conscious control. The wall of the bladder itself contains three layers of smooth muscle.

About 1 ml (¼ teaspoon) of urine is produced each minute and is pushed down the ureters by **peristaltic** waves into the bladder. When the bladder contains between 300 and 400 ml (10 and 14 fl oz) of urine, the bladder wall stretches, causing sensory receptors to send nerve impulses to the spinal cord. Nerve impulses returning from the spinal cord cause the internal sphincter to open and urine to pass to the top of the urethra. Other messages pass up the spinal cord to the brain and the person feels the need to urinate. The external sphincter is relaxed under conscious control, the bladder wall muscles contract, and urine is forced out of the body along the urethra.

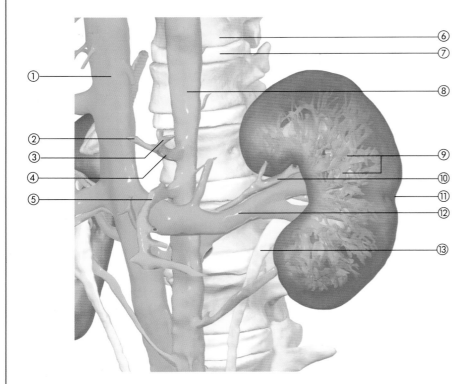

Anterior view of the left upper abdomen showing the left kidney and its blood supply.

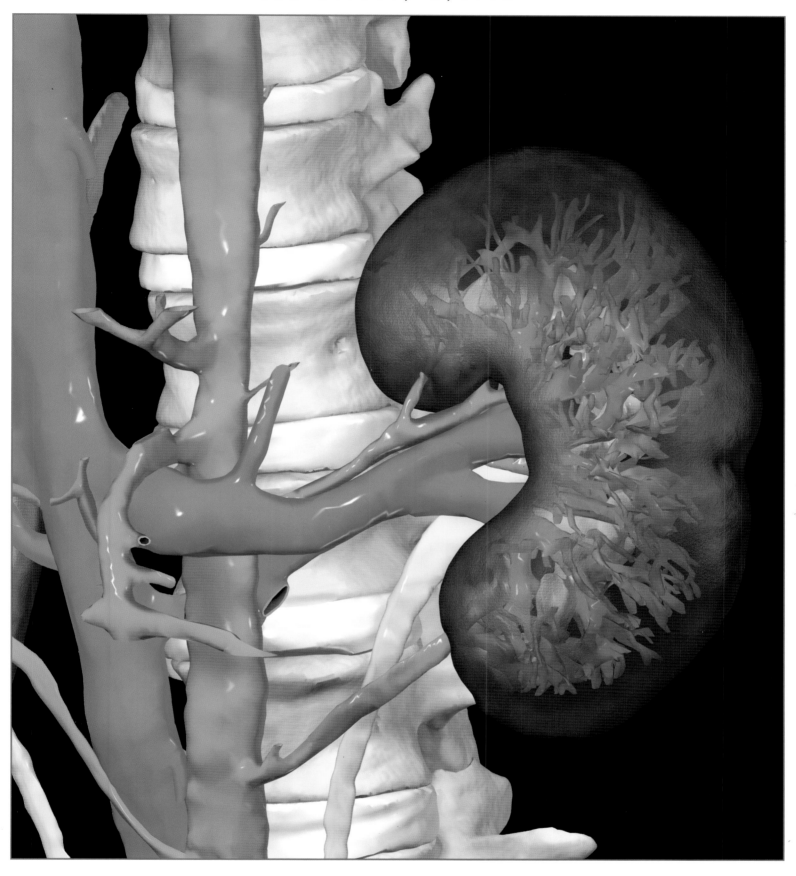

Although each kidney is only around 12 cm (4 in) long, between them they filter the body's entire blood volume approximately 20 times each hour, producing around 1 ml (¼ teaspoon) of urine per minute. These tireless filters process blood for 24 hours each day.

THE REPRODUCTIVE SYSTEM ENABLES HUMANS TO PRODUCE OFFSPRING. UNLIKE OTHER SYSTEMS, MALE AND FEMALE REPRODUCTIVE SYSTEMS ARE DIFFERENT, AND NEITHER STARTS WORKING UNTIL PUBERTY. THE PRIMARY ORGANS OF THE REPRODUCTIVE SYSTEMS —TESTES IN MEN AND OVARIES IN WOMEN—PRODUCE SEX CELLS. FOLLOWING SEXUAL INTERCOURSE, A SPERM (MALE SEX CELL) FUSES WITH AN EGG (FEMALE SEX CELL) INSIDE THE WOMAN DURING FERTILIZATION. THE RESULTING FERTILIZED EGG DEVELOPS INTO A BABY INSIDE THE WOMAN'S UTERUS.

The male reproductive system is designed for the production and subsequent transference of sperm into the female.

THE MALE REPRODUCTIVE SYSTEM

The male reproductive system consists of the testes, the penis (which also forms part of the urinary system), the ducts that connect testes to penis, and the accessory glands. The two testes are oval shaped organs that hang between the legs in the scrotum, a sac of skin and muscle. The sperm they produce are well adapted for their function: to swim in search of an egg in order to fertilize it. They have a streamlined shape, and consist of a head that carries genetic material, and a tail or **flagellum** that enables them to swim. Running along the posterior edge of each testis is the epididymis. Immature sperm from the testis spend 14 to 20 days inside this highly-coiled tube until they reach maturity.

The penis is a tube-shaped organ that facilitates the transfer of sperm into the female's vagina during sexual intercourse. It is held in place by an internal root; externally it consists of a shaft and its expanded tip, the glans. Within the penis are three cylinders of spongy tissue that enable the penis to become erect (*see page 154*). The lower cylinder, the corpus spongiosum, runs

along the underside of the shaft into the glans and surrounds the urethra, the duct that carries both urine and **semen** to the outside. The two upper cylinders, the corpora cavernosa, run in parallel along the upper part of the shaft.

The vas deferens (pl. vasa deferentia) is a duct that carries mature sperm from the epididymis to the urethra, which it joins just below the bladder. Emptying into each vas deferens, just behind the bladder, is a seminal vesicle. This, and the other accessory gland, the chestnut-sized prostate gland, which surrounds the urethra where it leaves the bladder, produce secretions that mix to form semen. Semen carries sperm, activates them, and provides them with "fuel" for their impending journey.

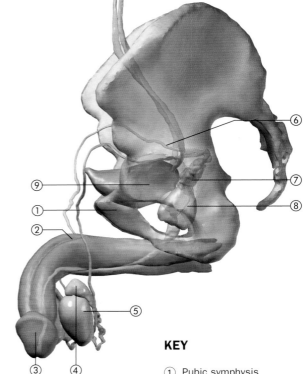

KEY

① Pubic symphysis
② Penis
③ Glans of penis
④ Epididymis
⑤ Testis
⑥ Vas (ductus) deferens
⑦ Seminal vesicle
⑧ Prostate gland
⑨ Urinary bladder

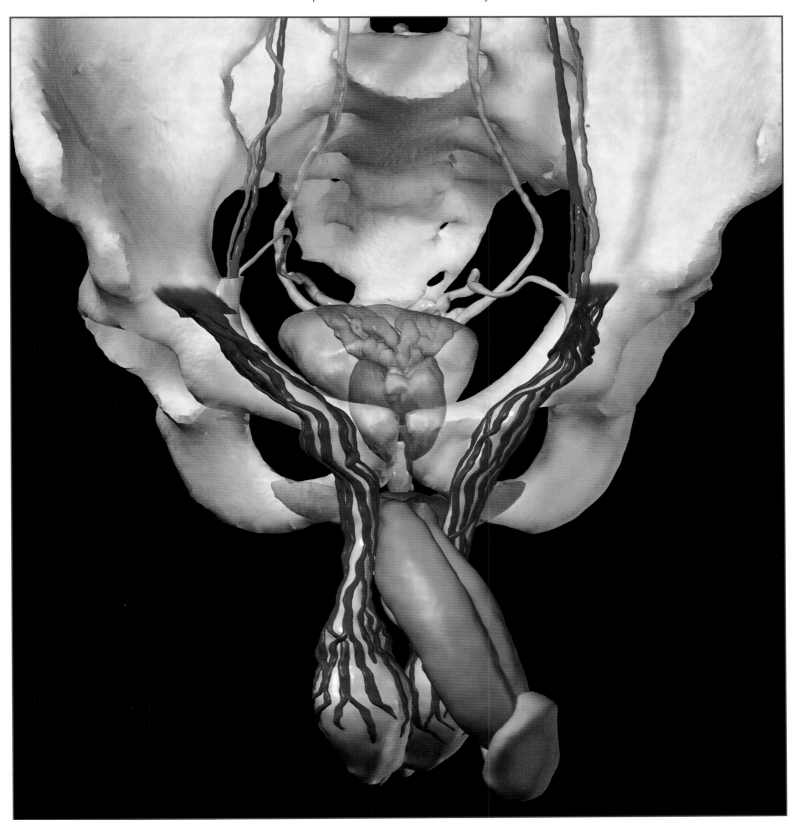

Housed outside the body within the scrotum, the testes are maintained at the ideal temperature for sperm production.

KEY

1. Urinary bladder
2. Seminal vesicle
3. Prostate gland
4. Vas (ductus) deferens
5. Penis
6. Testis
7. Pubic symphysis
8. Glans of penis

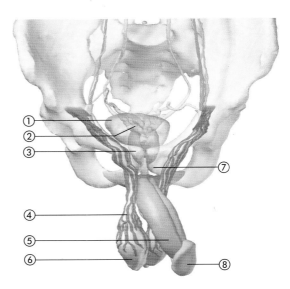

FOR THE MALE REPRODUCTIVE SYSTEM TO FUNCTION THE PENIS MUST BECOME ERECT, SO THAT IT CAN BE INSERTED INTO THE VAGINA, AND **EJACULATION** HAS TO OCCUR. ERECTION STIFFENS AND LENGTHENS THE NORMALLY FLACCID PENIS. IT IS A REFLEX ACTION CONTROLLED BY THE AUTONOMIC NERVOUS SYSTEM (ANS – *see page* 98). DURING SEXUAL AROUSAL, ARTERIOLES SUPPLYING THE PENIS GET WIDER. THE RESULTING INCREASED BLOOD FLOW FILLS SPACES IN THE SPONGY CYLINDERS INSIDE THE SHAFT AND GLANS OF THE PENIS CAUSING IT TO EXPAND AND STIFFEN.

THE MALE REPRODUCTIVE SYSTEM

Like erection, ejaculation is also a reflex action controlled by the ANS. It is triggered when sexual arousal has reached a critical level of excitement, consisting of two phases. In the first phase the vasa deferentia contract to squeeze sperm toward the base of the penis, and the prostate gland and seminal vesicles release their secretions to make semen. At this point the man knows his ejaculation is unstoppable and the second phase begins. Muscles at the base of the penis contract every 0.8 seconds and force semen out of the penis in up to 5 spurts. Altogether about 5 ml (about a teaspoon) of semen is released, containing, on average, approximately 300 million sperm. Following ejaculation the erection is lost.

Sperm production

Being suspended in the scrotum, the temperature of the testes is maintained at some 3°C (5°F) below **core body temperature**. This lower temperature is optimal for sperm production. A healthy, fertile man produces several hundred million sperm daily, between puberty and old age. However, the process of production and maturation for a single sperm takes over 2 months. Sperm are made inside tightly-coiled tubes called seminiferous tubules, of which there are between one and four within the 250 or so compartments, called lobules, in each testis. Sperm-making cells in the walls of the seminiferous tubules divide to produce millions of immature sperm each second. These pass along the seminiferous tubules to the epididymis where they mature. Sperm production is controlled by two pituitary gland hormones: luteinizing hormone (LH) and follicle stimulating hormone (FSH). LH stimulates interstitial cells surrounding the seminiferous tubules to secrete the male sex hormone testosterone; FSH and testosterone stimulate the seminiferous tubules to make sperm.

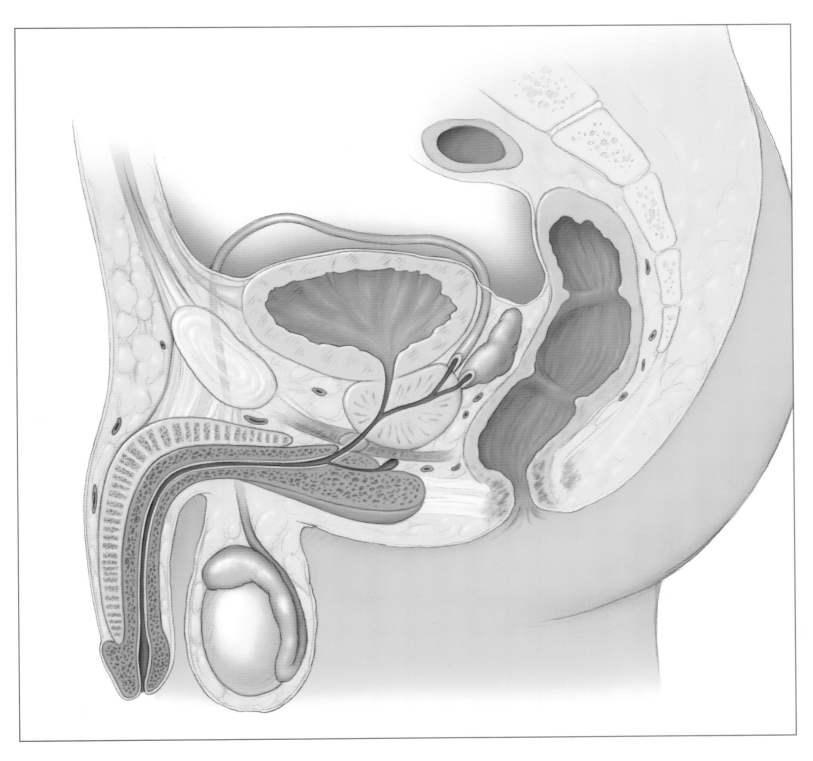

A sagittal section through the male body shows how the vas deferens links the testes, which produce sperm, to the urethra, which opens at the tip of the penis. Emptying into the urethra are the accessory glands—the seminal vesicles, prostate gland, and the bulbourethral gland.

KEY

1. Urinary bladder
2. Pubic symphysis
3. Urethra
4. Corpus cavernosum
5. Corpus spongiosum
6. Penis
7. Glans of penis
8. Vas (ductus) deferens
9. Rectum
10. Seminal vesicle
11. Prostate gland
12. Bulbourethral gland
13. Anus
14. Epididymis
15. Scrotum
16. Testis

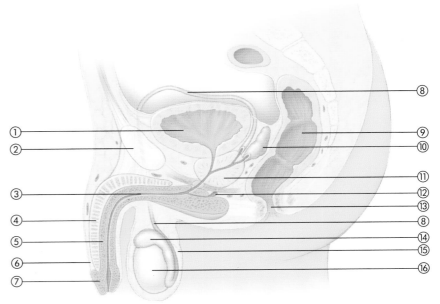

155

THE FEMALE REPRODUCTIVE SYSTEM PRODUCES SEX CELLS, CALLED EGGS OR OVA, AND

PROVIDES THE ENVIRONMENT FOR THE DEVELOPMENT OF A BABY SHOULD AN EGG BE

FERTILIZED BY A SPERM. IN ADDITION TO THE OVARIES, THE PRIMARY SEX ORGANS, THE

OTHER COMPONENTS OF THE FEMALE REPRODUCTIVE SYSTEM ARE THE UTERINE (FALLOPIAN)

TUBES, THE UTERUS, THE VAGINA, AND THE EXTERNAL GENITALS OR VULVA.

THE FEMALE REPRODUCTIVE SYSTEM

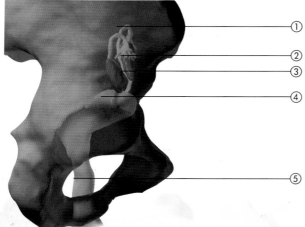

Unlike the male, the female's sex organs are situated entirely within the woman's body.

KEY

1. Fallopian tube
2. Fimbriae
3. Ovary
4. Uterus
5. Vagina

The ovaries

The two ovaries lie on each side of the uterus. Each is part-surrounded by the funnellike opening of a uterine tube that links the ovary to the uterus. At birth, the ovaries already contain a lifetime's supply —up to 2 million—of immature eggs. Between puberty and the menopause, one immature egg matures every month and is released. The ovaries themselves secrete the female sex hormones estrogen and progesterone that control the menstrual cycle (see below), as well as producing and maintaining secondary sexual characteristics such as breasts.

Ovarian and menstrual cycles

A cycle is a sequence of events, which occur in a fixed order, and that repeats itself. Each month, two linked reproductive cycles—the ovarian and menstrual cycles—are responsible, respectively, for the release of an egg from an ovary, and for the

preparation of the uterus to receive the egg should it be fertilized. Both cycles last, on average, for 28 days. The ovarian cycle is controlled by two pituitary gland hormones: luteinizing hormone (LH) and follicle stimulating hormone (FSH). FSH stimulates some follicles (sacs) containing immature eggs to grow and mature. Eventually, one follicle and its egg becomes much larger than the others. In mid-cycle, LH levels rise and cause ovulation: the follicle bursts, releasing its egg into the uterine tube. If the egg is not fertilized, a new ovarian cycle starts 14 days after ovulation.

The menstrual cycle causes a thickening of the endometrium, the lining of the uterus, in readiness to receive the fertilized egg. FSH stimulates the ovary to release estrogen, which stimulates endometrial thickening. Following ovulation, the ovary also secretes progesterone, which with estrogen stimulates further thickening of the endometrium. If fertilization does not happen, progesterone and estrogen levels drop, the endometrium fragments and falls away, and the woman has her period.

During both ovarian and menstrual cycles, as the controlling hormones—FSH, LH, estrogen, and progesterone—interact with each other their levels fluctuate, and these fluctuations control the events of the cycles.

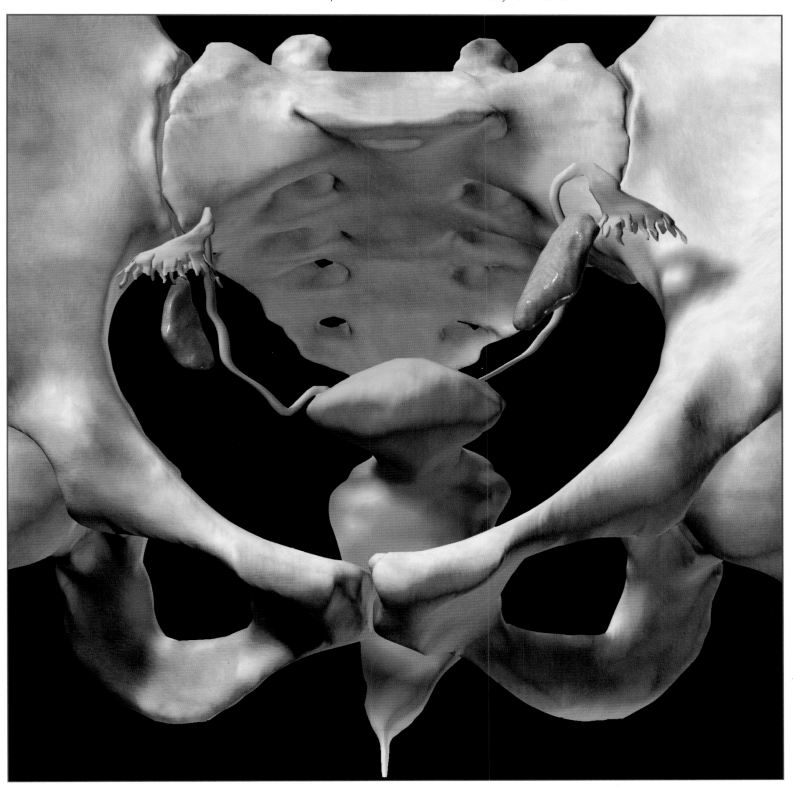

The female organs consist of the two ovaries, situated on either side of the uterus; the fallopian tubes; the cervix; the vagina; and the clitoris (not shown).

KEY

1. Pelvic girdle
2. Fallopian tube
3. Ovary
4. Fimbriae
5. Uterus
6. Cervix
7. Vagina

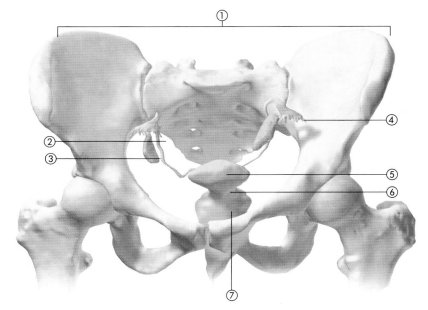

157

W HILE THE OVARIES PRODUCE EGGS, OTHER PARTS OF
THE FEMALE REPRODUCTIVE SYSTEM ARE RESPONSIBLE
FOR MAKING POSSIBLE THE UNION OF SPERM AND EGG,
AND NURTURING AN EGG IF IT IS FERTILIZED.

THE FEMALE REPRODUCTIVE SYSTEM

The uterine (fallopian) tubes receive eggs from the ovaries after ovulation, provide the location for fertilization, and carry the fertilized egg to the uterus. This hollow organ encloses and protects the **fetus** during its development. The wall of the uterus contains a thick layer of smooth muscle, the **myometrium**, that stretches enormously during pregnancy, and which contracts to push the baby out during birth. Lining the uterus is the velvety endometrium in which a fertilized egg embeds itself in order to develop.

The uterus is linked to the vagina by its neck or cervix. The vagina itself is a muscular tube between 8 and 10 cm (3 and 4 in) long that accommodates the penis during sexual intercourse and provides an exit route for discarded endometrium, during menstrual periods, and for the baby during birth.

The external genitals, or vulva, consist of the vaginal lips—the labia majora and minora—that protect the vulva, the vestibule surrounding the opening to the vagina and the urethral opening, and the clitoris. The clitoris is homologous with the penis, and is important in sexual arousal. Although its glans and shaft are much smaller than that of the penis, its internal anatomy—which has only recently been elucidated—is extensive.

The development of male and female external genitals

At six weeks after fertilization, an embryo inside the uterus is no bigger than a grape. At this stage the external genitalia are identical in both sexes. Which way the genitals develop depends on whether the embryo is genetically male—with XY sex chromosomes—or female—with XX chromosomes. In males, the Y chromosome sends out a message instructing testes to develop; as they do so the testes release testosterone, which instructs the external genitals to develop into a penis and scrotum. In the absence of a Y chromosome, a clitoris develops in place of a penis, and labia instead of a scrotum. By 12 weeks after fertilization, sex differences are evident, and at birth the baby is clearly either male or female.

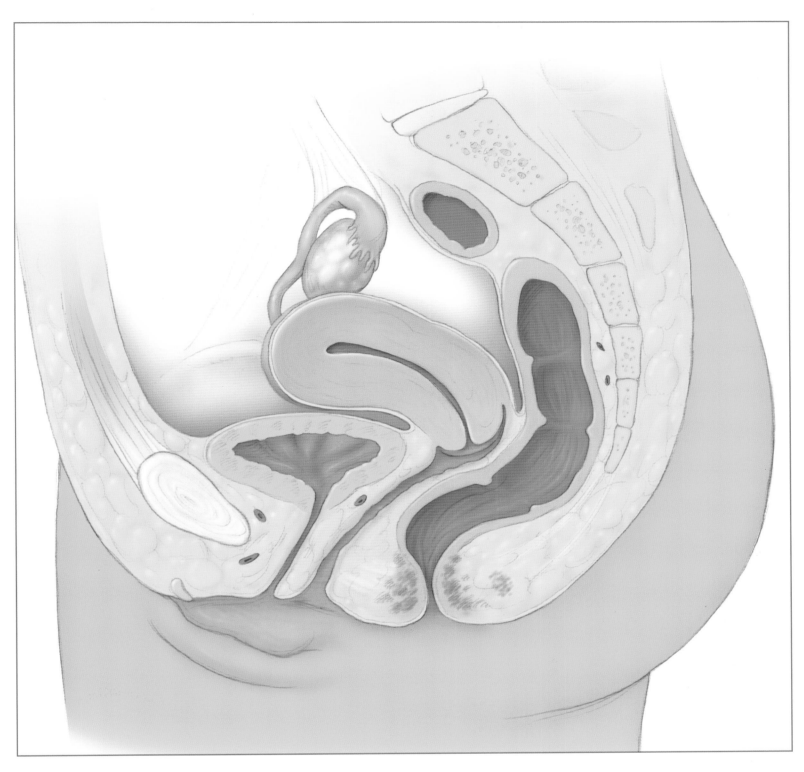

A sagittal section through the female body to show the internal reproductive organs—the ovaries, uterine tubes, uterus, and vagina—and the external genitals, including the clitoris.

KEY

1. Fimbriae
2. Ovary
3. Uterine (fallopian) tube
4. Round ligament of uterus
5. Urinary bladder
6. Pubic symphysis
7. Urethra
8. Clitoris
9. Labium majus
10. Labium minus
11. Vagina
12. Anus
13. Uterus
14. Cervix
15. Rectum

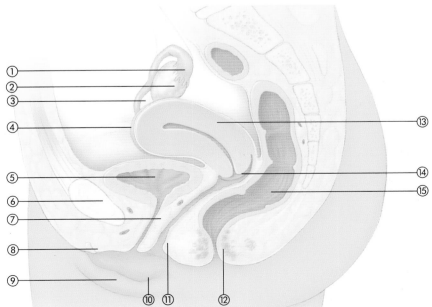

•SECTION TWO•

REGIONAL ANATOMY

THE HEAD HOUSES THE BODY'S CONTROL CENTER AND ITS MAJOR SENSORS. ITS FRAMEWORK IS FORMED BY THE SKULL, WHOSE CRANIAL BONES FORM THE DOMESHAPED CRANIUM THAT SURROUNDS AND PROTECTS THE BRAIN, AND FACIAL BONES, WHICH FORM THE FACE (*see page* 42). AS WELL AS THE BRAIN, THE HEAD ALSO HOUSES THE MAJOR SENSE ORGANS: THE EYES WITHIN BONY SKULL SOCKETS; THE EARS, PROTECTED WITHIN CAVERNS INSIDE THE TEMPORAL BONES; THE TONGUE, INSIDE THE MOUTH; AND THE OLFACTORY (ODOR) SENSORS INSIDE THE NOSE. TWO OPENINGS, THE MOUTH AND NOSE, ALLOW AIR INTO THE BODY, WHILE THE MOUTH ALSO PROVIDES AN ENTRY POINT FOR FOOD AND WATER.

THE HEAD & NECK

The head contains the brain, eyes, and ears and provides openings to the body through the mouth and nose. The neck connects the head to the trunk.

The neck supports the head, enabling it to move, and providing a link between it and the trunk. Supporting the neck are the seven cervical vertebrae—the two uppermost of which permit the head to turn from side to side and nod up and down (*see page 46*). Passing along the conduit formed by the neck are the major blood vessels that supply the head and brain; the trachea, which carries air to and from the lungs (*see page 130*); the esophagus, which carries food to the stomach (*see page 140*); and, protected within a tunnel formed by the cervical vertebrae, the spinal cord, which links the brain to the rest of the nervous system (*see page 96*).

Blood supply to the head and neck

Oxygen-rich blood is supplied to the head and neck by four pairs of arteries that branch directly or indirectly from the aortic arch.

- Right and left common carotid arteries each branch into an external carotid artery, which supplies most tissues of the head except the brain and orbit; and the internal carotid artery, which supplies the orbit and most of the brain.
- The vertebral arteries supply the neck, cerebellum, and part of the cerebrum.
- The thyrocervical trunks and the costocervical trunks supply the neck.

Blood drains from the head and neck along three pairs of veins that empty, usually via other veins, into the superior vena cava.

- The external jugular veins drain blood from the superficial head.
- The internal jugular veins drain blood from the brain.
- The vertebral veins drain blood from the neck.

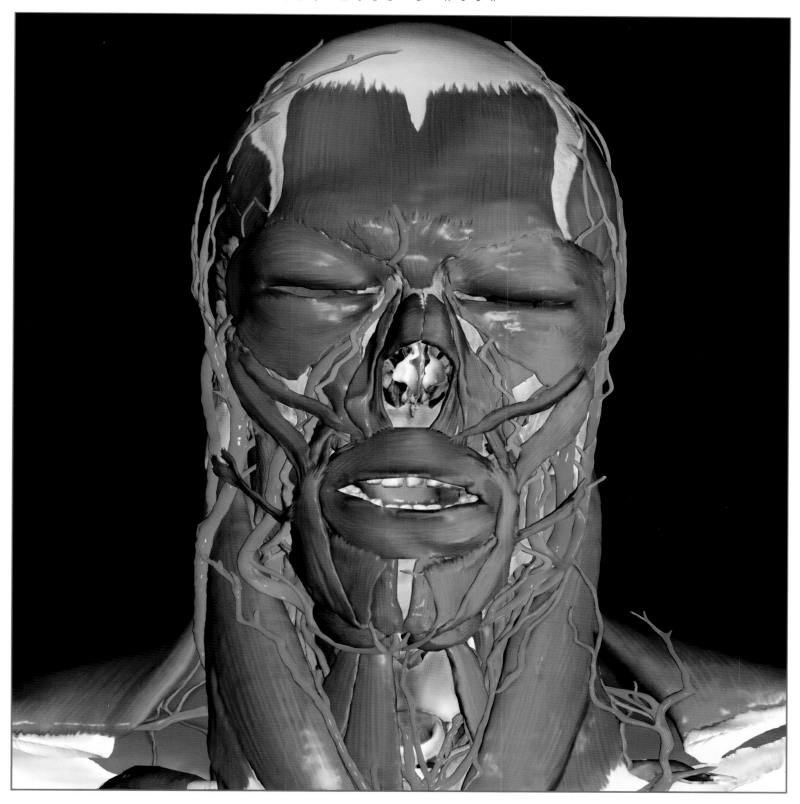

KEY

1. Temporalis
2. Levator labii superioris alaeque nasi
3. Nasal cartilage
4. External jugular vein
5. Facial Vein.
6. Mentalis
7. External carotid artery
8. Sternocleidomastoid
9. Frontalis
10. Orbicularis oculi
11. Levator labii superioris
12. Zygomaticus minor
13. Zygomaticus major
14. Orbicularis oris
15. Depressor anguli oris
16. Depressor labii inferioris
17. Sternohyoid
18. Larynx

Anterior view of the head and neck showing the superficial muscles and blood vessels. The facial muscles produce facial expressions while those of the neck either move the head or are involved in swallowing. The blood vessels supply the muscles, sense organs, and the brain.

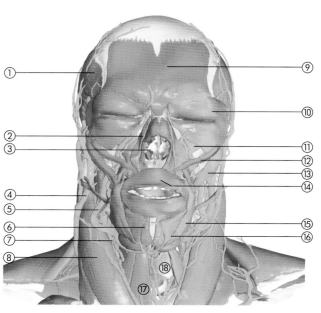

S EVERAL GROUPS OF MUSCLES ARE RESPONSIBLE FOR THE

MOVEMENTS OF THE HEAD AND NECK. MOST OF THESE

MUSCLES ARE CONTROLLED BY NERVE IMPULSES CARRIED BY

CRANIAL NERVES (*see page* 94).

THE HEAD & NECK

Anterolateral view of the skull and neck from the right side with the muscles and blood vessels removed.

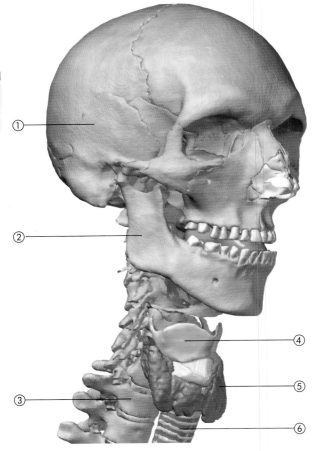

KEY

1. Cranium
2. Mandible
3. Vertebral column
4. Larynx
5. Thyroid gland
6. Trachea

including the masseter and temporalis, pull the jaw upward. Other smaller muscles move the jaw from side to side.

- The extrinsic muscles of the tongue (*see below*) protract and retract the tongue.
- The muscles of the front of the neck are mostly involved in swallowing.
- The sternocleidomastoid muscles flex the head and tilt it to the side.
- The muscles at the back of the neck extend the head and support it.

The tongue

This pink, muscular organ has a variety of functions relating to digestion, taste, and speech. The bulk of the tongue is made up of skeletal muscle. Extrinsic muscles attached to the mandible and hyoid bone change the position of the tongue, protruding it, retracting it, and moving it from side to side. Intrinsic muscles, which are not attached to bone, change the shape of the tongue, making it thicker or thinner. Tongue movements mix food with saliva during chewing, and push chewed food into the throat to initiate swallowing. Changes in tongue position also help convert raw sounds into understandable speech.

The upper surface of the tongue is covered by tiny protuberances, called **papillae**, of which there are three types. Numerous pointed **filiform papillae**, give the tongue a roughness that helps it grip food. Mushroom-shaped **fungiform papillae**, and the large **circumvallate papillae** at the rear of the mouth, house the taste buds. These contain sensory chemoreceptors that detect four basic tastes—sweet, salt, sour, and bitter—in food that has dissolved in saliva, and send nerve impulses to the gustatory (taste) areas of the cerebral hemispheres.

- Superficial muscles of the scalp, such as the frontalis, and of the face, such as the zygomaticus major, are responsible for producing the wide range of facial expressions that are so important in human communication. These muscles are unusual in that they insert into, and pull, the skin.
- The extrinsic eye muscles (*see page 170*) move each eyeball in its socket.
- Four pairs of mastication (chewing) muscles,

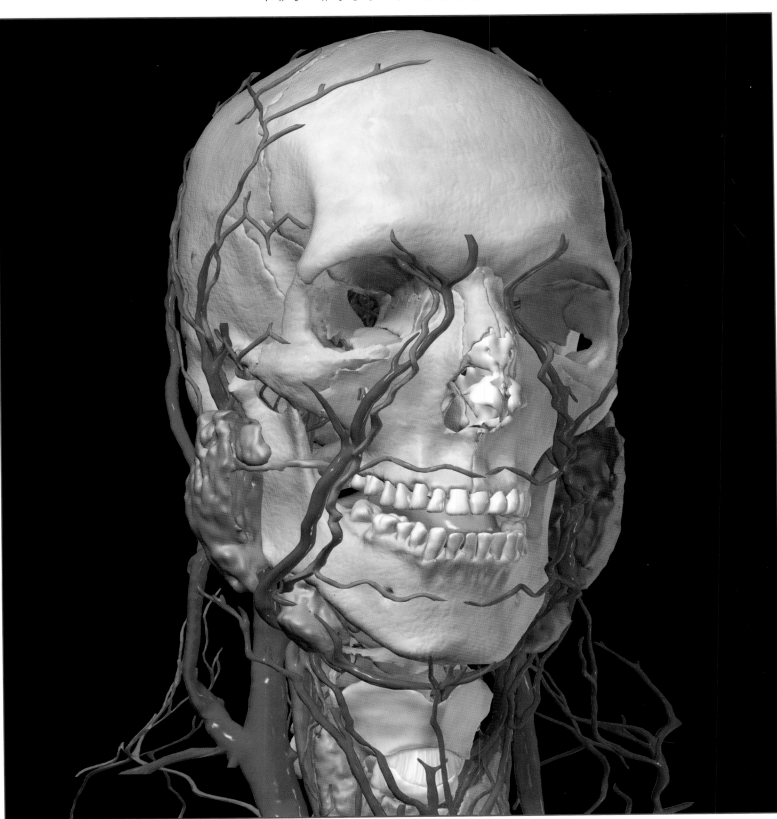

Anterolateral view of the head and neck from the right side with the muscles removed showing the major blood vessels.

KEY

1. Parietal bone
2. Sphenoid bone
3. Superficial temporal artery
4. Zygomatic bone
5. Retromandibular vein
6. Posterior auricular vein
7. Parotid gland
8. Facial artery
9. Internal carotid artery
10. Submandibular gland
11. Internal jugular vein
12. External jugular vein
13. Common carotid artery
14. Frontal bone
15. Nasal bone
16. Maxilla
17. Tongue
18. Mandible
19. Larynx
20. Thyroid gland

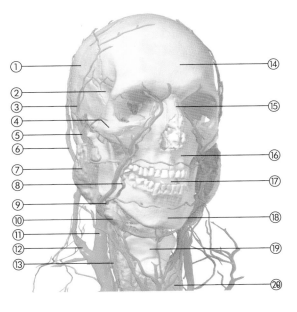

THE BRAIN ENABLES PEOPLE TO FEEL, THINK, AND MOVE, AS WELL AS AUTOMATICALLY REGULATING MOST OF THE ACTIVITIES THAT GO ON INSIDE THE BODY. ITS LARGEST PART IS THE CEREBRUM, THE SEAT OF PERCEPTION AND CONSCIOUS BEHAVIOR. IN HUMANS, THE CEREBRUM IS VERY LARGE, AND ITS SIZE HAS INCREASED WITH GREAT RAPIDITY DURING THE COMPARATIVELY BRIEF PERIOD OF HUMAN EVOLUTION. THE CEREBRUM HAS TWO HALVES, OR HEMISPHERES,

THE BRAIN

EACH OF WHICH IS COVERED BY A THIN LAYER CALLED THE CEREBRAL CORTEX. DESPITE ITS THINNESS, THE CORTEX IS THE SITE OF ALL ELEMENTS OF CONSCIOUSNESS. THE WALNUTLIKE SURFACE APPEARANCE OF THE BRAIN IS DUE TO ITS BEING FOLDED INTO **SULCI** (FOLDS) AND **GYRI** (BULGES). THIS MEANS THAT A LARGE SURFACE AREA OF CORTEX CAN BE SQUEEZED INTO THE LIMITED SPACE WITHIN THE SKULL. THE CORTEX OF EACH HEMISPHERE HAS FOUR LOBES: THE OCCIPITAL LOBE DEALS MAINLY WITH VISION; THE TEMPORAL LOBE IS INVOLVED WITH SOUND AND SPEECH; THE PARIETAL LOBE IS CONCERNED WITH MOVEMENT, TOUCH, AND RECOGNITION; AND THE FRONTAL LOBE DEALS WITH THINKING AND PLANNING.

Linking the two cerebral hemispheres is a band of nervous tissue, called the corpus callosum, which permits the constant exchange of information between the two halves. Posterior to the cerebrum is the cerebellum, a "mini-brain" that controls movement and balance. In the space below the corpus callosum are the components of the limbic system, a more primitive system in evolutionary terms. The limbic system generates emotions, and passes on information to the cerebral cortex; parts of

it are also involved in memory and in maintaining homeostasis. The brainstem, the most primitive part of the brain, serves to relay information between brain and spinal cord, and regulates basic functions such as heart rate and breathing rate.

Protection and cushioning of the brain

Brain tissue is soft and delicate and requires protection. Apart from the body covering provided by the skull, the brain is also surrounded and protected by three connective tissue membranes or **meninges**: the dura mater, the arachnoid mater, and, innermost, the pia mater. Beneath the arachnoid mater is a wide space that is filled with cerebrospinal fluid. This fluid forms a liquid cushion that reduces the weight of the brain and protects it from knocks and jolts. Derived from blood plasma, cerebrospinal fluid also helps to nourish the brain.

Lateral view of the brain from the right side with the grey matter (cerebral cortex) removed from the cerebellum.

KEY

① White matter of right cerebral hemisphere
② Cerebellum
③ Pons
④ Medulla oblongata

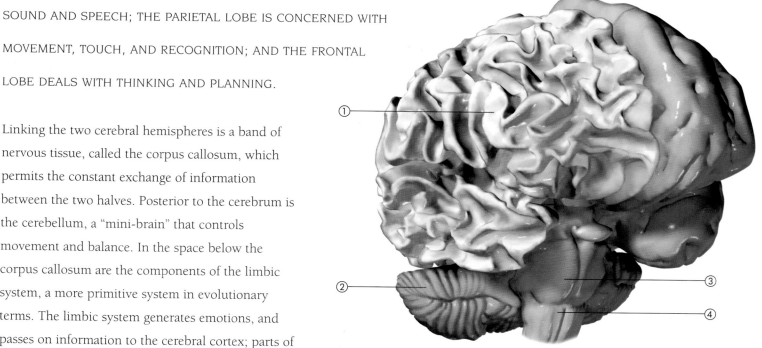

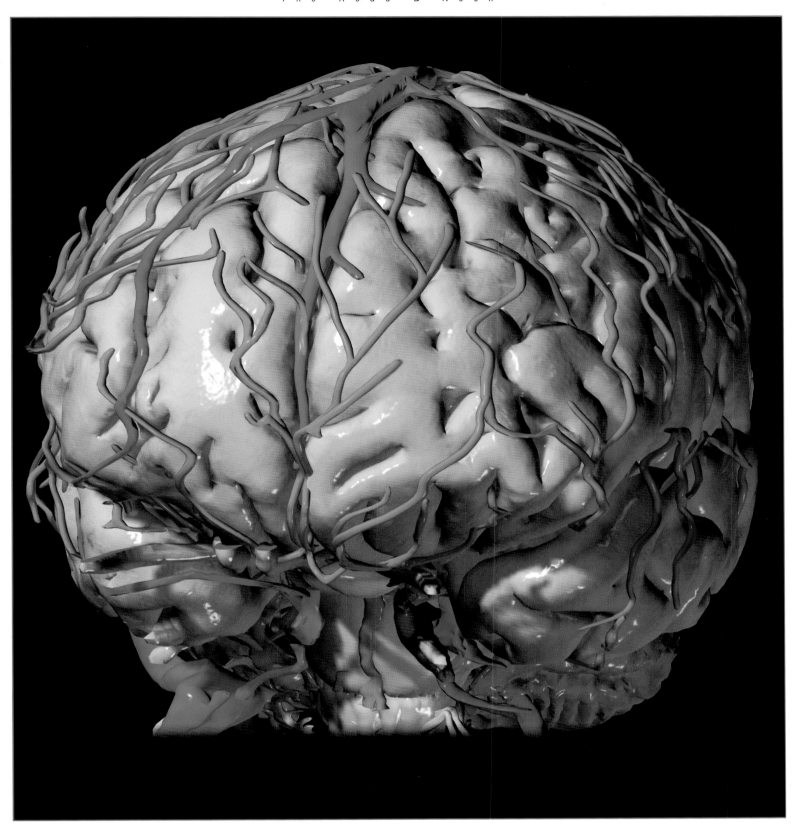

Anterolateral view of the brain from the left side showing the cerebral hemispheres, brainstem and cerebellum.

KEY

1. Superior sagittal sinus
2. Right cerebral hemisphere
3. Pituitary gland
4. Pons
5. Medulla oblongata
6. Left cerebral hemisphere
7. Cerebellum

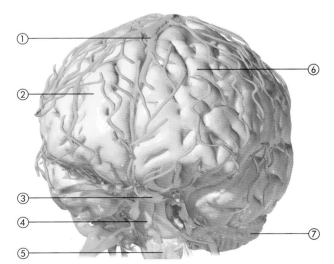

THE BRAIN STEM, WHICH LINKS THE SPINAL CORD TO THE
THALAMUS, HYPOTHALAMUS, AND OTHER PARTS OF THE BRAIN,
IS RESPONSIBLE FOR REGULATING AND CONTROLLING A
NUMBER OF BODY FUNCTIONS. ITS ACTIVITIES PROCEED WITHOUT
CONSCIOUS AWARENESS. IT CONSISTS OF THE MEDULLA OBLONGATA, ITS
MOST INFERIOR PART, WHICH IS CONTINUOUS WITH THE SPINAL CORD; THE
PONS, WHICH LINKS THE MEDULLA TO OTHER PARTS OF THE BRAIN; AND
THE MIDBRAIN, THE UPPERMOST PART. THE MEDULLA OBLONGATA

THE BRAIN

CONTROLS HEART AND BREATHING RATES, AS WELL AS OTHER ACTIVITIES
INCLUDING SWALLOWING, SNEEZING AND COUGHING. THE PONS WORKS
WITH THE MEDULLA TO CONTROL BREATHING RATES, AND IT ALSO GIVES
RISE TO SEVERAL CRANIAL NERVES THAT CONTROL FACIAL FUNCTIONS,
SUCH AS CHEWING AND MOVEMENT OF THE EYEBALLS. THE MIDBRAIN
CONTAINS THE SUBSTANTIA NIGRA, WHICH CONTROLS SUBCONSCIOUS
MUSCLE ACTIVITIES; IT ALSO CONTROLS PUPIL SIZE AND LENS SHAPE IN
THE EYE, AND SOME EYE MOVEMENTS.

The limbic system

A number of brain components—known collectively as the limbic system—encircle the brain stem close to the inner border of the cerebrum. These components include the hippocampus, the amygdala, the hypothalamus, and part of the thalamus and the fornix, which links these parts together. The limbic system is the "emotional brain", which deals with basic emotions such as fear, pain, pleasure, anger, sorrow, sexual excitement, and affection. It interacts closely with the cerebral cortex to produce a close relationship between feelings and thoughts; this interaction provides a conscious awareness of emotions and also enables us to control and limit the effects of basic and primitive emotional responses, and not express them under inappropriate circumstances. The hippocampus and amygdala also play a part in memory by converting new information into long-term memories. The hypothalamus, as well as playing a part in sexual arousal, also monitors and regulates many aspects of homeostasis including temperature control and hunger.

Anterolateral view from the right side of the basal nuclei— caudate nucleus and lentiform nucleus— that play a vital role in controlling movement and parts of the limbic system.

KEY

1. Fornix
2. Corona radiata
3. Tail of caudate nucleus
4. Hippocampus
5. Corpus striatum
6. Caudate nucleus
7. Putamen (lentiform nucleus)
8. Amygdala

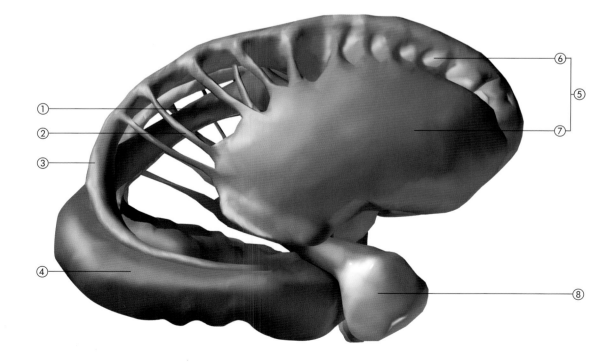

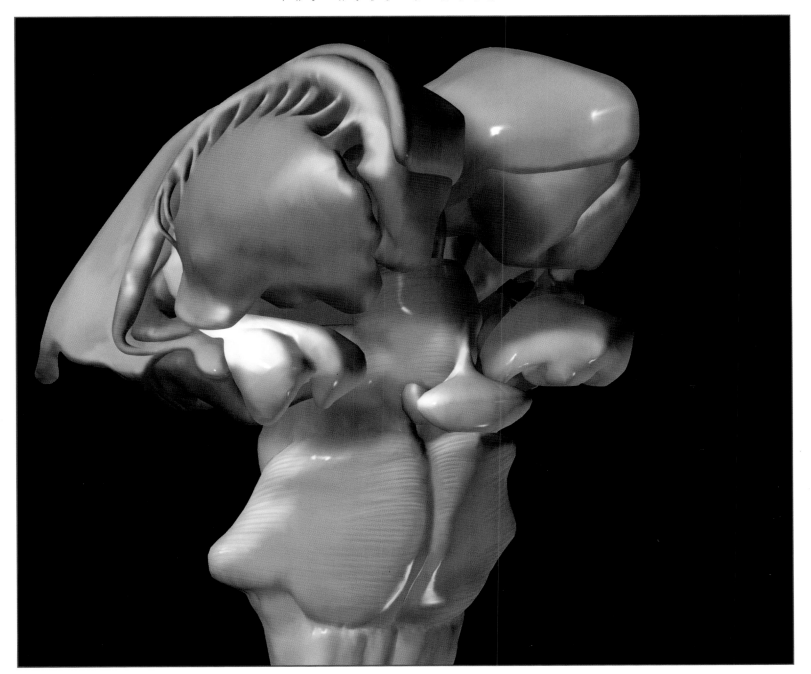

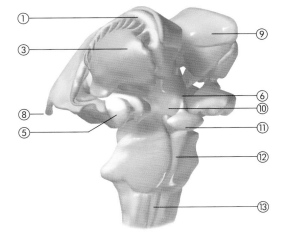

KEY

1. Caudate nucleus
2. Fornix
3. Putamen (lentiform nucleus)
4. Hippocampus
5. Amygdala
6. Thalamus
7. Mammillary bodies
8. Lateral ventricle (posterior horn)
9. Lateral ventricle (anterior horn)
10. Hypothalamus
11. Pituitary gland
12. Pons
13. Medulla oblongata

Anterolateral view from the right side of the corpus striatum and parts of the limbic system (top), and with the ventricles and brainstem (above).

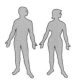

THE EYES ARE SENSE ORGANS THAT DETECT LIGHT. THE VISUAL INFORMATION THAT THEY GATHER IS ANALYZED BY THE BRAIN IN ORDER TO PROVIDE A CONSTANTLY UPDATED VIEW OF THE OUTSIDE WORLD. EACH SPHERICAL EYEBALL LIES PROTECTED WITHIN ITS ORBIT, A BONY SOCKET IN THE SKULL. EXTERNALLY, THE EYEBROWS PROTECT THE DELICATE SURFACE OF THE EYE FROM DRIPPING SWEAT AND EXCESS LIGHT, WHILE THE EYELASHES ENSURE THE REFLEX CLOSURE OF THE EYELIDS IF THEY ARE STIMULATED BY A GUST OF WIND OR IF THEY ARE TOUCHED.

THE EYE

Lateral view of the right eye showing the extrinsic muscles that move the eyeball and the optic nerve that conveys impulses from the eye to the visual areas of the brain.

KEY

1. Superior rectus muscle
2. Optic nerve
3. Lateral rectus muscle
4. Inferior rectus muscle
5. Inferior oblique muscle
6. Lacrimal gland

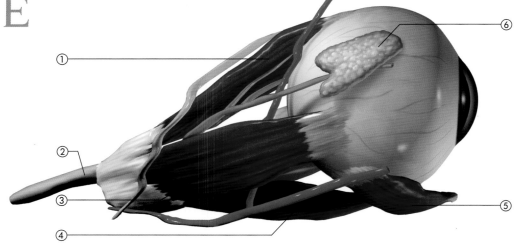

Lacrimal glands

Lacrimal glands, which lie within the orbit above the lateral end of each eye, continuously secrete a liquid known familiarly as tears. This dilute saline solution bathes the cornea and the conjunctiva—the thin membrane covering the rest of the front of the eye and the lining of the eyelids—so that the eyeball remains moist and lubricated. Tears also wash away dust particles, and contain an antibacterial substance called lysozyme. Released from the lacrimal glands through ducts, tears are swept across the eyeball every time blinking occurs. Tears drain from the eye through two medial openings, called lacrimal puncta, into paired lacrimal ducts, which drain into the nasal cavity through the nasolacrimal duct.

Extrinsic eye muscles

Each eyeball is moved by six extrinsic (external) muscles—four rectus muscles and two oblique muscles—that have their origins in the orbit and insert into the sclera of the eyeball. The rectus muscles, arranged at right angles to each other, move the eyeball up and down, and from side to side. The function of each is indicated by its name: the superior rectus (upward), inferior rectus (downward), lateral rectus (to the side), and medial rectus (towards the nose). The oblique muscles move the eyeball diagonally. The inferior oblique pulls the eyeball upward and laterally. The superior oblique, which inserts via a pulley-like loop of cartilage called the trochlea, swivels the eyeball downward and laterally. The eye muscles produce two types of movements: scanning movements enable the eye to follow moving objects even when the head is moving; saccades are short, jerky movements that allow the eye to scan the visual field rapidly when the head is still.

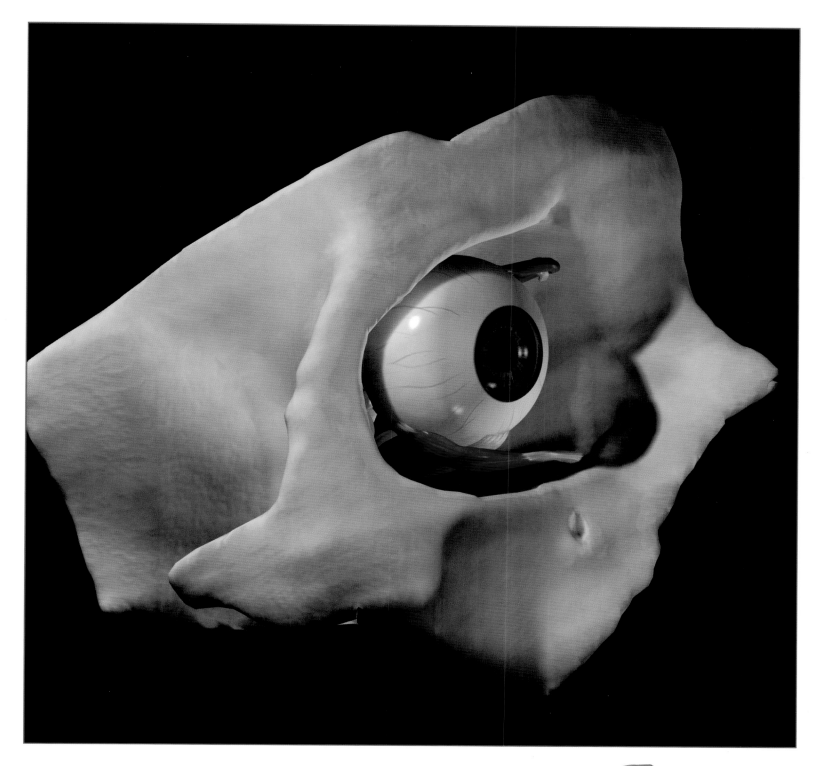

Anterolateral view of the right eye from the right side with the facial muscles removed. The eye is protected by the bony orbit.

KEY

1. Frontal bone
2. Sclera
3. Sphenoid bone
4. Temporal bone
5. Cornea
6. Nasal bone
7. Orbit
8. Maxilla
9. Infraorbital foramen
10. Zygomatic bone

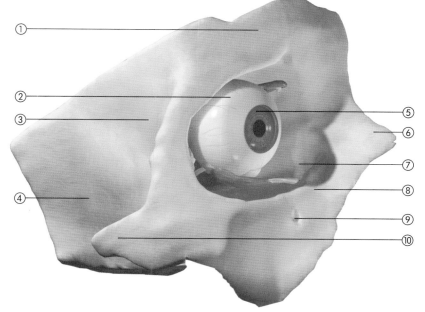

THE EYE HAS TO FUNCTION EFFICIENTLY AS A LIGHT SENSOR OVER A WIDE RANGE OF
DIFFERENT LIGHT INTENSITIES. THE COLORED PART OF THE EYE, THE IRIS, CHANGES THE
SIZE OF THE PUPIL, THEREBY CONTROLLING THE AMOUNT OF LIGHT ENTERING THE EYE.
THE IRIS HAS RADIALLY AND CIRCULARLY ARRANGED SMOOTH MUSCLE FIBERS. A REFLEX ACTION
ENSURES THAT, IN DIM LIGHT, THE RADIAL FIBERS CONTRACT, AND THE PUPIL DILATES (WIDENS); IN
BRIGHT LIGHT, THE CIRCULAR FIBERS CONTRACT, AND THE PUPIL CONSTRICTS (SHRINKS).

THE EYE

KEY

1. Eyeball
2. Inferior oblique muscle
3. Lateral rectus
4. Optic nerve
5. Trochlea of the superior oblique muscle
6. Superior oblique muscle
7. Medial rectus
8. Superior rectus

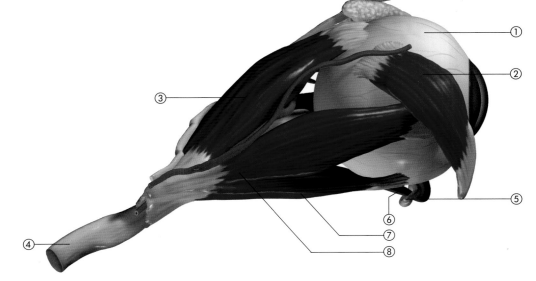

Inferior view of the right eye showing the extrinsic muscles that are inserted into the bony orbit and which move the eyeball.

How light is focused on the retina

During their passage through the eye, light rays are refracted, or bent, in order to focus them on the retina and produce a clear image. Light is focused by the cornea and lens. The cornea, the transparent zone at the front of the eye, provides most light **refraction** but its refractory powers are unchanging. The fine tuning required to focus light from objects regardless of whether they are near or distant is provided by the lens. This **biconvex**, transparent, elastic structure lies just behind the iris suspended by a ring-shaped suspensory ligament that links the lens to the ciliary body. Within the ciliary body is a circular mass of smooth muscle, the ciliary muscle. To focus light from distant objects, the ciliary muscle relaxes and the suspensory ligament is pulled taut, making the lens thinner. To focus light from near objects, the ciliary muscle contracts, the suspensory ligament becomes slack, and the lens recoils and gets fatter.

Rods and cones

Internally, the back of the eye is lined by the retina, a thin layer of about 130 million **photoreceptors**— cells sensitive to light—that fire off impulses along the optic nerve to the brain when they are stimulated. There are two types of photoreceptors: the majority are **rods**, which work best in dim light, generate **monochrome** images, and provide **peripheral vision**; the remainder are called **cones**, photoreceptors that work best in bright light, provide color vision, and which are mostly concentrated in a small area—the **macula lutea**— directly behind the lens.

Impulses from photoreceptors travel along nerve fibers in the optic nerve to the visual cortex at the back of each cerebral hemisphere. Here, different areas process different features—such as color, shape, size, distance, and movement—in order to produce an image.

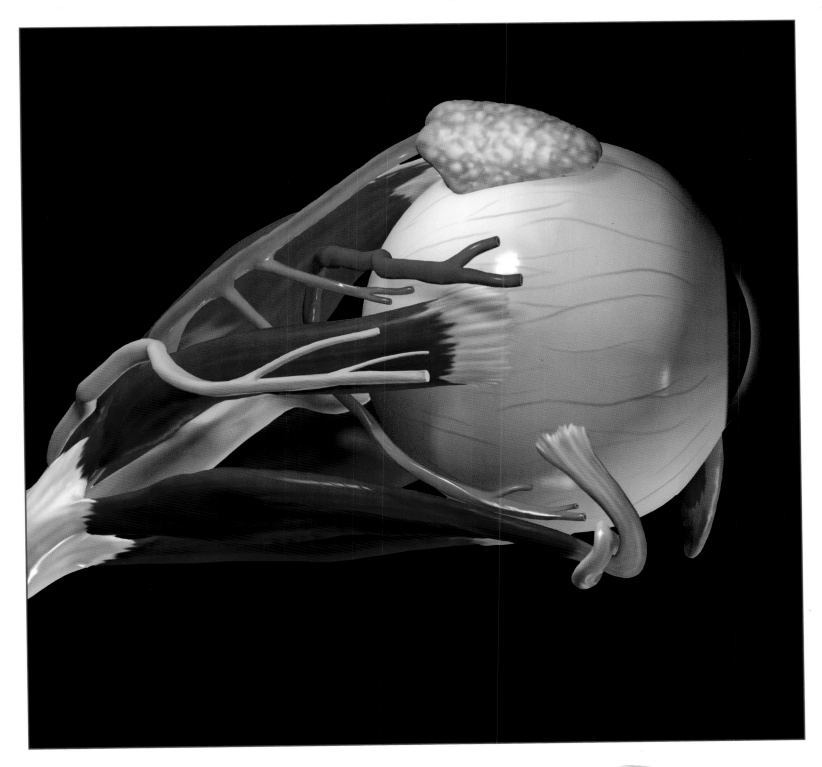

KEY

1. Optic nerve
2. Superior rectus
3. Lateral rectus
4. Medial rectus
5. Superior oblique muscle
6. Trochlea of the superior oblique muscle
7. Eyeball

Superior view of the right eye showing the extrinsic muscles and the optic nerve.

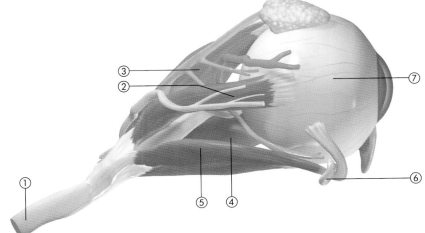

Most of the ear lies hidden within the temporal bone of the skull (*see page* 45). When incoming sound waves arrive from an external source they are directed into the auditory canal by the pinna or ear flap. When they reach the end of the auditory canal they make the eardrum, the taut skin stretched over the end of the canal, vibrate. This, in turn, sets up vibrations in the three tiny ossicles that traverse the air-filled middle ear. The ossicles

THE EAR

move back and forth as they vibrate, and the innermost, the stirrup (stapes), acts like a piston pushing the oval window—the boundary between middle and inner ears—in and out. This movement sets up vibrations in the fluid of the inner ear, and these vibrations are detected by hair cells in the **ORGAN OF CORTI**, part of the coiled, tubular cochlea. If these cells are stimulated—by having their projecting hairs distorted by vibrations—they send nerve impulses to the auditory area of the cortex, along the cochlear part of the vestibulocochlear nerve (*see page* 94) where they are interpreted as sounds.

The ear as an organ of balance

As well as detecting sounds, the ear also supplies the brain with information about the body's position. This is used to achieve balance or equilibrium when moving or standing still. At the base of each of the three fluid-filled semicircular canals in the inner ear is a small swelling called an **ampulla**. This contains sensory hairs embedded in a jellylike cupula. When the head moves, the fluid moves in the opposite direction and deflects the **cupula**, resulting in the hair cells, to which sensory hairs are attached, sending nerve impulses to the brain. Since the three semicircular canals are set at right angles to each other, the brain is aware of head movements in any direction. In the **vestibule** there are two further balance detectors, the **utricle** and **saccule**. These contain sensory hairs embedded in a jelly that is "weighed down" with crystals of calcium carbonate. The saccule detects whether the head is upright, tilted or upside down, and the utricle detects linear acceleration and deceleration. The brain combines the information obtained from these sensors with information from the eyes, feet, and muscles to ensure that balance is maintained.

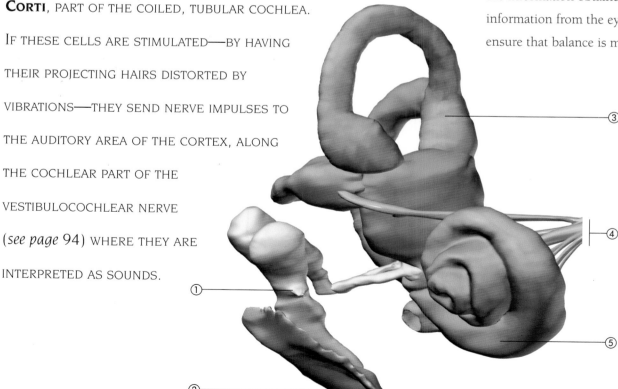

Lateral view of the right ear with skin and muscles removed but showing part of the pinna.

KEY

① Ossicles
② Tympanum (eardrum)
③ Semicircular canal
④ Vestibulocochlear nerve
⑤ Cochlea

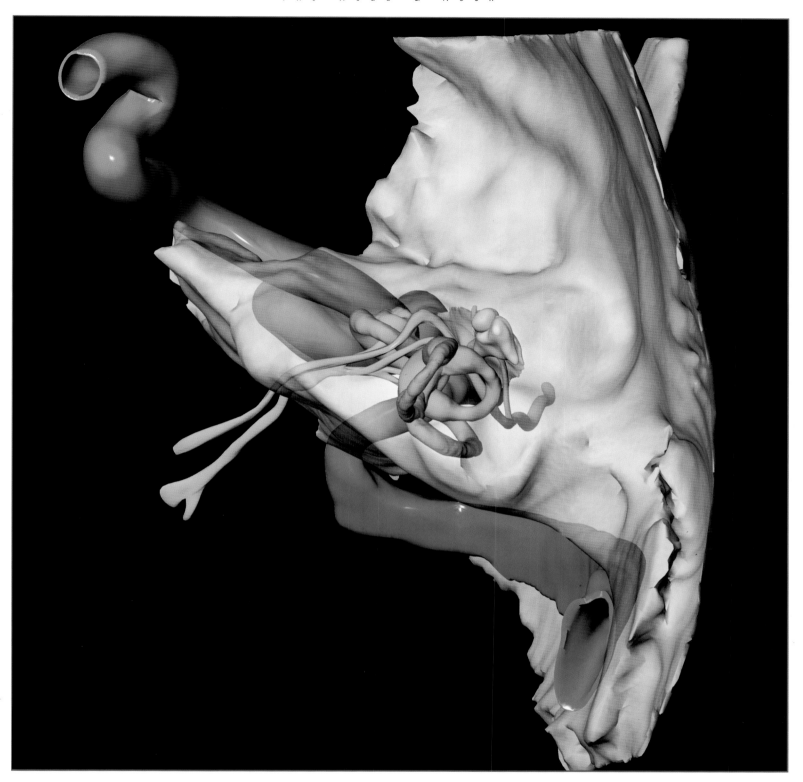

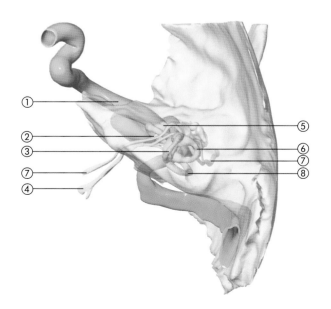

Anterolateral view of the internal part of the right ear from the right side.

KEY

① Internal carotid artery

② Cochlear nerve

③ Posterior semicircular canal

④ Vestibulocochlear nerve

⑤ Cochlea

⑥ Anterior semicircular canal

⑦ Facial nerve

⑧ Lateral semicircular canal

⑨ Incus

⑩ Stapes

⑪ Malleus

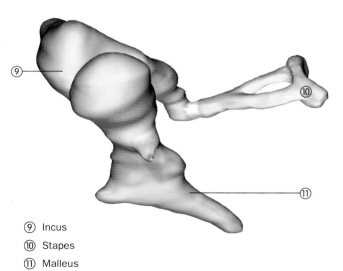

THE CENTRAL PART OF THE BODY—THE TRUNK OR TORSO—IS DIVIDED INTO TWO REGIONS: THE UPPER THORAX AND, BELOW IT, THE ABDOMEN. INTERNALLY, THESE DIVISIONS ARE REFLECTED BY TWO MAJOR CLOSED BODY CAVITIES: THE THORACIC CAVITY AND THE ABDOMINOPELVIC CAVITY. BOTH ARE CONFINED SPACES THAT CONTAIN ORGANS, REFERRED TO COLLECTIVELY AS **VISCERA**. LINING THE WALL OF EACH CAVITY AND THE SURFACE OF THE VISCERAL ORGANS IS A THIN SLIPPERY MEMBRANE, CALLED THE SEROUS MEMBRANE. WHEN THE ORGANS MOVE, THEREFORE, THEY SLIDE OVER EACH OTHER WITHOUT CAUSING ANY PAIN.

THE THORAX

Posterior view of the thorax shows the superficial muscles that cover its back wall. Beneath them the twelve ribs articulate with the vertebral column. Deeper muscles pull on the vertebral column to support the trunk.

The thorax, or chest, extends from the neck to the abdomen, from which it is separated by the diaphragm. External surface markings of the thorax include the outlines of the pectoralis major muscles, the ribs, and the **nipples**. The nipples are small and rudimentary in men, but larger in women, forming part of the breasts that surround the **mammary glands**, which lie over the pectoralis major muscles.

Forming the wall of the thorax are the ribs, costal cartilages, and sternum (*see page 48*); the 12 thoracic vertebrae in the backbone (*see page 46*); and the thoracic and intercostal muscles lying between the ribs (*see page 70*). As well as underpinning the structure of the thorax, these bones and muscles also protect the chest's organs.

The anterior thorax includes several major superficial muscles. The pectoralis major has its origins in the clavicle, sternum, and ribs, and its insertion in the humerus (*see page 70*). It pulls the arms forward and toward the body. Both the serratus anterior and the pectoralis minor have their origins on the ribs and insertion in the scapula. The "sawtooth" serratus anterior pulls the scapula outward and lifts the shoulder, while the pectoralis minor stabilizes and depresses the shoulder.

The deep muscles of the anterior thorax—the intercostal and the diaphragm (*see page 132*) play a vital role in producing breathing movements. The intercostals are short muscles that extend from the inferior border of one rib to the superior border of the rib below it. The external intercostals contract to pull the rib cage upward and outward during inhalation. The internal intercostals, which lie below and at 90° to the external intercostals, contract to pull the ribcage downward and inward during forced exhalation.

KEY

1. Scapula
2. Humerus
3. Latissimus dorsi
4. Trapezius
5. Infraspinatus
6. Teres major
7. Rhomboideus
8. Erector spinae

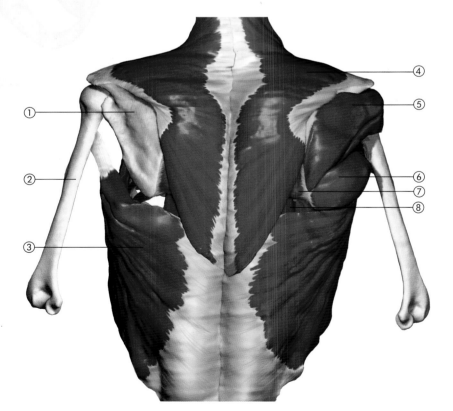

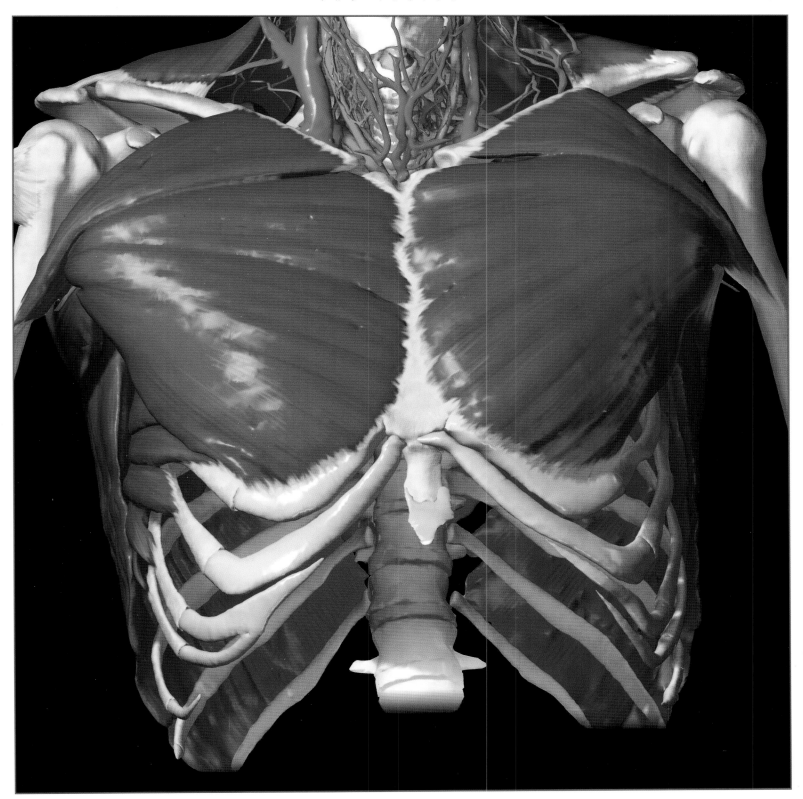

KEY

1. Clavicle
2. Sternum
3. Serratus anterior
4. Latissimus dorsi
5. Thoracic vertebra (12th)
6. Scapula
7. Trachea
8. Humerus
9. Pectoralis major
10. Rib (6th)
11. Costal cartilage

Anterior view of the thorax showing the ribcage, which surrounds and protects the lungs and heart, and the large pectoral muscles, which are the prime movers of arm flexion. The trachea, the duct which carries air into the lungs, is kept open by reinforcing C-shaped rings of cartilage.

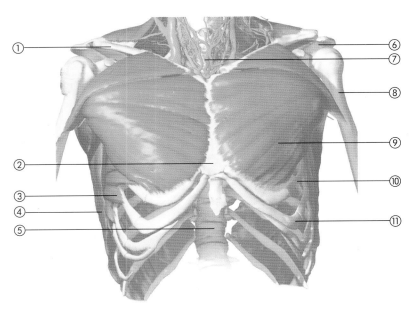

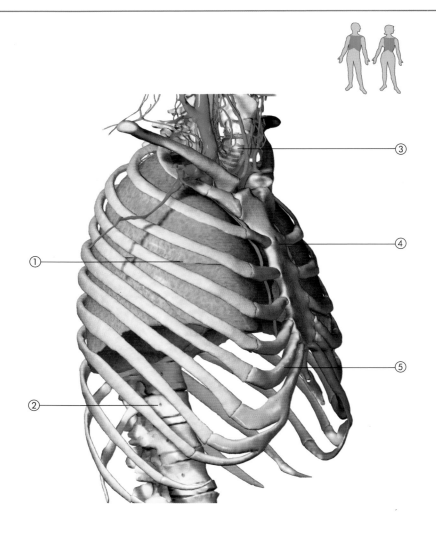

Anterolateral view of the ribcage from the right shows how it completely surrounds and protects the lungs and heart. Blood vessels supplying the neck, arms, and head, and the trachea, pass through the narrow opening at the top of the thorax.

KEY

① Right lung
② Thoracic vertebra (12th)
③ Trachea
④ Sternum
⑤ Costal cartilage

THE THORAX

INTERNALLY, THE THORACIC CAVITY CONTAINS THE MAJOR ORGANS OF THE CIRCULATORY AND RESPIRATORY SYSTEMS THAT, IN TURN, ARE PROTECTED BY THE RIBCAGE FORMED BY THE RIBS, STERNUM, AND BACKBONE. THE **THORACIC CAVITY** ITSELF IS SUBDIVIDED INTO SMALLER CAVITIES. LATERALLY, TWO LARGE PLEURAL CAVITIES EACH HOUSE ONE OF THE LUNGS. EACH CAVITY IS A NARROW FLUID-FILLED SPACE THAT LIES BETWEEN THE **PLEURAE**, THE SEROUS MEMBRANES THAT LINE THE WALL OF THE THORACIC CAVITY AND COVER THE LUNGS. PLEURAL FLUID, A LUBRICATING FLUID SECRETED IN THE NARROW SPACE BETWEEN THE MEMBRANES, ENABLES THE MEMBRANES TO SLIDE OVER EACH OTHER DURING BREATHING. IT ALSO HAS A HIGH SURFACE TENSION, WHICH ENSURES THAT THE LUNGS ADHERE CLOSELY TO THE THORACIC WALL AND EITHER EXPAND OR SHRINK AS THE VOLUME OF THE THORACIC CAVITY INCREASES OR DECREASES, RESPECTIVELY.

The **mediastinum**, between the two lungs, contains the esophagus, the trachea, and major blood and lymphatic vessels. It also contains the **pericardial cavity**, a fluid-filled cavity that lies between the pericardia, the serous membranes that cover the heart and line the thoracic cavity, and which allows the heart to contract and expand without friction during the cardiac cycle (*see page 184*).

The diaphragm

The diaphragm—the name means "partition across"—is a broad, skeletal muscle that forms the boundary between the thoracic and abdominopelvic cavities. Its origins lie in the lower border of the ribcage and sternum, the lower costal cartilages, and the lumbar vertebrae. Centrally is a boomerang-shaped tendon. The diaphragm is the prime mover of breathing movements, and is assisted by the intercostal muscles (*see page 70*). When relaxed it is domeshaped, as a result of being pushed upward by the abdominal organs. When the diaphragm contracts, it flattens, pushes the abdominal contents downward, expands the thorax, and draws air into the lungs; on relaxation, it assumes its dome shape, and pushes air out of the lungs. Sensory output from, and motor input into, the diaphragm is provided by the phrenic nerve. The diaphragm and its tendon are pierced by three foramina (openings)—for the aorta, inferior vena cava, and esophagus, respectively—that permit communication between thorax and abdomen.

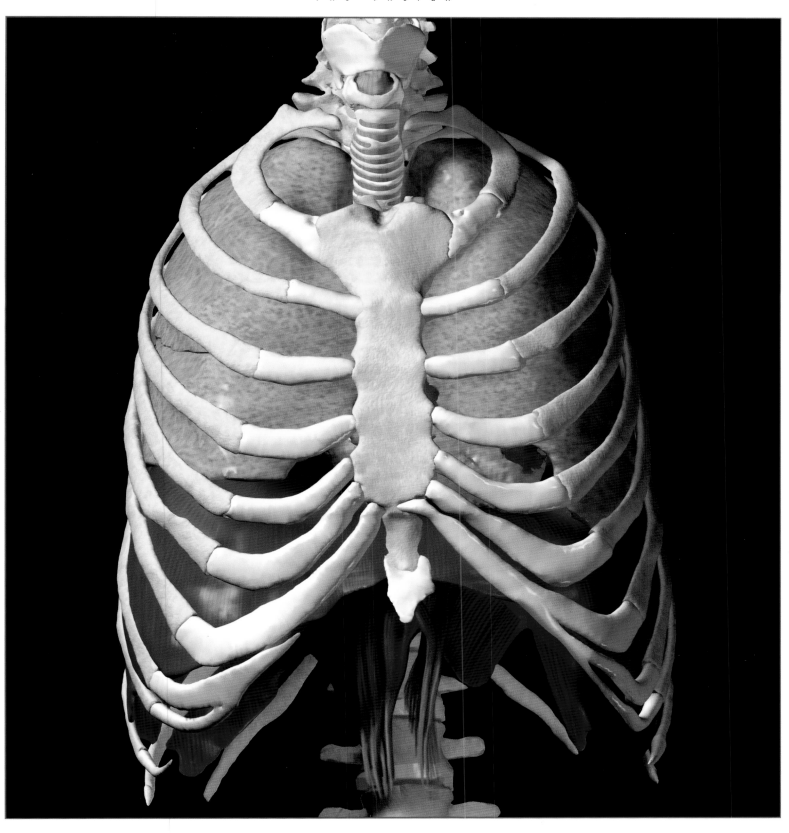

Anterior view of the bones—the sternum, ribs, and thoracic vertebrae—that make up the thoracic or rib cage.

KEY

1. Right lung
2. Sternum
3. Costal cartilage
4. Xiphoid process
5. Left lung
6. Heart
7. Rib (6th)

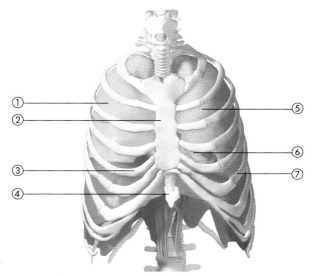

OCCUPYING MOST OF THE THORACIC CAVITY, THE TWO LUNGS ARE SOFT, SPONGY ORGANS THAT CONTAIN SOME 300 MILLION AIR SACS, CALLED ALVEOLI, IN WHICH GASEOUS EXCHANGE TAKES PLACE (*see page* 132): OXYGEN PASSES INTO THE BLOODSTREAM AND WASTE CARBON DIOXIDE PASSES INTO THE AIR FOR ELIMINATION. THE REMAINING LUNG TISSUE CONSISTS MAINLY OF ELASTIC CONNECTIVE TISSUE THAT ENABLES THE LUNGS TO EXPAND AND RECOIL DURING BREATHING (*see below*).

THE LUNGS

Ventilation

Ventilation, or breathing, moves air in and out of the lungs so that fresh supplies of oxygen can be brought in and waste carbon dioxide can be eliminated into the atmosphere. Air is taken in— inhaled —and pushed out—exhaled—of the lungs by the action of the diaphragm and the intercostal muscles. These muscles alter the volume of the thoracic cavity, changes that are followed passively by the lungs.

During inhalation, the diaphragm contracts and pushes the abdominal organs downward, while the external intercostal muscles contract to pull the ribs upward and outward. Together these actions increase the volume inside the thoracic cavity—and, therefore, inside the lungs. The pressure in the thorax and lungs decreases and air is sucked in from outside. During exhalation, the diaphragm relaxes and is pushed upward into a dome shape by the abdominal organs, and the ribcage moves downward and inward. This decreases the volume of the thoracic cavity and the lungs, and increases air pressure inside the lungs so that air is squeezed out. During forced breathing, the internal intercostal muscles contract to pull the ribcage downward. At rest, about 500 ml (17 fl oz) of air is taken in

Posterior view of the lungs, trachea and heart reveals that the cartilage rings of the trachea do not extend to its posterior surface where it is attached to the esophagus.

KEY

① Left lung
② Trachea
③ Heart
④ Right lung

with each breath. The lungs never empty of air; inhaled air serves to refresh the air that is already there. During exercise, both the rate and depth of breathing increases.

Nervous control of breathing

Breathing rate and depth are controlled by the respiratory centers in the brain stem (*see page 168*). The **inspiratory center** sends out regular "bursts" of nerve impulses along the phrenic and intercostal nerves that, respectively, cause the diaphragm and intercostal muscles to contract. When the thorax has expanded, the inspiratory center ceases activity, the muscles relax and exhalation takes place. Regular emissions from the respiratory center produce a breathing rate of between 12 and 18 breaths per minute. During exercise, increased levels of carbon dioxide in the blood are detected by chemoreceptors, while increased muscle activity is detected by stretch receptors. These receptors send "messages" to the brain stem, which cause the inspiratory center to increase its activity so that the breathing rate rises.

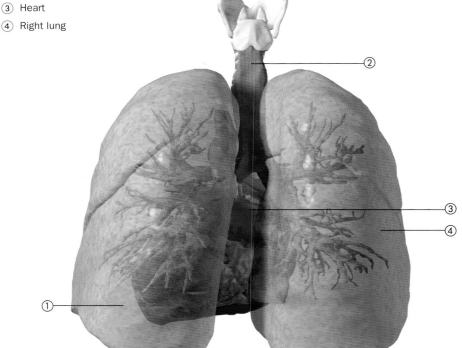

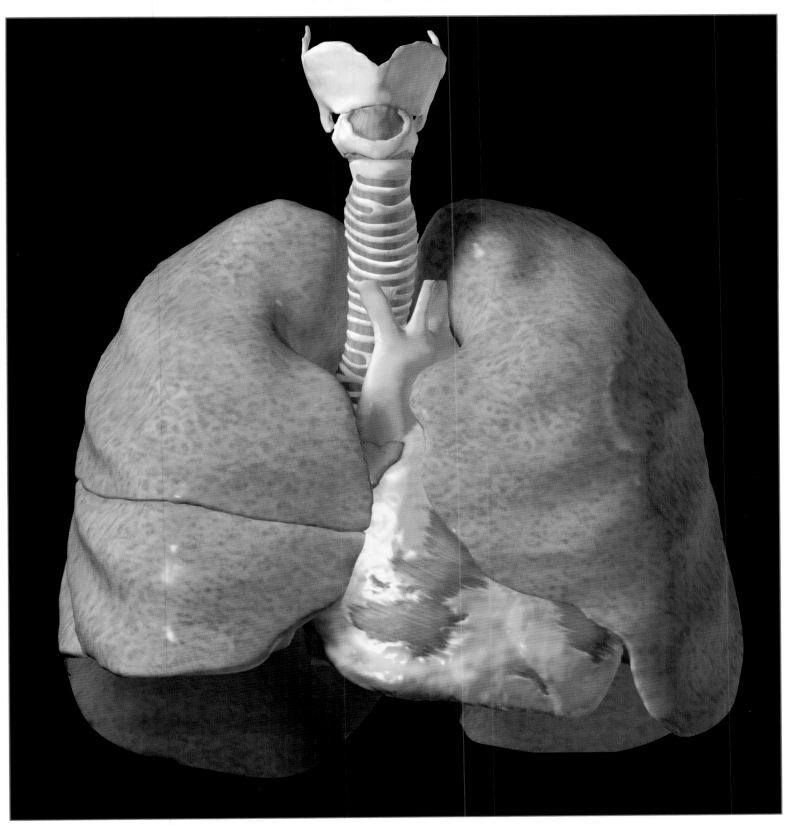

Anterior view of the lungs, trachea, and heart. The left lung has two lobes, while the right lung has three. The left lung is smaller than the right; a concavity in the left lung, the cardiac notch, accommodates the heart, which is tilted to the left.

KEY

① Trachea
② Right lung
③ Aortic arch
④ Superior lobe
⑤ Horizontal fissure
⑥ Middle lobe
⑦ Oblique fissure
⑧ Inferior lobe
⑨ Cartilage ring
⑩ Left lung
⑪ Heart
⑫ Cardiac notch

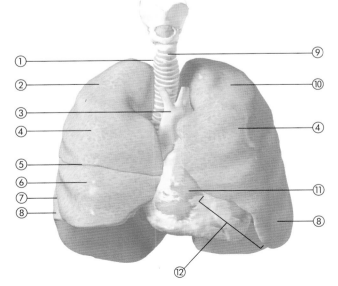

THE FIST-SIZED, CONE-SHAPED HEART IS A POWERFUL MUSCULAR PUMP THAT CONTRACTS TO MOVE BLOOD AROUND THE BODY. TIPPED SLIGHTLY TO THE LEFT, THE HEART LIES ANTERIOR TO THE BACKBONE AND POSTERIOR TO THE STERNUM, AND IS LATERALLY SURROUNDED, AND PARTIALLY OVERLAPPED, BY THE TWO LUNGS. THE HEART IS MADE PRIMARILY FROM CARDIAC MUSCLE, A TISSUE UNIQUE TO THE HEART THAT CAN CONTRACT CEASELESSLY WITHOUT TIRING. DAILY, THE HEART BEATS SOME 100,000 TIMES, AND IN A LIFETIME OF 70 YEARS IT WILL BEAT 2.5 BILLION TIMES WITHOUT STOPPING.

THE HEART

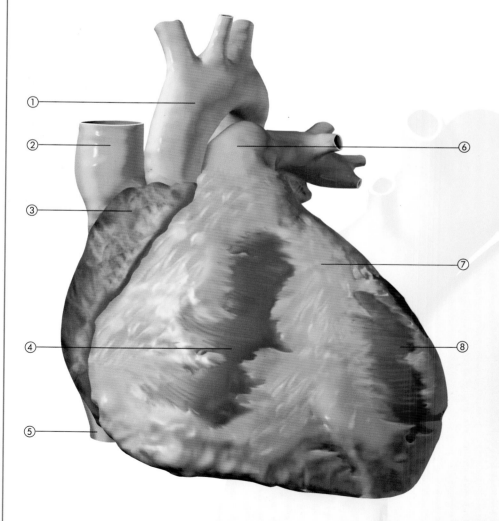

Externally, the heart is surrounded and protected by a tough double membrane, the pericardium. Internally, the heart is divided into left and right sides by a muscular septum. Each half has a smaller chamber called an atrium that receives blood and pumps it to the larger, thicker-walled ventricle below. The right atrium receives oxygen-poor blood from the body through the inferior and superior venae cavae; the left atrium receives oxygen-rich blood from the lungs through the pulmonary veins. The ventricles contract to push blood out of the heart. The right ventricle pumps oxygen-poor blood through the pulmonary trunk and arteries to the lungs; the left ventricle pumps oxygen-rich blood to the body through the aorta.

Heart valves

Heart valves play a vital role in ensuring that blood flows in the right direction when the heart contracts and relaxes. **Atrioventricular valves** between each atrium and ventricle—the **mitral valve** on the left, and the **tricuspid** on the right—open to permit blood to flow from atria to ventricles, but close when the ventricles contract to stop blood flowing backward into the atria. The **semilunar valves** are located where the pulmonary trunk and the aorta, respectively, exit the heart. These valves permit blood to leave the heart when the ventricles contract, but close to prevent backflow when the ventricles relax.

KEY

1. Aortic arch
2. Superior vena cava
3. Right atrium
4. Right ventricle
5. Inferior vena cava
6. Pulmonary trunk
7. Fatty tissue
8. Left ventricle

Anterior view of the heart showing the main blood vessels through which blood enters and leaves the heart. Fatty tissue, which underlies the pericardium, covers the coronary blood vessels.

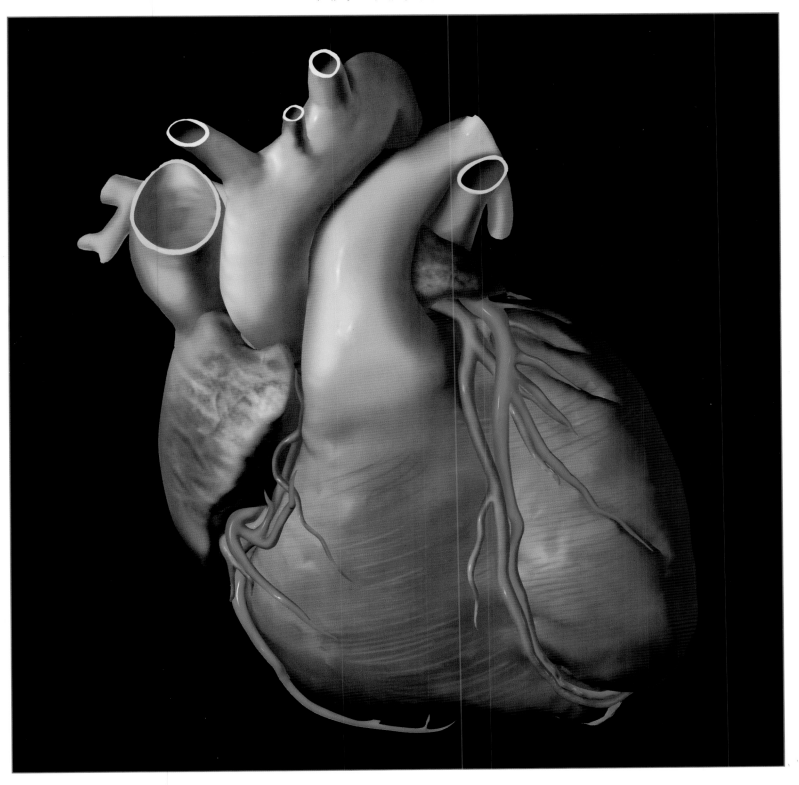

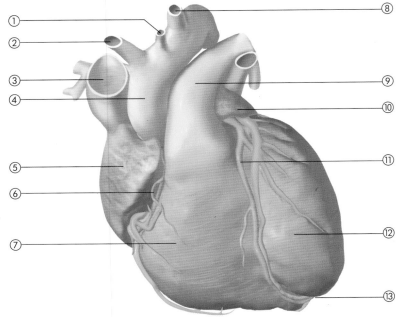

Anterior view of the heart with fatty tissue removed reveals the coronary blood vessels that supply the cardiac muscle in the heart wall with fuel and oxygen.

KEY

① Left common carotid artery

② Brachiocephalic artery

③ Superior vena cava

④ Aortic arch

⑤ Right atrium

⑥ Right coronary artery

⑦ Right ventricle

⑧ Left subclavian artery

⑨ Pulmonary trunk

⑩ Left atrium

⑪ Left coronary artery

⑫ Left ventricle

⑬ Apex

W HILE A HEART BEAT MAY FEEL LIKE A SINGLE CONTRACTION, IT IS ACTUALLY MADE UP OF THREE PHASES THAT OCCUR IN A PRECISELY TIMED SEQUENCE CALLED THE CARDIAC CYCLE. EACH CYCLE TAKES ABOUT 0.8 SECONDS WHEN A PERSON IS AT REST. THE THREE PHASES ARE **DIASTOLE**, **ATRIAL SYSTOLE**, AND **VENTRICULAR SYSTOLE**.

THE HEART

- Diastole—the atria and ventricles relax, blood enters the atria, and some flows into the ventricles. The semilunar valves close, and the atrioventricular valves are open.
- Atrial systole—the two atria contract and squeeze blood into the ventricles.
- Ventricular systole—the two ventricles contract and pump blood out of the heart. The atrioventricular valves shut, and the semilunar valves open.

When the valves close they produce the characteristic heart sounds used by doctors to diagnose possible heart problems. The closing of the atrioventricular valves produces a longer, louder "lub" sound; while the closing of the semilunar valves produces a shorter, sharper, "dup" sound.

Controlling heart rate

The timing and sequence of the cardiac cycle is controlled from within the heart. The **sinoatrial (SA) node** located in the wall of the right atrium produces regular bursts of electrical impulses and acts as a natural pacemaker. These impulses spread through the atria causing them to contract (atrial systole). They then reach the atrioventricular (AV) node, just above the tricuspid valve, which delays the signal for about 0.1 seconds to give time for the atria to contract. The electrical signals are then carried into the ventricle walls by specialized conduction tissue and the ventricles contract (ventricular

systole). Following diastole, another electrical signal is sent out by the SA node.

While the generation of the heart beat is internal, heart rate itself is controlled by the autonomic nervous system (ANS, *see page 98*) and adjusted according to the body's demands. Two centers in the medulla oblongata in the brain stem monitor changes in blood composition and pressure (*see page 168*), and send out signals to alter heart rate accordingly. The **cardioacceleratory center** sends impulses along sympathetic fibers to speed up heart rate—during exercise or stress, for example, when extra oxygen is needed by muscles—while the **cardioinhibitory center** sends impulses along parasympathetic fibers to slow the heart when the body is at rest. These two branches of the ANS exert their effects by altering the rate of "firing" of the SA node.

Lateral view of the heart from the left side shows the coronary blood vessels that cover the heart like a crown and provide its muscles with the fuel and oxygen they need to keep contracting.

KEY

1. Brachiocephalic trunk
2. Common carotid artery
3. Aortic arch
4. Pulmonary trunk
5. Left atrium
6. Left coronary artery
7. Right ventricle
8. Subclavian artery
9. Left pulmonary artery
10. Descending aorta
11. Circumflex artery (branch of left coronary artery)
12. Pulmonary veins
13. Left ventricle
14. Inferior vena cava

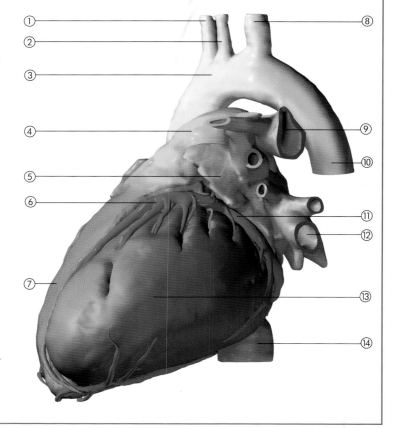

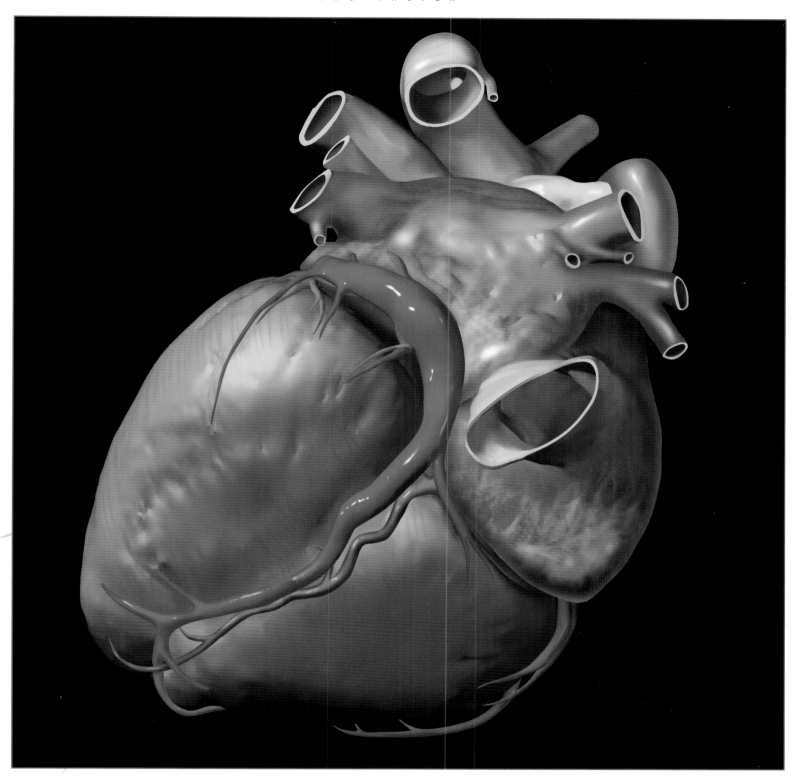

Posterior view of the heart with the superior and inferior venae cavae removed. The right and left pulmonary veins, which empty oxygen-rich blood into the left atrium, can be seen clearly. The coronary sinus (part of the cardiac circulation) collects oxygen-poor blood from heart muscle and empties it into the right atrium.

KEY

① Descending aorta
② Aortic arch
③ Left pulmonary artery
④ Left pulmonary veins
⑤ Circumflex artery
⑥ Coronary sinus
⑦ Left atrium
⑧ Left common carotid artery
⑨ Brachiocephalic artery
⑩ Superior vena cava
⑪ Right pulmonary artery
⑫ Inferior vena cava
⑬ Right atrium
⑭ Right ventricle

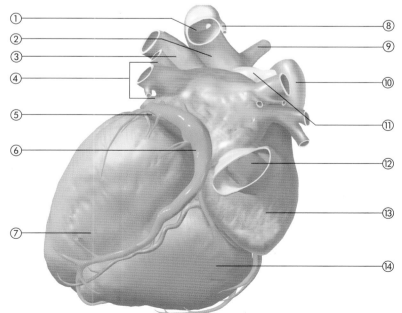

THE ABDOMEN, OR BELLY, MAKES UP THE LOWER HALF OF THE
TRUNK, EXTENDING AS IT DOES FROM THE DIAPHRAGM, THE
SHEET OF MUSCLE THAT SEPARATES IT FROM THE THORAX, TO
THE BASE OF THE PELVIS. FOR DESCRIPTIVE PURPOSES, THE ABDOMEN IS
NORMALLY DIVIDED INTO THE ABDOMEN PROPER, WHICH IS DESCRIBED IN
THIS SECTION, AND THE PELVIS, WHICH IS DESCRIBED IN CHAPTER 14.

THE ABDOMEN

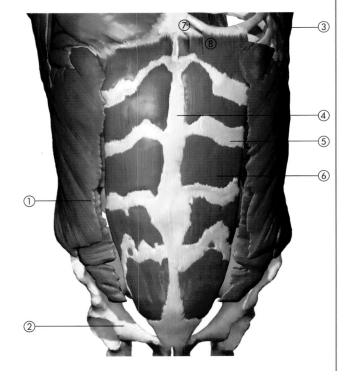

**Anterior, external view
of the abdomen, the
lower section of the
trunk, which is
separated internally
from the thorax by the
diaphragm.**

The abdominal wall is formed largely
from muscle (*see page 82*), a direct
contrast with the bony cage that
surrounds the thorax. The abdominal
muscles play an important role in
protecting and maintaining the
position of the viscera (organs) inside
the abdominal cavity; they also flex
and support the trunk. Anteriorly, the
abdominal wall is formed by the
straplike rectus abdominis muscle,
which runs medially and vertically; and three pairs
of layered muscles that extend round the side of the
body to form the lateral section of the wall. These
muscles are—from superficial to deep—the external
oblique, which runs medially and downward; the
internal oblique, which runs at 90° to the external
oblique; and the rectus abdominis, which runs
horizontally. When these muscles are well toned
they hold the abdominal contents in, but if not
sufficiently exercised they allow the organs to bulge
outward, forming a "potbelly". The posterior part of
the abdominal wall is formed by the lumbar section
of the backbone, and the quadratus lumborum
muscles that extend from the pelvis to the backbone,
and serve to maintain an upright posture.

The abdominal cavity is packed with organs. The
stomach, small intestine, and large intestine make

**Anterior view of the
abdominal muscles.
The abdomen lacks
any bony
reinforcement, so the
paired muscles of the
anterior and lateral
abdominal walls
protect and support
the internal organs.
They also flex and
rotate the trunk.**

KEY

① External oblique
② Pelvis
③ Latissimus dorsi
④ Linea alba
⑤ Tendinous intersection
⑥ Rectus abdominis
⑦ Sternum
⑧ Rib

up most of the digestive system (*see page 134*), the
latter two organs occupying most of the space inside
the abdominal cavity. The liver and pancreas are
accessory digestive organs that also have other
functions (*page 142*). The spleen is involved in
defending the body against disease (*see page 194*).
The two kidneys excrete wastes in the form of urine
and help maintain water and salt balance in body
fluids (*see pages 150 and 200*). Because the
diaphragm domes upward, the liver and stomach are
partly enclosed and protected by the lowest ribs.

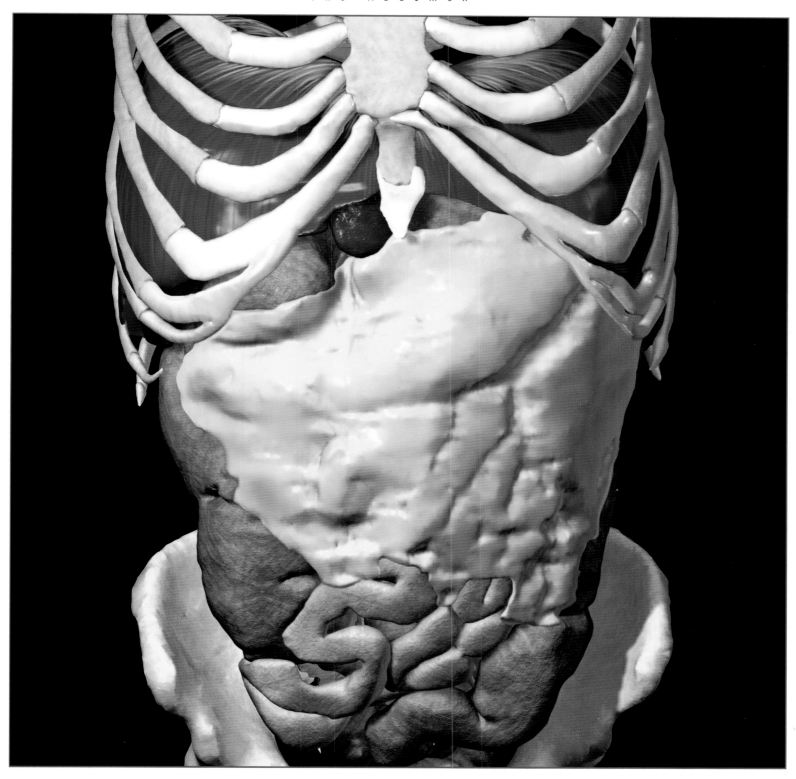

Anterior view of the abdomen with the abdominal musculature removed showing the greater omentum, part of the abdominal mesenteries, partially covering the stomach and intestines. Like an "apron" in appearance, the omentum stores fat, helps anchor the digestive organs to the abdominal wall, and contains lymph nodes that destroy pathogens entering the body through the abdominal organs.

KEY

① Diaphragm

② Ascending colon

③ Pelvis

④ Ileum

⑤ Sternum

⑥ Rib (6th)

⑦ Costal cartilage

⑧ Greater omentum

⑨ Descending colon

⑩ Rectum

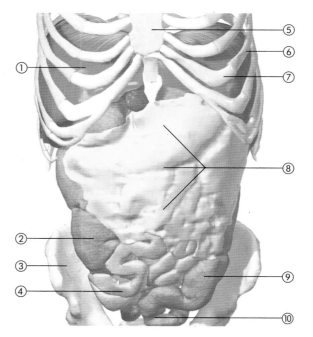

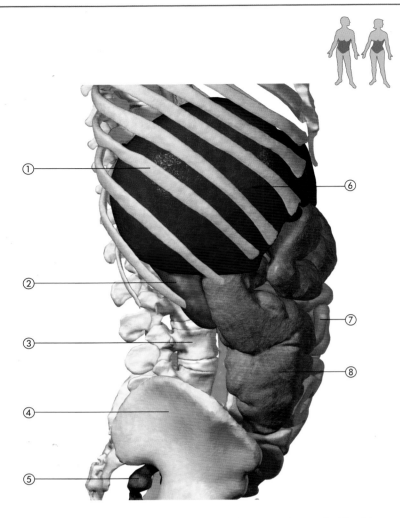

Lateral view of the
abdomen showing the
liver, small intestine,
and rectum.

KEY

1. Rib
2. Right kidney
3. Vertebral column
4. Pelvis
5. Rectum
6. Liver
7. Small intestine
8. Ascending colon

THE ABDOMEN

INTERNALLY, THE LOWER PART OF THE TRUNK IS OCCUPIED BY THE ABDOMINOPELVIC CAVITY WHOSE UPPER BOUNDARY IS FORMED BY THE DIAPHRAGM, AND LOWER BY THE PELVIC FLOOR MUSCLES. THIS CAVITY IS SEPARATED INTO AN UPPER ABDOMINAL SECTION THAT CONTAINS THE DIGESTIVE ORGANS (*see page* 134), SPLEEN, KIDNEYS, AND OTHER ORGANS, AND A LOWER PELVIC SECTION CONTAINING THE REPRODUCTIVE ORGANS AND BLADDER (*see pages* 152–159).

As in the thorax, the wall of the abdominopelvic cavity is lined by a serous membrane, which also covers the surface of its organs. Where it lines the cavity the membrane is called the **parietal peritoneum**, and where it covers organs it is referred to as **visceral peritoneum**. Fluid secreted by these peritonea lubricates their surfaces and allows digestive organs to slide over each other painlessly while digestive movements are taking

place. Some organs—including the kidneys and pancreas—lie between the peritoneum and posterior abdominal wall and are referred to as **retroperitoneal**.

Within the cavity the peritoneum forms large folds that serve to hold organs in place, while allowing a degree of movement. They also carry blood vessels, lymph vessels, and nerves to abdominal organs, and act as fat stores. These folds include the **mesentery**, **mesocolon**, and the lesser and greater **omenta**.

The fetal digestive system

The first signs of the digestive system appear just two weeks after fertilization. A pouch, called the primitive gut, arises that later differentiates into a **foregut**, **midgut** and **hindgut**. By eight weeks, the fetus has developed a continuous alimentary canal with openings at the mouth and anus. The foregut gives rise to the pharynx, esophagus, stomach, and part of the duodenum; the midgut forms the rest of the small intestine, and part of the large intestine; and the hind gut makes up the rest of the large intestine. Pouches arising from the foregut form the accessory digestive organs: the salivary glands, liver, gallbladder, and pancreas. In the uterus, the fetus receives all its nutrients from its mother by way of the placenta and **umbilical cord**. However, the alimentary canal is brought into operation when the fetus swallows some of the **amniotic fluid** surrounding it. This fluid contains chemicals that stimulate the maturation of the alimentary canal so that it is ready for its first feeds after birth.

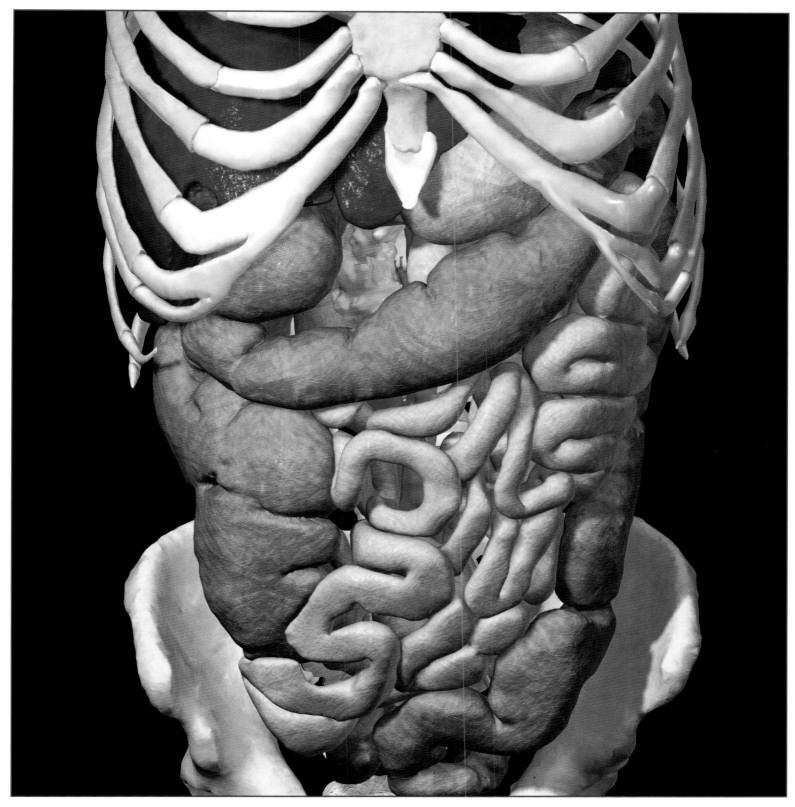

Anterior view of the abdomen showing the entire contents, but with the omentum removed.

KEY

① Liver
② Rib
③ Costal cartilage
④ Transverse colon
⑤ Ileum
⑥ Pelvis
⑦ Stomach
⑧ Pancreas
⑨ Descending colon
⑩ Sigmoid colon
⑪ Rectum

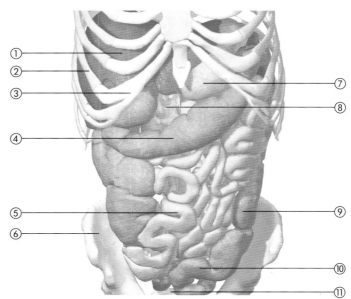

This expanded part of the alimentary canal provides a temporary holding station for food that has just been swallowed. It also secretes juices that start to digest proteins in the swallowed food and which, in conjunction with the powerful contractions of the three layers of smooth muscle in the stomach wall, produce a liquid paste called chyme, that is subsequently passed on to the small intestine. This storage function of the stomach is vitally important because we ingest food through the mouth much faster than we digest and absorb it in the small intestine. Without the stomach to delay its progress, food would pass through too rapidly to be digested (*see page* 134).

THE STOMACH

Partially obscured by the liver and diaphragm, the stomach lies on the left side of the abdominal cavity. It has four major regions (*see page 140*). The cardiac region is the upper part that surrounds the opening from the esophagus. The fundus is the upper, dome-shaped section. The body is the middle part of the stomach. Finally, the pylorus is the lower end of the stomach, which is continuous with the duodenum. The exit from the pylorus is guarded by a ring of muscle, the pyloric sphincter. While the cardiac region and pylorus are relatively immobile, the fundus and body actively expand when they fill with food, and move as their muscles contract to crush food. When empty, the stomach has a volume of about 50 ml (1.7 fl oz), and its internal lining is thrown into folds called **rugae**; after a meal, the elastic stomach wall stretches, the rugae disappear, and the volume can increase to up to 4 liters (8 pints).

The **concave** upper surface of the stomach forms its lesser curvature, while the **convex** lower surface forms its greater curvature. Two peritoneal membranes or mesenteries—the greater omentum and lesser omentum—attach the stomach to other organs and to the abdominal wall. The greater omentum extends from the greater curvature to cover the small intestine and then loops upward to attach to the posterior abdominal wall. Where it hangs downward it resembles a fatty apron, because it is filled with fat deposits. It also contains many lymph nodes that protect the abdominal organs from infection. The lesser omentum extends from the liver to the lesser curvature.

Interior surface shot of the stomach showing the many folds (rugae) that line it. The folds vastly increase the available surface area so that after a meal the volume can increase to 4 liters (8 pints).

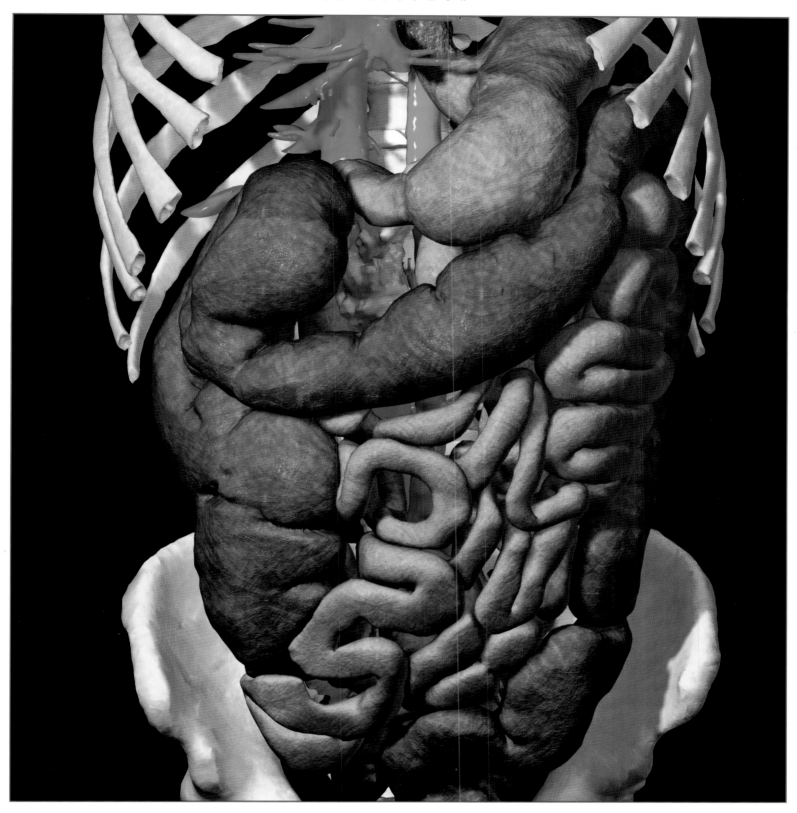

Anterior view of the abdomen with the liver and costal cartilages removed.

KEY

① Lesser curvature of the stomach
② Duodenum
③ Pyloric sphincter
④ Pancreas
⑤ Transverse colon
⑥ Ascending colon
⑦ Pelvis
⑧ Ileum
⑨ Esophagus
⑩ Stomach
⑪ Greater curvature of the stomach
⑫ Jejunum
⑬ Descending colon
⑭ Sigmoid colon
⑮ Inferior vena cava
⑯ Aorta

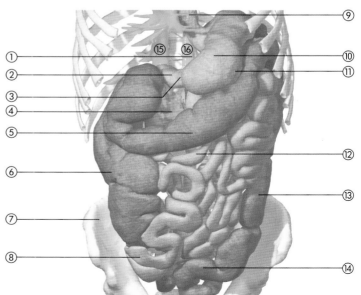

THE LIVER PLAYS A VITAL ROLE IN MAINTAINING THE COMPOSITION OF THE BLOOD. IT IS DIVIDED INTO TWO LOBES—THE RIGHT IS LARGER THAN THE LEFT—BY THE **FALCIFORM LIGAMENT**, A PIECE OF MESENTERY THAT ANCHORS THE LIVER TO THE ANTERIOR WALL OF THE ABDOMEN. ON ITS LOWER, POSTERIOR SURFACE IS THE **PORTA HEPATIS** ("LIVER GATEWAY"), AN OPENING THROUGH WHICH THE HEPATIC PORTAL VEIN—WHICH CARRIES NUTRIENT-RICH FOOD FROM THE SMALL INTESTINE—AND THE HEPATIC ARTERY—A BRANCH OF THE CELIAC TRUNK FROM THE AORTA,

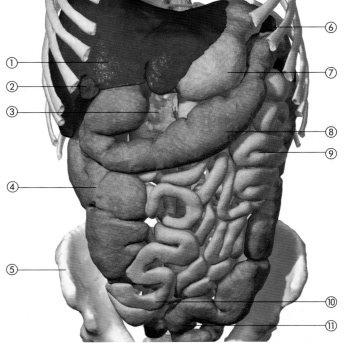

THE LIVER AND GALLBLADDER

WHICH DELIVERS OXYGEN-RICH BLOOD—BOTH ENTER THE LIVER, AND THE COMMON HEPATIC DUCT, WHICH CARRIES BILE, LEAVES. SUPERIORLY, RIGHT AND LEFT HEPATIC VEINS, WHICH CARRY BLOOD OUT OF THE LIVER, EMPTY DIRECTLY INTO THE INFERIOR VENA CAVA, WHICH PASSES VERTICALLY BEHIND THE LIVER.

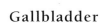

Inside the liver, millions of liver cells, or **hepatocytes**, process recently-absorbed nutrients, remove toxins, secrete proteins, release nutrients from stores, and secrete bile. Hepatocytes are organized into thousands of hexagonal lobules, each about 1 mm ($\frac{1}{16}$ in) in diameter. Inside the lobule strands of hepatocytes one cell thick fan outward from a central vein that empties into the hepatic vein. Running between these strands are blood channels called **sinusoids**. At the corners of the hexagon are branches of the hepatic portal vein and hepatic artery that deliver blood to be processed by the hepatocytes as it flows along the sinusoids towards the central vein. Bile—part excretory product, part digestive agent—secreted by hepatocytes, passes along tiny bile canaliculi, also located at the corners of lobules, which empty in the hepatic ducts.

Gallbladder

The gallbladder lies tucked into a small depression on the lower rear wall of the liver, and is connected to it by the common hepatic duct and cystic duct. A green, muscular sac some 10 cm (4in) long, the gallbladder stores and concentrates bile produced by the liver. As it fills with bile—the liver releases about 1 liter (1¾ pints) of bile each day—the gallbladder stretches and its folded inner surface becomes smooth. When chyme (semisolid food) enters the duodenum from the stomach, the intestines release **cholecystokinin**, a hormone that causes the gallbladder to contract, squeezing bile along the cystic duct and through the common bile duct into the duodenum where it assists in the digestion of fats.

Anterior view of the upper section of the abdomen, showing the liver, gallbladder, pancreas, spleen, duodenum and kidneys.
KEY

① Liver
② Gallbladder
③ Pancreas
④ Ascending colon
⑤ Ilium
⑥ Spleen
⑦ Stomach
⑧ Transverse colon
⑨ Jejunum
⑩ Ileum
⑪ Sigmoid colon

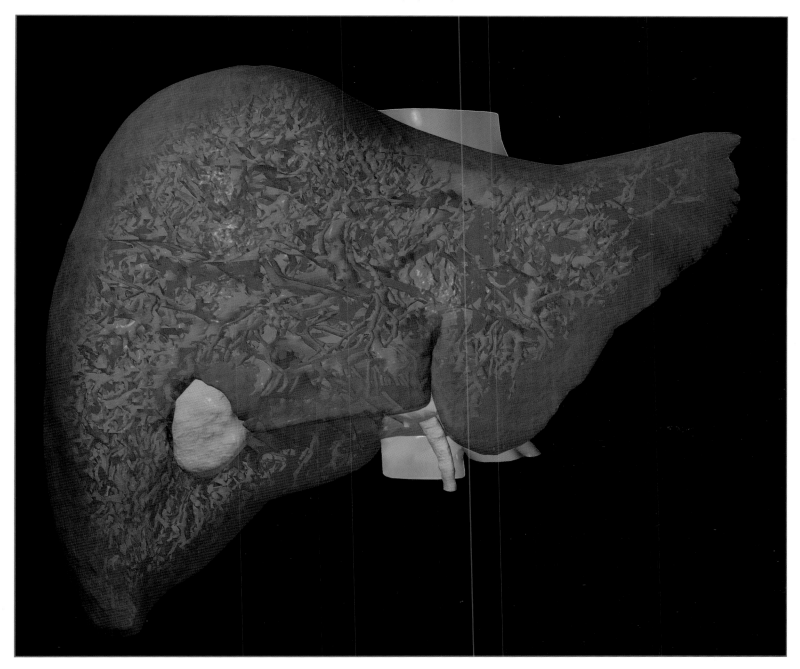

Anterior view of the liver showing the gallbladder and, internally, the extensive network of arteries and veins.

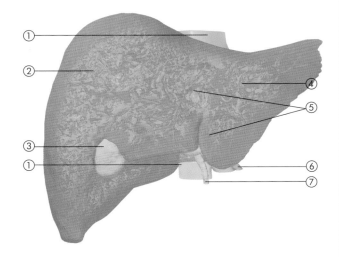

KEY

1. Inferior vena cava
2. Right lobe of liver
3. Gallbladder
4. Left lobe of liver
5. Branches of hepatic portal vein and hepatic artery
6. Hepatic artery
7. Common bile duct

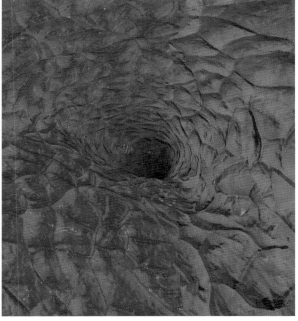

Interior view of the gall bladder and its exit through the cystic duct. When the gallbladder contains little bile its lining is thrown into folds, as seen here. These disappear as the gallbladder fills with bile and expands.

T HE FIST-SIZED SPLEEN LIES ON THE LEFT SIDE OF THE ABDOMINAL CAVITY JUST BELOW

THE DIAPHRAGM. AT 12 CM (5 IN) LONG, THE SPLEEN IS THE LARGEST OF THE

LYMPHATIC ORGANS (*see page* 126) AND HAS TWO MAJOR FUNCTIONS: AS PART OF THE

BODY'S IMMUNE SYSTEM; AND IN CLEANSING THE BLOOD. IN THE FETUS, THE SPLEEN

MANUFACTURES RED BLOOD CELLS, A FUNCTION THAT CEASES AFTER BIRTH. THE SPLEEN IS

SURROUNDED BY A PROTECTIVE, FIBROUS CAPSULE, AND HAS A **HILUS**, OR INDENTATION, ON ONE

SIDE THROUGH WHICH ITS BLOOD VESSELS ENTER. SERVING THE SPLEEN ARE THE SPLENIC ARTERY,

A BRANCH OF THE CELIAC TRUNK, ITSELF A BRANCH OF THE

AORTA; AND THE SPLENIC VEIN THAT EMPTIES INTO THE

HEPATIC PORTAL VEIN. THERE IS NO **AFFERENT** LYMPHATIC

SUPPLY INTO THE SPLEEN SO THAT, UNLIKE LYMPH NODES,

THE SPLEEN DOES NOT "FILTER" LYMPH.

KEY

① Stomach
② Spleen
③ Transverse colon
④ Kidney
⑤ Descending colon
⑥ Jejunum
⑦ Ileum
⑧ Sigmoid colon

THE SPLEEN

Anterior view of the abdomen showing the spleen and kidneys (note the adrenal glands). The liver, stomach, pancreas, and intestines have been cut away.

Inside the spleen there are two distinct tissue types. Around smaller branches of the splenic artery there are clusters of what is termed **white pulp**. This consists of lymphocytes suspended on fibers, and is the part of the spleen involved in the immune response. Here, **B-lymphocytes** proliferate and generate the antibody-producing plasma cells that target specific pathogens and mark them for destruction.

Forming a "sea" around the "islands" of white pulp is red pulp, a zone of connective tissue and blood spaces that is rich in **phagocytic** cells, called **macrophages**, and red blood cells (*see page* 124). Macrophages remove blood-borne **pathogens**, such as **bacteria** and **viruses**, by engulfing and digesting them. They also play a vital role in maintaining the quality of circulating blood by removing worn-out red blood cells and **platelets** (the spleen also stores platelets), as well as cellular debris and toxins. The macrophages also store salvaged breakdown products from red blood cells, such as iron, in order that they can be used again by bone marrow for the purpose of making new blood cells.

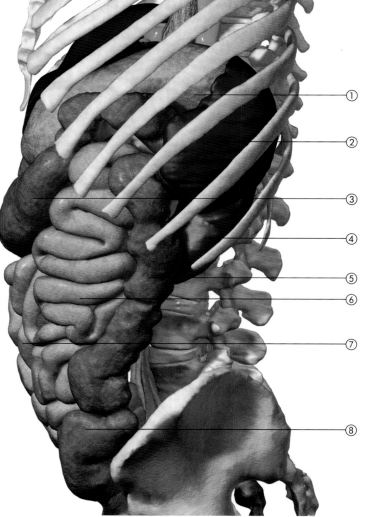

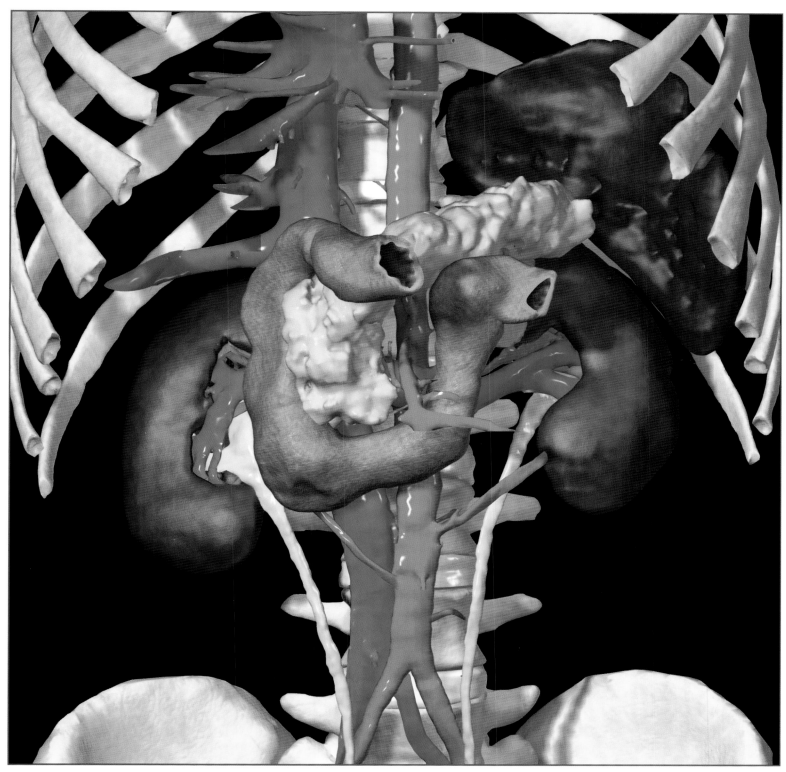

Anterior view of the abdominal cavity. With the liver, stomach, and intestines removed the spleen and kidneys can easily be seen.

KEY

① Abdominal aorta
② Inferior vena cava
③ Right kidney
④ Ureter
⑤ Pelvis
⑥ Spleen
⑦ Renal artery
⑧ Renal vein
⑨ Left kidney
⑩ Vertebral column
⑪ Common iliac artery
⑫ Common iliac vein

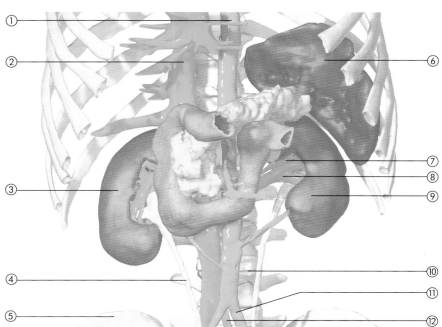

THE SMALL INTESTINE TWISTS AND TURNS AS IT MAKES ITS

WAY FROM THE PYLORIC SPHINCTER, THE EXIT POINT FROM

THE STOMACH, TO THE ILEOCECAL VALVE, THE ENTRANCE TO

THE LARGE INTESTINE (*see page* 146). AT 3 METERS (10 FEET) LONG

IN A LIVING PERSON AND ABOUT 7 METERS (23 FEET) IN A CADAVER

DUE TO THE LOSS OF MUSCLE TONE, THE SMALL INTESTINE IS THE

LONGEST PART OF THE ALIMENTARY CANAL AND THE MOST IMPORTANT,

FILLING MUCH OF THE LOWER PART OF THE ABDOMEN. THE FINAL STAGES

OF DIGESTION TAKE PLACE HERE, AND THE SIMPLE NUTRIENTS PRODUCED

ARE ABSORBED INTO THE BODY THROUGH THE WALL OF

THE SMALL INTESTINE.

THE SMALL INTESTINE

The small intestine has three sections: the duodenum (*see page 144*), the jejunum, and the ileum. The duodenum is about 25 cm (10 in) long, and receives secretions from the liver and pancreas. The jejunum, and the longer ileum, extend from the duodenum to the ileocecal valve. They are suspended like sausages by the fanshaped mesentery, a double fold of parietal peritoneum that attaches most of the small intestine to the posterior wall of the abdomen. As well as supporting the small intestine, the mesentery also carries the intestinal arteries—branches of the superior mesenteric artery arising from the aorta—that supply all parts of the small intestine with oxygen-rich blood. Oxygen-poor blood—but blood that is rich in nutrients—drains from the small intestine through the superior mesenteric vein, emptying into the hepatic portal vein which carries blood directly to the liver.

Internally, the small intestine is adapted to the function of digestion and absorption by being thrown into circular folds that increase the inner surface area. Covering these folds are tiny, fingerlike projections called villi that give the small intestine a surface rather like the nap of a towel and that further increase its surface area. The walls of the small intestine contain both circular and longitudinal layers of smooth muscle that contract rhythmically to either mix food (**segmentation**) or push it towards the large intestine (peristalsis, *see page 140*).

Interior surface shot of the duodenum looking up at the star-like pyloric sphincter. Note also the rough-looking surface. This is due to the tiny, finger-like villi that cover it.

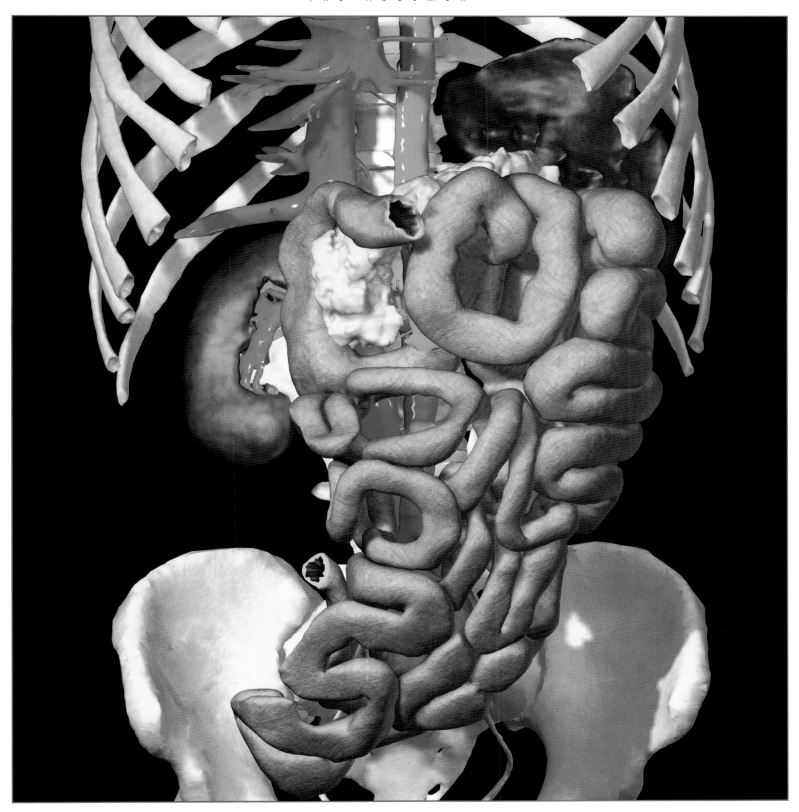

Anterior view of the abdominal cavity with the large intestine removed. Despite its name the small intestine is the longest part of the alimentary canal.

KEY

1. Inferior vena cava
2. Abdominal aorta
3. Kidney (right)
4. Ileum
5. Spleen
6. Duodenum
7. Pancreas
8. Jejunum
9. Pelvis

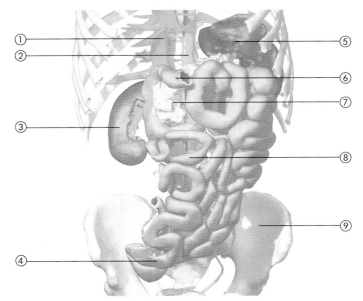

THIS FINAL SECTION OF THE ALIMENTARY CANAL IS ABOUT 1.5 METERS (5 FEET) LONG IN A

LIVING PERSON, AND SIGNIFICANTLY WIDER THAN THE SMALL INTESTINE. THE LARGE

INTESTINE EXTENDS FROM THE ILEOCECAL VALVE, WHERE IT JOINS THE SMALL INTESTINE, TO

THE ANUS, THE LOWER OPENING OF THE ALIMENTARY CANAL (*see page* 136). THE PRIMARY ROLE OF

THE LARGE INTESTINE IS TO RECEIVE LIQUID INDIGESTIBLE WASTES THROUGH THE ONE-WAY ILEOCECAL

VALVE AND, AS THESE WASTES ARE PUSHED ALONG THE LARGE INTESTINE BY PERISTALSIS, TO ABSORB

WATER AND SALTS FROM THE WASTES TO FORM NEAR SOLID FECES THAT ARE EGESTED THROUGH THE

ANUS. THE 1.5 LITERS (2 ½ PINTS) OF LIQUID WASTE THAT ENTERS THE LARGE INTESTINE DAILY IS

PROCESSED WITHIN ABOUT 12 HOURS TO FORM 450 G (16 OZ) OF SEMI-SOLID FECES.

THE LARGE INTESTINE

Interior surface shot of the cecum showing the ileocecal valve, the start of the large intestine. This one-way valve allows liquid indigestible waste to enter the large intestine.

The large intestine, which surrounds the small intestine on three sides, has four sections; the cecum, colon, rectum, and anal canal. The small, saclike cecum hangs downward just below the ileocecal valve; projecting from it is the fingerlike appendix. The colon, the main part of the large intestine, has four distinct regions. The ascending colon passes up the right-hand side of the abdominal cavity, and makes a right-angled turn at the right colic (hepatic) flexure. The transverse colon travels across the abdominal cavity and turns downward at the left colic (splenic) flexure. The descending colon passes down the left-hand side of the abdominal cavity and enters the pelvis as the S-shaped sigmoid colon. The sigmoid and transverse colons are attached to the posterior abdominal wall by peritoneal sheets called mesocolons; the other parts of the colon are retroperitoneal. While the colon wall has two muscle layers, like most other parts of the alimentary canal, the outer longitudinal layer is reduced to three strips of muscles called **teniae coli** ("ribbons of the colon"). The muscle tone produced by the teniae pulls the colon into pouches called **haustra**.

The 20 cm (8 in) long rectum has three lateral curves, reflected internally by transverse folds called **rectal valves**. These folds separate feces from **flatus** (gas produced by bacteria in the large intestine) so that the 500 ml (17 fl oz) of flatus that is produced, on average, each day can be voided through the anus without automatically pushing out feces at the same time. The anal canal, which opens to the outside through the anus, contains two sphincter muscles—internal and external—which relax only during defecation.

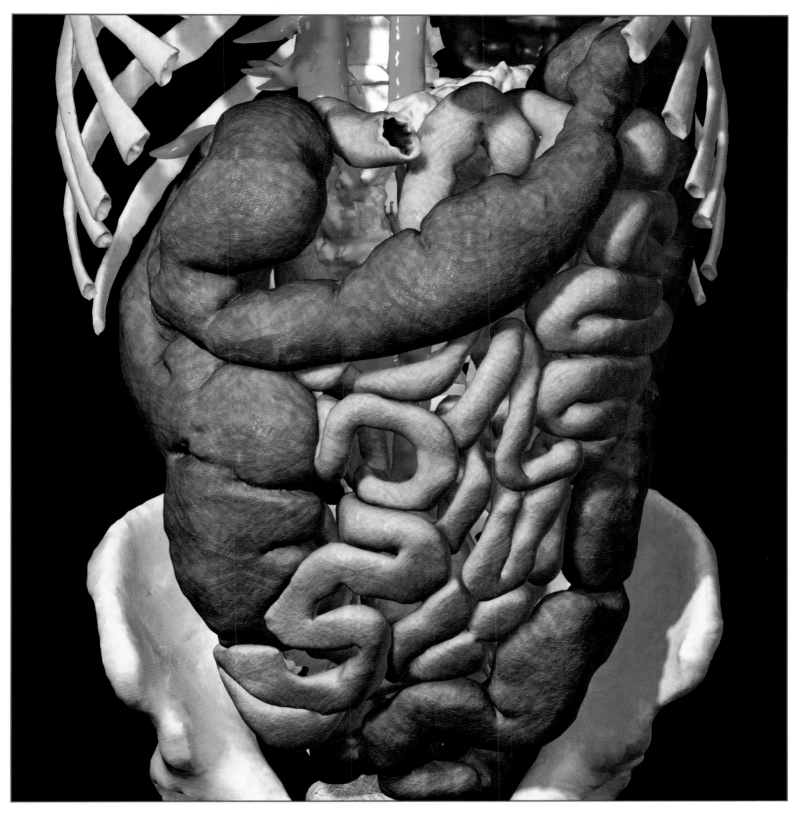

Anterior view of the abdomen with the liver, stomach, spleen and small intestine removed.

KEY

1. Inferior vena cava
2. Abdominal aorta
3. Transverse colon
4. Ascending colon
5. Ileum
6. Ilium
7. Spleen
8. Left colic (splenic) flexure
9. Jejunum
10. Descending colon
11. Haustrum
12. Sigmoid colon

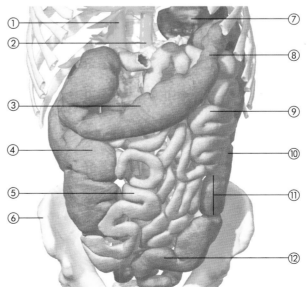

THE KIDNEYS ARE THE KEY ORGANS OF THE URINARY SYSTEM (*see page* 148). THEY ARE RESPONSIBLE FOR EXCRETING FROM THE BODY MUCH OF THE METABOLIC WASTE GENERATED BY CELLS, AND ELIMINATING EXCESS WATER AND SALTS IN ORDER TO MAINTAIN THE STABLE COMPOSITION AND VOLUME OF BLOOD AND OTHER BODY FLUIDS.

THE KIDNEY

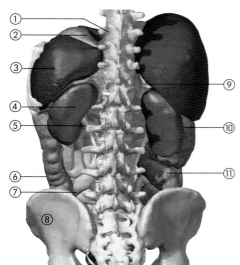

Posterior view of the abdomen with the ribs removed. The right kidney typically occupies a lower position, attached to the posterior abdominal wall, than the left kidney.

KEY

1. Vertebral column
2. Stomach
3. Spleen
4. Left kidney
5. Left ureter
6. Descending colon
7. Ileum
8. Coxal (hip) bone
9. Adrenal gland
10. Right kidney
11. Ascending colon

The two bean-shaped kidneys lie retroperitoneally—between the parietal peritoneum and the posterior abdominal wall—one on either side of the upper lumbar section of the backbone. In that position they receive some protection from the lowermost ribs. The right kidney is typically lower than the left.

The inner surface of each kidney has an indentation, or hilus, that leads to an inner space called the renal sinus through which blood vessels, lymph vessels, and nerves enter and exit the kidneys. Internally, the kidney has three distinct zones. The outer cortex, and the middle medulla—which on its inner surface takes the form of coneshaped **medullary pyramids**—contain millions of microscopic filtration units called **nephrons** (*see page 150*).

Nephrons selectively filter fluid from blood, returning useful and essential materials to the bloodstream while retaining wastes and excess water and salts to form urine. Urine passes along collecting ducts that empty through the medullary pyramids into the renal pelvis, the third and central zone of the kidney. This flattened, funnel-shaped tube branches into cup-shaped **calyces** that cover the tips of medullary pyramids and collect urine. Smooth muscle in the walls of calyces, the pelvis, and the

A close-up view of the left kidney. The kidney has been made transparent to aid visualization. Note the rich vascular network inside the kidney.

KEY

1. Intervertebral disc
2. Vertebral column
3. Left kidney
4. Branches of renal artery and veins
5. Renal hilum
6. Renal vein
7. Left ureter

ureters contract rhythmically to push urine toward the bladder. Blood enters each kidney through the renal artery—a branch of the aorta—which branches to form smaller arteries that pass between the medullary pyramids and enter the cortex. Veins from the cortex unite to form the renal vein that empties into the inferior vena cava.

Surrounding each kidney are three layers of protective and supporting tissue. The innermost, the **renal capsule**, is a fibrous coat that is continuous with the **renal sinus**, and which helps to prevent the spread of infection into the kidney. The adipose or fatty coat cushions the kidneys against blows and helps to insulate them. The outermost coat, the **renal fascia**, anchors the kidneys to the abdominal wall.

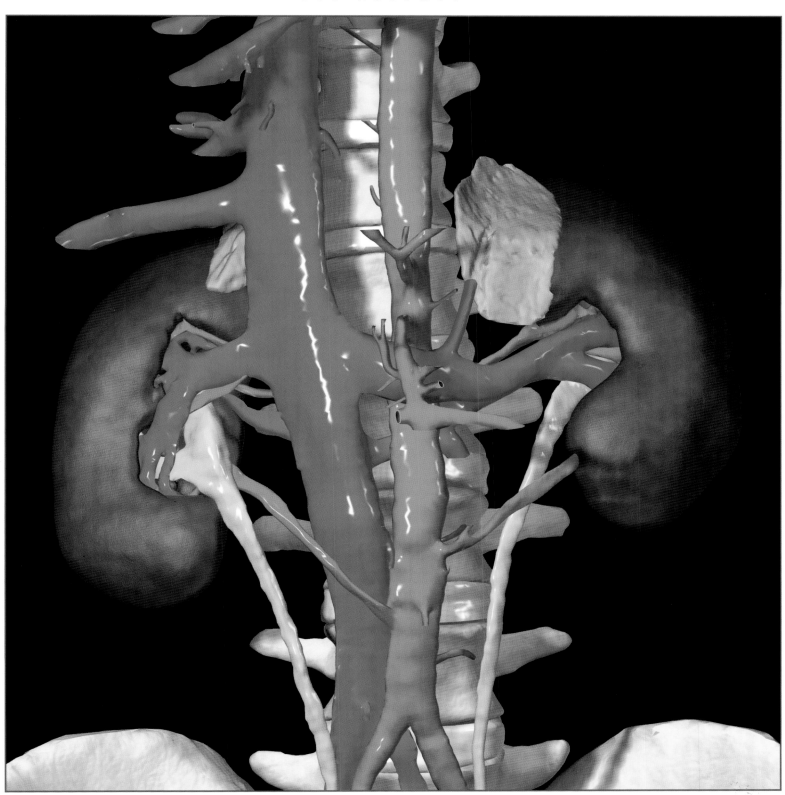

Close-up view of the kidneys and adrenal glands with the surrounding organs removed. Acting as the body's filtration system, the kidneys have a very rich blood supply.

KEY

1. Inferior vena cava
2. Vertebral column
3. Intervertebral disc
4. Abdominal aorta
5. Left adrenal gland
6. Left kidney
7. Left renal artery
8. Left renal vein
9. Left ureter

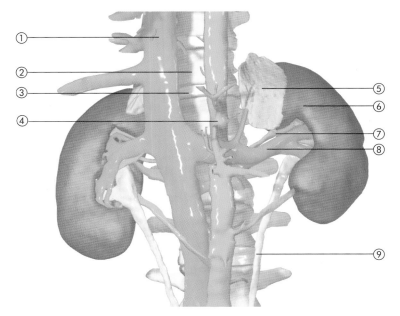

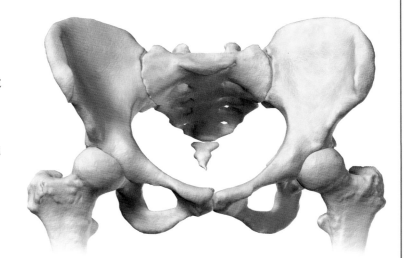

THE PELVIS, OR PELVIC REGION, IS THE LOWEST PART OF THE TRUNK AND IS SITUATED BETWEEN THE ABDOMEN (*see page* 186) AND THE JUNCTION BETWEEN THE TRUNK AND THE LOWER LIMBS. INTERNALLY, THE PELVIC REGION IS SUPPORTED BY A BONY FRAMEWORK FORMED ANTERIORLY AND LATERALLY BY THE PELVIC GIRDLE, AND POSTERIORLY BY THE SACRUM AND COCCYX AT THE BASE OF THE BACKBONE (*see page* 46). COLLECTIVELY THE TWO COXAE (HIP BONES), WHICH MAKE UP THE PELVIC GIRDLE, AND THE SACRUM AND COCCYX ARE CALLED THE PELVIS (*see page* 55).

THE PELVIS

The bony pelvis surrounds the pelvic cavity, the funnel-shaped lower section of the abdominopelvic cavity, and provides protection for the organs contained within it. Pelvic organs include the sigmoid colon, rectum, and anal cavity, the final sections of the alimentary canal (*see page 136*); the urinary bladder, the lower parts of the ureters, and the urethra (*see page 148*); and the internal reproductive organs (*see pages 152–159*). As in the abdominal cavity, much of the cavity's lining is covered by parietal peritoneum, and some of the organs by visceral peritoneum; however, some organs, such as the bladder, are **retroperitoneal**.

Unlike most other parts of the body, male and female pelvic regions are anatomically distinct because of differences in the shape and size of the pelvis, and because male and female reproductive organs are completely different. The lower opening of the pelvis—the pelvic outlet—is closed by pelvic floor muscles—or the pelvic diaphragm. These muscles support the organs of the pelvic cavity and prevent them being pushed downward by pressure from the abdominal organs above them.

As well as protecting and supporting pelvic organs, the bony pelvis also provides a large surface for the attachment of both trunk and leg muscles. Muscles passing from the pelvis to the legs include the iliacus, the prime mover of hip flexion; the adductors, which adduct and laterally rotate the thigh; the quadriceps, which extend the knee and flex the thigh at the hip; the gluteal (buttock) muscles, which extend the thigh; and the hamstrings, which extend the thigh and flex the knee. Muscles passing from pelvis to trunk include the muscles of the anterior and lateral abdominal wall, which hold the abdominal organs in place and flex and rotate the trunk; and the muscles of the lower back, which extend and support the trunk.

The large surface area of the bony pelvis houses and protects the delicate organs within. It also provides maximum surface area for muscular attachment.

All the images in this chapter are of the female pelvis.

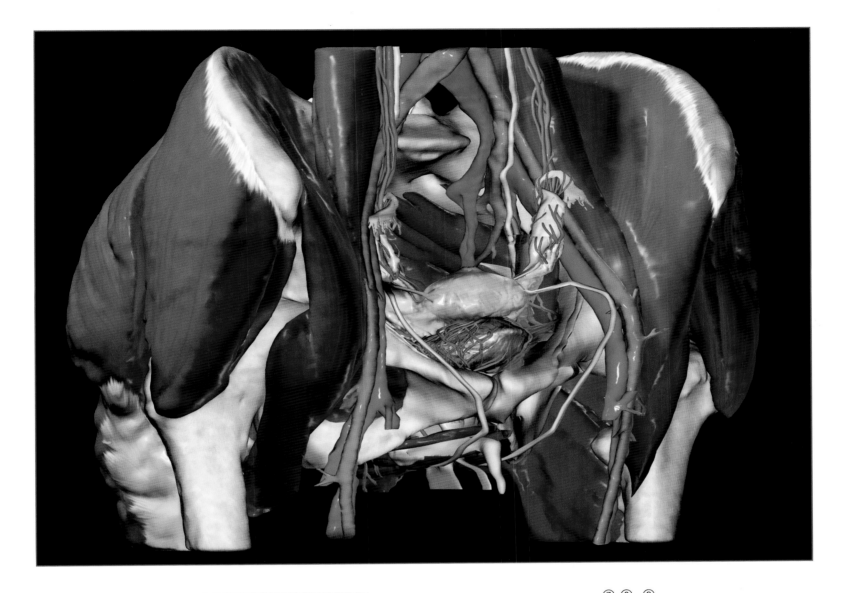

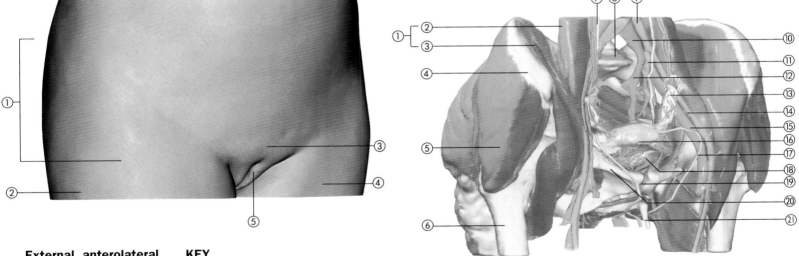

External, anterolateral view of the female pelvis from the right side shows the pelvis as the area between the abdomen and the junction of the trunk with the lower limbs. Between the legs the labia majora border the vulva and surround the openings of the urethra and the vagina.

KEY

1. Pelvis
2. Right leg
3. Mons veneris
4. Left leg
5. Labium majus

Anterolateral view of the female pelvis with the skin and superficial muscles removed.

KEY

1. Iliopsoas
2. Psoas
3. Iliacus
4. Iliac crest
5. Tensor fasciae latae
6. Femur
7. Ureter (right)
8. Sacrum
9. Common iliac artery
10. Common iliac vein
11. Internal iliac artery
12. Internal iliac vein
13. Ovary
14. External iliac artery
15. External iliac vein
16. Uterus
17. Round ligament of uterus
18. Urinary bladder
19. Pubic symphysis
20. Pubis
21. Clitoris

THE URINARY BLADDER STORES THE URINE THAT IS CONTINUOUSLY PRODUCED BY THE KIDNEYS (*see pages* 150 *and* 200) AND DELIVERED BY THE URETERS. THIS RETROPERITONEAL ORGAN IS, IN THE MALE, LOCATED ANTERIOR TO THE RECTUM AND POSTERIOR TO THE PUBIC SYMPHYSIS (*see page* 155), AND IS HELD IN PLACE BY THE PARIETAL PERITONEUM. WHEN EMPTY, THE BLADDER HAS A COLLAPSED, FLATTENED APPEARANCE, BUT ON FILLING IT BECOMES FIRST SPHERICAL AND THEN PEAR-SHAPED. AT ITS BASE, THE BLADDER EMPTIES INTO THE URETHRA, THE TUBE THAT CARRIES URINE TO THE OUTSIDE. URINE RELEASE IS CONTROLLED BY TWO SPHINCTER MUSCLES: AN INVOLUNTARY INTERNAL URETHRAL SPHINCTER AT THE BLADDER/URETHRA JUNCTION; AND A VOLUNTARY EXTERNAL URETHRAL SPHINCTER, WHERE THE URETHRA PASSES THROUGH THE MUSCLES OF THE UROGENITAL DIAPHRAGM.

THE PELVIS

The male urethra is about 20 cm (8 in) long, opens at the tip of the penis, and has three sections. The prostatic urethra extends about 2.5 cm (1 in) from the base of the bladder and is surrounded by the prostate gland, part of the reproductive system (*see page* 152). The membranous urethra is about 2 cm (¾ in) long and runs through the urogenital diaphragm. The remaining, longest section of the urethra is the penile or spongy urethra, which runs the length of penis and is surrounded by the corpus spongiosum (*see page* 155).

The primary male sex organs—the sperm-producing testes and the penis—lie outside the pelvis (*see pages* 152–155). The male internal reproductive structures are the ducts that link the testes to the penis, and the accessory glands that release secretions. The vas deferens, which carries sperm from testis to penis, loops over the pubic bone, arches over the ureter, and passes down the posterior edge of the bladder before joining the urethra within the prostate gland (*see page* 155). Just before this junction it joins the seminal vesicle to form a wider section, the ejaculatory duct. The seminal vesicles produce about 60 percent of semen and supply sperm with nutrients. The seminal secretions mix with sperm in the ejaculatory ducts just prior to ejaculation. The prostate gland has one-way trapdoorlike openings that release prostate secretions, which make up over 30 percent of semen, into the seminal fluid/sperm mixture as it is pumped into the prostatic urethra just before ejaculation. Two bulbourethral glands, one on either side of the spongy urethra at the base of the penis, release a clear, mucuslike secretion into the urethra during sexual arousal. This secretion neutralizes the normally acidic urethra and makes it more "sperm-friendly".

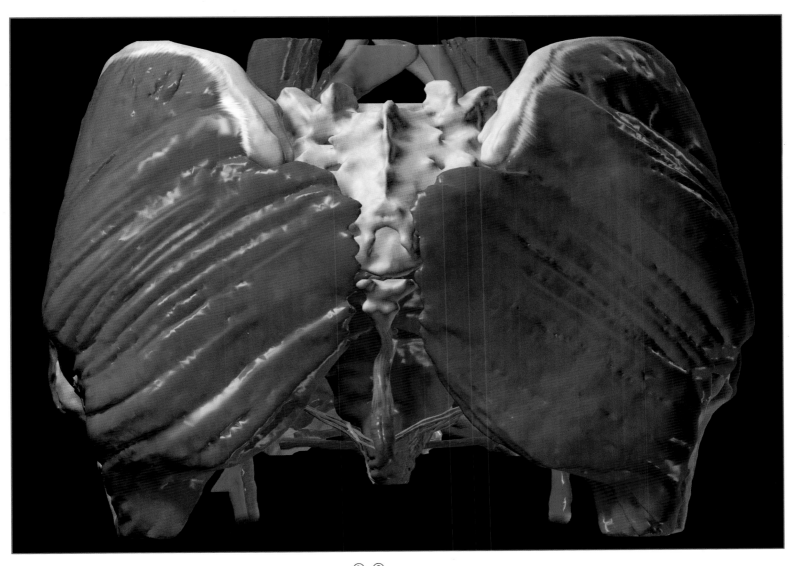

KEY

1. Common iliac artery
2. Common iliac vein
3. Iliac crest
4. Gluteus medius
5. Sacrum
6. Gluteus maximus
7. Coccyx
8. Levator ani muscle
9. Anus

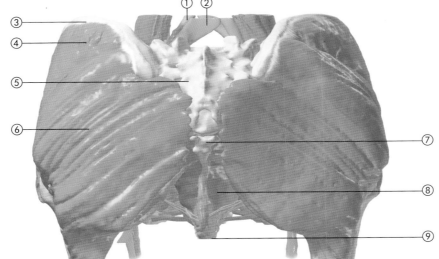

Posterior view of the female pelvis. The large gluteal muscles extend the leg at the hip during power movements such as climbing and jumping. The sacrum and coccyx, the lowest part of the vertebral column, link with the two coxal (hip) bones of the pelvic girdle to form the pelvis.

I N COMPARISON WITH THE MALE REPRODUCTIVE SYSTEM, MORE OF THE FEMALE REPRODUCTIVE ORGANS—INCLUDING THE PRIMARY SEX ORGANS, THE OVARIES—ARE LOCATED WITHIN THE PELVIC CAVITY. THE TWO ALMOND-SIZED, EGG-RELEASING OVARIES ARE LOCATED ON EACH SIDE OF THE UTERUS. EACH OVARY IS SUPPORTED BY A **SUSPENSORY LIGAMENT** THAT ANCHORS IT LATERALLY TO THE PELVIC WALL, AND BY AN **OVARIAN LIGAMENT**, THAT LINKS IT MEDIALLY TO THE

THE PELVIS

UTERUS. THE SUSPENSORY LIGAMENT IS PART OF A FOLD OF PERITONEUM CALLED THE **BROAD LIGAMENT** THAT ALSO SUPPORTS THE UTERINE TUBES, UTERUS, AND VAGINA.

The uterine (fallopian) tubes are narrow ducts, each about 10 cm (4 in) long, that carry eggs from the ovaries to the uterus and provide the site for fertilization. The distal end of each uterine tube expands to form fingerlike structures called fimbriae that surround, but do not form a direct link to, part of the ovary. Each month an egg is released into the peritoneal cavity and is "captured" by the fimbriae and conducted along a uterine tube by the beating action of the tiny hairlike cilia that line it.

The uterus is shaped like an inverted pear and lies posterior to the bladder and anterior to the rectum. This muscular organ is held in place by the **mesometrium**, part of the broad ligament and round ligaments, which secure it to the anterior body wall. The main part of the uterus is its body; the upper section where the uterine tubes join is the fundus; the lower, narrower **isthmus** leads into the cervix or neck of the uterus, which links it to the vagina. Surrounding the uterus is the **perimetrium**, a layer of visceral peritoneum.

Linking the uterus to the outside is the vagina. The vagina receives the penis during sexual intercourse, and carries the baby during birth and menstrual flow during a period. It is a thin-walled muscular tube between 8 and 10 cm (3 and 4 in) long. It is normally flattened, but expands considerably during childbirth and sexual intercourse. Its opening lies within the vulva, the external part of the female reproductive system.

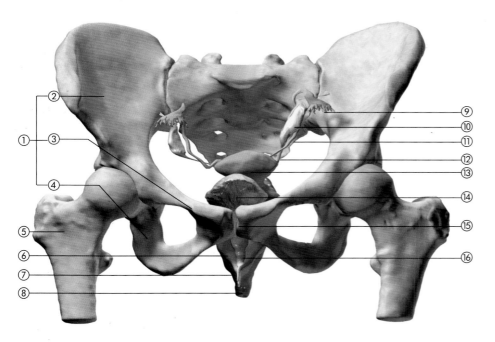

KEY

① Coxal bone
② Ilium
③ Pubis
④ Ischium
⑤ Femur
⑥ Vagina
⑦ Rectum
⑧ Anus
⑨ Fimbriae
⑩ Ovary
⑪ Uterine (Fallopian) tube
⑫ Ovarian ligament
⑬ Uterus
⑭ Urinary bladder
⑮ Pubic symphysis
⑯ Urethra

Anterior view of the female pelvis showing the reproductive organs and the urinary bladder. This aspect emphasizes the protective role of the bony pelvis since it completely encompasses these soft organs.

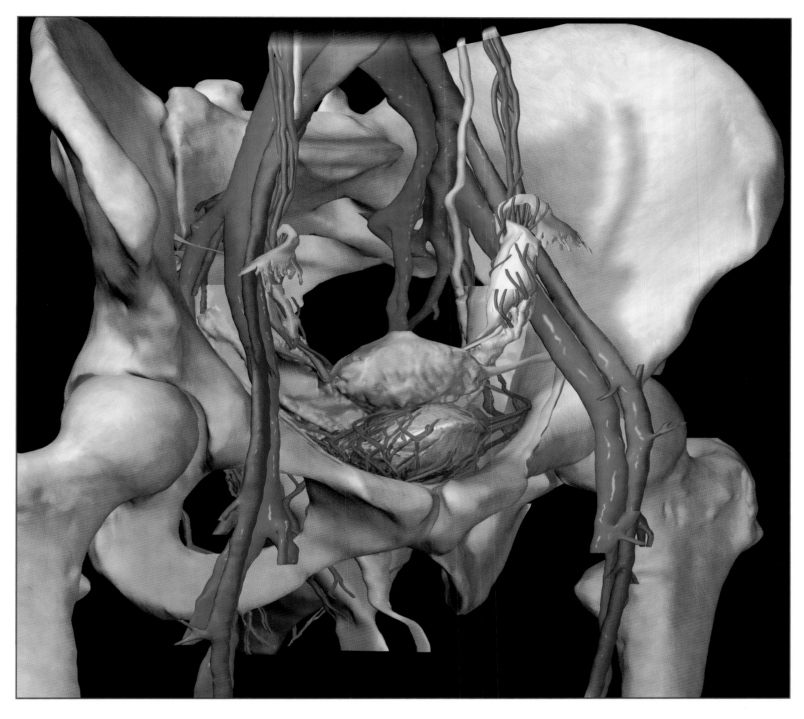

Anterolateral view of the female pelvis from the right side with the skin and muscles removed. Curving around the reproductive and urinary organs in the pelvis are the iliac arteries and veins, branches of the aorta and inferior vena cava that carry blood to and from the pelvic organs and the lower limbs.

KEY

1. Sacrum
2. Sacroiliac joint
3. Ilium
4. Pubis
5. Ischium
6. Coxal (hip) bone
7. Femur
8. Common iliac vein
9. Common iliac artery
10. Ureter
11. Internal iliac vein
12. Internal iliac artery
13. Fimbriae
14. Ovary
15. Uterine (fallopian) tube
16. Uterus
17. Urinary bladder
18. Urethra
19. Vagina
20. Rectum

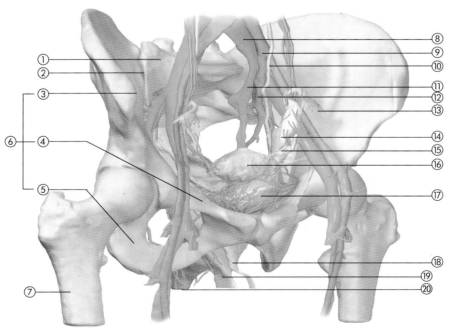

IN THE FEMALE, THE BLADDER LIES POSTERIOR TO THE PUBIC SYMPHYSIS AND ANTERIOR TO THE VAGINA AND UTERUS. THE UPPER SURFACE IS COVERED BY PERITONEUM, BUT THIS FORMS A FOLD BEHIND THE BLADDER AND IN FRONT OF THE NECK OF THE UTERUS TO FORM THE **VESICOUTERINE POUCH**. TYPICALLY, A FEMALE BLADDER IS SMALLER THAN A MALE'S BECAUSE OF THE ADDITIONAL SPACE OCCUPIED IN THE PELVIC CAVITY BY THE UTERUS.

THE PELVIS

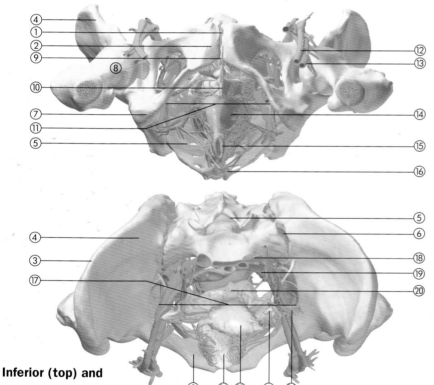

Inferior (top) and superior (bottom) views of the female pelvis with the skin and muscles removed. The inferior margin of the pelvis—the pelvic outlet—is wider in women than in men, an adaptation for childbirth. The structures visible here are normally held in place by the pelvic floor muscles that span the pelvic outlet.

KEY

① Pubic symphysis
② Pubis
③ Iliac crest
④ Ilium
⑤ Sacrum
⑥ Sacroiliac joint
⑦ Ischium
⑧ Head of femur
⑨ Urethra
⑩ Vagina
⑪ Pelvic outlet
⑫ Femoral artery
⑬ Femoral vein
⑭ Rectum
⑮ Anus
⑯ Coccyx
⑰ Pelvic inlet
⑱ Common iliac vein
⑲ Common iliac artery
⑳ Broad ligament
㉑ Urinary bladder
㉒ Uterus
㉓ Ovary
㉔ Fimbriae

As in the male, the urethra exits from the base of the bladder, where there is an internal sphincter muscle, and passes through the urogenital diaphragm (see below), where there is an external sphincter muscle. Between 3 and 4 cm (1¼ and 1½ in) long the female urethra is much shorter than the male; it also plays no part in the female reproductive system. Bound tightly to the anterior vaginal wall by connective tissue, the urethra opens through an external meatus or opening, which lies posterior to the clitoris and anterior to the vagina within the vulva.

The pelvic floor and perineum in males and females

The pelvic outlet—the lower opening of the pelvis— is closed by pelvic floor and perineal muscles that also support the pelvic organs and control the flow of urine, semen, and feces. There are, essentially, three layers of muscles involved here. The superior pelvic floor muscles, or pelvic diaphragm, consist of two paired muscles—the levator ani and the coccygeus—that elevate the pelvic floor, resist intra-abdominal pressure, and help to constrict the anus. Below the pelvic diaphragm is the perineum, the diamond-shaped area between thighs and buttocks. Within the perineum and inferior to the pelvic diaphragm is the urogenital diaphragm—the deep perineus and the external sphincter—that surrounds the urethra and controls the release of urine, as well as helping to expel the last drops of urine in both sexes and, in men, semen. Superficial to the urogenital diaphragm, and covered by the skin of the perineum are, anteriorly, the bulbospongiosus and ischiocavernosus muscles. These help squeeze out remaining drops of urine in both sexes; aid erection of the penis and push out semen in the male; assist in the erection of the clitoris; and close the vaginal opening in the female. Posteriorly is the external anal sphincter, which permits voluntary control of defecation.

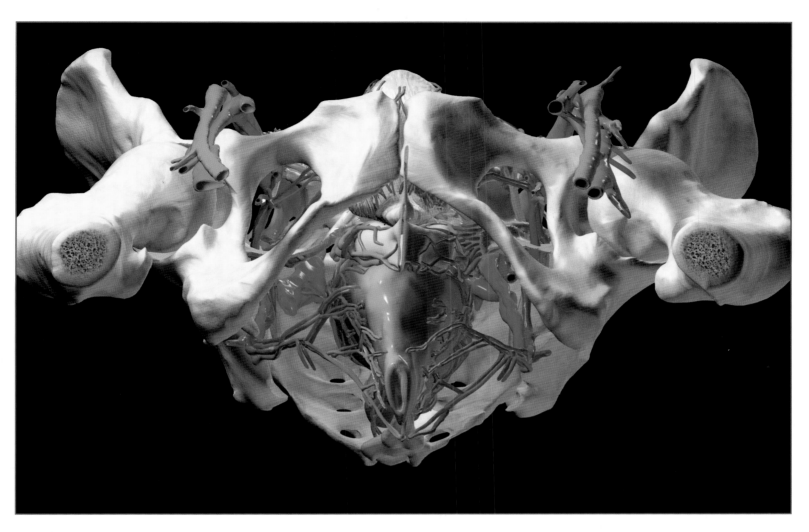

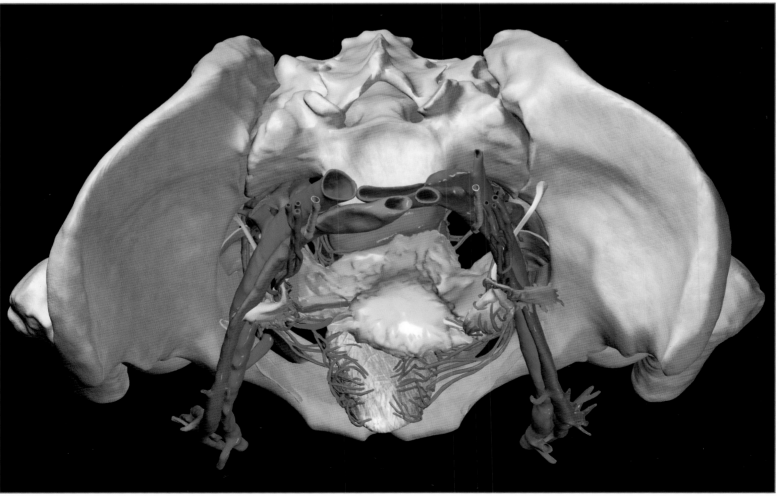

THE VERSATILE UPPER LIMB CAN PERFORM A WIDE RANGE OF MOVEMENTS. ITS BONY FRAMEWORK IS FORMED BY THE HUMERUS (UPPER ARM BONE), RADIUS AND ULNA (FOREARM BONES), AND THE CARPALS, METACARPALS, AND PHALANGES (HAND BONES). PROXIMALLY, THE HUMERUS ARTICULATES WITH THE SCAPULA IN THE SHOULDER AT A BALL AND SOCKET JOINT THAT PERMITS MOVEMENT IN ALL PLANES. DISTALLY, THE HUMERUS ARTICULATES WITH THE RADIUS AND

THE ARM AND ELBOW

ULNA AT THE ELBOW, OR CUBITAL ARTICULATION. THIS INCLUDES A HINGE JOINT BETWEEN THE HUMERUS AND THE RADIUS AND ULNA, WHICH PERMITS ONLY FLEXION AND EXTENSION, AND A PIVOT JOINT BETWEEN THE HEADS OF THE RADIUS AND ULNA, WHICH PERMITS ROTATION OF THE FOREARM. THE COMBINED EFFECTS OF THE JOINTS IS EXEMPLIFIED BY A TENNIS SERVE: THE SHOULDER JOINT ALLOWS THE ARM TO MOVE THROUGH A WIDE ARC, THE ELBOW ALLOWS THE ARM TO BEND AND THEN STRAIGHTEN DURING THE SERVE, WHILE THE FINGERS GRIP THE RACKET.

Two sets of muscles serve the upper arm and elbow. Nine muscles cross the shoulder joint and insert into the humerus: the pectoralis major, latissimus dorsi, and deltoid are prime movers of arm movement and are assisted by the teres major and corachobrachialis; the supraspinatus, infraspinatus, teres minor, and subscapularis (rotator cuff muscles) stabilize the flexible but also unstable shoulder joint. The second set of muscles are those that cross the elbow joint. The anterior forearm muscles—the biceps brachii, brachialis, and brachioradialis—flex the elbow; the posterior forearm muscles—the triceps brachii and anconeus—extend the elbow.

The main nerves supplying the upper arm are the musculocutaneous nerve, which serves the flexor muscles of the anterior arm; and the axillary nerve, which serves deltoid and teres minor muscles. The median, ulnar, and radial nerves pass through the upper arm to the forearm, although the latter also serves the triceps brachii.

Blood enters the upper arm through the axillary artery, which, as it passes through the axilla (armpit), becomes the brachial artery. This supplies the anterior forearm muscles while its branch, the deep brachial artery, supplies the posterior triceps brachii. Immediately below the elbow the brachial artery divides to form the radial and ulnar arteries. Blood drains from the upper arm through the brachial, cephalic, and basilic veins, which unite in the shoulder to form the axillary vein.

Posterior view of the right arm showing the muscles of the shoulder and upper arm and some superficial arteries and veins.

KEY

1. Spine of scapula
2. Teres minor
3. Infraspinatus
4. Teres major
5. Triceps brachii (long head)
6. Tendon of triceps brachii
7. Deltoid
8. Triceps brachii (lateral head)
9. Superficial veins

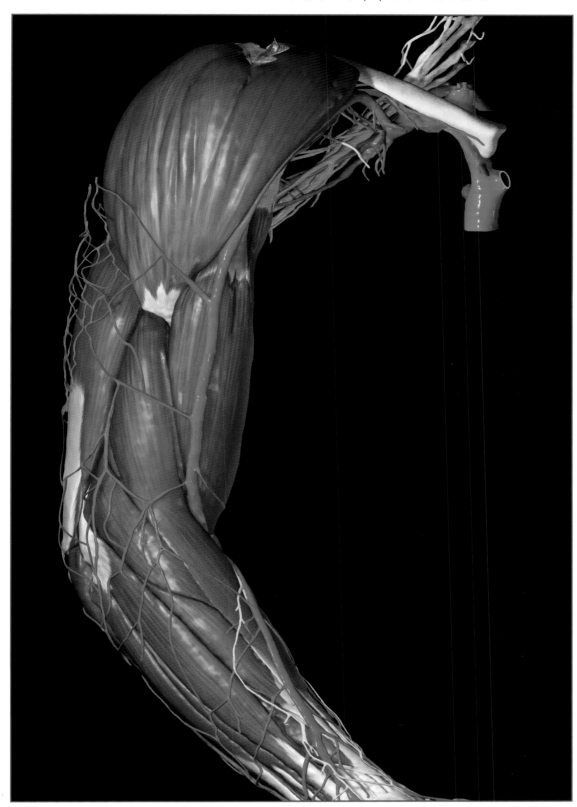

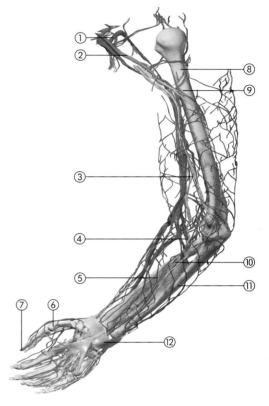

Posterior view of the right arm showing the bones and major arteries and veins.

KEY

① Cephalic vein
② Axillary artery
③ Brachial artery
④ Radial artery
⑤ Radius
⑥ Metacarpal of thumb
⑦ Distal phalanx of thumb
⑧ Humerus
⑨ Deep brachial artery
⑩ Ulnar artery
⑪ Ulna
⑫ Extensor reticulum

Lateral view of the right arm showing the muscles of the shoulder, upper arm and part of the forearm and the major veins.

KEY

① Deltoid
② Cephalic vein
③ Triceps brachii (medial head
④ Extensor digitorum
⑤ Clavicle
⑥ Subclavian vein
⑦ Superior vena cava
⑧ Axillary vein
⑨ Axillary artery
⑩ Brachialis
⑪ Biceps brachii
⑫ Brachioradialis
⑬ Extensor carpi radialis longus
⑭ Extensor carpi radialis brevis

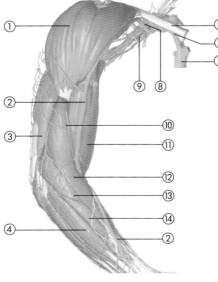

A COMPLEX NETWORK OF BONES, MUSCLES, NERVES, AND BLOOD VESSELS MAKES THE FOREARM AND HAND THE MOST EFFICIENT AND VERSATILE MANIPULATIVE DEVICE TO BE FOUND IN THE ANIMAL KINGDOM. UNDERPINNING THIS LOWER PART OF THE UPPER LIMB IS A FRAMEWORK OF 29 BONES. THE FOREARM BONES, RADIUS AND ULNA, HAVE PIVOT JOINTS AT THEIR PROXIMAL AND DISTAL ARTICULATIONS THAT PERMIT THE PALM OF THE HAND TO BE TURNED UPWARD OR DOWNWARD. THE HAND ITSELF CONSISTS OF 27 BONES (*see page* 52), THAT MAKE UP THE WRIST, PALM, AND FINGERS. WHERE THE RADIUS MEETS THE WRIST BONES IT FORMS A CONDYLOID JOINT THAT PERMITS MOVEMENT IN MOST PLANES.

THE FOREARM AND HAND

KEY

1. Radius
2. Radial artery
3. Palmar digital arteries
4. Ulna
5. Interosseous membrane
6. Ulnar artery
7. Extensor retinaculum
8. Palmar aponeurosis

Anterior view of the right forearm and hand showing the radius and ulna, and the interosseous membrane that links them, and the main arteries.

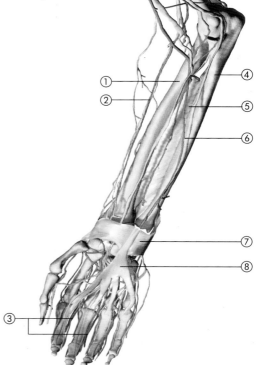

The wrist and fingers are moved primarily by the muscles of the forearm (*see page 80*). These muscles taper into long tendons that insert into the wrist, palm or fingers. Muscles of the anterior forearm are mostly flexors; they include wrist flexors, such as the flexor carpi radialis, and finger flexors, such as the flexor digitorum superficialis. Muscles of the posterior forearm are mainly extensors; they include wrist extensors, such as the extensor carpi ulnaris, and finger extensors, such as the extensor digitorum.

The main nerves passing along the forearm are the ulnar nerve, which follows the ulna along the medial forearm into the hand, the radial nerve, which follows the radius along the lateral side of the forearm, and the median nerve, which runs in the anterior forearm between these other two nerves.

The action of most flexor muscles of the forearm is controlled by the median nerve, although the flexor carpi ulnaris is controlled by the ulnar nerve. The radial nerve controls most of the extensor muscles of the forearm.

Blood is carried into the forearm by the branches of the brachial artery: the radial artery supplies the lateral muscles of the forearm while the ulnar artery supplies the medial muscles. Blood is drained from the forearm by the three superficial veins—the cephalic vein, which runs laterally, the basilic vein, which runs medially, and the median vein, which is located between the other two and merges with one of them at the elbow—and two deep veins—the radial vein and ulnar vein—that follow the course of the radius and ulna, respectively.

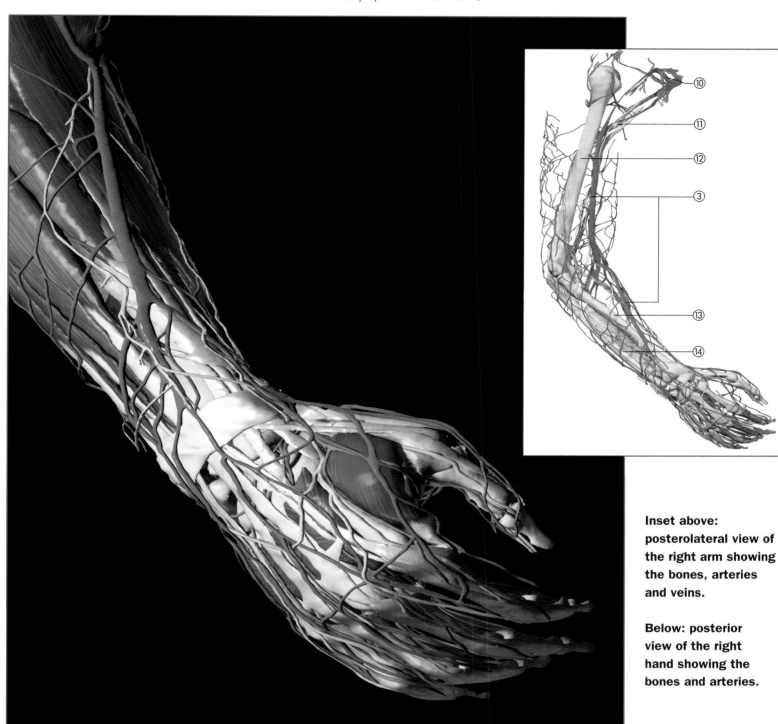

Inset above:
posterolateral view of
the right arm showing
the bones, arteries
and veins.

Below: posterior
view of the right
hand showing the
bones and arteries.

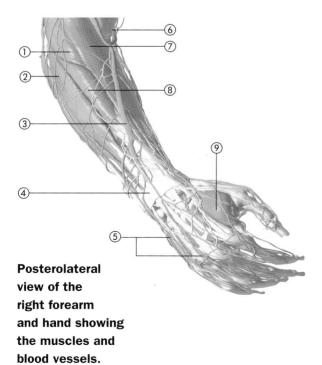

Posterolateral
view of the
right forearm
and hand showing
the muscles and
blood vessels.

KEY

① Extensor carpi radialis
 longus
② Extensor digitorum
③ Cephalic vein
④ Extensor retinaculum
⑤ Dorsal venous network of
 hand
⑥ Anticubital vein
⑦ Brachioradialis
⑧ Extensor carpi radialis
 brevis
⑨ 1st dorsal interosseous
⑩ Axillary vein
⑪ Brachial artery
⑫ Humerus
⑬ Radius
⑭ Ulnar
⑮ Palmar digital arteries

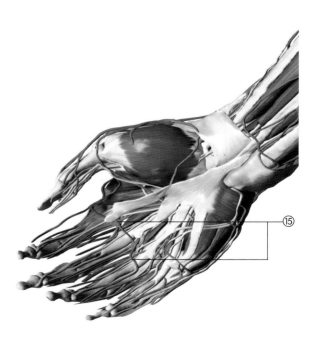

FROM THREADING A NEEDLE TO LIFTING A BARBELL, THE HAND CAN PERFORM A WIDE RANGE OF GRIPPING MOVEMENTS THAT INVOLVE VARYING DEGREES OF POWER AND PRECISION. THE SKIN OF THE FINGERS AND PALM ARE ALSO WELL ENDOWED WITH SENSORY RECEPTORS THAT MAKE THE HANDS AMONG THE MOST SENSITIVE PARTS OF THE BODY.

THE HAND

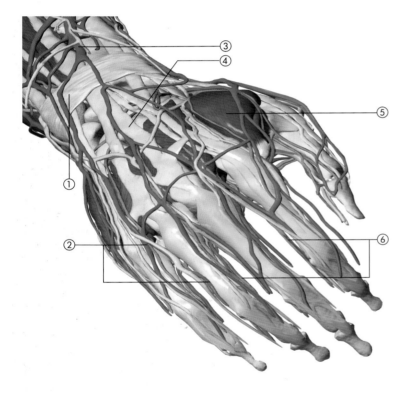

The versatility of movement and grip shown by the hand is underpinned by its bony framework. Twenty-seven bones make up the hand: 8 carpals (wrist bones), 5 metacarpals (palm bones), and 14 phalanges (finger bones). Plane joints between carpal bones and between the carpals and metacarpals of digits 2–5 (digit 1 is the thumb), allow small gliding movements but collectively they provide a flexible bridge between wrist and fingers. The metacarpophalangeal (knuckle) joints between the metacarpals and digits 2–5 are condyloid joints that allow movement in two planes. The joints

Posterior (palm down) view of the hand showing the muscles and major superficial blood vessels.

KEY

1. Extensor retinaculum
2. Dorsal digital veins
3. Cephalic vein
4. Tendon of extensor digitorum
5. Dorsal interosseous
6. Dorsal digital arteries

between phalanges are hinge joints that allow movement in just one plane. Between the carpals and the metacarpal of the thumb is a saddle joint that allows flexion and extension, abduction and adduction, and **opposition** and **reposition**. This latter set of movements allows the tip of the thumb to oppose (touch) the tips of all other digits, something that is vitally important in precise movements.

The main movers of the hand, the flexor and extensor muscles of the forearm (*see page 80*), are assisted by intrinsic muscles inside the hands. Five lumbrical muscles, and seven deeper interosseal muscles (4 dorsal and 3 palmar) flex the knuckles but extend the fingers. In addition, the dorsal interosseals abduct (spread) the fingers, and the palmar interosseals adduct (close) the fingers. At the base of the thumb are three muscles that move it: the abductor pollicis abducts the thumb, the flexor pollicis brevis flexes the thumb, and the opponens pollicis rolls the thumb toward the midline.

The median and ulnar nerves continue into the hand from the forearm. The median nerve serves the intrinsic muscles and the skin of the lateral part of the hand, while the ulnar nerve serves the other intrinsic muscles and the skin of the medial hand.

In the palm of the hand, branches of the radial and ulnar arteries **anastomose** (join) to form two palmar arches, one deep and one superficial, that loop around the palm. Metacarpal and digital arteries, which supply the fingers, arise from the palmar arches. Deep and superficial venous arches drain oxygen-poor blood into the radial and ulnar veins, while in the dorsum (upper part) of the hand, the dorsal venous arch drains blood into the cephalic, median, and basilic veins of the forearm.

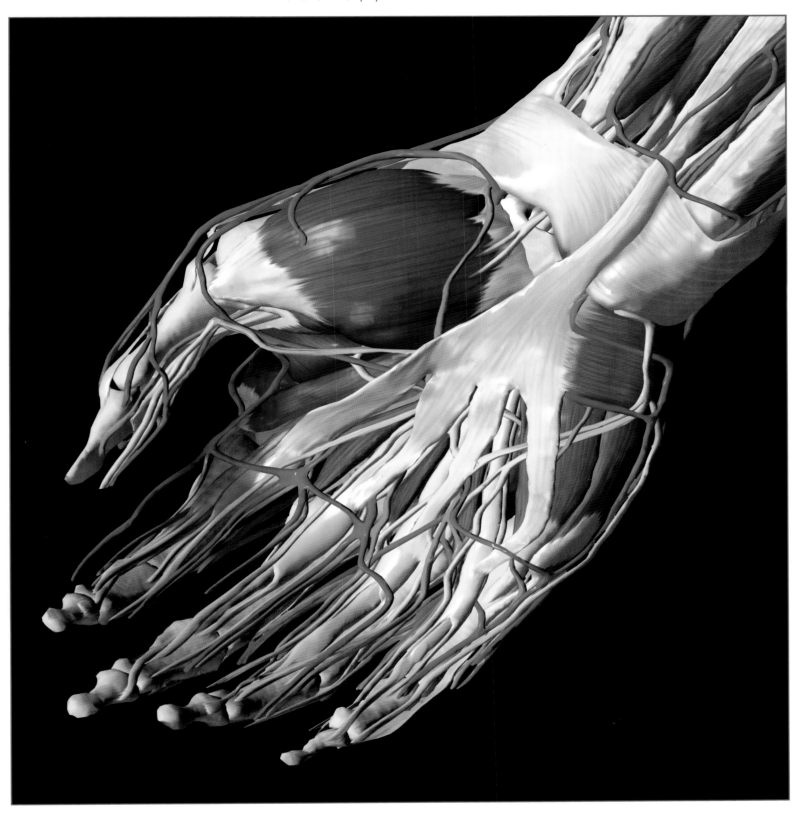

Anterior (palm up) view of the hand showing the muscles, arteries, and veins.

KEY

① Radial artery

② Abductor pollicis brevis

③ Lumbrical

④ Phalanges of third digit

⑤ Ulnar artery

⑥ Superficial palmar arterial arch

⑦ Palmar aponeurosis

⑧ Abductor digiti minimi

⑨ Metacarpal of third digit

⑩ Palmar digital veins

⑪ Palmar digital arteries

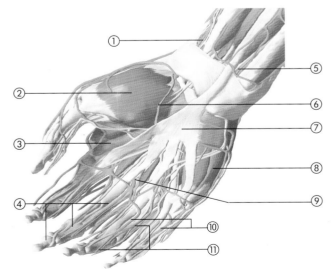

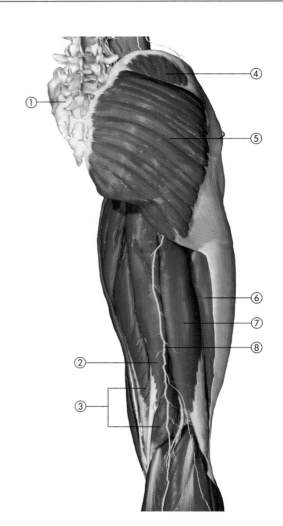

THE LOWER LIMBS SUPPORT THE WEIGHT OF THE BODY, MOVE

IT, AND WITHSTAND CONSIDERABLE FORCES DURING

MOVEMENT. THESE FUNCTIONS ARE REFLECTED IN THE LOWER

LIMB'S CONSTRUCTION. COMPARED TO THE UPPER LIMB, THE BONES OF

THE LOWER LIMB ARE THICKER AND ITS MUSCLES ARE LARGER AND

STRONGER. EACH LIMB HAS THREE SECTIONS: THE THIGH, WHICH

EXTENDS FROM PELVIS TO KNEE; THE LEG, WHICH EXTENDS FROM KNEE

TO ANKLE; AND THE FOOT.

THE THIGH AND KNEE

The femur, or thigh bone, articulates with the pelvis at the hip joint, a ball and socket joint that lacks the flexibility of the shoulder joint, but is more stable. At the knee the femur articulates with the tibia in a hinge joint that permits flexion and extension. The knee joint is reinforced by strong ligaments and is protected anteriorly by the patella or kneecap (*see page 56*).

Muscles that move the leg have their origins in the pelvis and either cross the hip joint to insert into the femur, or cross both hip and knee joints to insert into the tibia (*see pages 86–89*). Muscles of the anterior thigh, notably the powerful quadriceps femoris, typically flex the thigh at the hip and extend the limb at the knee producing the forward swing of the lower limb during walking. Muscles of the medial thigh are adductors that pull the leg medially. Muscles of the posterior thigh, notably the hamstring muscles, typically extend the thigh at the hip and flex the limb at the knee producing the backward swing of the lower limb during walking. The gluteal, or buttock, muscles are major hip extensors that are used during climbing and running.

Nerves supplying the lower limb arise from the lumbar and sacral plexuses. From the lumbar plexus, the femoral nerve serves the anterior thigh muscles and the skin of the anterior thigh; the obturator nerve serves the adductor muscles and the skin of the medial thigh; and the lateral femoral cutaneous nerve serves the skin of the lateral thigh. From the sacral plexus, the sacral nerve serves the hamstrings; the superior and inferior gluteal nerves serve the gluteal muscles; and the posterior femoral cutaneous nerve serves the skin of the buttocks and posterior thigh.

Blood is supplied to the muscles of the thigh by the external iliac artery, which becomes the femoral artery as it enters the thigh, and to the gluteal and adductor muscles by the internal iliac artery. The femoral artery becomes the popliteal artery as it approaches the knee. Blood is drained from the thigh through the femoral vein, which becomes the external iliac vein as it enters the pelvis, and superficially by the great saphenous vein.

Posterior view of the pelvis and thigh showing the muscles.

KEY

1. Sacrum
2. Semitendinosus
3. Semimembranosus
4. Gluteus medius
5. Gluteus maximus
6. Vastus lateralis
7. Biceps femoris
8. Posterior femoral cutaneous nerve

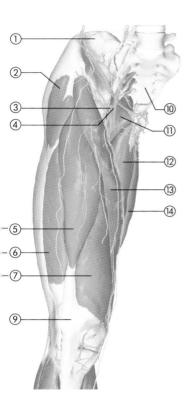

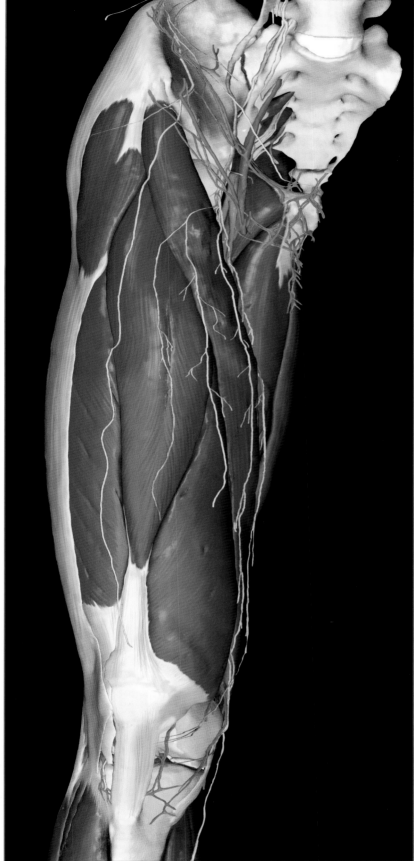

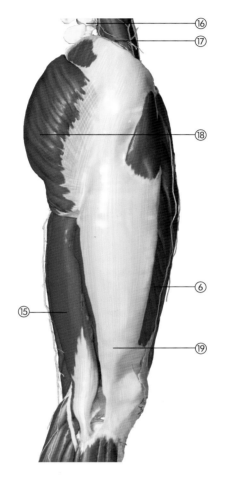

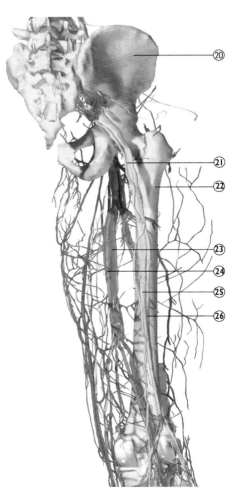

Above and center: anterior view of the thigh showing the muscles and, where the muscles are removed at the hip, the blood vessels.

Far right, top: lateral view of the right leg showing the muscles.

Far right, bottom: anterior view of the right leg showing the bones and the main arteries and veins.

KEY

1. Ilium
2. Tensor fasciae latae
3. Femoral artery
4. Femoral vein
5. Rectus femoris
6. Vastus lateralis
7. Vastus medialis
8. Quadriceps femoris
9. Patella

10. Sacrum
11. Pectineus
12. Adductor longus
13. Sartorius
14. Gracilis
15. Biceps femoris
16. Vertebral column
17. Iliac crest
18. Gluteus maximus

19. Iliotibial tract
20. Pelvis
21. Sciatic nerve
22. Femur
23. Femoral vein
24. Femoral artery
25. Tibial nerve
26. Common peroneal nerve

THE BONY FRAMEWORK OF THE LEG CONSISTS OF TWO PARALLEL BONES, THE TIBIA AND

FIBULA (*see page* 56). THE LARGER OF THE TWO, THE TIBIA, ARTICULATES PROXIMALLY

WITH THE FEMUR AT THE KNEE, AND DISTALLY WITH THE TALUS, A FOOT BONE, AT THE

ANKLE. BOTH OF THESE JOINTS ARE HINGE JOINTS THAT ALLOW FLEXION AND EXTENSION ONLY.

TIBIA AND FIBULA ARE BOUND BY AN INTEROSSEOUS MEMBRANE AND, ALTHOUGH THEY ARTICULATE

PROXIMALLY AND DISTALLY, THESE JOINTS, UNLIKE THOSE BETWEEN ULNA AND RADIUS IN THE

FOREARM, DO NOT ALLOW MOVEMENT. WHILE THE FOREARM IS ADAPTED FOR FLEXIBILITY AND

MOBILITY, THE LEG—SPECIFICALLY THE TIBIA—IS ADAPTED FOR STABILITY AND WEIGHT-BEARING;

THE FIBULA IS NOT WEIGHT-BEARING AND SERVES TO HELP STABILIZE THE ANKLE JOINT. THE FOOT

SUPPORTS THE BODY AND ACTS AS A LEVER TO PUSH THE BODY FORWARD DURING MOVEMENT.

THE LEG & FOOT

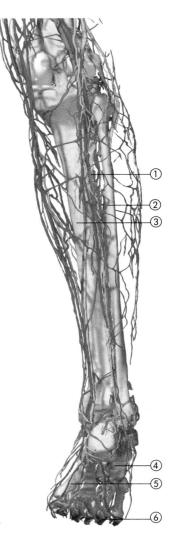

The muscles of the leg move the ankle and foot. Most leg muscles have their origin in the leg itself and, like the forearm muscles, taper into long tendons that cross the ankle and insert into foot bones (*see page 88*). The muscles are bound by a sock-like connective tissue fascia that stops them swelling excessively during exercise, and extend inward to form three compartments—anterior, posterior, and lateral—each with its own nerve and blood supply. The anterior leg muscles dorsiflex (bend upward) the foot to prevent the toes dragging along the ground while walking; two extensor muscles also straighten the toes. The more powerful posterior leg muscles plantar flex (bend downward) the foot thereby providing the thrust for movement; the flexor muscles also bend the toes. The lateral peroneal muscles plantar flex and evert (turn outward) the foot.

Nervous supply to the leg is provided by the two components of the sciatic nerve, the common peroneal and tibial nerves, which divide just above the knee. The common peroneal nerve branches to form the deep peroneal nerve, which serves the

anterior muscles and skin, and the superficial peroneal nerve, which serves the lateral muscles and skin. The tibial nerve serves the posterior muscles and skin.

Arterial blood is supplied by the popliteal artery, which divides below the knee into the anterior and posterior tibial arteries (*see page 123*). The anterior tibial artery supplies the anterior muscles. The posterior tibial artery supplies the posterior muscles, while its branch, the peroneal artery, supplies the lateral peroneal arteries. Blood is drained from the leg though the anterior and posterior tibial veins, which join at the knee to form the popliteal vein; the peroneal vein, which drains into the posterior tibial vein; and, superficially, through the smaller saphenous vein, which empties into the saphenous vein, and the greater saphenous vein (see page 125).

Posterior view of the right leg and foot showing the bones and blood vessels.

KEY

1. Posterior tibial artery
2. Fibula
3. Tibia
4. Tarsal
5. Metatarsal
6. Phalanx

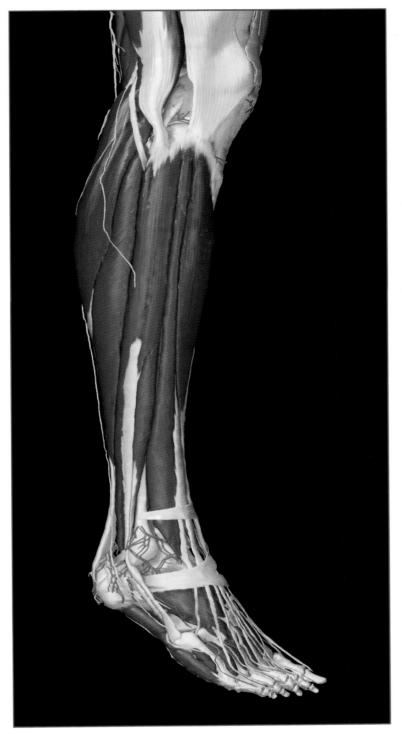

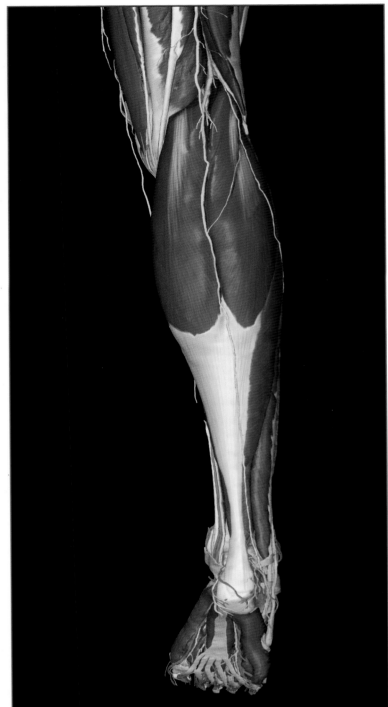

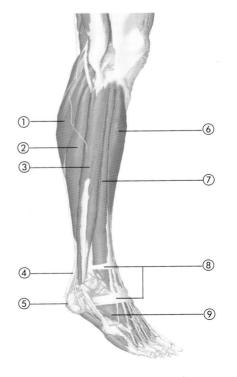

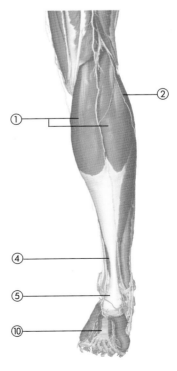

Lateral view of the right leg and foot (above left), and posterior view of the right leg and foot (above right) both showing muscles and superficial blood vessels.

KEY

① Gastrocnemius

② Soleus

③ Peroneus longus

④ Calcaneal (Achilles) tendon

⑤ Calcaneus (heel bone)

⑥ Tibialis anterior

⑦ Extensor digitorum longus

⑧ Extensor retinaculum

⑨ Extensor digitorum brevis

⑩ Plantar aponeurosis

WHILE ITS COMPONENT PARTS ARE SIMILAR TO THOSE OF THE HAND, THE FOOT HAS A VERY DIFFERENT JOB TO DO. THE FEET SUPPORT THE BODY, PROVIDE LEVERS THAT PUSH THE BODY OFF THE GROUND WHILE WALKING OR RUNNING, AND FORM A RESILIENT AND SPRINGY BASE THAT ACCEPTS THE WEIGHT OF THE BODY ON BOTH FLAT AND UNEVEN SURFACES.

THE FOOT

Plantar (underneath) view of the foot showing muscles and superficial blood vessels.

KEY

1. Plantar digital veins
2. Plantar digital arteries
3. Lumbrical
4. Abductor digiti minimi
5. Plantar aponeurosis
6. Calcaneus (heel bone)
7. Abductor hallucis
8. Flexor digitorum brevis

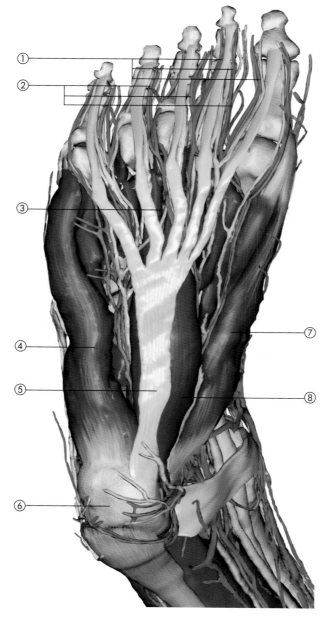

Twenty-six bones make up the framework of the foot (*see page 58*): 7 tarsal (ankle) bones; 5 metatarsal (sole bones); and 14 phalanges (toe bones). Between tarsal bones, and between tarsals and metatarsals, are plane joints that allow small gliding movements and provide limited flexibility to the bones that form the springy arches of the foot. Joints between phalanges are the same as in the hand, but the phalanges in the foot are much shorter and lack the same manipulative capabilities or functions.

The prime movers of ankle and foot movement, the leg muscles, are assisted by smaller intrinsic muscles in the foot (*see page 88*). These muscles also serve to maintain the stability of the foot as it adjusts to the constantly changing forces placed upon it. On the dorsal (upper) surface, the extensor digitorum brevis extends the toes. On the plantar surface, muscles flex, abduct (spread), and adduct the toes. Overlying the flexor digitorum brevis on the plantar surface is the plantar aponeurosis, which links the calcaneus to the toes and forms a protective sheet that holds muscles and tendons in place.

The tibial nerve serves the intrinsic muscles of the foot and the skin of the sole of the foot while the common peroneal nerve serves the skin of the upper foot. The anterior tibial artery becomes the dorsalis pedis artery as it passes through the ankle forming the arcuate artery, which gives rise to the metatarsal arteries of the sole of the foot. The posterior tibial artery divides into medial and lateral plantar arteries in the ankle. The lateral plantar artery forms the plantar arch, which gives off the digital arteries that supply the toes. Blood is drained from the toes along the digital veins, which enter the plantar arch and, via the lateral and medial plantar veins, the posterior tibial vein. The dorsalis pedis vein of the foot empties into the anterior tibial vein. Blood from the metatarsal veins drains via the venous arch into the great and small saphenous veins.

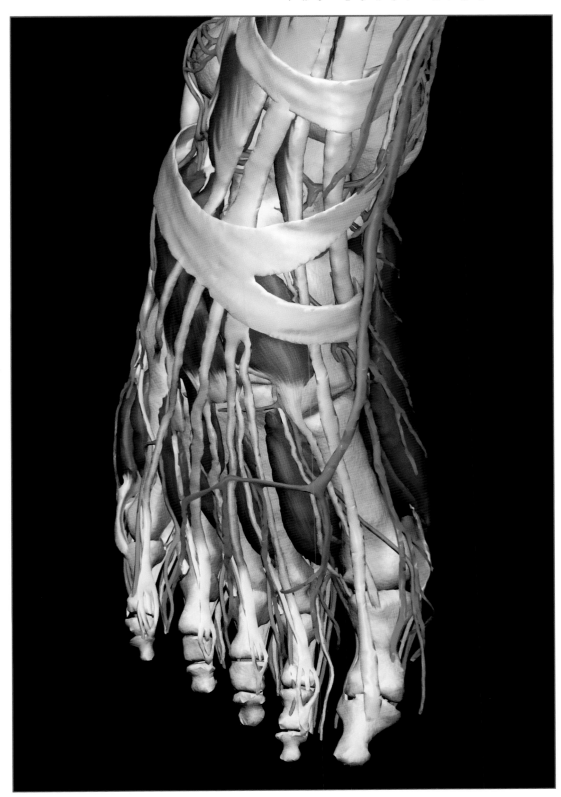

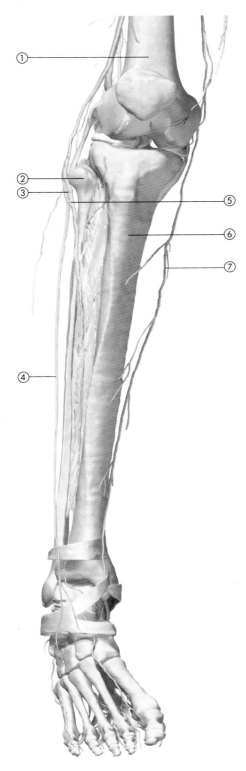

Below: anterior view of the right leg showing the bones and nerves.

KEY

1. Femur
2. Fibula
3. Common peroneal nerve
4. Superficial peroneal nerve
5. Deep peroneal nerve
6. Tibia
7. Saphenous nerve

KEY

1. Extensor digitorum longus
2. Extensor digitorum brevis
3. Tendons of extensor digitorum
4. Dorsal interosseous
5. Extensor retinacula
6. Dorsalis pedis artery
7. Metatarsal of first digit (great toe)
8. Dorsal digital arteries
9. Phalanges of first digit (great toe)

Above: view of the right foot from above, showing the muscles and superficial blood vessels.

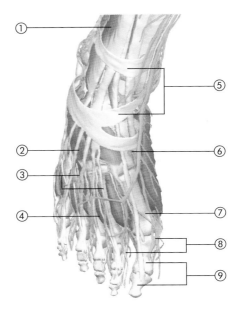

GLOSSARY

Abduction Movement of a bone or limb away from the midline of the body.

Absorption The process of absorbing simple nutrient molecules into the bloodstream.

Acini Cell clusters within the pancreas that secrete digestive juice.

Actin One of two proteins constituting the myofilament of muscle.

Adduction Movement of a limb or bone towards the midline of the body (opposite of abduction).

Adipose Fat; relating to fat.

Adrenaline *See* **epinephrine**.

Adrenocorticotropic hormone (ACTH) Hormone produced by the anterior pituitary gland in response to corticotrophin releasing hormone, produced by the hypothalamus. ACTH stimulates the adrenals to produce various steroid hormones.

Afferent Toward a center; usually relating to arteries, veins or nerves; e.g., afferent nerves carry input from sensory receptors to the central nervous system.

Agonist Prime mover; a muscle that provides the main force for a movement.

Aldosterone Hormone produced by the adrenal cortex that causes sodium retention by the kidneys.

Alpha cell Cells within the pancreatic islets of the pancreas that release the hormone, glucagon, in response to low glucose levels. Glucagon stimulates the liver to turn glycogen into glucose.

Amniotic fluid Protective fluid filling the amnion, the membrane surrounding the fetus, in which the fetus is free to move.

Ampulla A small dilation in a canal or duct.

Amylase Enzyme found in saliva that breaks down starch into maltose.

Anastomose Area where two branching communications networks, e.g., nerves, arteries, or blood vessels join.

Androgen Male sex steroid hormone. Principal mammalian androgen is testosterone.

Antagonist A muscle that opposes the action of a prime mover (e.g., the triceps brachii—the prime mover of forearm extension—is the antagonist of the biceps brachii—the prime mover of forearm flexion).

Anterior Before; in front of; in the front part of; anatomical term referring to the front part of the body, or of any structure. *See also* **ventral**.

Antibody Proteins produced by lymphocytes in response to an antigen (such as a toxin or bacteria), which the antibody then destroys.

Antidiuretic hormone (ADH) Hormone secreted by the posterior pituitary gland. Causes the kidneys to retain water, thus secreting more concentrated urine.

Aponeuroses Flat, straplike tendons that link muscle to bone and also muscle to muscle.

Arteries A blood vessel that usually carries blood away from the heart.

Atrial systole Contraction of the two atria during the cardiac cycle, causing them to empty of blood and consequently filling the ventricles.

Atrioventricular valve A valve within the heart that allows blood to flow in one direction only, from atria to ventricles.

Axial hair Secondary hair growth (armpit hair).

Axon The electrical impulse-carrying process of a nerve cell.

Bacteria Unicellular (single-celled) organisms that have an outer coating, the cell wall, in addition to a plasma membrane; do not have a nucleus or other membrane-bound organelles.

Biconvex A lens that is convex on both sides.

Bile A yellowish brown/green alkaline fluid secreted by the liver. It is discharged into the duodenum where it aids in the digestion of fats.

Binocular vision Three dimensional vision.

Bipennate A pennate muscle where fascicles are attached to both sides of the central tendon like a feather (e.g., rectus femoris).

B-lymphocyte A specialized lymphocyte that produces antibodies to a specific antigen.

Bone marrow Soft tissue filling the porous cavity of the bone shaft. Red marrow found in the ribs, vertebrae, pelvis, and skull produces blood cells; yellow marrow found in the center of long bones, consists of fatty material.

Broad ligament Fold of peritoneum that supports the uterus, uterine tubes, and vagina.

Brush border enzyme Enzymes attached to microvilli in the small intestine.

Calcitonin, *thyrocalcitonin* Hormone secreted by the parathyroid glands; decreases blood calcium levels by inhibiting bone resorption.

Calyces Small cup-shaped cavities in the kidneys formed from the branching of the renal pelvis; they cover the tips of the medullary pyramids and collect urine.

Capillaries Tiny blood vessels that link the arterial and venous systems.

Carboxypeptidase Enzyme found in pancreatic juice that breaks down proteins.

Cardiac cycle The heart beat; a regulated cycle of events that causes the heart to beat; includes systole (contraction) and diastole (relaxation).

Cardioacceleratory center Area of the medulla oblongata in the brain stem responsible for accelerating the heart rate when extra oxygen is needed.

Cardioinhibitory center Area of the medulla oblongata in the brain stem responsible for slowing the heart rate when the body is at rest.

Cartilage Specialized connective tissue found at joints; provides support and aids movement.

Catalyst Substance that speeds up a chemical reaction.

Caudal Anatomical term relating to the tail end. *See also* **inferior**.

Cellulose Polysaccharide sugar; the major nutritional constituent of grass, hay, and leaves; it forms the major energy source for herbivorous mammals.

Cerebrospinal fluid Clear fluid, similar to blood plasma; fills the ventricles of the brain, and the space surrounding the brain and spinal cord.

Cervical vertebra Seven small bones of the spine that form the neck.

Cholecystokinin A digestive hormone secreted from the wall of the duodenum; it causes contraction of the gallbladder and the subsequent release of bile into, and along, the common bile duct where it is released into the duodenum.

Chyme Semi-liquid paste produced from food by the action of gastric juice and the crushing action of the stomach.

Chymotrypsin Enzyme found in pancreatic juice that breaks down proteins.

Cilia Microscopic hairlike processes; produce a rhythmic paddling motion and that extend from the surface of many cell types. *See also* **flagella**.

Circumvallate papillae The largest of the papillae, to be found at the rear of the tongue; contain taste buds.

Collagen Tough, fibrous protein found in bone fibers, cartilage, and connective tissue.

Concave A surface that is depressed or is hollowed.

Conchae A shell-shaped structure projecting from the lateral wall of the nasal cavity.

Cones One of two types of photoreceptor cells found in the retina; very sensitive to color but not to light.

Convex A surface that is evenly curved or bulging outward.

Core body temperature The temperature of the inner body—the organs—as opposed to that of the skin.

Coronal Relating to a corona or crown.

Corpus cavernosa ("cavernous body") One of two parallel columns of erectile tissue in the penis.

Corpus spongiosum ("spongy body") Median column of erectile tissue located between the corpus cavernosa; terminates as the enlarged glans penis and is traversed by the urethra.

Corticosteroid Steroid hormones produced by the adrenal cortex. There are three groups: glucocorticoids, mineralocorticoids and gonadocorticoids.

Cortisol Glucocorticoid hormone; stabilizes blood glucose levels.

Coxal Of, or relating to, the hip.

Cranial Relating to the cranium or head; anatomical term referring to anything headward. *See also* **superior**.

Cupula A cup-shaped or domelike structure; the domelike end of the cochlea.

Dendrites Branched processes that carry nerve impulses towards the cell body.

Depression A downward movement; opposite of elevation; a movement that flattens or lowers a body part.

Diaphysis Bone shaft; composed of compact bone.

Diastole The dilation of the atria and the ventricles during the cardiac cycle, causing the atria to fill with blood.

Diffusion A passive-transport mechanism. The movement of molecules from an area of high concentration into an area of low concentration until the two are evenly balanced.

Digestion Breakdown of foods into simpler nutrient molecules.

Distal Situated away from the center of the body; anatomical term usually referring to an extremity or distant part of a limb or organ.

Dorsal Relating to the back, or back part of the body or organ. *See also* **posterior**.

Dorsiflexion Flexion of the foot (bending upwards).

Ductus arteriosus A blood vessel in the fetus that connects the left pulmonary artery with the abdominal aorta; allows fetal blood to bypass the nonfunctioning fetal lungs.

Effector A tissue complex capable of an effective response to the stimulus of a nervous impulse.

Egestion Elimination of undigested food.

Ejaculation The expulsion or emission of semen through the penis via the urethra.

Elastin The major fibrous connective tissue protein found in elastic structures.

Elevation A movement that raises a body part; lifting upward.

Endochondral Situated within, or taking place within cartilage.

Endocrine Secreting internally; usually refers to a gland that produces an internal secretion (such as a hormone).

Endothelium A layer of smooth, flat cells lining blood and lymphatic vessels; inner mucous membrane lining the uterus.

Enzyme Proteins that act as biological catalysts.

Epimysium A sheath of connective tissue binding groups of muscle fascicles.

Epinephrine, *adrenaline* Hormone secreted by the adrenal medulla in response to stimulation by the autonomic nervous system. It increases metabolic rates in preparation for the 'fight or flight' response.

Epineurium Outer connective tissue sheath surrounding bundles of nerve fascicles and the nerve's blood vessels.

Epiphysis Extremity (bone end); composed of spongy bone tissue.

Erythropoietin Hormone released by the kidneys. It stimulates the production of red blood cells.

Estrogen Family of sex hormones produced by the ovaries. Cause maturation and maintenance of the female reproductive system; responsible for the development of secondary female sexual characteristics; prepares the body for pregnancy.

Evert Turning the sole of the foot outward; opposite of inversion.

Exocrine Glandular secretion that is delivered to a surface through a duct.

Extension An increase in the angle of a joint (opposite of flexion).

Extracellular Outside cells.

Falciform ligament A crescent shaped fold of peritoneum that extends from the diaphragm to the liver and anchors the liver the anterior wall of the abdomen.

Fascicle A bundle of muscle or nerve fibers.

Feces Semi-solid, undigested matter that is stored in the large intestine until such time as it is excreted; consists of undigested food, epithelium, intestinal mucus and bacteria.

Feedback mechanism The return, as input, of output of a given system; functions as a regulatory mechanism.

Fetus An unborn embryo after 13 weeks development; the unborn young of a mammal that has taken form in the uterus; the product of conception.

Fibrin The insoluble, stringy plasma protein that forms the essential part of a blood clot.

Fibrinogen The inactive form of a coagulative protein; it is converted into insoluble fibrin during clot formation.

Filiform papillae Pointed papillae covering the surface of the tongue. The most numerous of the papillae, they give the tongue its rough surface.

Fixator A synergist that provides a stable origin for the action of the prime mover.

Flagellum (*pl.* flagella) A whiplike appendage of certain cells; used for locomotory purposes to propel a cell through a fluid environment; a whiplike, locomotory organelle.

Flatus Gas produced by anaerobic bacteria in the large intestine.

Flexion A decrease in the angle of a joint.

Follicle A small sac or secretory cavity.

Follicle-stimulating hormone Hormone secreted by the anterior pituitary gland; stimulates egg maturation and estrogen release in the ovary, and testosterone production.

Foramen ovale ("oval opening") The hole between the two atria in the fetal heart, diverting approximately one-third of the blood that arrives in the right atrium directly into the left atrium.

Foramen A natural opening or hole through a bone.

Foregut The upper (cranial) portion of the primitive alimentary canal in the embryo; eventually forms the esophagus, stomach, duodenum, liver, and pancreas.

Fulcrum The point on which a lever turns.

Fundus Upper region of the stomach.

Fungiform papillae Mushroom-shaped papillae scattered irregularly over the surface of the tongue; contain taste buds.

Ganglion A swelling at the junction between the preganglionic and postganglionic neurons.

Gastric pits Depressions within the lining of the stomach; contain glands that produce stomach acid (gastric juice).

Glans A conical acorn-shaped structure (often refers to glans penis; the conical extension of the corpus spongiosum forming the head of the penis).

Glomerular capsule Cup-shaped end of the renal tubule.

Glomerulus Mass of blood capillaries within the nephron of the kidney.

Glucagon Hormone produced by the pancreas that promotes the conversion of glycogen into glucose.

Glucocorticoid Corticosteroids produced by the adrenals; important in protein and carbohydrate metabolism.

Glucose A simple sugar, very important in metabolism and the principle source of energy for the brain.

Glycogen A polysaccharide broken down by glucagon into glucose; the principle carbohydrate reserve.

Gonadocorticoid Androgens or male sex hormones.

Gonadotrophic hormones Hormones (luteinizing hormone and follicle stimulating hormone) released from the pituitary; influence the activity of the gonads.

Granulocyte A white blood cell; it detects, surrounds, engulfs, and digests pathogens.

Growth hormone (GH) Hormone secreted by the anterior pituitary gland; stimulates growth during childhood and adolescence, and converts glycogen into glucose.

Gyrus (*pl.* **gyri**) A convolution (ridge) in the cortex of the cerebral hemisphere of the brain, separated by sulci.

Haustra The pouches or bulges in the colon formed by the uneven pull of the teniae coli.

Hemoglobin The globular iron-containing protein found in red blood cells; responsible for oxygen and carbon dioxide transport.

Hepatocyte A liver cell.

Hilus A small indent or depression in an organ where arteries, veins, and nerves enter and leave.

Hindgut The caudal or terminal portion of the embryonic alimentary canal; eventually forms the large intestine, rectum and anal canal.

Homeostasis The state of balance and stability that exist inside a healthy body regardless of changes in the internal and external environments.

Hormone Chemicals synthesized and secreted by endocrine glands into the bloodstream; may have local or general effects.

Hydrolysis The splitting of a compound by the addition of water.

Ileocecal valve Valve separating the ileum from the large intestine.

Inferior Lower; below, in relation to another structure. *See also* **caudal**.

Ingestion Process by which food is taken into the body.

Insertion The end of a muscle to which is attached a moving bone.

Inspiratory center Area of the brain stem that controls breathing rate and depth.

Insulin Pancreatic hormone that regulates sugar levels; facilitates the conversion of glucose into glycogen.

Interstitial cells, *Leydig cells* Cells of the testes that produce testosterone on stimulation with luteinizing hormone.

Interstitial fluid Fluid found between cells that bathes and nourishes surrounding body tissues.

Intervertebral disc Jellylike cartilaginous pad that lies between each vertebra.

Intracellular Inside cells.

Intramembranous Inside membrane.

Invert Turning the sole of the foot inward; opposite of eversion.

Islets of Langerhans Microscopic endocrine cells of the pancreas. There are three types: alpha cells secrete glucagon; beta cells secrete insulin and delta cells secrete gastrin.

Isometric contraction Muscle contraction whereby tension develops and the muscle exerts a pulling force, but does not shorten due to opposing forces.

Isotonic contraction Muscle contraction whereby the muscle contracts and gets shorter, causing movement.

Keratin A tough protein that forms the outer layer of hair and nails; soft in hair and hard in nails.

Lactase The enzyme that breaks down lactose (milk sugar) into glucose and galactose in the small intestine.

Lacteal Lymphatic capillary network that extends into the villi of the small intestine.

Lateral Away from the midline of the body (to the side).

Leydig cells *See* **interstitial cells**.

Libido Conscious or unconscious sexual desire. A term introduced by Freud.

Lipase Enzyme found in pancreatic juice that breaks down fats.

Lumbar vertebra The five large bones that form the small of the back.

Lumen The interior space within a tube-shaped structure or body.

Luteinizing hormone (LH) Hormone secreted by the anterior pituitary gland. It stimulates ovulation and progesterone secretion in females, and testosterone secretion in males.

Lymphocyte A white blood cell formed in lymphatic tissue; main producers of antibodies.

Macrophage Any large mononuclear phagocytic cell; may be wandering or fixed.

Macula lutea The central area of the retina; only contains cones.

Maltase Brush border enzyme found in pancreatic juice; breaks down maltose into glucose.

Mammary gland The breast; rounded eminence composed mainly of adipose (fat) and glandular tissue; produces milk during lactation.

Median An anatomical term. Towards the midline of the body.

Mediastinum The thin-walled cavity between the two lungs. It contains the esophagus, trachea, blood, and lymphatic vessels, and also the pericardial cavity.

Medullary pyramids Cone-shaped filtration units within the inner core of the kidney.

Meninges The three protective tissue layers (dura mater, arachnoid mater, and pia mater) that surround and encase the brain and spinal cord.

Menopause The cessation of the menstrual cycle in the mature female.

Menstrual cycle The monthly cycle of events occurring between puberty and the menopause that prepares the uterus for pregnancy. If pregnancy does not occur, the endometrium, mucus, and blood discharge through the vagina.

Mesentary Fused and folded layers of visceral peritoneum that attach abdominopelvic organs to the cavity wall.

Mesocolon The fold of visceral peritoneum that attaches the colon to the posterior abdominal wall.

Mesometrium Part of the broad and round ligaments; secures the uterus in the pelvic cavity.

Metabolism The sum of all physical and chemical processes that occur in the body. May either build up or breakdown substances.

Microvilli Microscopic hair-like projections lining the intestinal surface.

Midgut The central portion of the alimentary canal in the embryo (small intestine); situated between the foregut and the hindgut;

Mineralocorticoid A corticosteroid hormone secreted by the adrenal cortex. Maintains salt (sodium and potassium) levels.

Mitral valve The left atrioventricular heart valve; also known as the bicuspid valve.

Monochrome Single color; images generated by the rods of the retina.

Monocyte Mononuclear phagocytes formed in bone marrow and transported to tissues where they develop into macrophages.

Motor neuron Carry motor output from the CNS to muscles and glands.

Multipennate A pennate muscle with many bipennate units (e.g., deltoid).

Myofibril Small fibers within a single muscle fiber. Each fiber is packed with thousands of myofibrils that run the entire length of the muscle fiber.

Myoglobin The red pigment, similar to hemoglobin that is found in muscles.

Myometrium The middle, muscular layer of the uterus.

Myosin A large protein that makes up the thick myofilaments of muscle fibers.

Nephron The functional filtration unit of the kidney; each kidney contains millions of nephrons, all of which independently filter blood to produce urine; microscopic unit within kidney that filters blood to produce urine.

Nerve impulses Electrical signal that passes at high speed from one end of a nerve to another.

Neurons Nerve cells.

Neurotransmitter Chemical released from the synaptic knob of a neuron, which travels across the synapse generating a nerve impulse in the recipient neuron.

Nipple Cylindrical or conical projection from just below the center of the breast, from where glandular secretions (colostrum and breastmilk) are emitted.

Nitrogenous Nitrogen containing.

Noradrenaline *See* **norepinephrine**.

Norepinephrine, *noradrenaline* Hormone secreted by the adrenal medulla in response to stimulation by the autonomic nervous system. It increases metabolic rates in preparation for the 'fight or flight' response.

Nuclease Enzyme found in pancreatic juice that breaks down nucleic acids (such as DNA).

Nucleus A large spherical membrane-bound cellular organelle; present in most cells, it contains most of the cell's DNA and RNA; a cluster of neuronal cell bodies in the CNS.

Olfactory Pertaining to the sense of smell.

Omentum (*pl.* **omenta**) The fold of peritoneum that encloses the main digestive organs and hangs like an apron in front of the intestines.

Oocyte An immature ovum (egg).

Opposition Movement of the thumb to touch (oppose) the tip of another finger.

Organ of Corti The organ of hearing.

Origin The end of a muscle attached to a bone that does not move.

Osseous Bony.

Ossicles The bones of the ear; malleus (hammer), incus (anvil), and stapes (stirrup).

Ossification The formation of bone from soft hyaline cartilage or fibrous membrane.

Osteoblast Bone cell capable of forming new bone matrix; usually found on the growing portions of bones.

Osteoclast A multinuclear cell capable of destroying bone; usually found at places of bone resorption.

Osteocyte Bone cell found in mature bone tissue; helps to regulate calcium concentrations in the body by releasing calcium from bone into the blood. The principle type of cell found in bone.

Osteon Concentric cylinder of calcified bone that makes up compact bone.

Ovarian cycle The monthly cycle of events leading up to the release of a mature egg or ovum.

Ovarian ligament Ligament that anchors each ovary medially to the uterus.

Ovulation Monthly process in which a mature egg (ovum) is released from the ovary in preparation to be fertilized.

Ovum An egg; the female sex cell.

Oxytocin Hormone secreted by the pituitary; stimulates uterine contractions during labor and the release of breastmilk.

Papillae Small projections on the surface of the tongue, palate, throat, and posterior surface of the epiglottis that contain taste buds.

Parathormone *See* **parathyroid hormone**.

Parathyroid hormone (PTH), *parathormone* Hormone released by the parathyroid glands; helps to raise blood calcium levels.

Parietal peritoneum The serous membrane that lines the outer wall of the abdominal cavity.

Pathogens A virus, microorganism or other foreign substance that causes disease.

Pennate muscle A muscle where the fascicles are arranged obliquely to a long tendon.

Peptidase Brush border enzyme; breaks down peptides into amino acids.

Pericardial cavity Fluid-filled cavity that lies between the pericardia, the serous membranes that cover the heart and line the thoracic cavity; allows the heart to contact without friction.

Perimetrium Layer of visceral peritoneum that surrounds the uterus; the serous coat of the uterus.

Perimysium A connective tissue sheath that binds each muscle fascicle.

Perineurium Sheath of connective tissue surrounding each nerve fascicle.

Periosteum Membrane that covers bone.

Peripheral vision The outer edge of the visual field.

Peristalsis Wave of successive muscle contractions and relaxations that push substances through biological tubes (e.g., food through the esophagus, urine through the ureter).

pH Measure of the acidity or alkalinity of a solution.

Phagocyte A scavenger cell that engulfs and digests other cells, bacteria, microorganisms or foreign matter.

Photoreceptors Light sensitive sensory receptors that are found in the retina.

Placenta A thick spongy tissue bed containing a rich supply of blood vessels that forms in the wall of the uterus during pregnancy. It supplies nutrients to the fetus and in return collects waste material via the umbilical cord.

Plantar flexion Extension (straightening) of the foot.

Platelets A cell fragment found in blood that is important for blood clotting.

Pleura (*pl.* **pleurae**) The serous membrane covering the lungs and lining the walls of the pleural cavity.

Plicae circulares Circular folds in the small intestine that increase the available surface area for the absorption of nutrients.

Porta hepatis Area of the liver, situated on the lower posterior surface through which blood vessels, nerves, lymphatics, and ducts enter and leave the liver.

Posterior Behind, after; opposite of anterior. *See also* **dorsal**.

Postganglionic Second (recipient) neuron in the two neuron chain of the ANS.

Preganglionic First neuron in a two neuron chain of the ANS.

Primary visual cortex Area of the brain (located in the occipital lobe) that perceives and interprets visual images.

Prolactin Hormone that encourages breast tissue growth and milk production.

Pronation A movement of the forearm that turns the palm downward; opposite of supination (turning the palm downward).

Prostate A male secretory gland surrounding the urethra at the neck of the bladder. Its secretions reduce vaginal acidity and increase sperm motility.

Proximal Situated nearer or towards the center of the body (or attached end of a limb); anatomical term usually referring to a limb or organ; opposite of distal.

Puberty The state of reaching sexual maturity. When one is capable of sexual reproduction.

Pulmonary Pertaining to the lungs.

Pulmonary circuit The circuit whereby deoxygenated blood is pumped by the right side of the heart to the lungs via the pulmonary artery. Oxygenated blood is returned to the left side of the heart via the pulmonary vein.

Pylorus Funnel-shaped lower region of the stomach that links with the duodenum.

Rectal valves Three transverse folds within the rectum that enable feces to be separated from flatus, enabling flatus to be voided without pushing out feces.

Refraction The bending of light waves as they pass between two mediums of different densities.

Releasing factor Hormone secreted by the hypothalamus that stimulates the release of pituitary hormones.

Renal capsule One of three tissue layers that surrounds the kidney; a fibrous coat that helps to prevent the spread of infection into the kidney.

Renal fascia The third and outermost tissue layer surrounding the kidney; it anchors it to the abdominal wall.

Renal sinus Central recess within the kidney that follows on from the hilus; is continuous with the renal capsule and is almost entirely filled with the renal pelvis and renal vessels.

Renal tubule Tube that loops between cortex and medulla of kidney (part of the nephron) and that empties into the renal pelvis through a collecting duct.

Reposition Movement of the thumb away from the tip of another finger.

Retinacula Flat, fibrous straps that hold tendons in place.

Retroperitoneal Located external or posterior to the abdominopelvic cavity and the peritoneum.

Rods One of two types of photoreceptor cells found in the retina; they are very sensitive to light but not to color.

Rostral Situated at, or directed towards the anterior end of an organism.

Rotation A pivoting movement that twists a body part on its long axis; movement of a bone around its long axis.

Rotator cuff muscles The four scapula muscles (supraspinatus, infraspinatus, teres minor, and subscapularis) that stabilize the shoulder joint.

Rugae Folds or ridges within the lining of a tissue, such as the stomach or vagina.

Saccule A small sac or pouch. The smaller of the two balance detectors in the vestibule of the ear.

Sagittal A plane of section in the line of an arrow shot from a bow. *See also* **median**.

Sarcomere Fundamental unit of muscle contraction; consists of parallel arrays of actin and myosin, contractile protein filaments; chains of linked sarcomeres make up the myofibril.

Sebum The oily secretion found at the base of hair follicles.

Segmentation The act of dividing into segments; a term used to refer to the mixing of food in the small intestine.

Semen Male penile ejaculatory fluid containing sperm and other secretions from the epididymis, prostate gland, seminal vesicles, and bulbourethral gland.

Semilunar valve Valves within the heart that prevent blood in the pulmonary artery and aorta from flowing back into the ventricles.

Seminiferous tubules Coiled tubes in the testes that produce sperm.

Sensory neuron Carries input from sensory receptors to the CNS.

Sharpey's fibers Extensions of collagen fibers that anchor a tendon to its base.

Sinoatrial node The heart's pacemaker; a node within the wall of the right atrium that sends out regular electrical impulses that cause the atria to contract.

Sinusoids Blood channels found within certain organs (liver, spleen, red bone marrow).

Sphincter A ring-shaped muscle that acts as a valve; a circular muscle with concentric rows of fascicles.

Stratum (*pl.* **strata**) Layer or layers that form any given structure, such as the skin or the retina.

Substrate The substance acted upon and changed by an enzyme.

Sucrase Enzyme that catalyzes the hydrolysis of sucrose into glucose and fructose.

Sulcus A groove (fold) in the surface of the cerebral hemisphere of the brain, separated by gyri.

Superior Above, toward the head; a directional term. *See also* **cranial**.

Supination A movement of the forearm that turns the palm upward; opposite of pronation; movement of the radius around the ulna.

Suspensory ligament Ligament that anchors each ovary laterally to the pelvic wall.

Suture Fixed immovable joint between two bones.

Synapse Junction between two neurons.

Synergist A muscle that complements the action of a prime mover.

Synovial fluid Oily fluid that lubricates the cartilage covering the end of each bone, allowing them to slide over one another.

Teniae coli ("ribbons of the colon") Where the bands of the outer longitudinal muscle layer of the colon are collected; the muscle tone produced by this forms pouches called haustra.

Testosterone Male sex hormone produced by the interstitial (Leydig) cells of the testes (or the adrenals in women); aids sperm production and is necessary for the development of male reproductive organs and secondary sexual characteristics.

Thyrocalcitonin *See* **calcitonin**.

Thoracic cavity The cavity formed from the 12 thoracic vertebrae, the 12 pairs of ribs and the sternum; separated internally into smaller cavities, it houses the chief organs of the circulatory and respiratory systems.

Thoracic vertebra The 12 bones that make up the middle part of the spine.

Thyroid hormone Combination of triiodothyronine and thyroxine released by the thyroid gland; functions as the body's "accelerator pedal" to speed up metabolic rate; helps promote growth and ensures normal functioning of the heart and nervous system.

Thyroid-stimulating hormone (TSH) Hormone released by the anterior pituitary gland. It stimulates the release of thyroid hormone by the thyroid gland.

Thyroxine Hormone released by the thyroid gland. It increases metabolism and the sensitivity of the cardiovascular system to the nervous system.

Trabeculae Tiny spikes of bone tissue surrounded by calcified bone matrix; predominantly found in the interior of spongy bone.

Tricuspid valve The right atrioventricular heart valve.

Triiodothyronine Hormone released by the thyroid gland; increases metabolism and the sensitivity of the cardiovascular system.

Trypsin Enzyme found in pancreatic juice that breaks down proteins.

Tunica adventitia The tough fibrous outer layer of an arterial wall; consists mainly of collagen fibers and elastic tissue.

Tunica intima The inner lining of the lumen of an artery.

Tunica media The middle, and thickest, layer of an arterial wall; consists of smooth muscle and elastic tissue.

Umbilical cord A tube that connects the embryo and the placenta; carries oxygen and nutrients to the embryo, and carbon dioxide and nitrogenous waste matter from the embryo.

Unipennate A pennate muscle where fascicles are attached to one side of the tendon (e.g., extensor digitorum longus).

Urea Nitrogenous waste product produced by the chemical breakdown of proteins in the body; excreted in urine.

Urethra The duct through which urine (and semen in the male) passes from the bladder to the exterior.

Urine Excretory waste fluid produced by the kidneys; consists mainly of water, urea, salts, phosphates, sulfates, creatinine and uric acid.

Uterus A hollow, muscular organ situated behind the bladder that houses, nourishes and protects the developing fetus.

Utricle The larger of the two balance detectors in the ear.

Vas deferens The excretory duct of each testicle, extending between the epididymis of each testicle and the ejaculatory duct.

Veins A blood vessel that usually carries deoxygenated blood to the heart.

Ventral Directional term; towards the front of the body. *See also* **anterior**.

Ventricular systole Contraction of the ventricles during the cardiac cycle, causing the ventricle to empty of blood.

Vesico-uterine pouch Fold of peritoneum that forms behind the bladder and in front of the neck of the uterus.

Vestibule A cavity, chamber, or channel serving as an approach or entrance to another cavity; refers to the central chamber of the labyrinth of the middle ear.

Villi Tiny fingerlike processes in the mucosa of the small intestine that increase the available surface area.

Virus The specific agent of an infectious disease; a group of microorganisms; consist of a coat of protein units arranged around a central nucleic acid (RNA or DNA) core.

Viscera The internal organs of the body.

Visceral peritoneum The serous membrane that covers the abdominal organs.

Visual association area Area of brain (surrounding primary visual cortex) that compares incoming visual information with previously seen images, allowing recognition of familiar objects/faces.

White pulp Area of the spleen involved in the immune response; consists of suspended lymphocytes that generate antibody producing cells.

FURTHER READING

Agur AMR (1995) *Grant's Atlas of Anatomy*. Lippincott Williams & Wilkins, Philadelphia, USA.

Alcamo E (1997) *Anatomy Coloring Workbook*. Random House USA Inc, NY, USA.

Bastian G (1993) *The Cardiovasuclar System*. Addision Wesley Longman Higher Education, NY, USA.

Bastian G (1993) *The Lymphatic and Immune System*. Addison Wesley Longman Higher Education, NY, USA.

Bastian G (1993) *The Muscular and Skeletal Systems*. Addison Wesley Longman Higher Education, NY, USA.

Bastian G (1993) *The Nervous System*. Addison Wesley Longman Higher Education, NY, USA.

Bastian G (1993) *The Reproductive System*. Addison Wesley Longman Higher Education, NY, USA.

Bastian G (1993) *The Urinary System*. Addison Wesley Longman Higher Education, NY, USA.

Chase RA (1989) *The Bassett Atlas of Human Anatomy*. Gruber WB, Bassett DL (Photographers) Addison-Wesley Publishing Co, NY, USA.

Clemente CD and Nathwani B (1997) *Anatomy: A Regional Atlas of the Human Body (4th Edition)*. Lippincott, Williams & Wilkins, Philadelphia, USA.

Ellis H, Logan B and Dixon A (1994) *Human Cross-sectional Anatomy Pocket Atlas*: Body Sections and CT Images. Butterworth-Heinemann, Oxford, UK.

Hale RB and Coyle, T (1988) *Albinus on Anatomy*. Dover Publications, NY, USA.

Netter FH (1997) *Atlas of Human Anatomy (2nd Edition)*. Dalley AF II (Consulting Editor). Novartis, NJ, USA.

Pernkopf E (1989) *Atlas of Topographical and Applied Human Anatomy (3rd Edition)*. Williams & Wilkins, Baltimore, USA.

Roberts JB and Tomlinson JDW (1992) *The Fabric of the Body*. Oxford University Press, Oxford, UK.

Rogers Peck S (1990) *Atlas of Human Anatomy for the Artist*. Oxford University Press, Oxford, UK.

Rohen JW, Yokochi C and Lutjen-Drecoll E (1999) *Color Atlas of Anatomy: A Photographic Study of the Human Body (4th Edition)*. Lippincott, Williams & Wilkins, Philadelphia, USA.

Romanes GJ (1986) *Cunningham's Manual of Practical Anatomy: Volume 2. Thorax and Abdomen*. Oxford University Press, Oxford, UK.

Romanes GJ (1986) *Cunningham's Manual of Practical Anatomy: Volume 3. Head and Neck and Brain*. Oxford University Press, Oxford, Uk.

Saunders JB deCM and O'Malley CD (1973) *The Illustrations from the Works of Andreas Vesalius of Brussels*. Dover Publications, NY, USA.

Schider F (1981) *An Atlas of Anatomy for Artists (3rd Edition)*. Wolf B (Translator), Dover Publications, NY, USA.

Schlossberg L (Illustrator) (1997) *The Johns Hopkins Atlas of Human Functional Anatomy (4th Edition)*. Zuidema GD (Editor). Johns Hopkins University Press, MA, USA.

Schoen M and Quay MJ (1990) *Bellybuttons Are Navels* (Young Readers Series) Prometheus Books, Loughton, UK.

Sinnatamby CS (1999) *Last's Anatomy*. Churchill Livingstone, Edinburgh, UK.

Snell RS (1995) *Clinical Anatomy for Medical Students*. Lippincott Williams & Wilkins, Philadelphia, USA.

Sobotta J (1990) *Atlas of Human Anatomy: Head Neck, Upper Extremities (11th Edition)*. Williams & Wilkins, Baltimore, USA.

Sobotta J (1990) *Atlas of Human Anatomy: Thorax, Abdomen, Pelvis, Lower Limbs, Skin (11th Edition)*. Williams & Wilkins, Baltimore, USA.

Spitzer VM and Whitlock DG (1998) *National Library of Medicine Atlas of the Visible Human Male: Reverse Engineering of the Human Body*. Jones and Bartlett Publishers, Inc. London, UK.

Tenllado AM (1997) *Atlas of Anatomy*. Parramon's Editorial Team. Barrons Educational Series, UK.

Tortora G (1998) *Atlas of Human Anatomy and Physiology*. Addison-Wesley Publishing Co, NY, USA.

Van de Graaff KM (1996) *A Photographic Atlas for the Anatomy and Physiology Laboratory*. Morton Publishing, CO, USA.

Weir J and Abrahams PH (1996) *Imaging Atlas of Human Anatomy*. Mosby, St. Louis, USA.

Wilkins Williams R (1991) *Grant's Atlas of Anatomy (9th Edition)*. Williams & Wilkins, Baltimore, USA.

Williams PL (1995) *Gray's Anatomy (38th Edition)*. Churchill Livingstone, Edinburgh, UK.

INDEX

Page numbers in **bold type** refer to main discussions of a subject; page numbers in *italic* refer to diagrams.

N

nails 36
nares 104, *105*, *129*, *138*
nasal bone *43*, 44, *45*, *165*, *171*
nasal cartilage *163*
nasal cavity 42, 44, 94, 104, *105*, 130, 170
nasal septum 44, 104, *138*
nasal vestibule *131*
nasalis 67
nasolacrimal duct 170
nasopharynx *105*, *138*
navicular 58, *58*, *59*
neck **66**, **68**, 76, *111*, *139*, **162**, *163*, *164*, **164**, *165*
nephrons 150, 200
nerve fibers 96, 100
nerve impulses 44, 90, 92, 98, 102, 110, 112, 150, 174, 180
nervous system **90**, *91*, 106, 110
　function 90
　motor output 90
　nervous transmission 92
　processing and integration
　　function 90
　sensory input 90
　see also autonomic nervous
　　system; central nervous
　　system ; peripheral nervous
　　system
Netter, Frank H. 17
neural arch 46
neurons 90, **92**, 106
　association neurons 92, 96
　motor neurons 90, 92, 96, 98
　postganglionic neurons 98
　preganglionic neurons 98
　random firing 94
　sensory neurons 90, 92, 96, 98
neurotransmitters 92
nicotine 94
nipples 176
nitrogenous compounds 148
noradrenaline 113
norepinephrine 112, 113
nose 25, 38, 44, **104**, *105*, 128, **130**, *131*, 162
nostrils 66, 104, *129*, 130, *138*
nucleases 142
nucleic acids 142
nutrients 120, 124, 134, 144, 192, 196, 204

O

oblique muscles 170, *170*, 172, *173*
obturator nerve 216
occipital bone 42, 44, 45
occipital condyle 42, *42*
occipital lobe 100, 166
occipitalis 63, 68, *68*
oculomotor nerves 94, *95*, 99
olecranon *51*, 76, *78*, *79*
olfactory cortex 104
olfactory epithelium 104, *105*
olfactory nerve 94, *95*, 104
olfactory receptors 104
olfactory sensors 162
olfactory tracts 104
omenta *187*, 188, 190
oocytes 116
opponens pollicis 214
opposition 214
optic chiasma 95
optic nerve 25, 94, *95*, 100, *101*, 170, 172, *172*, *173*
oral cavity *131*
orbicularis oculi *61*, 66, *67*, *163*
orbicularis oris *61*, 66, *67*, *163*
orbits 42, *43*, 44, 66, 170, *171*
organ of Corti 174
oropharynx *138*
osseous tissue 40, 42, 52
ossicles 42, 102, *103*, 174, *174*
ossification 42, 52
　endochondral ossification 42, 52
　intramembranous ossification 42
osteoblasts 40, 42, 52, 56
osteoclasts 40, 56
osteocytes 40
osteons 40
ova 116, 152, 156, 158, 206
　fertilization 116, 152, 158
ovarian cycle 116, 156
ovarian ligament 206, *206*
ovaries 106, 108, **116**, *117*, 152, 156, *156*, *157*, 158, *159*, *203*, 206, *206*, *207*, *208*
ovulation 108, 156
oxygen 76, 94, 112, 120, 122, 124, 126, 128, 132, 180, 184
oxytocin 108

P

palate 104
　hard palate 44, 138, *138*
　soft palate 138, *138*
palatine bone 42, 44
palm 36, 50, 52, 80, 212
palmar aponeurosis *215*
palmar arches 214, *215*
palmaris longus *61*, 80, *81*
pancreas 106, *107*, **114**, *115*, *135*, 136, *137*, **142**, *143*, 186, 188, *189*, *191*, *192*
　pancreatic duct 142
　pancreatic islets 114
　pancreatic juices 142, 144
papillae 164
paranasal sinuses *129*, 130
parasympathetic fibers 184
parasympathetic nervous system 98
parathyroid glands 106, *107*, **110**
parathyroid hormone (PTH) 110
paravertebral ganglion *99*
parietal bone 42, *43*, 44, *45*, 165
parietal lobe 166
parietal peritoneum 188, 196, 202, 204
parotid gland *165*
patella 38, *39*, *41*, 56, *56*, 84, 85, 216, *217*
patellar ligament 85
pathogens 122, 124, 126, 194
pectineus 83, 84, *85*, *217*
pectoral girdle 40, 50
pectoral muscles *177*
pectoralis major *61*, 70, *70*, 72, 74, *74*, 176, *177*, *186*, 210
pectoralis minor 70, *70*, 72, 176
pelvic bones 38
pelvic diaphragm 202, 208
pelvic floor muscles 150, 188, 202, 208
pelvic girdle *39*, 40, 54, 82, 84, 86, *157*, 202
pelvic inlet 54, *208*
pelvic outlet 208, *208*
pelvic splanchnic nerves *99*
pelvis 40, 44, 46, **54-55**, 83, **84**, 86, *87*, *135*, 136, *137*, *186*, *187*, 188, *189*, *191*, 195, 197, *202-209*, **202**, *203*, *204*, *205*, *206*, *207*, *217*

female pelvis 54, *54*, *55*, *106*, 202, *203*, *205*, *207*, 208-209, *208*, *209*, 206
male pelvis 54, *54*, *55*, *106*, 202, 204
penis *118*, 148, *149*, 152, *152*, *153*, 154, *155*, 158, 204, 208
pepsin 140
peptidases 144
peptides 140
pericardia 178
pericardial cavity 178
pericardium 182
perimetrium 206
perimysium 64
perineal muscles 208
perineum 208
perineurium 96
periosteum 40, 78
peripheral nervous system 90, 96, 98
peripheral vision 172
peristalsis 136, 140, 146, 150, 196, 198
peritoneal membranes 190
peritoneum 188, 208
Pernkopf, Eduard 16
peroneal artery *120*, *123*, 218
peroneal nerve 218, 220, *221*
peroneal vein *120*, 218
peroneus brevis 62, 88, *89*
peroneus longus *61*, 62, 88, *89*, *219*
peroneus tertius 88, *89*
pH environment 140
phagocytic cells 194
phalanges 52, *53*, *57*, 58, *58*, *59*, 210, 214, *215*, 218, 220, *221*
pharynx 104, *129*, 130-1, *131*, 136, 138, 188
phosphate 40
photoreceptors 100, 172
phrenic nerves 178, 180
pia mater 166
pineal gland 106
pinna 102, *103*, 174, *174*
pisiform 52, *53*
pituitary gland 106, *107*, **108**, *109*, 110, 116, 118, *167*, *169*
pituitary hormones 108, 154, 156
placenta 128, 188
planes of section 32, *32*

ACKNOWLEDGEMENTS

The publisher and Anatographica LLC would like to thank the following for
providing illustrations for this book.

All digital images of Human Anatomy derived from the
Visible Human Project™ © Visible Productions LLC.

Illustrations on p.60–63, 90, 91, 98, 99, 126, 127, 154, 155, 158, 159,
© Visible Productions LLC.

The locator images on pages 36–158, and 160–220
by Beatriz Waller for Anatographica LLC.

Historical images p.12, p.14, p.15 (top and bottom),
p.16, p.17, p.21, provided by Agile Rabbit Editions.

Images from the Visible Human Project™ p.24, p.25, p.138, p.139 (top)
provided by Dr Vic Spitzer, PhD, Center for Human Simulation,
University of Colorado Health Sciences Center, Aurora, Colorado.